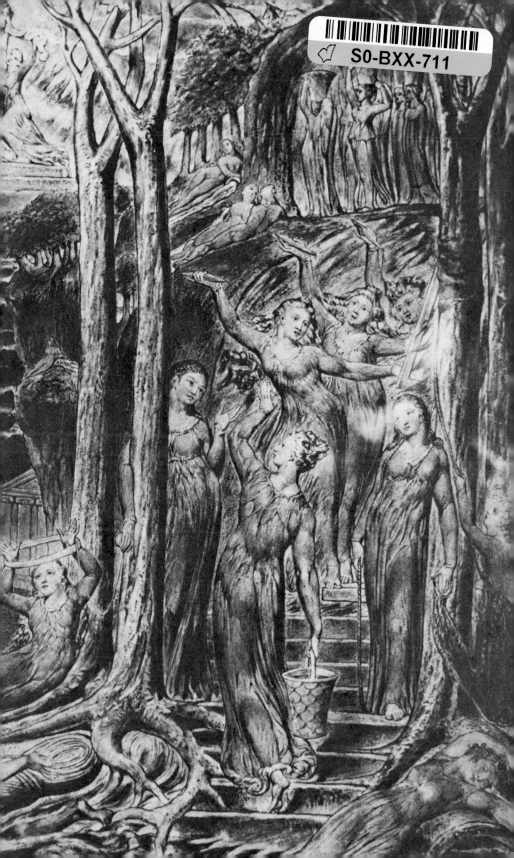

The Visionary Hand

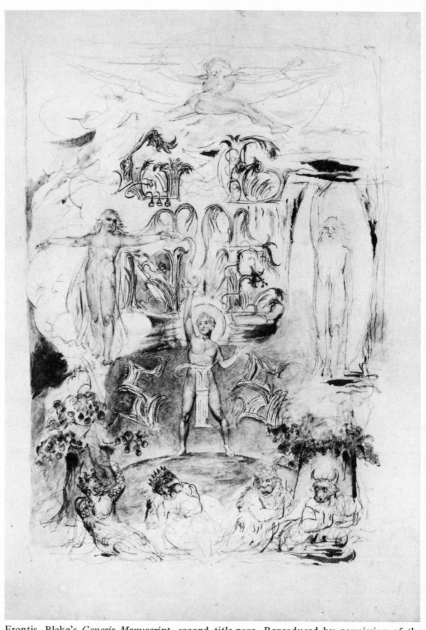

Frontis. Blake's *Genesis Manuscript*, second title-page. Reproduced by permission of the Henry E. Huntington Library and Art Gallery.

The Visionary Hand
Essays for the Study of
William Blake's Art and Aesthetics

Edited and with an Introduction by

Robert N. Essick

HENNESSEY & INGALLS, INC.
Los Angeles
1973

To the Memory of My Mother
Jeannette Marie Essick

Contents

List of Illustrations

Preface

Part I of this volume contains excerpts from early description of, and possible sources for, Blake's techniques of relief etching. The section concludes with Ruthven Todd's essay on his experiments in Blake's methods, reprinted here for the first time, with revisions and new illustrations supplied by the author. Part II contains twentieth-century essays on Blake's art and aesthetic theories reprinted in their entirety. Only the essay by Northrop Frye has been previously reprinted; the concluding essay by Jenijoy La Belle is printed here for the first time. The essays by David Erdman, Thomas Helmstadter, and W. J. T. Mitchell have been revised by their authors especially for this volume.

All quotations from any edition of Blake's works edited by Geoffrey Keynes have been revised according to his most recent text, *Blake: Complete Writings with Variant Readings*

(London: Oxford Univ. Press, 1971 printing with revisions of
the 1969 edition). All quotations from David V. Erdman, ed.,
The Poetry and Prose of William Blake (Garden City, New
York: Doubleday, 1965) have been retained as originally
printed. For all quotations from Blake reference is made to
both the Keynes ("K" followed by the page number) and
Erdman ("E" followed by the page number) editions, the
first text cited being the one actually quoted. In some essays,
as well as in the notes revised by the editor, Blake's
illuminated books are cited by short title, plate number
followed by a colon, and line number(s). Wherever possible,
footnotes have been revised in accordance with *The MLA
Style Sheet*, second edition. In some cases footnotes have
been further expanded or revised to provide fuller infor-
mation or reference to more recent editions of the works
originally cited. Except for these minor changes, all editorial
comments are clearly indicated as such (preceded by "Ed.").

I am indebted to many librarians, editors, and fellow
Blakeans for kind assistance in preparing this book. I wish
particularly to thank the English and Photographic depart-
ments of California State University, Northridge, Roger
Easson and Kay Easson, editors of *Blake Studies*, Morris
Eaves, Managing Editor of the *Blake Newsletter*, Martin
Butlin and the staff of The Tate Gallery, Robert Wark and
the staff of the Huntington Library and Art Gallery, Joseph
Burke, W. J. T. Mitchell, Thomas Helmstadter, John Grant,
David Erdman, Edward Rose, Ruthven Todd, Sir Anthony
Blunt, and Sir Geoffrey Keynes. For continued friendship
and help I thank Morton Paley, Richard Vogler, Reginald
Hennessey, G. E. Bentley, Jr., and Jenijoy La Belle.

Acknowledgements

All illustrations which originally accompanied the essays reprinted in Part II are reproduced here. Included are works from the collections listed below. Acknowledgment is gratefully made for permission to reproduce these works, listed here by Illustration number.

Boston Museum of Fine Arts: 57-63.

British Museum, London: 11-13, 18-24, 36, 65, 70, 71, 73, 97, 107-109, 111, 121-132.

Robert N. Essick: 3, 14-17, 47, 72, 76, 150-152, 154, 156, 162-164.

Fitzwilliam Museum, Cambridge, England, reproduced by permission of the Syndics: 74, 75.

Fogg Museum of Art, Harvard University, Cambridge, Massachusetts: 113.

The Houghton Library, Harvard University: 1, 5.

The Huntington Library and Art Gallery, San Marino, California: 43, 49, 50, 158-161.

Sir Geoffrey Keynes: 153.

City of Manchester Art Galleries: 56.

Collection of Mr. and Mrs. Paul Mellon: 32, 106.

The Metropolitan Museum of Art, New York: 2 (Rogers Fund), 42.

The Pierpont Morgan Library, New York: 46, 133-144, 147.

The National Gallery of Art, Rosenwald Collection, Jenkintown, Pennsylvania: 4, 10, 37-41, 55.

National Gallery of Victoria, Melbourne: 83, 84, 86, 89, 90, 92, 94, 102.

The National Trust, Arlington Court: 146.

The Tate Gallery, London: 29, 44, 48, 64, 66, 68, 69, 99, 103.

Ruthven Todd: 6-9.

Whitworth Art Gallery, University of Manchester: 25.

The following reproductions were made from Blake Trust facsimiles published by The Trianon Press, Paris: 104, 105, 110, 112, 114-120, 155. In all these cases, the illustrations accompanying the first appearance of the essays were also made from Blake Trust facsimiles.

All reproductions not listed above were supplied by the authors or publishers of the essays they illustrate. In a few cases, reproductions of engravings were not made from the same copies as those used for the original illustrations.

Acknowledgments for permission to reprint are given at the beginning of each essay.

Introduction

It is symptomatic of Blake's nineteenth-century reputation that, except for the *Songs of Innocence and of Experience*, he was best known for his designs to Blair's *Grave*. Softened and conventionalized by Schiavonetti's graver, harnessed to Blair's intelligible if turgid poem, the illustrations were accessible to those unwilling or unable to cope with Blake's more arcane productions, whether visual or verbal. The second volume of Gilchrist's *Life of Blake* (1863 and 1880) is about equally divided between a selection from Blake's poems and a catalogue of his art; the Poet and Painter were given equal, if at times uninformed, attention. In this century the balance has shifted towards the poetry, for the pace-setting American Blakeans (Damon, Percival, Frye, Erdman) have devoted far more attention to Blake's writings than to his visual statements. The English (Keynes, Todd, Raine) by and large have been more old-fashioned, and thus more balanced, in their view, but most of us come to Blake's art with modes of

inquiry developed through the study literature. It is no mere coincidence that most of the contributors to this volume, as well as its editor, are teachers of English Literature rather than English Art. Fortunately, Blake was a very literary artist, working from a tradition of illustration and history painting sharing many thematic and iconographic interests with poetry. Still, the literary bias can create its own kind of limited, Urizenic vision leading to a neglect of the formal dimensions of Blake's pictorial art which contribute to its meaning and value. When dealing with visual images we usually assume that meaning is a function of representation. That is, the artist represents a lion, and then we begin to determine what a lion signifies in this or that iconic language. But meaning can also be a function of style or technique. That Blake used a process of relief etching involving corrosive acids and resulting in a unique kind of sculptured lineation is part of the meaning of his illuminated books. Similarly, the mottled textures are part of Blake's image of the natural world presented in the great color prints of 1795. Some of the earlier twentieth-century essays, such as those by Binyon, Baker, and Blunt reprinted here, on Blake's style and the pictorial sources of his images serve an important purpose in bringing to our attention aspects of Blake's art sometimes overlooked when concentrating on the minute particulars of content. Further, the understanding of Blake's technical experiments offered by studies such as Ruthven Todd's presented here can help to illuminate an iconography of technique to accompany the iconography of images.

The investigation of Blake's symbolic motifs will continue to be of central interest, as it is for most of the essays reprinted here. While the exegesis of symbolic meanings in individual works has obvious value, we also need a hermeneutics for the interpretation of Blake's visual symbolism. As

Joseph Burke's essay suggests, Blake's images directly set forth the forms springing from Blake's eidetic-visionary imagination. As such they are incarnations of values and psychological states rather than simply illustrative or representational pictures, both the cause and product of a mind where the usual distinctions between perception and creation, between the symbol and what it symbolizes, vanish. Blake's implicit contention that these images further relate to an eternally existent world of spirit (whose history is recorded in his prophetic books) places his art within the tradition of Neo-platonic pictorial symbolism. Much of art history and criticism, with its emphasis on the history of representation in pictorial space, is irrelevant to a study of Blake's art, or at best serves as an example of that which Blake was working against. Blake comes off rather badly when evaluated from a point of view developed for the study of representational space – his perspective is faulty, his nudes poorly proportioned, his coloring childish. Blake's rejection of conventional perspective tends to emphasize the symbolic, at the expense of the representational, functions of his images – or at least to blur the differences between these functions. Like E. H. Gombrich and Marshall McLuhan in our own day, Blake was deeply concerned with the psychology of pictorial space. He saw that the rational view of the world implicit in perspective and naturalistic coloring tended to negate his own attempts to see through the eye, not with it, and to look beyond the appearance of things and into their teleological significance. Blake's symbols live within spaces and modes of representation which are themselves symbolic.

By combining the stylistic and art-historical approaches with a knowledge of Blake's vocabulary of pictorial symbols, we can see Blake's art with the expanded perception to which it repeatedly calls us. The essays on the following pages can

help in reaching that goal. Some concentrate on the visions embodied in Blake's art and their meaning; others delve into the techniques and styles he employed to give imagination material form. Together they reveal Blake's visionary hand.

Part 1
Blake's Techniques of Relief Etching: Sources and Experiments

from J. T. Smith, NOLLEKENS AND HIS TIMES

Ed.: Reprinted from John Thomas Smith, *Nollekens and his Times* (London: Henry Colburn, 1828), II, 461. Smith's brief account is the first published description of Blake's process of relief etching and the visionary explanation of its discovery.

Blake, after deeply perplexing himself as to the mode of accomplishing the publication of his illustrated songs, without their being subject to the expense of letter-press, his brother Robert stood before him in one of his visionary imaginations, and so decidedly directed him in the way in which he ought to proceed, that he immediately followed his advice, by writing his poetry, and drawing his marginal subjects of embellishments in outline upon the copper-plate with an impervious liquid, and then eating the plain parts or lights away with aqua fortis considerably below them, so that

the outlines were left as a stereotype. The plates in this state were then printed in any tint that he wished, to enable him or Mrs. Blake to colour the marginal figures up by hand in imitation of drawings.

from Alexander Gilchrist, LIFE OF WILLIAM BLAKE

Ed.: Reprinted from Alexander Gilchrist, *Life of William Blake, "Pictor Ignotus"* (London and Cambridge: Macmillan, 1863), I, 68-70. Gilchrist repeats the story of Blake's transmundane instruction in relief etching first presented by J. T. Smith and provides a few more details on the process itself. Gilchrist's brief explanation of Blake's vision as the result of extreme mental concentration suggests a condition similar to the merging of memory and visionary experience explored in Joseph Burke's essay on eidetic imagery reprinted in Part II of this collection.

Though Blake's brother Robert had ceased to be with him in the body, he was seldom far absent from the faithful visionary in spirit. Down to late age the survivor talked much and often of that dear brother; and in hours of solitude and inspiration his form would appear and speak to the poet in consolatory dream, in warning or helpful vision. By the end of 1788, the first portion of that singularly original and significant series of Poems, by which of themselves, Blake established a claim, however unrecognised, on the attention of his own and after generations, had been written; and the illustrative designs in colour, to which he wedded them in inseparable loveliness, had been executed. The *Songs of*

Innocence form the first section of the series he afterwards, when grouping the two together, suggestively named *Songs of Innocence and of Experience.* But how publish? for standing with the public, or credit with the trade, he had none. Friendly Flaxman was in Italy; the good offices of patronising blue-stockings were exhausted. He had not the wherewithal to publish on his own account; and though he could be his own engraver, he could scarcely be his own compositor. Long and deeply he meditated. How solve this difficulty with his own industrious hands? How be his *own* printer and publisher?

The subject of anxious daily thought passed—as anxious meditation does with us all—into the domain of dreams and (in his case) of visions. In one of these a happy inspiration befel, not, of course, without supernatural agency. After intently thinking by day and dreaming by night, during long weeks and months, of his cherished object, the image of the vanished pupil and brother at last blended with it. In a vision of the night, the form of Robert stood before him, and revealed the wished-for secret, directing him to the technical mode by which could be produced a fac-simile of song and design. On his rising in the morning, Mrs. Blake went out with half-a-crown, all the money they had in the world, and of that laid out 1*s.* 10*d.* on the simple materials necessary for setting in practice the new revelation. Upon that investment of 1*s.* 10*d.* he started what was to prove a principal means of support through his future life,—the series of poems and writings illustrated by coloured plates, often highly finished afterwards by hand,—which became the most efficient and durable means of revealing Blake's genius to the world. This method, to which Blake henceforth consistently adhered for multiplying his works, was quite an original one. It consisted in a species of engraving in relief both words and designs. The

verse was written and the designs and marginal embellishments outlined on the copper with an impervious liquid, probably the ordinary stopping out varnish of engravers. Then all the white parts or lights, the remainder of the plate that is, were eaten away with aquafortis or other acid, so that the outline of letter and design was left prominent, as in stereotype. From these plates he printed off in any tint, yellow, brown, blue, required to be the prevailing, or ground colour in his fac-similies; red he used for the letter-press. The page was then colored up by hand in imitation of the original drawing, with more or less variety of detail in the local hues.

He ground and mixed his water-colours himself on a piece of statuary marble, after a method of his own, with common carpenter's glue diluted, which he had found out, as the early Italians had done before him, to be a good binder. Joseph, the sacred carpenter, had appeared in vision and revealed *that* secret to him. The colours he used were few and simple: indigo, cobalt, gamboge, vermilion, Frankfort-black freely, ultramarine rarely, chrome not at all. These he applied with a camel's hair-brush, not with a sable, which he disliked.

He taught Mrs. Blake to take off the impressions with care and delicacy, which such plates signally needed, and also to help in tinting them from his drawings with right artistic feeling; in all which tasks she, to her honour, much delighted. The size of the plates was small, for the sake of economising copper; something under five inches by three. The number of engraved pages in the *Songs of Innocence* alone was twenty-seven. They were done up in boards by Mrs. Blake's hand, forming a small octavo; so that the poet and his wife did everything in making the book,—writing, designing, printing, engraving,—everything except manufacturing the paper: the very ink, or colour rather, they did make. Never before surely was a man so literally the author of his own book.

George Cumberland, "NEW MODE OF PRINTING"

Ed.: Reprinted from *A New Review; with Literary Curiosities, and Literary Intelligence for the year 1784*, ed. Henry Maty, vol. VI (1784), 318-19. Blake was very likely familiar with this brief essay by Cumberland, one of his first patrons, although the "Mr. Blake" mentioned in the article is apparently W.S. Blake, engraver of Exchange Alley, not William Blake the poet-engraver. Even if Cumberland's account did stimulate Blake to experiment with new etching techniques for printing a text, the process described here could not have been that used by Blake. Cumberland's procedure would necessitate writing in reverse directly on the plate, something that the style of lettering in Blake's illuminated books indicates he did not do in spite of Gilchrist's description in the preceding excerpt (see Geoffrey Keynes, *A Study of the Illuminated Books of William Blake: Poet, Printer, Prophet* [New York: Orion Press, 1964], pp. 14-15). Furthermore, Cumberland indicates that the plate is to be etched in intaglio, rather than in relief as in Blake's method.

It had long been conjectured by the author of this paper, in the course of his practice of etching on copper, that a new mode of printing might be acquired from it, viz: by writing words instead of delineating figures on plates. As this is in the power of almost every man, it required only to know the facility with which it may be accomplished for it to be generally practised.

The inventor in January last, wrote a poem on copper by means of this art; and impressions of it were printed by Mr. Blake, in Exchange-alley, Cornhill, which answered perfectly well, altho' it had cost very little more time than

common writing. Any number of impressions, in proportion to the strength of the biting in, may be taken off. The method of performing it is as follows: Heat a copper plate over a fire, holding it in a hand-vice, then anoint it with a hard varnish tied up in a piece of thin silk, which is composed of the following ingredients.

Two ounces of virgin wax, two ounces of asphaltum, half an ounce of Burgundy pitch and half an ounce of common pitch, melted together.

Afterwards, whilst the plate is still warm, smooth the ground with a dabber made of thin silk stuffed with cotton, and then smoke the whole surface over the flame of a candle till it is quite black.

All these operations a servant may be taught to execute. Next you are to write with a pen (of gold if possible) on the varnished plate, so as to leave the copper bare; and lastly, after making a ridge of wax round the plate, searing it down, (which in small works, will be best done with a common bougie flattened on account of the cotton wick which keeps it from separating) pour on it a mixture of one-third strong aqua-fortis, and two-thirds common water, which must remain on it a longer or shorter time as the engraving is designed to be deep or faint.

The author thinks this mode of printing may be very useful to persons living in the country, or wishing to print very secretly.

George Cumberland,
LETTER TO HIS BROTHER, EARLY 1784

Ed.: Reprinted from *The Cumberland Letters*, ed.
Clementina Black (London: Secker, 1912), pp. 317-18.
Cumberland here corrects his failure to mention in the
preceding article that his invention would result in reversed
letters if corrective measures were not taken. The suggested
remedy of counter-proofing from the first impression would
probably result in a weak and unsatisfactory final printing.
Cumberland's insistance on the economy of his process may
have been particularly attractive to Blake, who wrote in his
Prospectus of 1793 that his own method "produces works at
less than one fourth of the expense" of conventional printing
and engraving (K 207, E 670, both quoting Gilchrist, *Life of
Blake*, II, 263).

The occasion of my writing to-day is to send you the
enclosed specimen of my new mode of printing—it is the
amusement of an evening and is capable of printing 2000 if I
wanted them—you see here one page which is executed as
easily as writing and the Cost is trifling for your Copper is
worth at any rate near as much as it cost besides you are not
obliged to print any more than you want at one time, so that
if the Work don't take you have nothing to do but to cut the
Copper to pieces or clean it. —But if it does, you may print 4
editions, 2000, and then sell the Plates as well. All this would
be . . . much if there was not some difficulty. A work [thus]
printed can only be read with the help of a looking Glass as
the letters are reversed . . . however we have a remedy for this
defect also, for in printing 20 we can have 20 more right by
only taking off the impression while wet—in fact this is only
etching words instead of Landscapes, but nobody has yet

thought of the utility of it that I know of the expense of this page is 1/6 without reckoning time, wh. was never yet worth much to authors, and the Copper is worth 1/0 again when cut up. In my next I will tell you more and make you also an engraver of this sort, till when keep it to yourself.

from Abraham Rees, THE CYCLOPAEDIA

Ed.: Reprinted from the article on "Etching" in Abraham Rees, *The Cyclopaedia; or, Universal Dictionary of Arts, Sciences, and Literature* (London: Longman, Hurst, Rees, Orme, & Brown, 1819), XII. *The Cyclopaedia* was published many years after Blake's development of relief etching, and thus is in no way a possible source. This excerpt suggests, however, that Cumberland's difficulties with the reversal of his text would have been easily solved by anyone who, like Blake, had been schooled in the traditional methods of transferring a preliminary drawing to the copper-plate. If the preliminary design and accompanying text were drawn on heavy paper or a board in a medium resistant to acid, the process described here would effectively transfer the design and text to the plate. An acid bath would then etch the plate, leaving design and text ready for printing after removal of the acid resistant material. The preliminary design would of course be lost in this method, thus explaining the absence of extant fair copies of Blake's illuminated texts or fully developed engraver's preliminaries of his designs for the books in relief etching. Another transfer method, with specific references to writing rather than just drawing, is described in Alexander Browne's *Ars Pictoria* (1675), a book

with which Blake was very likely familiar. The passage in Browne's work is quoted by Ruthven Todd in his essay reprinted in this volume.

When the copper-plate is thus varnished, and is quite cold, it remains to transfer from paper to the varnished plate, the tracing, or outline of the design. If the outline be reduced from an oil or water-colour picture or other original of larger dimensions than the intended etching, and be executed with lead pencil or red chalk upon drawing or writing paper, the method most in use among English engravers, is, to take the varnished plate and outline to the rolling-press printers, and (suffering the latter to lie between wetted paper for a quarter of an hour or so, that it may become sufficiently damp for the lead or chalk to be in a certain degree liquified, while the paper is sufficiently softened to do no injury to the etching ground,) to pass it through the press, the upper roller thereof being supplied with blankets in the same quantity, and the press adjusted to about the same degree of pressure, as for printing. If this be carefully performed, the outline will appear at once transferred, and reversed on to, the surface of the etching-ground, and the artist have nothing to do but to proceed with his etching. By these means the trouble both of retracing and *reversing* (*i.e.* of changing the right hand view of his picture round to the left, and *vice versa*, the left to the right, as it would appear if reflected in a looking-glass,) is saved to the engraver.

from Robert Dossie, THE HANDMAID TO THE ARTS

Ed.: Reprinted from [Robert Dossie], *The Handmaid to the Arts* (London: J. Nourse, 1764), II, 151-52. Blake may have owned a copy of this work—see G.E. Bentley, Jr. and Martin K. Nurmi, *A Blake Bibliography* (Minneapolis, Minn.: Univ. of Minnesota Press, 1964), pp. 203-4. Drawing and writing in an acid resistant medium would require a substance more liquid for a longer period of time than the usual stopping-out varnish. The material described here by Dossie, quoting Abraham Bosse, is intended for repair work or additions after the application of varnish to a plate for etching in intaglio. Bosse's formula would seem to have the properties Blake needed. Cumberland's experiments in etching a text, the usual engraver's practice of reversing a drawing onto a copper-plate as explained by Rees, and a liquid stopping-out medium of the sort described by Dossie would provide Blake with materials and techniques essential for the production of his own stereotypes. It would seem, however, that the integration of these elements into a successful production method and the idea of writing and drawing in an acid resistant medium have their source in Blake's inventive genius.

The mixture for securing the plates from further corrosion is, according to Mr. Le Bosse, thus made.

"Take an earthen-ware pot varnished, of a greater or less size, in proportion to the mixture that is to be made, and put into it some olive oil, and place it on the fire. When the oil is hot, throw into it the tallow of a candle, which being melted, some of the mixture must be taken out with a pencil, and dropt upon any thing hard and cold; as for example, on a plate of copper. If the drops are found moderately fixt and

firm, it is a proof that the proportion of tallow and oil is well adapted; but, if it be too liquid, the obvious remedy is the adding more tallow; and, on the contrary, if it be too stiff, more oil must be put to it. Having accommodated the mixture properly, it should be very well boiled for the space of an hour, in order that the tallow and oil may be well mixt and incorporated together; the boiling may be continued till the mixture become red, or approaching to it, as otherwise the ingredients are apt to separate when they are used."

The reason why oil is mixt with the tallow, is only to render it more liquid, and to prevent its setting so soon; for it is evident that if tallow was melted alone, it would be no sooner taken up by the pencil than it would grow hard, and set before it was brought to the necessary place of its application.

THE TECHNIQUES OF
WILLIAM BLAKE'S ILLUMINATED PRINTING

by
Ruthven Todd

\mathcal{A}lthough William Blake died only one hundred and twenty years ago, on August 12, 1827, the amount of nonsense which has grown so lushly about the matter of his printing techniques can only be compared with the luxuriant jungle of balderdash which surrounds the subject of Albrecht Dürer's "Melancholia."

One of the reasons for this is the unfortunate, but none the less patent, ignorance of the average museum expert. He may know all about the various states of an engraving, but of the practical side of print-making he has little knowledge and less experience. Of course, he has probably read the standard books on the techniques, but these works, at their best, are

Ed.: Reprinted by permission of the author, with his revisions of the notes and new illustrations, from *The Print Collector's Quarterly*, 29 (Nov., 1948), 25-37. Copyright retained by the author.

only pointers, and cannot supply the knowledge which comes from working with grounds and acids, with burin and needle. Often a method which seems all right on paper will turn out to be technically impossible.

These notes, which may do something to clarify the position regarding Blake's work, are largely the results of invaluable help received from two modern engravers, Stanley William Hayter and Joan Miró.

Mr. Hayter had always been puzzled by the strange texture of the ink upon the pages of Blake's writings, and, on a visit to the collection of Mr. Lessing J. Rosenwald, at Jenkintown, Pa., we attempted to work out methods by which this texture might be obtained. Last May in Atelier 17, New York, we printed a plate by M. Miró with effects that justified us in thinking that our deductions were correct.

Besides the sixteen plates of the *Songs of Innocence and of Experience,* which now exist only in the form of the electrotype plates traced by me in England and presented by Mr. Geoffrey Keynes and myself to the Fitzwilliam Museum, Cambridge, there is, at Jenkintown (eventually destined for the Library of Congress) a small fragment of a cancelled plate from Blake's *America a Prophesy*, 1793. So far as is known at present, this is the only surviving example of Blake's relief-etched plates, and, by the generosity of Mr. Rosenwald in lending us this treasure, we were enabled to pull the proofs which have been used to illustrate this article [see Illustrations 3, 4].

Examining the plate, Mr. Hayter pointed out that it was so shallowly bitten that it would be quite impossible to obtain a clean surface impression by the normal methods of inking, with a pad of cloth or with a leather or gelatin roller. To have used these would have resulted in a smirching or even a filling in of the whites, which, in all the plates of

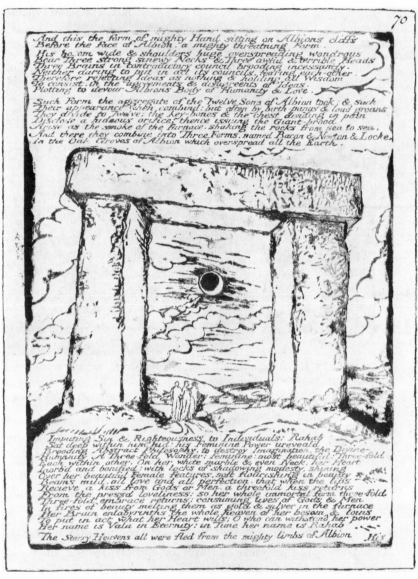

1. Blake, *Jerusalem*, pl. 70. Keynes & Wolf *Census* copy D. Houghton Library, Cambridge, Massachusetts.

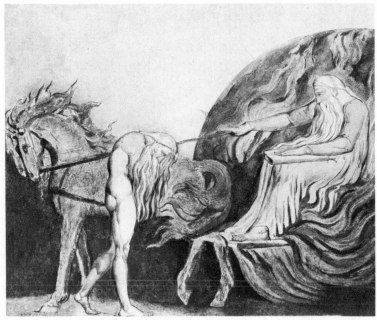

2. Blake, "God Judging Adam." Note the reticulated surface. Metropolitan Museum of Art, New York.

Blake's own printing, are remarkably free from traces of the ink. Further, no conventional inking method could have produced the granulated surface to which I have already referred.

To discover the method employed by Blake, careful consideration had to be given to the rest of his graphic production.

It is well known that Blake, an experimenter in artistic matters of the same stature as Robert Hooke in those scientific, made, in 1795, a series of twelve works by a process which he described as "colour printed drawing." The titles of these works are: "The Elohim creating Adam"[1] [Illustration 48], "Satan exulting over Eve,"[2] "Lamech and his Two Wives,"[3] "Ruth parting from Naomi,"[4] "God Judging

Adam"[5] [Illustrations 2, 103], "Nebuchadnezzar,"[6] "Christ appearing to the Apostles after the Resurrection,"[7] "The Triple Hecate"[8] [Illustration 68], "Pity like a Naked New-Born Babe"[9] [Illustration 69], "The Lazar House,"[10] "Newton"[11] [Illustration 29], and "The Good and Evil Angels."[12]

As a reference to my notes will show, there are (except for the first) at least two copies known of each, so that they should, strictly speaking, be described as color printed polytypes. The method used in making them was roughly outlined by Frederick Tatham, who inherited Blake's possessions from Mrs. Blake, and much elaborated by Mr. W. Graham Robertson, the owner of the finest English collection of Blake's drawings and paintings.[13]

As a painter, Mr. Graham Robertson set to work to see if he could duplicate Blake's effects, and he did so with such success that one of his efforts, a copy of "The Third Hour," in his own collection, appeared at Sotheby's in 1925[14] and would have been sold as an original but for his intervention.

The method used for the production of these polytypes was, according to Tatham in a letter to Alexander Gilchrist, as follows: "Blake, when he wanted to make his prints in oil (*sic*) took a common thick millboard and drew, in some strong ink or colour, his design upon it strong and thick. He then painted upon that in such oil colours and in such a state of fusion that they would blur well. He painted roughly and quickly, so that no colour would have time to dry. He then took a print of that on paper, and this impression he coloured up in water-colours, repainting his outline on the millboard when he wanted to take another print. This plan he had recourse to, because he could vary slightly each impression; and each having a sort of accidental look, he could branch out so as to make each one different."[15]

3. Blake, fragment of *America* copper-plate. This print, produced by attempting to ink the plate with an ordinary gelatin roller, shows the impossibility of keeping the whites clean, and also gives some idea of the worn condition of the plate, which only survived because Blake's pupil, Master Thomas Butts, made an engraving on the reverse. Essick Collection.

4. Blake, fragment of *America* copper-plate. Printed by method described in the text. The occasional blurs are due to the worn condition of the plate. Rosenwald Collection.

This account shows that, in spite of his closeness to Mrs.
Blake, Tatham had comparatively little idea of the techniques
or mediums employed by Blake himself (and this seems
strange as his friend, Samuel Palmer, consistently used a
water-colour or tempera which he called "Blake's white"). [16]

Blake's horror of oil-colors is notorious, and his
condemnations are vehement and frequent; "Oil has falsely
been supposed to give strength to colours: but a little
consideration must shew the fallacy of this opinion. Oil will
not drink or absorb colour enough to stand the test of a very
little time and of the air. It deadens every colour it is mixed
with, at its first mixture, and in a very little time becomes a
yellow mask over all that it touches. Let the works of
modern Artists since Rubens' time witness the villany of
some one at that time, who first brought oil Painting into
general opinion and practice: since which we have never had
a Picture painted, that could shew itself by the side of an
earlier production. Whether Rubens or Vandyke, or both,
were guilty of this villainy, is to be enquired in another work
on Painting, and who first forged the silly story and known
falshood, about John of Bruges inventing oil colours: in the
meantime let it be observed, that before Vandyke's time, and
in his time all the genuine Pictures are on Plaster or Whiting
grounds and none since." [17]

Blake's intentions with regard to his own painting were
made clear when he claimed that his exhibition displayed,
"The grand Style of Art restored; in Fresco, or Water-colour
Painting, and England protected from the too just imputation
of being the Seat and Protectress of bad (that is blotting and
blurring) Art. In this Exhibition will be seen real Art, as it
was left us by *Raphael* and *Albert Durer, Michael Angelo,*
and *Julio Romano*, stripped from the Ignorances of *Rubens*
and *Rembrandt, Titian* and *Correggio*." [18]

Remembering this abhorrence of oil, and having the works beside him to enable him to study the medium carefully, Mr. Graham Robertson was able to add considerably to the account given of the method used to produce the polytypes. He wrote, "Tatham's information is correct as far as it goes—but it goes no further than the first printing. This initial process may, in fact must, have been carried out as he relates, save that the paint used—though of an oily nature, was not mixed with actual oil. The medium employed was probably yolk of egg, which, though practically an oleate and from which an essential oil can be extracted, would not leave heavy stains upon the paper. The drawing being made upon thick millboard, the main lines were traced over in a paint thus mixed (usually a warm brown or Indian red), and an impression from this was stamped upon paper while the paint was still wet. Thus a delicate outline of the whole composition was obtained. Then, still with the same medium, the shadows and dark masses were filled in on the millboard and transferred to the paper, the result having much the appearance of an uncoloured page in one of the prophetic books. This impression was allowed to dry thoroughly. Then came the stamping of the local colours. For these later printings water-colour was probably used, though a very similar effect can be obtained by the use of diluted carpenter's glue and varnish, well mixed together, and of course applied when warm. . . . When those printings have been carried sufficiently far, the whole was worked over and finished by hand in water-colour."[19]

From my own experiments, I am convinced that Mr. Graham Robertson's explanation is the true one, although I would doubt whether Blake made more than two printings with his millboard before finishing the work with pen and ink and water-color.[20] The evidence of his own works, notably

5. Blake, "Introduction" to *Songs of Experience*, Keynes & Wolf *Census* copy b. One of the prints produced by Frederick Tatham after Blake's death, this shows his failure to obtain the effect to be seen in the following illustrations. Houghton Library, Cambridge, Massachusetts.

"Lucifer and the Pope in Hell"[21] and the famous "Dance of Albion"[22] [Illustration 11], shows that Blake sometimes used this technique to produce "colour printed drawings" from his copperplates, where the outlines had already been produced by his burin or etching-needle.[23] The opaque tempera color used in printing these copper-plate polytypes was applied so thickly that, as a rule, the casual glance is not sufficient to distinguish between them and the ordinary millboard printed drawings. But, and this is important, in the ordinary polytypes, having no engraved line to hide, Blake made use of transparent colors with results that are very close to those produced by the surrealists with the process known as *decalcomanie*.[24] (This process will be familiar to anyone who has played the childhood game of placing blobs of paint on one side of a folded sheet of paper and then squashing it flat—to find that the pressure has produced a phantasmagoric form.)

Looking at one of the ordinary polytypes, "Christ appearing to the Apostles after the Resurrection," it occured to Mr. Hayter and me that we had found a way of inking these shallowly bitten plates without marring the whites, a method which would also produce the characteristic reticulated texture.

Further evidence was supplied by an examination of the posthumous prints issued by Frederick Tatham in the years following Blake's death, before the plates "were stolen by an ungrateful black he had befriended, who sold them to a smith as old metal."[25] Tatham, judging from the few drawings which I have seen (he was a semi-itinerant portrait-maker put out of business by the invention of the daguerreotype), was an inept and clumsy workman who must have felt himself baffled by the problems raised by the printing of the plates. However, he seems to have managed to avoid an undue dirtying of the whites by the expedient of inking the plates

with the tip of his finger, possibly covered with a piece of cloth. The texture of the prints thus produced is quite different from that in the plates printed by Blake himself. Apart from the fact that the inking was consistently inadequate, so that words fail to print clearly, the total result is extremely unhappy.[26]

Regarding the actual printing of the plates, it would appear that Blake printed these pages of written matter in a press of the screw type, used for block-printing, as there is practically no plate-mark in any of the pages he printed. By this means he was able to use both sides of his paper, as in an ordinary book.[27] Further, it may be doubted whether he used his paper in the soaked condition common among modern copper-plate printers. It would seem more likely that his system was that of an old letter-press printer whom I knew in England, who, having to use handmade or rag paper, would remove it from its wrappings at least two weeks before starting on the job and leave it lying beside the press to absorb the natural dampness of the printing-shop.

For our first experiment we took a plate by M. Miró, bitten as a relief-etching, and inked an unengraved plate of the same size by running a roller across the face. This we placed carefully on top of the engraved plate and worked over it with our hands to transfer the ink to the other surface. Next the plates were separated, leaving the bitten one with a reticulated layer of ink. We then took a pull of this in an ordinary rotary press and found that, in every respect except that of plate-mark, the print, speaking technically, resembled one of Blake's own printing. (Incidentally, noticing the impression of the relief-etching remaining upon the blank plate, we took a pull of that and got a kind of polytype with the print a reverse of that produced from the engraved surface.)

By this method of inking, we found, it was not only possible to vary the depth of the color from one side of the plate to the other, but also to change color as Blake himself did in some of his books.

Regarding the ink which Blake used, Mr. Hayter points out that he did not use printer's ink, or oil-ink, as a microscopic examination of a plate washed broadly with water-colours does not show the hair-line of white round the inked portions which would be inevitable if the medium was oil. It is almost certain that he used egg-yolk, as that is water-proof when dry and does not reject water-color.[28]

There is another problem which seems to have puzzled Blake students for generations, namely, the sources of his writing with an acid-resistant ground upon his plates. Blake himself declared that the method had been revealed to him by the spirit of his brother Robert[29] who had died, probably of tuberculosis, in 1787, and in *The Ghost of Abel*, 1822, he noted "Blake's Original Stereotype was 1788."[30] However, it is well known that his friend, George Cumberland, was experimenting with methods of writing upon copper[31] and there can be little doubt that Blake knew of these experiments, which, as Lt. Col. W. E. Moss has pointed out to me in a personal correspondence, were only a part of the late eighteenth-century interest in the matter.

As early as *An Island in the Moon*, probably written between 1784 and 1788, Blake had shown his own concern. In a passage, unfortunately incomplete, he wrote:

" '–them Illuminating the Manuscript.'
'Aye,' said she, 'that would be excellent.'
'Then,' said he, 'I would have all the writing Engraved instead of Printed, & at every other [*word del.*] leaf a high finish'd print–all in three Volumes folio–& sell them a hundred pounds apiece. They would print off two thousand.'
'Then,' said she, 'whoever will not have them will be ignorant fools & will not deserve to live.' " [32]

JOAN MIRÓ

Once there were peasant pots and a dog brown here
Upon the olive table in that magic farm;
Once all the shamen were blown about the fair
And none of them took hurt or any harm.
Once a man set his fighting bull to graze
In the strict paths of the forgotten maze.

This was that man who knew the secret line
And the strange shapes that went
In dreams: his was the bewitched vine
And the spying dog in the sky's tent.

Once he had a country where the sun shone
Through the enchanted trees like lace,
But now it is troubled and happiness is gone,
For the bombs fell in that fine place
And the magician found when he had woken
His face filled, his gay pots broken.

1937

6. Poem with designs by Joan Miró, surface printed in black. Plate mark: 17.5 x 13.7 cm. Author's Collection.

8. The same poem as Illustration 6, inked for intaglio printing with black ink, wiped and surface color applied by the method described in the text. The reticulation is also visible here. Author's Collection.

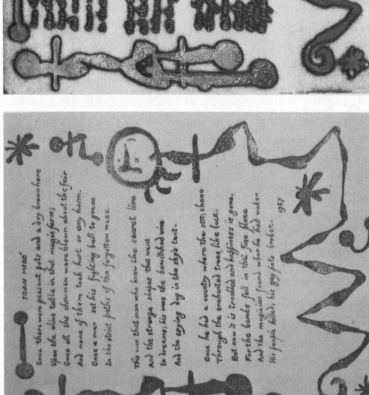

7. The same poem as Illustration 6, surface printed in colors. Note the reticulation of the impression. Author's Collection.

However, one of the more obvious sources for the suggestion has not previously been mentioned. In a closely argued article [33] Mr. C. H. Collins Baker has attempted to show that Blake derived pictorial inspiration from the plates in the *Ars Pictoria* of Alexander Browne, [34] for certain details in his drawings and in particular for the donkey which appears in his "Triple Hectate," already mentioned, and again in the water-color of "The Rest on the Flight into Egypt." [35] [It should be mentioned that this etching in *Ars Pictoria* is a reverse copy of an etching by Simone Cantarini, which Browne wrongly attributed to Guido Reni, but Mr. Collins Baker's other evidence makes it clear that Blake knew it from the book and not from the original.]

The case for Blake's dependence upon the plates is well made out, but, strangely enough, Mr. Collins Baker's curiosity seems to have stopped at the illustrations. He does not seem to have read the text where a simple account of a method of transferring writing to a copper-plate is given.

Browne wrote: "Take some *Charcole* and kindle them, then take a *hand-vice* and screw it to the corner of the plate, and hold it over the *fire* till it be warm, then take a piece of *Virgins wax*, and rub it all over the *plate* untill it is covered every where alike; this being done, take a *stiff feather* of a *Ducks wing* that is not *ruffled*, and drive it even and smooth every where alike, and let it coole, then write the *hand* and *letter* which you intend to *grave* upon the *plate*, on a piece of *paper* with *ungum'd Ink*; then take the *paper* which you have written, and lay that side which is written downwards next to the wax, and fasten the four *corners* with a little *soft wax*, but be sure to place the writing so, that the lines may run straight, then you must take a *Dogs Tooth*, and rub the *paper* all over which is *fastened*, and not miss any place; this being done, take off the paper from the *plate* and you shall see the

very same Letters which you wrote on the paper hath left their *perfect impression* upon the *wax*; then take a *Stift* and draw all the Letters through the wax upon the *plate*, and when you have done that, warm the *plate*, and take a *linnen rag* and rub the wax clean off, and you shall see all the Letters drawn upon the Copper, then get some good *French Gravers* and *grind* them, as they should be very *sharp* towards the *points* upon a *Grind-stone*, and after-wards whet them very smooth and sharp upon a good *Oyl stone*, then *Grave* the Letters with them." [36]

With this hint and his own inventiveness Blake seems to have developed the method of relief-etching which he described in a memorandum, written many years later, probably about 1807: "To Woodcut on Copper: Lay a Ground as for Etching; trace &c, & instead of Etching the blacks, Etch the whites & bite it in." [37]

As it seemed to us unlikely that Blake could have written the whole of the hundred plates of *Jerusalem* alone, not to mention his other books backwards, Mr. Hayter and I set about finding a method of transferring writing to a copper-plate, without the need of learning mirror-writing.

Not knowing the ingredients of Blake's stopping-out mixture, we wrote out a poem by the present writer in a mixture of two-thirds bituminous varnish to one of resinous upon a piece of paper which had been coated with gum-arabic. We laid the varnish on as thickly as we could manage without destroying the legibility of the writing. We then heated a copper-plate and laid the paper, which had previously been soaked, face down upon it. This we rolled off under heavy pressure. To encourage the lettering to transfer, we then rubbed the back of the paper with an agate burnisher. Upon removing the paper, with water, we found that the poem had been transferred in reverse to the copper

and only required a small amount of retouching before being bitten in a two-one solution of nitric acid. Before the biting M. Miró drew designs in the varnish which were also left in relief. [38]

Although we could not claim that our text was as perfect as that of Blake, we felt justified in thinking that some such method of transference must have been used, for an examination of Blake's writing, with its curves and swellings, shows that it must have been written in the conventional manner—that is, from left to right. One further suggestive point remains to be mentioned; this is the fact that no fair copy of any of Blake's engraved writings has survived to the present day, and that we found that the method we employed removed all the varnish from the paper, leaving it blank.

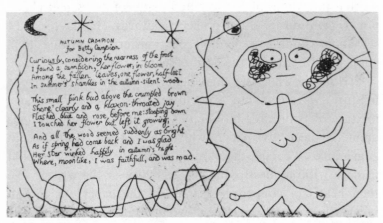

9. Small plate (plate mark: 7.5 x 15 cm.), etched on hard ground with a phonograph needle held in a pin-vise. This experiment was carried out while one of the relief-etched plates was biting, partly to see what kind of handwriting the poet could achieve working in reverse with a needle, and partly to help his understanding of how the process had been used in *The Book of Ahania* and *The Book of Los*. Author's Collection.

NOTES

Recognizing that the original notes, written in 1947 and published in 1948, were inaccurate, completely out of date, and useless as references to a reader in the 1970s, I have done my best to correct the originals. Since this essay is being reprinted as "an historical document" I have not been able to interfere with the text, beyond correcting the title of one of the "Colour Printed Drawings." I have, however, while trying to respect the exiguousness of space, taken advantage of the occasion to add a few notes both to admit the ignorance which I showed then and, I hope, to help a reader today. R. T., May, 1972.

1. "The Elohim Creating Adam." a) Tate Gallery, London–Graham Robertson collection; b) offered by Blake in a letter to Dawson Turner, 9 June 1818 (K 867), not traced.

2. "Satan Exulting over Eve." a) Gregory Bateson, Honolulu, Hawaii; b) John Craxton, London.

3. "Lamech and His Two Wives." a) Tate Gallery–Graham Robertson collection; b) ex Miss S. H. Pease, private collection, Scotland.

4. "Ruth Parting from Naomi." a) Victoria & Albert Museum, London; b) Sir Geoffrey Keynes, Brinkley, Suffolk, destined for the Fitzwilliam Museum, Cambridge.

5. "God Judging Adam." a) Tate Gallery–Graham Robertson collection; b) Metropolitan Museum of Art, New York; c) Mrs. William T. Tonner, Philadelphia, bequeathed to the Philadelphia Museum of Art.

6. "Nebuchadnezzar." a) Tate Gallery—Graham Robertson collection; b) Museum of Fine Arts, Boston; c) Minneapolis Institute of Arts.

7. "Christ Appearing to the Apostles after the Resurrection." a) Yale University Art Gallery, New Haven; b) Tate Gallery—Graham Robertson collection; c) National Gallery of Art, Washington—Rosenwald Collection.

8. "The Triple Hecate." a) Tate Gallery—Graham Robertson collection; b) National Gallery of Scotland, Edinburgh; c) Huntington Library, San Marino, California.

9. "Pity Like a Naked New Born Babe." a) Tate Gallery—Graham Robertson collection; b) Metropolitan Museum of Art, New York; c) ex Miss S. H. Pease, private collection, Scotland. Smaller version: British Museum, London.

10. "The House of Death." a) Tate Gallery—Graham Robertson collection; b) British Museum, London; c) Fitzwilliam Museum, Cambridge.

11. "Newton." a) Tate Gallery—Graham Robertson collection; b) Mrs. William T. Tonner, Philadelphia, bequeathed to the Lutheran Church in America, Philadelphia.

12. "The Good and Evil Angels Struggling for Possession of a Child." a) Tate Gallery—Graham Robertson collection; b) Mr. & Mrs. John Hay Whitney, New York.

13. Following the death of Graham Robertson, who was indefatigable in helping me in my Blake researches, the collection was sold at Christie's, July 22, 1949. It was, however, recorded in *The Blake Collection of W. Graham Robertson*, ed. Kerrison Preston (London: Faber and Faber, 1952).

14. Sale of E. J. Shaw, July 29, 1925, lot 141. Nobody, including Mr. Graham Robertson, has the least idea how Mr. Shaw obtained this; his sale was notable for the number of forgeries and false attributions it contained.

15. Alexander Gilchrist, *Life of William Blake*, ed. Ruthven Todd (London: Everyman's Library, 1942, second ed., 1945), p. 366.

16. A. H. Palmer, *The Life and Letters of Samuel Palmer* (London: Seeley & Co., 1892), p. 51; see also Geoffrey Grigson, *Samuel Palmer, The Visionary Years* (London: Kegan Paul, 1947), p. 156.

17. Blake, *A Descriptive Catalogue*, 1809, p. 2 (K 565, E 521).

18. Blake's "Advertisement of A Descriptive Catalogue," discovered by me in 1942, and printed in Gilchrist, *Life of Blake*, ed. Todd (second ed., 1945), p. 406 (K 562, E 519).

19. Alexander Gilchrist, *The Life of William Blake*, ed. W. Graham Robertson (New York: Dodd, Mead, [1907]), pp. 405-06; reprinted in Gilchrist, *Life of Blake*, ed. Todd (1942), pp. 395-96 and second ed. (1945), p. 397.

20. Further experiments which I have been carrying out have now (May, 1972) persuaded me that this is a misstatement, and that, indeed, as in the "Newton," Blake possibly used several printings.

21. I neglected to mention, when I first wrote this essay, the use of the method in *The Song of Los, The Book of Ahania, The Book of Los*, the small and large *Books of Design*, as well as sundry other prints.

22. Color copy in the Huntington Library, San Marino, California; uncolored impression in the British Museum, London.

23. The finest colored impression is that in the British Museum; a second colored copy is in the Huntington Library, San Marino, California. There are uncolored impressions in the British Museum and the Rosenwald Collection of the Library of Congress. This plate is sometimes called "Glad Day."

24. Oscar Dominguez, who was born in Tenerife, Las Canarias, in 1906, and who committed suicide on New Year's Eve, 1957, using gouche, introduced "decalcomania-without object" to the Surrealists in 1935. This pressing-down of a color-loaded sheet upon another surface and its removal to leave a mottled, reticulated and spread area of paint has much in common with the "colour printed drawing" method used by Blake. Simple versions of the process have given us drawing-room games and also the Rorschach "blots." Yves Tanguay, using various methods of control, experimented with the process for a short time, as did many others, but it probably achieved its peak among the Surrealists when exploited by Max Ernst in America in 1940. Dominguez, however, has an historical place as the author of this revival of the "colour printing" process.

25. Gilchrist, *Life of Blake*, ed. Todd (1942, 1945), p. 105.

26. Relief-etched plates, mounted type-high, can easily be printed upon an ordinary platten press, such as a Price & Chandler, an Albion, or a Columbian. However, the substitution of rollers for balls or pads in the inking of type did not occur until about 1818. This date is also

that of the invention of stereotyping on curved plates which made possible the use of the rotary principle in place of flat forms of type.

27. The matter of printing-presses before 1818 would need more space than this article occupies. Harry Hoehn and the writer found that, using an ordinary rolling-press (i.e., "etching-press"), most carefully adjusted for pressure, we could print without making platemarks on the paper and consequently used both sides of the sheet.

28. This seems to be incorrect. After a quarter of a century I find that the prints in my possession, in spite of the wide areas printed in oil-colors, show no such hair-line, even when examined under an engraver's lens.

29. See J. T. Smith, *Nollekens and His Times* (London: Henry Colburn, 1828), II, 460-61.

30. K 781, E 270.

31. See Mona Wilson, *The Life of William Blake* (London: Rupert Hart-Davis, 1948), pp. 330-31 and Laurence Binyon, *The Engraved Designs of William Blake* (London: Ernest Benn and New York: Charles Scribner's Sons, 1926, reprinted New York: Da Capo Press, 1967), pp. 10-11.

Ed.: See also the article by Cumberland reprinted in this volume.

32. K 62, E 456.

33. C. H. Collins Baker, "The Sources of Blake's Pictorial Expression," *Huntington Library Quarterly*, 4 (1941), 360-64.

Ed.: Baker's article is reprinted in this volume.

34. Alexander Browne, *Ars Pictoria: or an Academy Treating of Drawing, Painting, Limning, Etching* (London: Tooker and Battersby, second ed., 1675). This book is rather rare, but there is a previously unrecorded copy in the Library of the Metropolitan Museum of Art, New York.

 Ed.: There are also copies in the British Museum (first ed. and two issues of the second ed.) and the Huntington Library, San Marino, California (second ed.).

35. Metropolitan Museum of Art, New York.

36. Browne, *Ars Pictoria*, p. 108.

 Ed.: See also the contemporary writings on etching methods reprinted in this volume.

37. K 440, E 672.

38. While I am aware that the use of "Dutch mordant" in the biting of the plates would avoid the tendency to under-cut the lettering and designs which is liable to happen with nitric acid, I am not aware that Blake ever made use of the former. Nancy Bogen, who has seen many of the Copies of *Songs* and *The Book of Thel*, tells me that, examining these carefully for this purpose, she has found that Blake has retouched the lettering with the correct color in order to repair such errors. With experience such accidents became less and less frequent so that they do not seem to have occurred at all in *Jerusalem*.

 I have also described my experiments in Blake's relief etching methods in "Miró in New York: A Reminiscence," *The Malahat Review*, 1 (Jan., 1967), 77-92, where I describe the biting of the plate as follows: "My words, however crudely, once safely upon the copper

plate, Miró then made his designs around them with a brush, using the same acid-resistent varnish. The plate was then given a backing of a different protective varnish and lowered into a bath of dilute nitric acid. There it was left until the unprotected parts were bitten away to a depth of about two millimeters, or even a little more. During this part of the proceeding a great deal of attention had to be paid to the plates as the action of the acid, even though I knew exactly how strong the solution was, varied according to the daily temperature and atmospheric conditions, and these experiments were taking place during the heat and humidity of a New York summer. The period of immersion in the bath of acid varied from eight to as many as fourteen or fifteen hours, and I had to be in constant attendance during those hours in case the heat engendered by the action of the acid caused it to creep beneath the varnish and lift it off" (*The Malahat Review*, pp. 83-84). During a visit to my friend, Reuben Kadish, the sculptor, in upper New Jersey, I had collected a plentiful supply of chicken-feathers. While baby-sitting the plate in its acid-bath, I used one of these to brush away bubbles when I noticed them gathering around the lettering or other areas of sup- posedly protected parts of the plate. Despite this underbiting *did* occur.

This article owes its existence to the co-operation and encouragement which I have received from my friends Joan Miró and S. H. Hayter, and to Mr. Lessing J. Rosenwald for lending us the fragment of plate men- tioned.

Ed. Postscript: Brief descriptions of the relief etching process may also be found in Todd's *William Blake The Artist* (London: Studio Vista, 1971), pp. 20-21, where he estimates that "according to the temperature of the room in which the biting was being done, it would take from about six to eight hours" to completely etch one of Blake's plates; S. W. Hayter, *New Ways of Gravure* (London: Oxford Univ. Press, 1966), pp. 64, 130 and Illustrations 34a, 34b; Geoffrey Keynes, *A Study of the Illuminated Books of William Blake Poet, Printer, Prophet* (New York: Orion Press, 1964), pp. 14-16; Keynes and Edwin Wolf, *William Blake's Illuminated Books: A Census* (New York: Grolier Club, 1953, reprinted New York: Kraus, 1969), pp. vii-[xix]. Norman R. Eppink, following the discoveries of Todd and Hayter, has also produced plates using Blake's processes. The results are briefly described and reproduced in Eppink's *101 Prints: The History and Techniques of Printmaking* (Norman: Univ. of Oklahoma Press, 1971), p. 52 and facing plate. For more on Blake's methods used to produce the color printed drawings, see Martin Butlin, "The Evolution of Blake's Large Color Prints of 1795," in *William Blake: Essays for S. Foster Damon*, ed. Alvin H. Rosenfeld (Providence, R. I.: Brown Univ. Press, 1969), pp. 109-30.

Part 2
Critical Essays on Blake's Art and Aesthetics

THE ENGRAVINGS OF
WILLIAM BLAKE AND EDWARD CALVERT

by

Laurence Binyon

*W*illiam Blake's fame as a poet and seer, the spiritual intensity of his art and its challenge to the mind: these have served inevitably to obscure, or at least to distract attention from, his remarkable qualities as a technician. The popular conception of Blake is that of a man filled with wonderful ideas which he was unable adequately to carry out or express,—but in so far as this inability is held to imply lack of interest in the use of materials, this conception is untrue. If we regarded Blake's art from the technical side only, we should find far more of interest and originality than in many an artist who is entirely lacking in the imaginative and intellectual power of Blake.

Ed.: Reproduced by permission of the publisher from *Print Collector's Quarterly*, 7 (1917), 305-32. The footnotes have been supplied by the editor.

In this paper I wish to say something of Blake's original engravings, leaving out of account the plates he engraved after the work of others; and to treat with them the beautiful, though few and little known, prints by his disciple Edward Calvert. Both artists worked on copper, on wood, and on stone; and the mere mention of this fact shows a technical versatility and interest in medium and material remarkable indeed at the time in which they worked. And Blake besides used experimental processes of his cwn.

To realise Blake's importance in the history of the engraver's art, we have to remember that since Dürer and the Little Masters, engraving on metal had been abandoned by artists as a medium for the reproduction of their own designs. It was superseded by the easier method of etching. The use of the acid to bite a drawing on a copper plate did not involve the labour and training required for the use of the graver. The amount of that labour and training can be exaggerated, however; if the artist be content with the standard of mechanical skill which sufficed to the early Italian engravers, he need not be crushed by the arduousness of the toil of furrowing the bare copper. In fact, it was the marvellous technical skill attained by Dürer which killed the art of original engraving. Those who came after, by patience and long training, could rival his technical skill; but these were not men of the creative temperament; they were craftsmen, rather, who saw their way to developing the engraver's art further towards a brilliantly finished execution, capable of rendering an oil painting with something like adequacy of effect. So this art became definitely committed to imitation and reproduction, with such brilliant results as we see in the Flemish engravers after Rubens, the French portraitists, the English landscape-engravers after Turner. Men of miraculous accomplishment, these! Yet there are moods in which we

turn with a kind of relief from their prized masterpieces to
the work of fifteenth-century Italians, mere stumblers and
stammerers by comparison, or that of men like the French-
man Jean Duvet,—work which is without virtuosity, but
which is personal and felt, and at the same time has its own
peculiar quality and virtue as a print, distinct from that of an
etching. For the very freedom with which the etcher's needle
moves on the varnished surface of the copper has its seducing
dangers. Resistance in the material is a tonic to the artist.
When a sculptor of to-day, like Mr. Eric Gill, instead of
modelling in ductile wax or clay, cuts and carves his
conceptions out of hard stone, we find that the severer
conditions yield a fresh quality and character that could
never be got by modelling: and it is a similar difference that
the graver gives.

 Blake was a professional engraver all his life long, and
the completeness of his training in the accepted methods of
the day—the whole system of formula for translating tone
into line—encumbered him when he wanted to express his
own conceptions directly by means of burin on metal. With
what natural felicity and fire he works when, in his old age,
he attacks the wood block for the first time, without any
professional training or prejudice! As a metal-engraver, on the
other hand, he was always trying, if not always quite
consciously, perhaps, to work free from the ingrained habit
of hand acquired in long apprenticeship and to find a more
expressive way of handling the familiar tools.

 The first original, or partly original, work on copper that
we know of Blake's is a single plate, *Joseph of Arimathea
among the Rocks of Albion* [Illustration 153]. It is dated
1773, when Blake was sixteen, and had been already two years
apprenticed to James Basire. It is described as engraved
"from an old Italian drawing." Then follows the character-

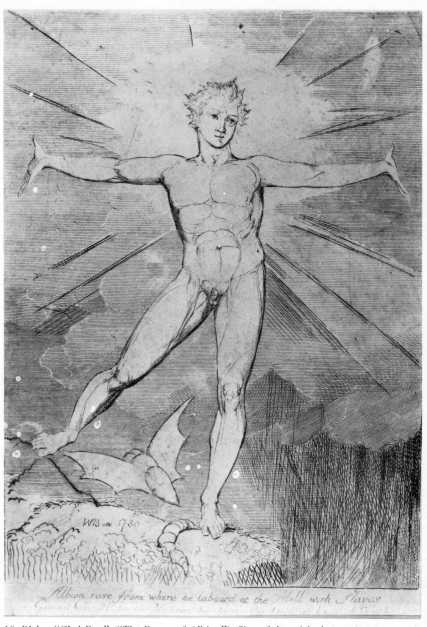

Albion rose from where he laboured at the Mill with Slaves

10. Blake, "Glad Day" ("The Dance of Albion"). Size of the original engraving, 10 x 7-3/8 inches. Rosenwald Collection.

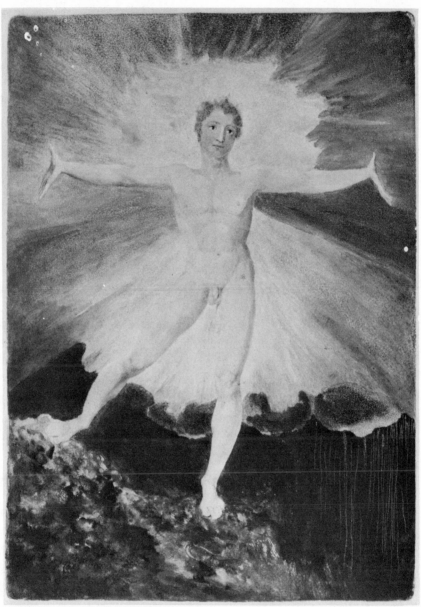

11. Blake, "Glad Day" ("The Dance of Albion"), stamped with color. Size of the original engraving, 10-3/4 x 7-7/8 inches. British Museum.

istic statement, "This is one of the Gothic Artists who Built the Cathedrals in what we call the Dark Ages, wandering about in sheep-skins and goat-skins, of whom the World was not worthy. Such were the Christians in all Ages." Below this is "Michael Angelo Pinxit." The figure is, in fact, borrowed from Michelangelo; it is the figure prominent in the extreme right of the foreground of the fresco of the Crucifixion of St. Peter in the Cappella Paolina of the Vatican. But we cannot doubt that the setting of rock and sea is Blake's own. The effect of the light gleaming on the dark water is one he was always fond of; and the composition, with the cliff rising to the top of the print and giving a glimpse of sea and sky at the side only, is recalled in some of the designs to Dante done at the very end of his life. The figure is very closely modelled on Michelangelo, though with a difference of expression in the face. As for the engraving, it is careful and patient but not without energy and animation. But just as the massive and muscular Michelangelo type appears imperfectly assimilated (as throughout Blake's art) to the spiritualized "Gothic" atmosphere of the artist's mind, so too the mechanical "lozenge and dot" and other devices for rendering relief and shadow, affected by the engravers of the eighteenth century, seem to cloud the freshness and dim the fire of his native gift. Intensely original as Blake was, he absorbed from the training of his student days and also from the current ideals of the art of his own day a good deal more than is often admitted by his admirers.

The next engraving in order of time forms a striking contrast to the last. It is wholly of Blake's invention. This is the print known as *Glad Day*, which represents a naked youth,—

"New-lighted on a heaven-kissing hill,"–

with the sunrise radiant behind him [Illustration 10]. His
arms are stretched out wide. At his feet a gross moth takes to
flight, and a worm crawls to its hiding-place. It is signed and
dated 1780. Instead of being closely and elaborately worked
up with the burin, the design is lightly sketched in, with
scarcely any attempt at modelling or the representation of
shadow. One conjectures that Blake was dissatisfied with the
laborious and mechanical methods he had learnt, for the
expression of so ethereal and radiant a theme, but had not
acquired a congenial method of his own and so left the plate
with just the essentials of the design on it, but unclothed in
the special beauty of which the burin is capable. The
conjecture receives confirmation from the fact that Blake
made another print of this same subject, in a totally different
method [Illustration 11]. Mr. A. G. B. Russell, indeed, in his
admirable "Catalogue of the Engravings of William Blake,"
assumes the second print to be merely a coloured impression
of the first.[1] But this is a demonstrable error. The two plates
are of different dimensions. In the colour-print the space
between the figure and the plate-mark is increased by a
quarter of an inch at the top and half-an-inch at the bottom,
and also to a less degree at the sides. Moreover, there is no
trace of the moth and the worm between the feet of the
figure. In fact, there can be no doubt that this second print
was produced by the process of relief-etching used by Blake
for the "Songs of Innocence" and the "Prophetic Books."
The only impression known to me is the one in the
Print-Room of the British Museum, which has been so richly
coloured over by hand in opaque pigment that it is
impossible to say in what colour it was originally printed;
possibly it was printed in several colours, the different tints
being dabbed on to the plate at the same time. Usually, as is
well-known, Blake printed his relief-etchings in a single

tint—tawny yellow, green or blue—and then enriched each impression by hand with glowing colour, though the earliest of the prints produced in this way,—or what may be presumed from their style to be the earliest,—the tiny designs combined with text on "Natural Religion," were printed in more than one colour and were not afterwards touched by hand. The colour-print of *Glad Day*, then, must date from some time (probably several years) after 1788, when Blake first used the relief-process; and it is perhaps the most splendid example existing of what the artist called "illuminated printing."[2] Though so characteristic of Blake's genius, and, in fact, peculiar to him, the works produced by this process partake so much of the character of original drawings that I shall not say more about them here. The prints in themselves are rough productions, and are more interesting from the printer's than the engraver's point of view, being meant only as foundations for the final colouring by hand.

When Blake took up his design of *Glad Day* and reproduced it by his own process as an "illuminated print" he must have been struck with the meagreness and austerity of his youthful engraving when placed beside the gorgeous radiance of the new print. But how was he to get a similar expressiveness and felicity without colour and by the graver alone?

Blake's painting, with its general absence of detail and lack of "intimacy," its indifference to textures and surface appearances, was inevitably composed in large flat spaces; and there was always a danger of dryness and emptiness, of which the artist himself was evidently conscious. He used various devices for rendering these surfaces more alive and interesting. When it came to engraving he seemed for a long time unable to choose between the elaborate formalities of his professional training and a meagre inexpressiveness.

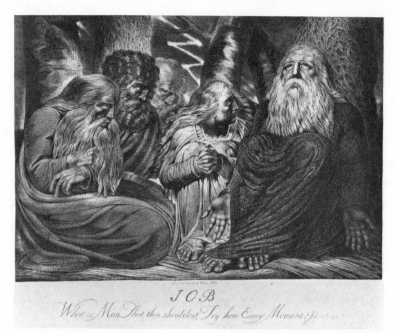

12. Blake, *Job*, "What is Man That thou shouldest Try him Every Moment?"
Size of the original engraving, 13-5/8 x 19-1/4 inches. British Museum.

Compare, for instance, the engravings in the little book
for children, "The Gates of Paradise," published in 1793,
with the two large prints of *Job* [Illustration 12] and *Ezekiel*
[Illustration 13], published in the same year. The diminutive
designs of "The Gates of Paradise" are fascinating in their
originality of conception, but they are little more than
translations of drawings. They all suffer more or less from
formal cross-hatching, and betray the habit of a hand trained
to work after other men's designs. The best is the *Element of
Water*; but this again is a sketch on copper like *Glad Day*, and
though the treatment happens to be congenial to the subject,
it is, as engraving, meagre and unpromising. The *Job* and
Ezekiel, on the other hand, are ambitious works on a large

scale, in which Blake has put to use all his professional accomplishment. These are impressive prints, and the execution of them shows great power and energy, though as designs they are tinged—especially the *Job*—with Blake's least happy mannerisms; but there are still many traces of routine and over-elaboration in the burin-work, which was doubtless prepared by a heavily bitten etching-in of the whole design.

We must note, however, that in this regard the *Ezekiel*, which was slightly later in date, is a distinct improvement on the *Job*. Impressions of these rare engravings were recently acquired by the British Museum Print-Room.

In the illustrations to Young's "Night Thoughts," engraved in 1796 and 1797, Blake returns to a less elaborate

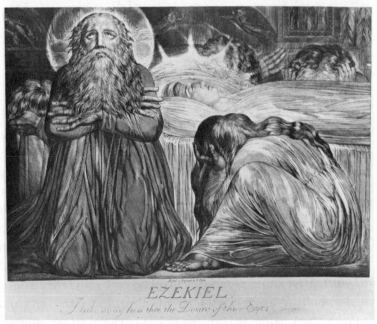

13. Blake, *Ezekiel*, "I take away from thee the Desire of thine Eyes." Size of the original engraving, 13-7/8 x 18-7/8 inches. British Museum.

manner. While the best of the designs are instinct with energy and communicate the sense of rushing movement with the peculiar power of the artist, the style of engraving is dry and cold; and the painfully regular systems of parallel lines or neat lozenge-work in the shading show a complete inability to master the problem of filling blank spaces with dark tone in a satisfying manner. The ethereal impetuosity of the figure-drawing is as incongruous with these tamenesses of execution, as Blake's imaginative fire is with the pompous and wearisome solemnity of Young's blank verse. The engraving of the designs to the "Night Thoughts" is indeed inferior to that of the *Job* and *Ezekiel*, where Blake had attained to some vibrancy and expressiveness in the handling of his tools on the copper.

Thirty years were to pass before Blake again took up his burin for a similarly ambitious series of original engravings: the famous illustrations of the Book of Job. The interval had been occupied with uninterrupted work, both painted and engraved; but very little of the engraved work was original, apart from the two prophetic books "Milton" and "Jerusalem," which were, like their earlier companion books, etched in relief, text and design together. The large print of the *Canterbury Pilgrims* was published in 1810; it shows the old encumbered method in which Blake was taught to engrave, with little of his redeeming energy and fire. Mr. Russell would place a little later than this another single print, *Mirth and her Companions*, inspired by Milton's "L'Allegro," which I have seen only in reproduction. Here certainly Blake seems to be nearer attaining a genial and expressive method of engraving, though he has by no means quite worked off the old routine element.

In 1818 Blake first became acquainted with Linnell; and Linnell is said to have urged on him the study of Marcantonio

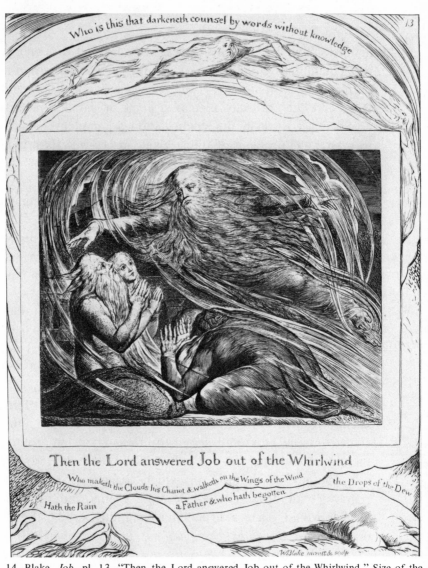

14. Blake, *Job*, pl. 13. "Then the Lord answered Job out of the Whirlwind." Size of the original engraving, 7-5/8 x 5-3/4 inches. Essick Collection.

and of Bonasone. In Blake's earlier engravings he had followed the practice of his time and etched the whole ground-work of the design, reserving the burin for the work of deepening the lines, adding fine detail, and completing the whole in a brilliant manner. In the *Job* it seems certain that he abandoned the use of acid and used the burin alone. There is certainly a wholeness and congruity of effect in these plates which was often missing before. And from men like Bonasone Blake learnt to use his graver with more ease and freedom, and to avoid formal cross-hatching. The gain is great; for if one can imagine the illustrations of *Job* carried out with (from the engraver's point of view) a more triumphant felicity, they are so fine that we forgive any defects, and instead of being inferior to the drawings from which they were done surpass the drawings in intensity and expressiveness. The series represents, indeed, the greatest achievement in original engraving since the time of Dürer and Mantegna, besides being one of the finest imaginative creations of any English artist [Illustration 14].

There is, I fancy, small likelihood of Blake's ever having seen the rare set of engravings of the Apocalypse by Jean Duvet, the French master of the early sixteenth century. It must be only a natural affinity which makes one inevitably think of Blake in looking at Duvet's work. The Englishman is a much more powerful genius and more original inventor; but in both there is something of the same kind of spiritual emotion, together with similar tendencies in composition, though Duvet takes over Italian and classic where Blake takes over Gothic forms. As an engraver Duvet is not perhaps a brilliant master, but he achieves a beautiful silvery quality of tone and works with freshness and feeling; he gains, in fact, from not possessing all the technical apparatus which Blake had laboriously learnt.

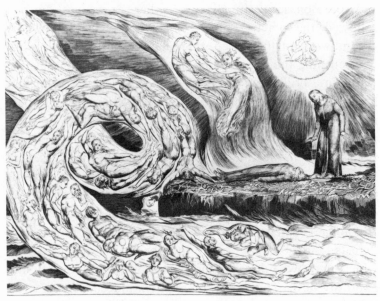

15. Blake, "Paolo and Francesca, and the Whirlwind of Lovers" (Dante's *Inferno*, Canto v). Size of the original engraving, 9-1/4 x 13-1/8 inches. Essick Collection.

In the projected plates of illustrations of Dante, of which only seven were taken in hand when he died, Blake essayed his newer methods of engraving on a larger scale. With less success, however; for a certain dryness of manner which is scarcely perceived in the more concentrated, close-wrought design of the Job series is less disguised in the more open compositions of the Dante. We can hardly judge of the Dante plates, however, as none of them is finished, except perhaps the one illustrating Canto V of the "Inferno," with the episode of Paolo and Francesca [Illustration 15]; in this the burin-work is more felicitous and direct than in any of Blake's previous plates, except the *Job*, and the design is full of characteristic beauties, especially in the rendering of

movement. On the whole, however, the Dante designs fall decidedly below the level of the *Job*.

Though the *Job* must rank as Blake's greatest work, there are many who find a yet more intimate satisfaction in the little woodcuts made in 1821 for Ambrose Phillips' imitations of the "Eclogues of Virgil," edited by Dr. Thornton [Illustrations 16, 17]. Though these are the only

16. Blake, *Virgil's Pastorals*, "Thenot." Of the same size as the original woodcut. Essick Collection.

17. Blake, *Virgil's Pastorals*, "The Blasted Tree." Of the same size as the original woodcut. Essick Collection.

engravings made on wood by Blake, he made a few engravings in a perfectly similar manner on pewter. Such are *The House of the Interpreter*, from "The Pilgrim's Progress," a small oblong print, and two illustrations to a ballad, "Little Tom the Sailer," written by Hayley for the widowed mother of a sailor-boy. In these prints the pewter is treated just as Blake

treated the wood block in the Virgil set. Instead of conceiving the design in black on a white ground, he took the black ground which would result from taking an impression from the unengraved block and using that as the foundation of his design, worked, like a mezzotinter, from black to white.

The "white line" in woodcut had been occasionally used by certain Italians of the sixteenth and seventeenth centuries, like Giuseppe Scolari, with striking effect; but it is particularly associated with William Bewick, whose success had given such an impetus to the wood-engraver's art in England at the end of the eighteenth century. Blake, of course, like Bewick, worked on boxwood with a graver, not, like the older artists, with a knife on a plank of pearwood. Not having been trained to work on wood, as he had been trained to engrave on metal, Blake had no formula to unlearn and expressed himself directly, impetuously, and with a kind of instinctive mastery of the medium. Rough and clumsy the woodcuts appeared to the professional engravers, the followers of Bewick, who were now bent on refining their strokes into a semblance of the delicate tones of the steel-engravers; but they were racy of the wood, and may stand as models in their own line for the few who in these days care to do original designs on the wood-block. It is astonishing how much bigness and grandeur Blake contrived to get into these tiny prints, and yet leave no impression of being cramped. The tragic design of the stormy moon, with the beaten corn and blasted tree, is one of Blake's happiest inventions. Wood-engraving of this kind was, indeed, peculiarly fitted to be the language of Blake's impassioned speech. The impatience of completeness which mars much of his design, but which we forgive for the sake of his strength and fire, here seems not inappropriate, and indeed, on so small a scale becomes a kind

of felicity; for we do not look for elaboration or searching
draughtsmanship, we are content with the gleaming shapes
and gestures that the artist has struck out of the solid
shadow.

One cannot write of Blake's woodcuts without saying a
word on the woodcuts of his youthful friend and disciple
Edward Calvert. Doubtless the small engravings of Calvert
owe their existence to Blake's example, but in some ways the
pupil surpasses the master [Illustrations 18-24].

Calvert was born in 1799 and was twenty-seven when
Blake died. He had been a midshipman in the navy and had
been in action at the bombardment of Algiers; but, resolved
to become an artist, he had quitted the navy and at the age of
twenty-four came up from Plymouth to London with a letter
of introduction to Fusch. Through the unlikely medium of a
stockbroker he came to hear of the little band of young
artists who sat at the feet of Blake in his old age, and soon
became not only acquainted with them but admitted to their
circle. These were Samuel Palmer, George Richmond and
John Linnell. Had the creative and imaginative powers of
these young men been strong enough to sustain this early
enthusiasm, they might have achieved the like of what
Rossetti and his associates were to achieve years later. (And
Rossetti also admired Blake intensely.) Calvert was the most
original nature of the group, and even the powerful impress
of Blake's art left little actual trace on his work, though it
was doubtless an abiding source of stimulation. It was the
Blake of the "Songs of Innocence" and of the "Virgil's
Pastorals" who especially appealed to Calvert, as to Palmer;
for both aspired to paint poetic idylls. In Calvert this bent
represented the profoundest impulses of his nature; he was
haunted by a vision of the Morning of the World, and the
myths of the Greeks presented themselves as an imaginative

language through which to express the secrets of his own ideal. No one, indeed, has re-interpreted mythic Greece with such intimate freshness and sincerity of heart as Calvert. This is more clearly seen in the work of his maturity, when colour, and suggestion by means of the music of colour, had come to be his great preoccupation; but the "Arcadian" temper is manifest also in the engravings of his youth. Strangely enough, Calvert never seems to have engraved after the age of twenty-nine, though he showed so singular a gift for original engraving. He continued to give all his time and thought to art during a long life, while remaining quite unknown to the world. He lived till 1883. But his production was always extremely limited; he was fastidious, and never satisfied; he destroyed more than he preserved of his own work as a painter, and very little remains as a record of his genius.

Calvert's exquisite engravings might have remained in total oblivion had not his son Samuel Calvert reprinted them in his "Memoir" of his father, published in 1893, and again as a portfolio through Messrs. Carfax & Co. in 1904. The set includes two copper-engravings, seven wood-engravings and two lithographs. Thirty copies only were printed of the Carfax edition, and the copper-plates and blocks were then presented to the British Museum. The lithographs were remainders of the original edition of 1829, and the stones were cleaned at the time.

It is an exiguous *oeuvre*, but how rich in charm! Everything that Calvert did was done with sensitive feeling; and in the wood-block especially he was intensely alive to the capacities of the medium and its most intimate beauties. Without any professional training he seems to have arrived at once at a perfect felicity of method. One of these little cuts, indeed, *The Chamber Idyll* [Illustration 18], is simply astonishing for its sheer subtlety of skill, though there is no

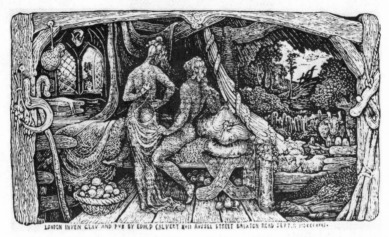

18. Calvert, "The Chamber Idyll," first state. Size of the original woodcut, 1-5/8 x 3 inches. British Museum.

parade of dexterity; it is all as if unconscious. Marvel of delicacy though this engraving is, it is on the edge of over-refinement. But as a whole the woodcuts are remarkable for their beautiful balance. The subjects are more completely imagined than with Blake; and in every detail there is imaginative feeling. *The Cyder Feast: a Vision of Joy and Thanksgiving* [Illustration 19] is said to have been a very early design of Calvert's and is one of the earliest of the engravings. The white line is here used very happily in the foliage, but the main part of the design is in black on white. The design is steeped in the artist's Arcadian spirit; but how genuine a thing it is with him, how far removed from the cold pastoralism of classical tradition! For Calvert is always romantic, though he derives all his inspiration from classic sources, and therefore he is far nearer to the Greeks than the

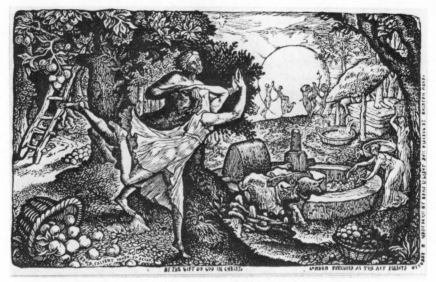

19. Calvert, "The Cyder Feast," first state. Size of the original woodcut, 3-1/8 x 5-1/8 inches. British Museum.

20. Calvert, "The Plowman," first state. Size of the original woodcut, 3-1/4 x 5-1/8 inches. British Museum.

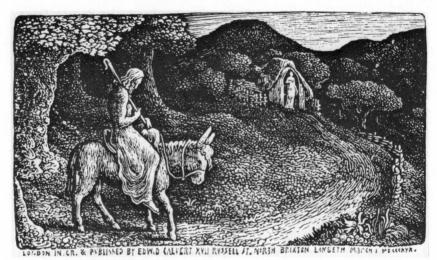

21. Calvert, "The Return Home," first state. Size of the original woodcut, 1-11/16 x 3-1/32 inches. British Museum.

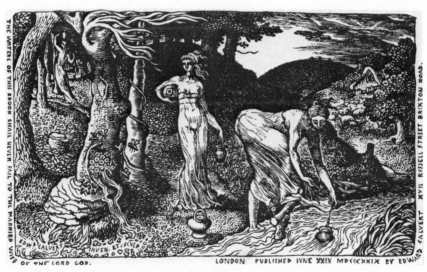

22. Calvert, "The Brook," first state. Size of the original woodcut, 2-1/16 x 3-5/8 inches. British Museum.

vast majority of those who have followed and imitated them. The Gothic side of Blake did not appeal to him. Only in the impressive woodcut called *The Ploughman*, also known as *The Last Furrow of Life* [Illustration 20], is there any trace of Blake's mystical invention; and Blake's influence is seen in the type of the principal figure. It is strange that the man who could produce two such memorable prints as these, worthy to stand with the finest original wood-engravings in the world, should have cared to produce so little more. But all we have besides is five small engravings, one a figure of a Bacchante playing on a lyre and looking over her shoulder with hair streaming in the wind, and four little idylls: *The Lady and the Rooks, The Return Home* [Illustration 21], *The Brook* [Illustration 22], and the *Chamber Idyll* already mentioned. Each of these has its distinctive beauty as a wood-engraving; we feel that in no other form but this could the design have found its perfect expression.

There are only two copper-engravings by Calvert; but here again there is no crudeness or immaturity. I reproduce the larger of the two; it is called *The Bride* [Illustration 23]. The figure of the shepherd striding away over the hill recalls Blake somewhat; but the whole conception is Calvert's own. Would that Blake had earlier found a method of line-engraving as appropriate to his design as this is to Calvert's! The other plate, called *The Sheep of His Pasture*, is a small pastoral landscape, without human figures, redolent of the spirit of peace and evening.

There remain two little lithographs: *Ideal Pastoral Life*, and *The Flood* [Illustration 24], which I reproduce. Blake had made one lithograph, a subject from Job.[3] It was a contribution to one of the parts of "Specimens of Poly-autography," published about 1806; but it was only a casual experiment done at the printer's invitation, and Blake never

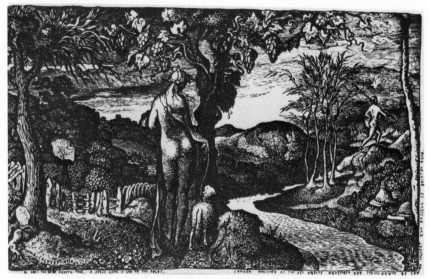

23. Calvert, "The Bride," first state. Size of the original woodcut, 4-7/16 x 6-9/16 inches. British Museum.

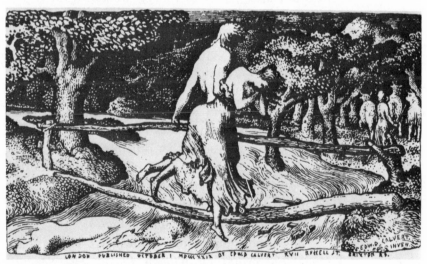

24. Calvert, "The Flood." Size of the original lithograph, 1-11/16 x 3-1/32 inches. British Museum.

explored the resources of the medium. Calvert also seems only to have made these two essays in lithography, and his method of using the stone is scarcely differentiated from the method he used in wood-engraving, though the lithographs have stronger contrasts of black and white. It is in his wood-engraving that he seems to have found most perfect expression for the conceptions he had in his mind. Taking this little collection of prints as a whole, how satisfying one finds it! How full of charm, how richly conceived and exquisitely felt is each one of them! In English art they stand alone.

NOTES

1. Ed.: *The Engravings of William Blake* (Boston and New York: Houghton Mifflin, 1912), pp. 54-55. David Erdman, in his article reprinted in this volume, and Geoffrey Keynes in *Engravings by William Blake: The Separate Plates* (Dublin: Emery Walker, 1956), p. 7 accept Russell's opinion that there is only one plate from which both versions of "Glad Day" were printed. A second colored copy of "Glad Day," unknown to Binyon in 1917, is in the Huntington Library, San Marino, California.

2. Ed.: For more recent studies of the dating of "Glad Day" (now usually known as "Albion rose" or "The Dance of Albion"), and other separate plates by Blake referred to in this essay, see David V. Erdman, "The Dating of William Blake's Engravings," reprinted with revisions in this volume, and Geoffrey Keynes, *Engravings by William Blake: The Separate Plates.*

3. Ed.: This lithograph is now known as "Enoch." See Keynes, *Engravings by William Blake: The Separate Plates*, pp. 43-4, pl. 26.

BLAKE'S "ANCIENT OF DAYS":
THE SYMBOLISM OF THE COMPASSES
by
Anthony Blunt

*N*o one who has turned the
pages of Blake's *Prophetic Books*, as they were originally
printed and illuminated by his special method, will easily
forget the frontispiece to the poem *Europe, a Prophecy*,
[Illustration 25]. It represents an old bearded figure kneeling
on one knee, stretching down his left hand, and resting a pair
of huge compasses on a sphere, of which a part is just visible
as a scratch in some versions of the original. It is one of
Blake's most impressive inventions, and one of which we
know that he himself was particularly fond, for he coloured a
copy of it for Tatham on his death-bed.[1]

We are told that Blake was originally inspired to carry
out his design by a vision which hovered over his head at the
top of the staircase when he was living in Lambeth.[2] There is
no reason to doubt that this was so, any more than in a

Ed.: Reproduced by permission of the author and publisher from the
Journal of the Warburg and Courtauld Institutes, 2 (1938), pp. 53-63.

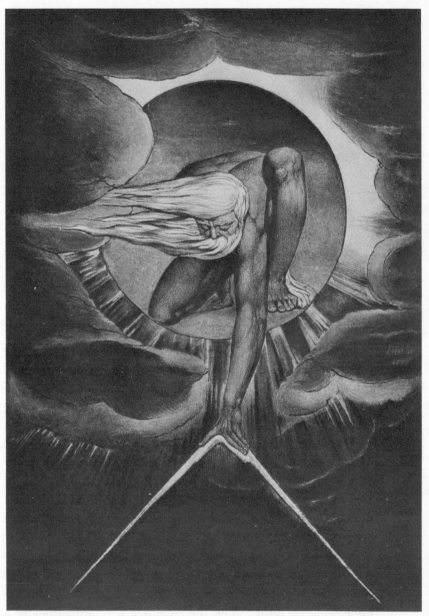

25. Blake, "The Ancient of Days," frontispiece to *Europe*. Colored print. Whitworth Art Gallery, Manchester.

hundred other cases in which Blake talked of his paintings and poems as the direct records of what the spirits showed him. But though the vision was no doubt spontaneous, it clothed itself—at least when it had been put down on paper—partly in traditional forms. For the imagination, even of the most mystically minded artist, is conditioned by what he has seen in the material world, and any new vision must of necessity take to some extent the shapes in which the artist has been accustomed to think.[3]

The subject of the design is usually (but, as will be seen later, not quite accurately) described as 'The Ancient of Days' and it illustrates essentially the phrase referring to the Creation from Proverbs VIII. 27: "When he set a compass upon the face of the depth." This theme is one which occurs quite frequently in mediaeval cycles of illuminations representing the Creation, in which it stands for the second day [Illustration 26].[4] The compasses mark the delineation of the Firmament, and symbolise the imposition of order on chaos.[5]

Now Blake's method of illumination has always been regarded as in some sense an attempt to adapt the methods of printing in order to achieve the results obtained by mediaeval illuminators. Moreover, Blake had a passionate admiration for everything mediaeval, and it is therefore quite likely that he studied mediaeval manuscripts in one of the libraries of the time, or in the sale rooms which he frequented. He may well have seen there some representation of this theme.

But Blake's use of the mediaeval design is modified by other factors, of which the first depends on the historical development of symbolism, and the second on Blake's own philosophy. During the later Middle Ages and the Renaissance, as has been shown by E. Panofsky and F. Saxl,[6] the compasses become the symbol of mathematics and, even

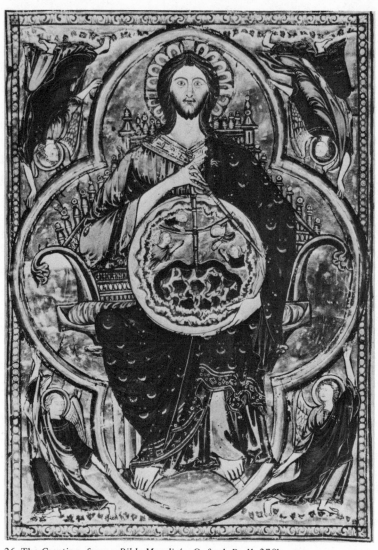

26. The Creation, from a *Bible Moralisée*. Oxford, Bodl. 270b.

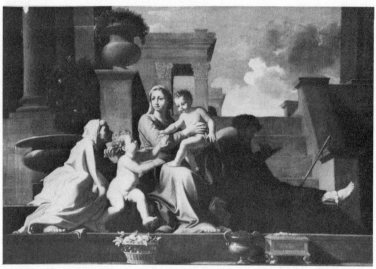

27. N. Poussin, "Holy Family on the Steps." Duke of Sutherland.

more widely, of science and philosophy in general.[7] Often, however, they are found not alone, but in conjunction with either a ruler or a set-square. Usually in this case they are the symbols of some specifically mathematical study. For instance in the sets of designs representing the Liberal Arts, Geometry always holds compasses and set-square or ruler.[8] But they are also still to be found as the attributes associated with more general intellectual faculties. Ripa, for instance, puts the compasses and set-square into the hands of *Giuditio*, and gives compasses and ruler to *Consideratione*. In these cases the presence of the mathematical instruments is intended to show that the conclusions of philosophy can only be arrived at by methods based on the logical and certain processes of mathematics.

It is less common to find the compasses and ruler or set-square introduced into religious painting, but there is one curious case of their occurrence. In the 'Holy Family on the

Steps' [Illustration 27] Poussin shows in the background the figure of Joseph seated and absorbed in measuring with a pair of compasses on a tablet.[9] The depiction of Joseph in this way seems to be extremely rare;[10] and the explanation usually given is that the instruments are intended to show that Joseph was a carpenter. This may be part of Poussin's idea, but, though the compasses and ruler occur among the tools of the carpenter they are primarily mathematical instruments, and when shown without the others they imply more intellectual pursuits.[11] In the 17th century, for instance, they are commonly the attributes of the architect.[12]

There are two preliminary drawings for Poussin's painting which make its meaning clearer.[13] In these Joseph is not shown measuring on a tablet but reading a book, though in one of them (No. 43) the compasses and set-square lie on the step below. That is to say, Poussin seems to have been hesitating between the idea of making Joseph read, and that of giving him the compasses and set-square as attributes. Now the depiction of Joseph reading is common in the 17th century, and it is no doubt intended to illustrate what is said of him by Isolanis in his *Summa de Donis S. Joseph*, published at Pavia in 1522, namely that he was possessed of the most profound knowledge in all branches of theology and philosophy.[14] Since Isolanis specifically mentions philosophy as one of the attainments of Saint Joseph, it seems almost certain that the compasses and ruler or set-square, which Poussin eventually substituted for the book in his painting, have their current meaning as the symbols of philosophical and particularly of mathematical knowledge.[15]

* * *

In Blake the compasses have a significance which is only a development from that current in the 16th and 17th

centuries. To see exactly what he means by them we shall have to examine the general intention of the frontispiece to *Europe*, and its connection with other designs by the artist.

I said above that the description of the print as 'The Ancient of Days' was not quite accurate. Properly speaking the figure represented is not the God of the Bible, but Urizen, one of Blake's mythical figures. [16] His creation of the universe is described as follows in the *First Book of Urizen:*

> He form'd a line and a plummet
> To divide the Abyss beneath;
> He form'd a dividing rule;
> He formed scales to weigh,
> He formed massy weights;
> He formed a brazen quadrant;
> He formed golden compasses,
> And began to explore the Abyss; [17]

The essence of the creation of Urizen therefore is the imposition of the rational methods of mathematics on chaos, the introduction into the universe of an order controlled by measurement:

> Times on times he divided & measur'd
> Space by space in his ninefold darkness, [18]

But this imposition of order means for Blake the reduction of the infinite to the finite, and therefore the destruction of the imagination. Urizen, as his name—a punning combination of *Your Reason*—implies, is the rational as opposed to the imaginative power, and he stands for all that Blake loathed in the materialism of his time, against which he struggled all his life. There are many passages in his writings which show how deeply he hated the limiting effects of reason and the destruction of the imagination to which it leads, [19] and in the symbolical poems this limitation is always associated with Urizen. On the first sketch for the frontispiece to *Europe* is a line from the poem, referring to Urizen, which reads: "Who shall bind the Infinite?" [20]

The effect of Urizen's creation was to crush man's sense of the infinite, and to shut him up within the narrow wall of his five senses. In the *First Book of Urizen* the effect on the senses is described as follows:

> Six days they shrunk up from existence,
> And on the seventh day they rested,
> And they bless'd the seventh day, in sick hope,
> And forgot their eternal life. [21]

In these lines Blake evidently intended a parallel with the account of the Creation in Genesis, and this leads to the second fact about Urizen, namely that he is usually identified by Blake with the Jehovah of the Old Testament. [22] But since Urizen is always an evil force Blake is here adopting a Gnostic heresy, according to which the creator of the world was not God, but an evil daemon. [23]

We are not concerned here with all the various ideas with which Urizen is associated by Blake, but two of them are of importance for the interpretation of the frontispiece to *Europe*. In certain contexts Urizen is explicitly identified with God the Son in *Paradise Lost*. Blake put a very curious interpretation on Milton's Christ, whom he regarded as the exact opposite of the Christ in whom he believed. In the *Marriage of Heaven and Hell* he describes the crushing of desire by reason and restraint, that is to say by Urizen, and adds: "The history of this is written in Paradise Lost, & the Governor or Reason is call'd Messiah." And a little later: "In Milton, the Father is Destiny, the Son a Ratio of the five senses, & the Holy-ghost Vacuum!" [24] Now in *Paradise Lost* it is the Son and not the Father that performs the act of creation. This is described in the following lines, which were written by an early 19th century hand below the frontispiece of the copy of *Europe* in the British Museum, and which, as has often been pointed out, Blake very probably had in mind when he made the composition:

> ... in this hand
> He took the golden compasses, prepared
> In God's eternal store, to circumscribe
> This universe, and all created things.
> One foot he centred, and the other turned
> Round through the vast profundity obscure,
> And said, "Thus far extend, thus far thy bounds;
> This be thy just circumference, O World." [25]

The last, and for the purpose of this article the most important, metamorphosis of Urizen is when he appears as the Demiurge who creates the world in Plato's *Timaeus*, for it seems to be above all in this capacity that he stands on the title page of *Europe*.

When Blake speaks of rationalism, he often associates it with the philosophy of the Greeks and above all with that of Plato: "The Gods of Greece & Egypt were Mathematical Diagrams—See Plato's Works." [26] "Christ addresses himself to the Man, not to his Reason. Plato did not bring Life & Immortality to Light. Jesus only did this." [27]

Moreover the account quoted above of the creation of the world by Urizen agrees exactly with that in the *Timaeus*, in which the Demiurge imposes on chaos the rational laws of mathematics. But there is a profound difference in the attitudes of Blake and Plato to this creation. For to Plato the imposition of order on chaos is a good act, but for Blake, as has already been said, it is evil. [28]

Blake is in the same position with regard to Plato over the whole relationship of reason to imagination. He finds the same opposition between them as Plato, but whereas the latter throws the artists out of his republic, Blake condemns reason in the name of imagination. Plato's chief argument against poetry and the arts is that they come into conflict with rational truth, that their conclusions are contrary to facts which can be checked by weight, measurement and number. [29] Blake on the other hand felt that this kind of

standard was inferior and contrary to that of the imagi-
nation, [30] and in the 'Proverbs of Hell' he includes two,
which taken together seem to form a direct reference to the
Platonic view of the arts: "Bring out number, weight and
measure in a year of dearth," and: "Exuberance is
Beauty." [31]

Now the theme of the first part of *Europe* is how the
'Secret Child' came to save Enitharmon, Inspiration, and Los,
Poetry, from the tyranny in which they had been held by
Urizen. The 'Secret Child' is another of Blake's composite
figures. Primarily he is Christ, who by his birth into the world
destroyed the old dispensation of Jehovah and heralds the
new dispensation of the Gospel. But Christ is also identified
with Imagination: ". . . Abstract Philosophy warring in
enmity against Imagination (Which is the Divine Body of the
Lord Jesus . . .)." [32] Moreover in a note on Berkeley Blake
writes: "What Jesus came to Remove was the Heathen or
Platonic Philosophy, which blinds the Eye of Imagination,
The Real Man." [33] It seems likely therefore that in *Europe*
the particular aspect of Urizen which Blake had in mind was
the Platonic Reason, in whose name the imagination was
condemned.

This hypothesis is confirmed by another design by
Blake, namely an illustration to Milton's *Il Penseroso* [see
Illustration 141]. According to Gilchrist [34] it bore the title:
"The Spirit of Plato," and it illustrates the lines:

> Or let my lamp at midnight hour
> Be seen in some high lonely tower,
> Where I may oft outwatch the Bear
> With thrice great Hermes, or unsphere
> The spirit of Plato to unfold
> What worlds or what vast regions hold
> The immortal mind that hath forsook
> Her mansion in this fleshly nook;
> And of those daemons that are found

> In fire, air, flood or under ground,
> Whose power hath a true consent
> With planet, or with element.[35]

The symbolism of the illustration seems to be as follows. Milton sits surrounded by the four elements referred to in the poem. Below him is the earth, to the right is water, to the left fire, and round his head air. Each of these elements is shown with its daemon, those of air being the dreams of the poet, which, according to the Platonic doctrine of Inspiration, lead up to the higher non-material spheres depicted in the top of the composition. Plato points down with his left hand, and up with his right, left and right in Blake being usually associated with the material and the spiritual. Above him are the three spheres of Jupiter (right), Venus (left), and Mars (behind), the same symbolism of left and right still applying; for the spheres correspond to the three parts into which Plato divides the soul, Jupiter standing for the Reason, Venus for the Senses, and Mars for the Energy. Above appear the three Fates; and on the right "thrice great Hermes" and the constellation of the Bear, as in Milton's text. The sphere of Mars contains a bat-winged figure, holding a spear, and strongly reminiscent of Blake's usual representations of Satan, the embodiment of energy. The sphere of Venus shows the goddess herself, who presses her breast, and is therefore probably to be identified with Blake's Vala or Nature. Below is the Fall of Man, conceived as the descent from harmony into division. The right hand sphere, that of Jupiter, shows an old man seated, holding the torch of rational belief in his left hand, and drawing with a pair of compasses with his right. Behind him a figure appears to set in motion the circle which he has made. This is an accurate rendering of the Creation as described in the *Timaeus*, for there the Demiurge, who is the old man, is said to have

assistants to whom he deputes part of the work of creation. His place would properly be in the sphere of Jupiter, for, according to later writers, the *vous* or soul of the world which the Demiurge creates, is identified with this god. As Mars is identified with Satan, and Venus with Vala, so the Demiurge is here Urizen, and the likeness to the figure on the frontispiece to *Europe* is so great as to suggest that Blake had above all a Platonic conception in mind when he made the latter design, although as has already been shown, the figure is also charged with many other allusions. [36]

The same ideas reappear in two other designs by Blake. One of them is now lost and we only know it from Gilchrist's description. [37] It showed the Christ child asleep on his cross (a theme traditional in the 17th century), [38] and beside him Joseph using a pair of compasses. It is possible that Blake took the idea of giving Joseph this attribute from Poussin's 'Holy Family on the Steps,' for the picture was engraved, and Poussin was the one artist of the 17th century for whom Blake had a certain respect. [39] But the idea of the painting is entirely Blake's, for the compasses stand not merely for learning but for rationalist knowledge, for the old dispensation to which Joseph still belonged, as opposed to the new order represented by Christ. This theme is worked out more clearly in another painting showing Christ in the carpenter's shop [Illustration 28]. In 17th century representations of the subject Christ is learning the art of carpentry, and is supposed to see in the wood which is being cut the cross of his passion. [40] But here he is depicted holding the compasses and set-square, while Joseph and Mary look on, the former holding a saw. Here again we have not the traditional Christ, but the 'Secret Child' of *Europe*, and the Christ who supersedes the rationalism of Plato. But it must be noticed that in this painting Christ does not destroy the weapons of

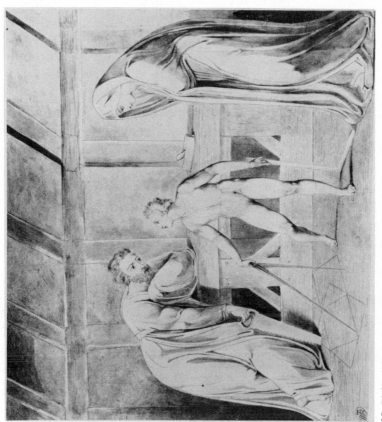

28. Blake, "Christ in the Carpenter's Shop." Collection of Miss Carthew.

rationalism; on the contrary, he seems actually to be using them, and to be drawing with them a mathematical figure. This means that in the final state, when Jerusalem has been built, the conflict between reason and imagination will be resolved, and the truths of poetry and science will be finally reconciled. This is the state described by Blake in the phrase: "Length, Bredth, Highth again Obey the Divine Vision."[41]

This however is only the perfect state to which the world will ultimately attain. Meanwhile mankind has many trials to face. One of these is told in a later part of *Europe*. [42] The salvation brought by the advent of the Secret Child is spoiled by disagreements between Los and Enitharmon. This leads to the sleep of Enitharmon which lasts for nearly 1800 years, when a new salvation is granted. This is brought about as follows. The first stage is that "A mighty Spirit . . . nam'd Newton" appears. [43] Now Newton is for Blake the great rationalist and representative of Urizen in modern times. [44] But he serves a useful purpose in that he gives a visible form to error, which can then be destroyed. The destroyer is Orc, the Spirit of Revolt, son of Los and Enitharmon, who brings about the French and American Revolutions. This amounts to a repetition of the same process as before but with different actors. In the first case Christ overcomes Urizen-Jehovah-Plato; now Orc drives out Newton, the earthly representative of Urizen and, according to Blake's ideas, the continuer of Plato. [45] Newton's share in this incident is alluded to in *Jerusalem*, when Los says:

> I saw the finger of God go forth
> Upon my Furnaces from within the Wheels of Albion's Sons,
> Fixing their Systems permanent, by mathematic power
> Giving a body to Falsehood that it may be cast off for ever,
> With Demonstrative Science piercing Apollyon with his own bow. [46]

And in the marginal decoration to this passage we see again the compasses which always appear as the symbol of the rationalism spoken of here. In this case they are held by a figure flying downwards and applying them to a sphere, not solid, but composed of longitudinal ribs. The compasses appear again, this time as the attribute of Newton himself in the magnificent colour print showing the scientist as a naked figure gazing downward and drawing a mathematical figure on the ground [47] [Illustration 29].

To round off this analysis of Blake's frontispiece to *Europe*, something should be said of the sources from which he drew the forms in which his vision expressed itself. Blake was certainly acquainted with the works of Italian and Flemish Renaissance and Mannerist painters through engravings; and there is no doubt that he took from them elements

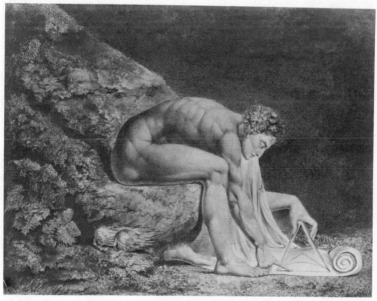

29. Blake, "Newton." Color print. Tate Gallery.

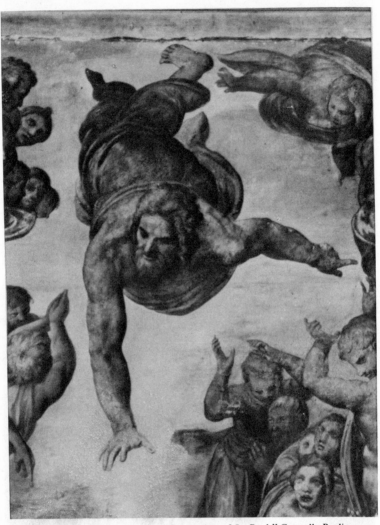

30. Michelangelo, Christ from the "Conversion of St. Paul." Cappella Paolina.

which he repeats often almost without alteration in his own designs. For the frontispiece to *Europe* it is not possible to point to any one figure which inspired Blake directly. But there are several Italian originals which bear great likeness to it. The dramatic gesture of the arm stretched very straight downwards occurs in one of the trumpeting angels in Michelangelo's 'Last Judgment,' but much more obviously in the Christ of the 'Conversion of St. Paul' in the Pauline Chapel[48] [Illustration 30]. The crouching attitude and the distorted knee of Blake's figure recall the colossal statue by Giovanni de Bologna at Pratolino[49] [Illustration 31].

Blake's design for *Europe* can therefore be shown to be a compound of many elements. Based on a mediaeval theme, incorporating a Platonic symbol, and modelled in terms borrowed from Mannerist painting, it expresses a personal, anti-rational doctrine of the artist. This composite work is typical of Blake, who in his own way was just as much an eclectic as his arch-enemy Reynolds, whom he condemns precisely on this score.[50] But it is only another proof of Blake's imaginative power that out of the pickings from these very miscellaneous sources, he was able to make one of his most impressive designs.[51]

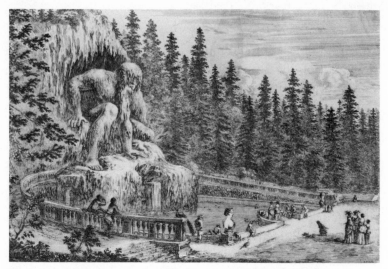

31. Stefano della Bella, engraving after Giovanni da Bologna's "Apennines."

32. Blake, "God Creating the Universe," drawing. Collection of Mr. and Mrs. Paul Mellon.

NOTES

1. Mona Wilson, *Life of William Blake* (London: None-such Press, 1927), p. 86.

 Tatham's copy is now in the Whitworth Art Gallery, Manchester, and is reproduced here by the courtesy of the Director. A rough sketch of the same subject is in the collection of T. Lowinsky [Ed.: now in the collection of Mr. and Mrs. Paul Mellon. See Illustration 32]. It shows the Almighty kneeling on one knee, facing left, and putting the compasses to the clouds by his feet. The conception is quite different from that on the title-page [Ed.: frontispiece] of *Europe* and less heroic. In many ways it is more closely connected with the *Newton* discussed later. The inscriptions are not in Blake's hand.

 Yet another version occurs in the manuscript of *Vala* (p. 13) where Urizen is shown holding a huge pair of compasses over his head. This drawing illustrates the building of the "Mundane Shell" by Urizen around Albion, which is another allegory of the creation of the world. Cf. K 280-81, E 309.

2. Wilson, p. 86.

3. Blake habitually talked of his paintings as exact and uncalculated copies of his visions, just as he talked of his poems as "dictated" by the spirits. But the preliminary sketches which exist for many of the former, prove as conclusively as the early drafts of the latter that, however deeply Blake may have been originally inspired by the spirits, he evolved his works by the same conscious stages as less mystical artists.

4. The version here reproduced occurs in a *Bible Moralisée* (cf. Erwin Panofsky and Fritz Saxl, " 'Melancolia 1.'

Eine quellen-und Typengeschichtliche Untersuchung,"
in *Studien der Biblioteck Warburg* [Leipzig and Berlin:
B. G. Teubner, 1923], 67). These authors also quote
other examples, to which may be added a Bible in the
British Museum (Royal, 19 D iii, vol. 1, f. 3v.), another
Bible at Chantilly (Ms. fr., 1045, vol. i, f. 1) and a
manuscript of Boccaccio's, *Des cas des Nobles Hommes
et Femmes* (cf. *Pantheon*, 1[1932], 39).

5. In late Mediaeval and early Renaissance art they
 sometimes occur, accompanied not by the figure of God
 the Father, but by the three eyes symbolising the divine
 wisdom, as a representation of the Creation, e. g. in a
 Tuscan manuscript of Dante dating from about 1400
 (cf. Hermann, *Die Handschriften und Inkunabeln der
 italienischen Rennaissance* [Leipzig, 1932], III, p. 1). In
 Engelgrave's *Lux Evangelica* (Cologne: Jacobun à Meurs
 Amstelodami, 1655), emblem 23, the hand of God
 appears holding the compasses accompanied by the
 inscription: "Stetit in medio," from John XX:19, and
 "Medio stans perfecit orbem." An allusion to the
 Creation is evidently intended, though the explanation
 of the emblem contains no further reference to it. The
 engraving, incidentally, is taken from Rubens' design for
 the Plantin printer's mark.

6. Panofsky and Saxl, p. 67.

7. They are to be found, for instance, on the title-page of
 various Renaissance editions of the *Philosophia Natu-
 ralis* of Albertus Magnus (cf. Victor Masséna, prince
 d'Essling, *Études sur l'art de la gravure sur bois à Venise.
 Les livres à figures venitiens* [Florence: L. Olschki and
 Paris: H. Leclerc, 1908], I, part 2, p. 291), and in
 Jacopo de' Barbari's portrait of Luca Pacioli at Naples.

They appear in Raphael's "School of Athens" in the hands of Euclid. At a later date they appear constantly as a general symbol of wisdom, for instance in the printer's mark of the Plantin Press. A more curious case is noticed by S. Foster Damon, *William Blake, His Philosophy and Symbols* (New York and London: Houghton Mifflin, 1924), p. 348. The frontispiece to Robert Fludd's *Utriusque Cosmi majoris historia* (Frankfort, 1617) shows the scheme of the whole universe according to Fludd's ideas. At the top appears the hand of God, holding a chain of which Nature takes the other end. Nature in her turn is linked by another chain to the figure of an ape, who sits on the sphere of the world, and holds in his hand a pair of compasses which he applies to a globe. The background of the plate shows all the various activities of nature and man, and the part to which the ape corresponds is the realm of the arts, particularly of those dependent on mathematics. The arts are described by Fludd as *Simia Naturae* in the second *Tractatus* of the book, on the separate title-page of which the ape again appears, this time without compasses, in control of the various arts. With Fludd, therefore, the compasses again signify the weapon of human knowledge held by the ape of nature.

Ed.: The compass motif also appears on Motte's frontispiece to Newton's *Principia*, London, 1729 (cf. Martin K. Nurmi, "Blake's 'Ancient of Days' and Motte's Frontispiece to Newton's *Principia*," in *The Divine Vision: Studies in the Poetry and Art of William Blake*, ed. Vivian de Sola Pinto [London: Victor Gollancz, 1957], pp. 205-16), and on the frontispiece to the second volume of James Hervey's *Meditations*

Pater quem requirebat et considerabat ... plenus sapientia ... in certis ille

34. Bigot, "Christ in the Carpenter's Shop," engraving.

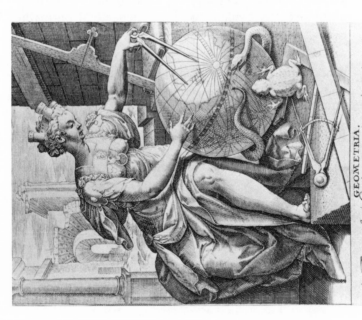

GEOMETRIA.

Terrarum spatia Geometria ponit
Dissimilisq; plagas, montesq; ac flumina lustrat.

33. Pieter de Jode, "Geometry," engraving.

among the Tombs, third ed., London, 1748 (cf. Geoffrey Keynes' "Description and Bibliographical Statement," note to pl. 10 of series b, in the Blake Trust facsimile of Blake's *There Is No Natural Religion* [London: Trianon Press for the Blake Trust, 1971]).

8. Cf. the "Geometry" on the Campanile at Florence, and the engraving by Pieter de Jode [Illustration 33] in which Geometry applies the compasses to a model of the earth in almost the same way as God the Father applies them to the earth itself in the mediaeval manuscript. This representation of Geometry was even made the basis for portraits, as for instance in one by Pierre Mignard of Mademoiselle de Montpensier, "La Grande Mademoiselle," with Messrs. Spink. This shows the great intellectual and Frondeuse appropriately as Minerva, sitting, holding a pair of compasses to a globe, and encircled with all the attributes of the arts of peace and war. On a book of music are written the lines:

> La deesse des arts des lettres et des armes
> Que le premier des dieux forma de son cerveau
> Pour embelir la terre y paroist de nouveau
> Avec cetter valeur cet esprit et ces charmes.

9. Otto Grautoff, *Nicolas Poussin* (1914), no. 131. The original belongs to the Duke of Sutherland. A comparison of his painting with the version belonging to M. Lerolle has recently shown that the latter is a contemporary copy.

10. Another painting of the Holy Family, based on a drawing by Poussin at Windsor (11988), of which versions exist in the National Gallery, at Chantilly and at Pavlovsk, shows Joseph leaning on a measuring rod, with a set-square on a ledge behind, but without the

compasses. These mathematical instruments do not appear in the drawing; they were only added in the painting which is probably not by Poussin, but by Le Sueur.

11. When Joseph is represented as a carpenter, as is common in the 17th century, he is usually shown with the plane and chisel and the practical tools of his trade. [cf. Illustration 34]. Out of many examples of this the following may be quoted: Murillo's "Holy Family" at Chatsworth; Annibale Carracci's "Christ in the Carpenter's Shop," belonging to the Countess of Suffolk (Cf. Exhibition of 17th century art at Burlington House [London: 1938], No. 306); Schedoni's "Holy Family" in the Palazzo Reale at Naples; Lebrun's *Bénédicité* in the Louvre, and others mentioned by Mâle, *L'Art Religiuex après le Concile de Trente* (Paris: A. Colin, 1932), p. 311. The motive can be traced back to the 15th century, when it occurs for instance in a Flemish coloured woodcut of 1840-1500 (cf. Wilhelm Ludwig Schreiber, *Handbuch der Holz- und Metallschnitte d. XV. Jh.* [Leipzig: K. Hiersemann, 1926-30], no. 638).

12. This occurs commonly in paintings and also in the engraved portraits forming the frontispieces to architectural treatises, such as that of Montanus, Rome, 1691.

13. See Walter Friedlaender, *The Drawings of Nicolas Poussin* (London: The Warburg Institute, 1938), Part I, nos. 43, 44.

14. Cf. Mâle, pp. 314, 319. The idea goes back in painting to Andrea del Sarto who uses it in his Holy Family lunette in the cloister of the SS. Annunziata in Florence, executed in 1525, three years after the publication of Isolanis' book. Poussin seems to have had

this painting in mind both for this motive and for the general arrangement of the design.

15. The figure of Joseph in the painting is apparently derived from the Naason among Christ's ancestors on the ceiling of the Sistine Chapel.

16. Wilson, p. 86.

17. K 233-34, E 79-80. Cf. also the description in *Vala*, mentioned above, note 1.

18. *Book of Urizen* (K 222, E 69).

19. "Art is the Tree of Life ... Science is the Tree of Death," "The Laocoön" (K 777, E 271). "All that is Valuable in Knowledge is Superior to Demonstrative Science, such as is Weighed or Measured," "Annotations to Reynolds" (K 475, E 648). "Energy is the only life, and is from the body; and Reason is the bound or outward Circumference of Energy," *Marriage of Heaven and Hell* (K 149, E 34).

20. K 239, E 60. The sketch is on page 96 of Blake's *Notebook (Rossetti Manuscript)*.

21. K 236, E 82.

22. Cf. Damon, p. 69.

23. Blake's view of the God of the Old Testament as the evil, rational creator is shown in one of his simplest couplets; entitled "To God":

> If you have form'd a Circle to go into,
> Go into it yourself & see how you would do.
> (K 557, E 508)

24. K 150, E 34-35.

25. *Paradise Lost*, vii, 224-31. Keynes, in John Milton, *Poems in English with Illustrations by William Blake*

(London: Nonesuch Press, 1926), I, 358, maintains that the identification of Urizen with the Son in *Paradise Lost* should not be too much stressed, but the texts seem to make it clear that Blake intended Urizen to stand for Milton's figure as he, Blake, understood him. It is amusing to notice that Voltaire picks on just the passage in Milton which Blake illustrates as an instance of barbarism. When Candide asks the Venetian Senator Pococurante whether he admires Milton, the latter says: "Qui? Ce barbare ... qui défigure la création, et qui tandis que Moyse représente L'Être Éternel produisant le Monde par la parole, fait prendre un grand compas par le Messiah dans une armoire du Ciel pour tracer son ouvrage?" (*Candide*, ch. 25).

26. "The Laocoön" (K 776, E 271).

27. "Annotations to Berkeley" (K 774, E 653). Blake extended his hatred of Greek ideas to Greek art and for the same reason. He felt it was based on mathematical principles and he could see in it no trace of real imagination. His engraving of the Laocoön is covered with all sorts of inscriptions satirising the art of antiquity ("The Laocoön"; K 775-77, E 270-72), and in others of his writings we find constant attacks on it, coupled usually with praise of the Gothic: "Grecian is Mathematic Form: Gothic is Living Form" (*On Homer's Poetry & On Virgil*; K 778, E 267).

28. Damon, p. 120.

29. *Republic*, X, 602. The Platonic idea that the world was created according to mathematical laws appears also in the Bible, where it is to be found in Wisdom, XI:20: "By measure and number and weight thou didst order all things."

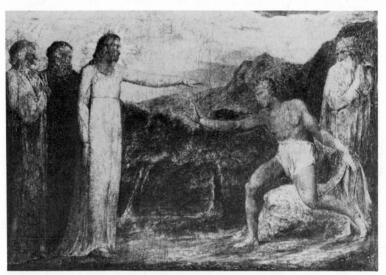

35. Blake, "Christ Healing the Blind Man." Collection of Mrs. Clifton.

30. Cf. above, note 19.

31. *Marriage of Heaven and Hell* (K 151, 152; E 35, 37).

32. *Jerusalem* 5:58 (K 624, E 147).

33. K 775, E 625. This sentence is no doubt the idea
 underlying the painting by Blake of "Christ Healing
 Blind Men," belonging to Mrs. Clifton [Illustration 35].
 Contrary to pictorial tradition, the blind man is here
 young, and Blake has made him of markedly classical
 appearance.

34. *Life of William Blake* (London: Macmillan, 1880), II,
 248.

35. Lines 85-96.

36. Panofsky and Saxl, p. 66 f. show that the compasses are
 already associated with the Platonic doctrine of the
 validity of weight, number and measure in the 16th

century, and particularly in Dürer's etching of Melancolia. It is known that Blake had a copy of this etching on the wall of his studio for many years, (cf. A. G. B. Russell, *The Engravings of William Blake* [Boston and New York: Houghton Mifflin, 1912], p. 20) and though it is unlikely that he understood the full meaning of the symbols in the design, it is possible that he was conscious of this connection.

It must not be imagined that Blake was opposed to Plato on all matters. On the contrary he accepts many of his theories, for instance on the question of Inspiration.

37. Gilchrist, II, 244.

38. Cf, Mâle, p. 331. Another painting of the same theme by Blake shows the Virgin watching the Christ child asleep, Joseph not being present. In this case the compasses and ruler stand against the wall in the background, presumably with the same meaning as in Blake's other versions of the theme. This painting is now in the collection of W. Stirling, Keir.

Ed.: The painting formerly in the Stirling collection is now in the Victoria and Albert Museum, London. A third version of the design, in the collection of George Goyder, shows Joseph holding the compasses above the Christ Child.

39. Cf. "Annotations to Reynolds" (K 469, E 644).

40. Mâle, p. 311.

41. Blake, *Jerusalem* 36:56 (K 664, E 177); cf. Wilson, p. 246.

42. K 239 ff., E 60 ff.

43. *Europe* 13:4-5 (K 243, E 63).

44. He is usually coupled with Locke, and sometimes with Bacon. Cf. *The Song of Los*: ". . . Till a Philosophy of Five Senses was complete. / Urizen wept & gave it into the hands of Newton & Locke" (K 246, E 66). And in *Jerusalem:* "To Converse concerning Weight & Distance in the Wilds of Newton & Locke?" (K 611, E 175). Cf. also Wilson, pp. 55, 96.

45. The parallel between Christ and the spirit of Revolt was one which Blake loved to make, e.g. in *The Everlasting Gospel*, cf, Damon, p. 115.

46. K 631, E 153.

47. In the collection of W. Graham Robertson. [Ed.: Now in the Tate Gallery, London. Another version is in the collection of Mrs. William T. Tonner, Philadelphia. For a further analysis of "Newton," see Robert N. Essick, "Blake's Newton," *Blake Studies*, 3 (Spring, 1971), 149-162.] A pencil sketch belongs to G. Fenwick Owen. [Ed.: Now in the collection of Sir Geoffrey Keynes.] In this figure Blake seems to have had in mind the action of Euclid in Raphael's "School of Athens," but to have expressed it in forms borrowed rather from Michelangelo. Cf. the figure of Abias below the Persian Sibyl on the ceiling of the Sistine Chapel, of which a drawing by Blake, probably after an engraving, exists in the British Museum [Illustration 36].

In the illustrations to Young's *Night Thoughts* the compasses constantly recur, always with associations of the kind which we have already found elsewhere. Sometimes they stand for mathematics in general, as in the drawing of a boy being taught the elements of geometry, illustrating the line:

36. Blake, "Abias," drawing after Michelangelo. British Museum.

The task
Injoin'd must discipline his early Pow'rs.
(Night 8, line 258)

There is a similar design in the illustrations to Gray, showing "Virtue nurs'd in the lap of Adversity," the compasses again symbolising education.

In another Young design a man measuring with compasses on a sundial, has reference to the phrase:

. . . since oft
Man must *compute* that Age he cannot *feel*
(Night 2, line 441)

Elsewhere the connection is with science and astronomy, as in a lovely drawing showing a figure standing on a sphere in the sky and stretching up to measure the distance between two other celestial bodies with a pair of compasses, following the sentence:

. . . to rise in Science, as in Bliss
Initiate in the Secrets of the Skies.
(Night 6, line 91)

This is the only occasion on which we find the compasses used to show science as a good and not as an evil force, but the sentiments here are those of Young rather than Blake. In another case there is a direct reference to Newton. Three figures stand, two beside a telescope, the third holding the compasses, illustrating the appeal:

Ye searching, ye Newtonian Angels
(Night 9, line 1836)

In yet another drawing a figure holding the compasses is shown looking down in terror at a man dying, and the theme is given by the phrase:

Strong Reason's shudder at the dark Unknown.
(Night 6, line 658)

The last example in the Young illustrations is rather more obscure. The lines referred to are:

> Want and Convenience, Under-works, lay
> The Basis on which *Love of Glory* builds.
> (Night 7, line 414)

The drawing shows two figures building at the bottom; above stands a man, crowned with laurel and holding the compasses. The top figure is explained by the lines in which the usefulness of Love of Glory is elaborated:

> Thirst of Applause is Virtue's *Second* Guard;
> *Reason*, her first; but Reason wants an Aid.
> (Night 7, line 422)

The top figure therefore is the virtuous man, who is supported by Reason, the Compasses, but further crowned by human praise, represented by the laurel wreath.

The only other case known to me in which the compasses occur in Blake's paintings is in the water-colour of "Jacob's Ladder" (cf. Darrell Figgis, *The Paintings of William Blake* [London: Ernest Benn, 1925], Pl. 80). The composition seems to show the various ways which lead man to heaven. Near the bottom of the spiral staircase are two figures. One goes up carrying a scroll, and perhaps symbolises poetry; the other goes down, holding a huge pair of compasses, and probably stands for science. In this case the directions in which they walk would be significant, poetry leading up to heaven, science leading down from it.

It is perhaps worth noticing that the compasses are the symbol of reason in Free Masonry, and it is just possible that Blake may have been influenced from Masonic sources.

48. We know from the engraving of Joseph of Arimathea that Blake was acquainted with the frescoes in the Pauline Chapel from prints. Cf. Russell, p. 53.

49. This statue was engraved by Stefano della Bella.

50. In the margin of Reynolds' *Third Discourse* Blake wrote: "The following [Lecture *del.*] Discourse is particularly Interesting to Block heads, as it Endeavours to prove That there is No such thing as Inspiration & that any Man of a plain Understanding may by Thieving from Others become a Mich. Angelo" (K 457, E 635).

51. Sidney Hook (*The Metaphysics of Pragmaticism* [Chicago and London: Open Court, 1927], p. 17) gives a quite personal interpretation of the frontispiece to *Europe*. He states that it "illustrates a profound metaphysical meaning." The compasses imply the existence of the world, which they can only modify as instruments by marking out and defining; and the design therefore illustrates the principle that the mind of man cannot create anything in the world, on which it can only act as an instrument. But there is nothing in Blake's philosophy which leads us to suppose that this was his meaning here.

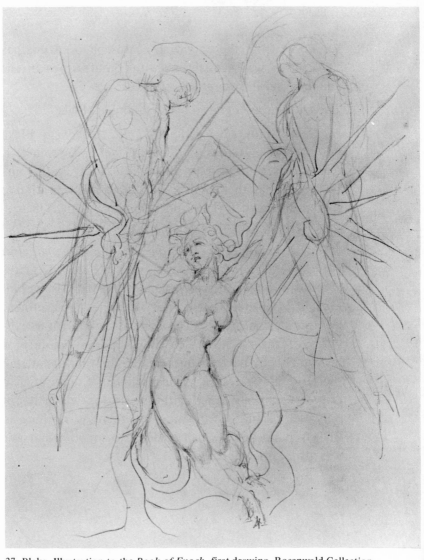

37. Blake, Illustration to the *Book of Enoch*, first drawing. Rosenwald Collection.

BLAKE'S DRAWINGS FOR
THE *BOOK OF ENOCH*

by

Allan R. Brown

\mathcal{A}mongst the material re-
ceived by John Linnell from William Blake and sold at the
dispersal of the Linnell collection at Christie's in 1918, were
five pencil drawings for the *Book of Enoch*.[1] The drawings
are on folio sheets, two of which are watermarked *W.
ELGAR* 1796. The others are without dated watermark. Two
of the sheets are endorsed at the top *from the Book of
Enoch*, two are endorsed *Book of Enoch*, and one, *B of
Enoch*.

Geoffrey Keynes in his bibliography, while noting that
these may have been illustrations to the pseudepigraphical
Book of Enoch, lists the series under the head of *Works Lost
or Conjectural*, and states that the indications on the designs

Ed.: Reprinted by permission of the publisher from *Burlington
Magazine*, 77 (1940), 80-[85].

suggest that the *Book of Enoch* may have been a projected work of Blake's. Keynes admits that such a work is not referred to elsewhere, but he is apparently influenced in his opinion by the notation on the side of one of the sheets, *No. 26 next at p. 43.* This notation, like the other endorsements, is not in Blake's handwriting. In any event, the fidelity of the designs to the text of the early work, in minute particulars which cannot be accidental, shows that they are not illustrations of an original work by Blake.

The drawings are preliminary sketches instinct with all the spontaneity of primary artistic conceptions. While strikingly characteristic of Blake both in drawing and meaning, they are quite free from the mannerisms which sometimes mar the effect of Blake's work for those weaker brethren whose power of imagination is darkened by memory of nature, if we may use the phraseology of the *Descriptive Catalogue.* Aside from their beauty and vigour, however, the drawings have a distinct historical interest as exhibiting the power, range and continuity of Blake's mental processes during the latter part of his life. They deserve closer scrutiny than they have yet received.

While the drawings are undated, there is little difficulty in determining the period to which they should be assigned. The *Book of Enoch,* although exercising an important influence upon the writings of the New Testament, early fell into disuse, and was lost to western Christianity until an Ethiopic manuscript was brought back from Abyssinia in 1773 by James Bruce, the Scottish explorer. It seems little likely that Blake could have had any knowledge of the contents of the book until the year 1821 when the first English translation was published.

The *Enoch* drawings therefore must have been produced between 1821, when Blake was in his sixty-fifth year, and

1827, when he died. Probably they belong to the end of the period, for until 1825 Blake was occupied with the engraving of his inventions to the *Book of Job,* that tremendous epic into which he was able to put so much of his own theology. Then came the series of Dante illustrations, which with all their overwhelming power, failed to give Blake the same opportunity for the promulgation of his own gospel. It is at this time that we might expect to find him searching about for other possible vehicles for his spiritual teaching. In fact, the drawings for *Genesis,* a series somewhat similar in character to the *Enoch* drawings, are dated 1827.

From Blake's *Descriptive Catalogue* it appears that earlier in life he had been sufficiently interested in the first published translation of the *Bhagavad Gita* into English to embody the incident in an ideal design (K 583, E 539). Small wonder that the translation of the *Book of Enoch* attracted the attention of the close Bible student. Enoch is cited by name and quoted in the epistle of Jude, and we know that Blake had studied that epistle, from his water-colour drawing of *Satan and the Archangel Michael contending for the Body of Moses*, an incident recorded only in Jude.

The *Book of Enoch* is a curious collection of diverse materials, including even a section which attempts to deal scientifically with the laws of the heavenly bodies. The book opens with the story of the fall of the angels and their intercourse with the daughters of men and of Enoch's unsuccessful intercession for them before God. Then vision follows vision. The bounds of Sheol are traversed by Enoch and his angel guide. Famous sinners are seen in torment. God, the Lord of Spirits, and His Elect, the Son of Man, are seen and described in words of considerable beauty and poetic feeling. There is a vision of the last judgment. Finally the history of the Jews is narrated in symbolic form. The likeness

of parts of this work to the Dante epic in which Blake was so engrossed is obvious and has been heretofore pointed out. Blake's own *Marriage of Heaven and Hell* affords perhaps an even closer analogy. The whole book was eminently fitted to attract Blake's pencil as soon as its translation made it available to him.

Rossetti says that the *Enoch* drawings are "as intangible for description as the average of the designs of the *Prophetic Books*. A miscellany of naked figures in conditions that one does not accurately comprehend." We must conclude that Rossetti was not familiar with the *Book of Enoch*, for the drawings are in fact not at all obscure. The designs for Blake's *Prophetic Books* are not infrequently obscure because they do not follow the text but amplify and interpret it, sometimes even presenting new ideas only indirectly connected with the theme of the prophecy. The *Enoch* drawings on the other hand are like the Dante set in their careful adherence to the text which they illustrate.

The first three designs illustrate the episode of the fall of the angels and represent three stages in that story of progressive degeneration.

> And it came to pass in the days when the children of men had multiplied that there were born unto them beautiful and comely daughters. And the angels, the children of heaven, saw and lusted after them, and said to one another, "Come, let us choose wives for ourselves from among the daughters of man and beget us children." And they were in all two hundred; who descended and took unto themselves wives, and each chose for himself one; and they began to go in unto them and to defile themselves with them, and they taught them charms and enchantments and the cutting of roots, and made them acquainted with plants, and revealed to them all kinds of sin.
>
> And they became pregnant and bare great giants, whose height was three thousand ells. And these consumed all the acquisitions of men. And when men could no longer sustain them, the giants turned against them and devoured mankind. And they began to sin against

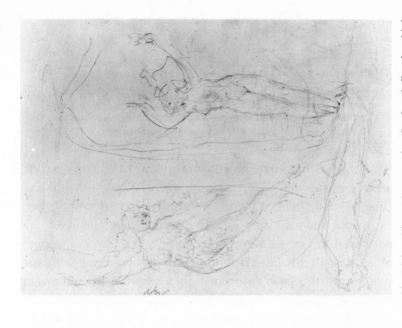

39. Blake, Illustration to the *Book of Enoch*, third drawing. Rosenwald Collection.

38. Blake, Illustration to the *Book of Enoch*, second drawing. Rosenwald Collection.

> birds and beasts and reptiles and fish, and to devour one another's
> flesh and drink the blood.
>
> And there arose much godlessness, and they committed fornication
> and were led astray and became corrupt in all their ways. And the
> whole earth was filled with blood and unrighteousness. And the
> women also of the angels who went astray became sirens.

In the first drawing [Illustration 37] the composition centres about the nude figure of one of the "beautiful and comely" daughters of men. Two angels descend towards her. By a bold and strikingly effective arrangement the angels are portrayed not only anthropomorphically but also in the guise of stars with phallic attributes. This is to accord with the symbolism of a later vision of Enoch where, with somewhat disconcerting bluntness, they are so represented. It is not to be believed that Blake conceived this notion independently. He could only have taken it from the *Book of Enoch*.

In the second picture [Illustration 38] the woman again occupies the centre of the composition. An angel, descending with the rushing sweep which Blake could depict so masterfully, whispers in her ear the secrets of sin, particularly root-cutting and enchantments with herbs and plants, if we may judge by the surrounding leaves and flowers and branches. In the background at either side of the woman, and very striking features of the composition, are two of the giant children. They are not the only fruit of sin, however, for the attitude of the woman has clearly become acquiescent, while the body of the angel has begun to develop that scaly covering with which Blake so often invests the evil genius.

In the third drawing [Illustration 39] the moral *débacle* is complete. The woman has become a siren, or as we should perhaps say, vampire. Wearing the scales of sin, she rises exultant from the prone body of a man, while an

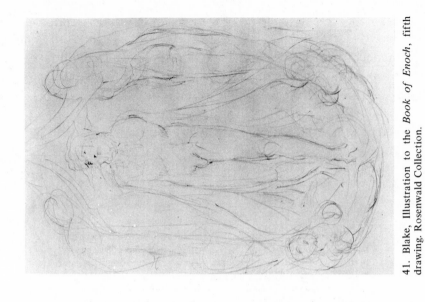

41. Blake, Illustration to the *Book of Enoch*, fifth drawing. Rosenwald Collection.

40. Blake, Illustration to the *Book of Enoch*, fourth drawing. Rosenwald Collection.

innocent sister, balancing the composition, stands at his feet, frozen with grief and horror.

The fourth design [Illustration 40] portrays Enoch standing with his angel guide before the throne of the Great Glory, where he has come to plead for forgiveness for the fallen angels.

> And I looked and saw a lofty throne: its appearance was as crystal, and the wheels thereof as the shining sun. From underneath the throne came streams of flaming fire so that I could not look thereon, and His raiment shown more brightly than the sun and was whiter than any snow. None of the angels could enter and behold His face by reason of the magnificence and glory, and no flesh could behold Him. The flaming fire was round about Him, and a great fire stood before Him, and none could draw nigh Him: ten thousand time ten thousand stood before Him, yet needed He no counsellor. And the most holy ones who were nigh to Him did not leave by night nor depart from Him. And until then I had been prostrate on my face, trembling: and the Lord called me with His own mouth and said to me: "Come hither, Enoch, and hear My word." And one of the holy ones came to me and made me rise and approach the door: and I bowed my head downwards.

The fifth design [Illustration 41] portrays the Messiah, called in *Enoch* the Son of Man, the Elect. He is shown surrounded by his four attendant spirits, counterparts of the four archangels of the presence of God. This drawing might well serve as a frontispiece for the entire work, for the Messiah doctrine is the most prominent and important feature of the book and Blake has grasped its full significance. The mingled majesty and tenderness of the figure make it by far the most successful of Blake's attempts at the portrayal of the Christ.

> And I asked the angel who went with me and who showed me all the hidden things, concerning the Son of Man, who he was and whence he was and why he went with the Head of Days. And he answered and said unto me:
>
> This is the Son of Man who hath righteousness, with whom dwelleth righteousness, who revealeth all the treasures of that which is

hidden; because the Lord of Spirits hath chosen him, and whose lot hath pre-eminence before the Lord of Spirits forever.

For he is mighty in all the secrets of righteousness, and unrighteousness shall disappear as a shadow and have no continuance. Because the Elect One standeth before the Lord of Spirits, and his glory is forever and ever, and his might unto all generations. And in him dwells the spirit of wisdom, and the spirit which gives insight, and the spirit of understanding and might, and the spirit of those who have fallen asleep in righteousness. And he shall judge the secret things, and none shall be able to utter a lying word before him; for he is the Elect One before the Lord of Spirits according to His good pleasure.

We have seen how closely Blake adhered in these illustrations to the text of the *Book of Enoch*. But the man of four-fold vision was not satisfied with this. Just as he was able in the first design to depict both the literal and symbolic aspects of the descent of the angels, so also he made all the designs a vehicle for the expression of his own doctrines.

In the first three designs is represented the evil domination of the Female Will, personified in his system as Vala. By this he meant material beauty, carnal love, leading to the sleep of materialism, spiritual death. This evil influence he described in the Prophecy of *Europe*, where Enitharmon, the Emanation of Los, is able, by appeal to the physical attractions, to sleep (that is, maintain the ascendancy of materialism) for 1800 years after the birth of Christ or Orc. The doctrine is further expressed in Jerusalem 34:25-35:

What may Man be; who can tell! but what may Woman be?
To have power over Man from Cradle to corruptible Grave?
There is a Throne in every Man, it is the Throne of God;
This, Woman has claim'd as her own, & Man is no more:
Albion is the Tabernacle of Vala & her Temple,
And not the Tabernacle & Temple of the Most High.
O Albion, why wilt thou Create a Female Will?
To hide the most evident God in a secret covert, even
In the shadows of a Woman & a secluded Holy Place.
That we may pry after him as after a stolen treasure,
Hidden among the Dead & mured up from the paths of life.

In these designs the woman represents Vala. The mingled desire and distress upon her face in the first design exactly express Vala's lament in *Jerusalem* 33:45-8:

> Wherefor did I, loving, create love, which never yet
> Inmingled God & Man, when thou & I hid the Divine Vision
> In clouds of secret gloom which, behold, involve[s] me round
> about?
> Know me now, Albion: look upon me. I alone am Beauty.

It is significant that the posture of the woman in this design is a combination of the attitudes of the two central figures in design 99 of the Dante series. That design, which must have been produced at about the same time, represents *The Queen of Heaven Enthroned*. The Virgin Mary is pictured naked holding a mirror and a fleur-de-lis on a staff like a sceptre or thyrsus. The Virgin with Blake again and again represents the evil Female Will, the source of the carnal part of Christ.

In the second design the leaves and branches represent the vegetable life, which is Blake's term for the life of the senses. The giant children, their hair flames of passion, suggest the *Book of Los*, 3:25-6:

> And Wantoness of his own true love
> Begot a giant race.

In the third design Vala, triumphant, is covered with scales. She is thus represented in *Vala, Night II*, lines 85, 89; "she grew a scaled Serpent," "Till she became a Dragon, winged bright & poisonous." The tree with Blake represents error. Destruction is now complete. Man sleeps the sleep of spiritual death at the foot of the tree. In the same way Eve sleeps at the foot of the cross in the *Paradise Lost* series. The second woman in this design represents Jerusalem, the Emanation of Albion, the tender part of his nature from which man by the fall became separated.

Jehovah, the God of punishment, was always abhorrent to Blake. This was Satan. His god was Jesus, the God of forgiveness. Therefore the features of the Almighty in the fourth design have something sinister. Blake could have pleaded the cause of the fallen angels better than Enoch did.

In the last design the four spirits represent the fourfold nature of man—humanity, spectre, emanation and shadow. This is the basis of Blake's doctrine of man. The design perfectly illustrates *Vala, Night I*, lines 9-11.

> Four Mighty Ones are in every Man; a Perfect Unity
> Cannot Exist but from the Universal Brotherhood of Eden.
> The Universal Man, to Whom be Glory evermore.
> Amen.

NOTES

1. They appear as No. 129 of the uncoloured works in the annotated lists of Blake's paintings, drawings and engravings compiled by William Michael Rossetti for Gilchrist's *Life of William Blake* (London and Cambridge: Macmillan, 1963), II, 251 and second ed. (London: Macmillan, 1880), II, 270 no. 157.

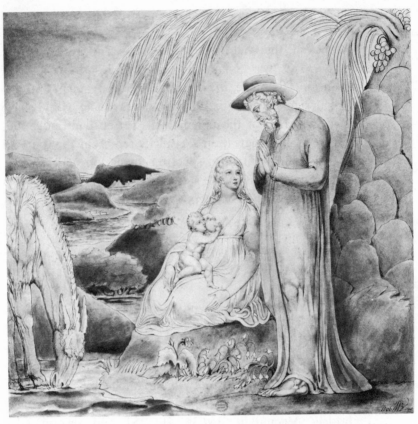

42. Blake, "Rest on the Flight into Egypt." Metropolitan Museum of Art, New York.

THE SOURCES OF BLAKE'S
PICTORIAL EXPRESSION

by
C. H. Collins Baker

*A*ll who study Blake are
aware of unexplained things: for example, the way in which
he acquired pictorial training and experience; the strange
inequality of his technique; the curious mosaic, in his work,
of derivation and originality, and, sometimes, the meta-
morphosis of borrowed motifs into original conceptions.

What has been published concerning his training does
not explain these things completely. We know that at the age
of ten he worked in Henry Par's school; that at the age of
fourteen he was apprenticed to the engraving firm of Basire,
where he spent some seven years; that for a short time he
attended the Royal Academy schools; that he privately
studied engravings after Raphael, Michelangelo, and Giulio
Romano, and deeply admired the engravings of Marc Antonio

Ed.: Reprinted by permission of the publisher from *Huntington Library Quarterly*, 4 (1940-41), 359-67.

and Dürer. In the Huntington Library there is a small oil copy, by Blake, of a figure in Michelangelo's "Last Judgment": a proof that he was familiar with copies of Michelangelo by his contemporaries. All Blake students are familiar with his engraved "crib" of the figure in Michelangelo's "Crucifixion of St. Peter"; his use of the little crawling figure in the background of Dürer's print of "St. John Chrysostom"; and the origin of his "Glad Day,"[1] in Scamozzi's *Idea del' architettura* (1615).

His students are generally aware of these; but they have not yet particularly studied the habitual way in which this singular genius cruised about, cutting out and snapping up prizes. They have not sufficiently scrutinized the completed fabric of his designs, to recognize the pieces of which they are in part composed, and to realize how vitally they were used. If such a study is completed our conception of Blake will not be seriously impaired. We shall understand him better in understanding his habit of bee-like quest: we shall more closely grasp the efforts he made to overcome his difficulties and more clearly see his genius for assimilation and making vital.

This paper will suggest but a few of the sources of his expression; it is no more than a signpost for Blake's closer students, who, if they already know all about this aspect of him, have kept it singularly quiet. Familiar to us all are Blake's "Hecate" and his water color, "Rest on the Flight into Egypt" [Illustration 42, in the Metropolitan Museum]. In each we are impressed by the rather sinister Ass, projecting into the picture from the side. Some no doubt have said, "No one but Blake would have imagined that gaunt, shaggy beast"; others may have wondered where it came from. Their curiosity is answered if we look at the "Rest on the Flight" ("G. R. inv.") on page 30 of Alexander Browne's *Ars pictoria*

Vem Dilecte mi, egrediamur in agrum, commoremur in villis. cantic. cap. vu. vers. ii.

43. "Rest on the Flight," "G. R. Inv." From A. Browne's *Ars Pictoria*. Huntington Library.

of 1675 [Illustration 43]. There we find the source of Blake's donkey, and recognize that, in passing from *Ars pictoria* to Blake, the Ass became a sort of dynamic animal, much more in keeping, by the way, with "Hecate" than with the "Holy Family."

Blake could not afford models for his work: instead he must always have been looking about for suggestions, or actual adaptable material in drawings and engravings of others. Whether he knew what he wanted or simply took inspiration from what he found, is debatable. For example, needing a back view of a man for the Adam in his "Temptation of Eve" (in his *Paradise Lost* series), he again used Browne's *Ars pictoria*. In that volume (p. 23) is a sheet of studies which we can hardly doubt was before him when

he drew Adam wandering away, while Eve was in the Tempter's coils.[2] As so often happened he used the same idea repeatedly. Blake's similar appropriation and adaptation from Dürer's "St. John Chrysostom" is well known: we can hardly doubt that the invention of his Nebuchadnezzar came about in this wise. The little crawling figure in the background of Dürer's print caught his fancy, so that when he wanted an idea for Nebuchadnezzar he thought, "Why, that's the very thing; but I will show the face." Incidentally, that alteration and an attempt to exhibit the outcast King's emaciation, deplorably overtaxed Blake's anatomical knowledge.

These uses of Dürer and *Ars pictoria* are evident instances of Blake's habit of cruising round for serviceable material. Another, if debatable, example of his piracy may perhaps be recognized in his illustration of the "Death of the Wicked Man" for Blair's *Grave*. There is no doubt that the anguished woman, bending over the body, is strangely baroque for Blake. And I submit for consideration that she was derived from Annibale Carracci's Magdalen, in his famous "Three Maries," which came to England about 1792, having been engraved in the Orleans Gallery *Catalogue*.

Blake's drafts on Michelangelo, direct, or by adaptation, are not hard to find; engravings of course were current, and, as I have said, actual copies of the "Last Judgment" were accessible to him. An interesting compote of Blake's Michelangelesque inspiration occurs in an unidentified Dantesque subject [Illustration 44] at the Tate Gallery, London (No. 3364).[3] Some of the figures in this remarkable design are so well constructed that one suspects that Blake had good prints or drawings before his eyes. But the shockingly constructed standing figure, which far exceeded his anatomical capacity, must, I suggest, have come from a bad engraving, imperfectly understood, of that dimly seen figure that supports the

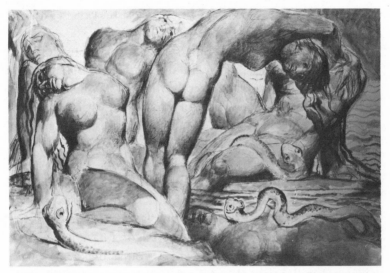

44. Blake, Dantesque subject, "The Punishment of the Thieves." Tate Gallery.

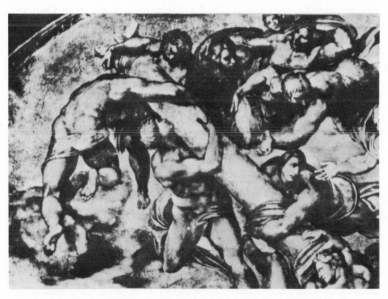

45. Michelangelo, detail from the "Last Judgment." Sistine Chapel.

column in Michelangelo's "Last Judgment" [Illustration 45].
This seems to me to be a capital example of Blake's naïve
childishness: he could not keep his fingers off Michelangelo's
exciting figure, but he knew not what to do with it, nor how
to draw it. Incidentally, the Michelangelesque figure of
Achan in Blake's "Stoning of Achan" is relatively so well
constructed that I should like to know its source. Was it
Flaxman?

Among the other sources of Blake's pictorial expression
that should be investigated are Flaxman and Greek or
Greco-Roman art. Two or three years ago[4] I hazarded a guess
at some of the channels by which young Blake may have
become familiar with classical art. Fuller consideration would
suggest many more. There is no doubt he was familiar with
engravings of discoveries at Herculaneum and Pompeii; he
must have been familiar, too, with such works as Chandler's
Ionian Antiquities, Stuart's *Antiques of Athens*, and Dalton's
engravings. And presumably the publications of D'Agincourt
and Winckelmann were accessible to him.

It seems likely that Blake freely used the channel
opened by Flaxman. For example, in his "Job Sacrifices," we
see Job (and in other designs God the Father) with arms spread
across the sky [Illustration 46]. This motif came, I think,
from Flaxman's "Giant on Mount Ida" [Illustration 47].
Blake was so pleased with it that, again, he used it frequently.
Blake's "Christ Offers to Redeem Man" (in the Huntington
Library) is one of his most beautiful *Paradise Lost* designs.
Perhaps the central idea—the throned figure embracing the
Son—is Blake's inspired adaptation of a classical "Zeus and
Ganymede"—or the "Education of Olympus." For the
cruciform of his design and the inclosing inverted arch of
angels casting down their crowns, he may well have had in his
mind Flaxman's "Triumph of Christ" from the *Paradiso*,

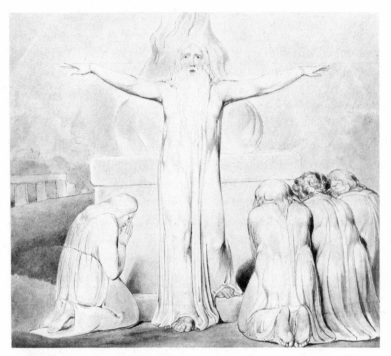

46. Blake, "Job's Sacrifice," number 18 in the Butts water color series. Pierpont Morgan Library.

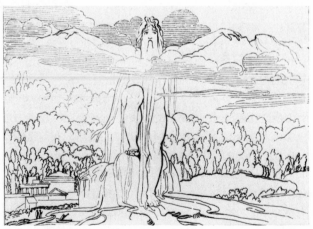

47. "The Giant on Mount Ida," pl. 15 of Flaxman's Dante illustrations. Essick Collection.

combined with Flaxman's "Iris" from his *Hesiod*. A circle of
seraphim like that in Flaxman's "Christ" is found in Blake's
"Rout of the Rebel Angels" (in the Huntington Library),
encircling the Archer. The ill-drawn mass below, with the
plunging figures clasping their heads, was almost certainly
suggested by the falling figures in Flaxman's *"Purgatorio,"*
plus ideas from Michelangelo's "Last Judgment." Instances of
Blake's close adaptation of Flaxman's figures or conceptions
can easily be multiplied—it is, for example, interesting to
compare their renderings of "The Hypocrites with Caiaphas,"
in their *Inferno* illustrations, and to see how immeasurably,
in adapting, Blake surpassed Flaxman.

The main part of Blake's neoclassical nudes and semi-
nudes can be traced to Herculaneum, Pompeii, and other
Greco-Roman sources. A typical example of such a study is
his "Satan Comes to the Gates of Hell"—the larger version in
the Huntington Library. The main idea, two combatants one
each side of a figure—half woman, half monster—seems to be
Blake's adaptation of the well-known classic rendering of
"Archemorus" (called "Cadmus" in Winckelmann) or
"Scylla." In this connection we may note the similarity of
Flaxman's "Scylla." The back-view figure of Death, standing
with legs apart, seems to be traceable to one of Dalton's
engravings of an Amazonian battle frieze.

Lastly, we may speculate about Blake's supreme in-
vention—his "Elohim" moving upon the face of the Dark
Waters; molding Man from the dust of the Earth, where no
man had been [Illustration 48]. Blake himself used mysteri-
ously to allude to visions of Egyptian Art—culled, I suspect,
from engravings. Francis Hayman, by the way, also had seen
"Egyptian visions." Some of Blake's devotees, pondering his
"Elohim," have wondered what oriental inspiration lay
behind this magnificent conception. For my part, I have no

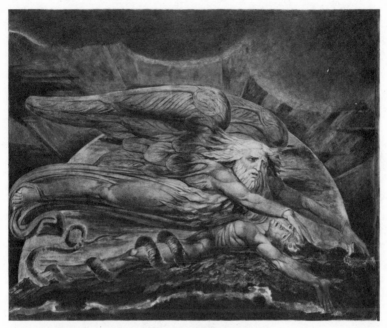

48. Blake, "Elohim Creating Adam." Tate Gallery.

doubt that its germ was Dalton's, or some other anti-
quarian's, rendering of Skiron (the southeast wind) on the
Temple of the winds [Illustration 49].[5] Perhaps no richer
testimony to Blake's genius and imagination can be offered
than this proof of his capacity for breathing living flame into
the driest bones.

NOTES

1. See Anthony Blunt, "Blake's Glad Day," *Journal of the
 Warburg and Courtauld Institutes*, 2 (1938), 65-68 and
 the article by Blunt reprinted in this volume.

2. This sheet and others, of anatomical drawings, are by "J. Collenbina," engraved by A. de Jode.

3. Ed.: This design has been entitled "The Punishment of the Thieves" and identified as an illustration to *Inferno* XXIV, 77-95 in Martin Butlin, *William Blake: A Complete Catalogue of the Works in the Tate Gallery* (London: Tate Gallery, 1971), p. 69.

4. "William Blake, Painter," *Huntington Library Bulletin*, 10 (1936), 141-42.

5. Ed.: This same figure is also illustrated in James Stuart and Nicholas Revett, *The Antiquities of Athens* (London: John Haberkorn, 1762), I, Chap. III, pl. XIX. The plate was engraved by James Basire, Blake's master. Blake himself engraved four plates for the third volume of Stuart and Revett, published in 1794.

49. R. Dalton, engraver, The frieze on the Temple of the Winds. From Richard Dalton, *Antiquities and Views in Greece and Egypt* (London, 1791). Huntington Library.

A TITLE-PAGE IN BLAKE'S
ILLUSTRATED GENESIS MANUSCRIPT

by
Piloo Nanavutty

*A*mong the rich and varied collection of Blake material in the Huntington Library, there is the unique illustrated "Genesis" manuscript (*ca.* 1826). The two title-pages and the eleven leaves of the manuscript have so far not been edited or reproduced in facsimile. According to Mr. Keynes, this fragment is "the beginning of an illustrated copy of 'Genesis' or of the Bible, and was done for John Linnell."[1] It was acquired by the late Henry E. Huntington at the Linnell Collection sale at Christie's in March 1918.

Blake carries the transcript of the book of "Genesis" up to Chap. IV, verse 15, in the eleven leaves which contain the text. He gives, however, his own interpretive headings to each chapter:

Ed.: Reprinted by permission of the author and publisher from the *Journal of the Warburg and Courtauld Institutes*, 10 (1947), 114-22.

The coloured title-pages and the rough pencil sketches towards the end of the manuscript form its most distinctive features. Of the two title-pages, one is in a very rudimentary state, but the more elaborate design is crowded with symbols and lends itself to emblematic interpretation. It is with this latter page [Illustration 50] that the present article is concerned.

The delicately tinted drawing, with its pale gold, green, pink, blue and red washes, is very satisfying to contemplate in spite of being unfinished. At the top of the page strides the very embodiment of energy in the shape of a nude, winged figure, probably a woman. She reminds one of the illustration in *The First Book of Urizen* (p. 3) and of the water-colour, formerly in the late Miss A. G. E. Carthew's Collection, of the young Orc (revolution), walking through flames.[3] The figure in the "Genesis" title-page seems to illustrate Blake's statement in *The Marriage of Heaven and Hell*, "Energy is Eternal Delight."[4] The sketch is an apt image for the creation theme.

Beneath the furiously striding figure are the heavily ornate initials, "G" and "E". They begin the word GENESIS that forms so crucial a part of the design in the title-page.

50. Blake, "Genesis Manuscript" title-page, second version. Huntington Library. See also frontispiece.

51. Nymphaea Nelumbo, from R. J. Thornton's *Temple of Flora*, 1804.

52. Lilium Martagon, from J. J. Plenck's *Icones Plantarum*, 1790.

The top half of the initial "G" has stylized green leaves. The broad base has three bell-shaped plants hanging slenderly over the edge. These may be taken to represent the fruit of the *Nelumbo nucifera* or Sacred Lotus.[5] Normally, the lotus pod stands erect, but when it is ripe, and the seeds ready to be ejected, the stem loses its succulence and becomes flaccid so that the pod is apt to incline over the surface of the water. Blake's drawing closely resembles the lotus pod in the beautiful coloured plate [Illustration 51] in Dr. Thornton's *Temple of Flora* with which Blake was familiar. The plate is inscribed "The Sacred Egyptian Bean, London, published Dec. 1st, 1804, by Dr. Thornton."[6] When describing the plant, Dr. Thornton writes:

> Nature, as if designing these plants to be the masterpiece of her creative power, besides superior grace and beauty, has also added utility; for the *seed-vessels* contain nourishing food for man, as also the *roots*, which produce, as will be hereafter shewn, the profitable *potatoe*. As the Egyptians worshipped whatever was useful, they accounted these plants sacred; in their feasts they crowned themselves with the flowers, and their altars are decorated with the same. The Egyptian Ceres has the seed-vessel of the blue lotos in her hand, which the Romans corrupted into the poppy; and sometimes also that of the Nelumbo, which the Greeks mistook for the horn of Amalthea.[7]

Returning to the "Genesis" title-page, it will be noticed that the round curve of the initial "G" is represented by a basket containing an ear of corn, while the upward stroke, which completes the letter, is simply a sheaf of corn. Sheaves of corn symbolizing industry, prosperity and plenty, were often used by the emblem writers and occur in Claude Paradin,[8] Geoffrey Whitney,[9] George Wither,[10] and several of the Continental emblem writers such as Paolo Giovio[11] and J. J. Boissard.[12] The popularity of the emblem continued down to the eighteenth century.[13] Blake's sheaf of corn is nearest in design to the emblem in Wither (p. 44).

From the Christian standpoint, the corn would signify the bread of life, and be an appropriate emblem in this particular context.

Besides the sheaf of corn, and the fruit of the Nelumbo, Blake has yet another emblem of fertility and creation on the title-page. This is hidden in the initial "N" which is drawn below the initial "G" and under the out-stretched left arm of Christ.

Tinted in pale gold and spring green, the initial "N" has an azure lily emerging from the centre stroke. The lily is the *Nymphaea caerulea,* or flower of the blue lotus. Here again, Blake is indebted to Dr. Thornton, who, in the quotation given above, explains that the Egyptian Ceres carries the "seed-vessel of the blue lotus in her hand." Blake, taking his cue from Dr. Thornton, paints the flower of the Egyptian lotus the fruit of which he had drawn in the initial "G." The blossom gracefully raises its head above the cerulean blue of the surrounding waters. The succulent, undulating stalk, so characteristic of this species, is clearly defined.

Blake owes the meaning of the symbol to Dr. Thornton. The latter is eager to establish the "antiquity of the flower of the Nelumbium." He therefore introduces an English translation by Sir William Jones of "An Hindoo Hymn" addressed to the "Spirit of Spirits." The fourth verse of the hymn contains the lines,

> But pensive, on the lotos-leaf he lay,
> Which blossomed at his touch, and shed a golden ray.

To this, Dr. Thornton has an illuminating footnote:

The first action of Brahma, was the creation of the flower of the Nelumbium. Sir William Jones uses, perhaps, the word *golden* for beautiful. . .

This was sufficient evidence for Blake, and the blue water lily duly appears as an emblem of creation, not in a Hindu, but a Christian setting.

It is typical of Blake to place the emblems of creation, fertility, and abundance, on the side of Christ. In marked contrast, the emblems of martyrdom and suffering, hidden in the two "E" initials are placed on the side of Jehovah.

The initial "E," which faces the initial "G," is also coloured in pale gold and spring green, its main feature being three roses on one stem. One blossom arches over the apex of the top horizontal stroke of the letter, while the other two are grouped, behind each other, in the centre of the initial. They are tinted a deep rose. The red roses of martyrdom are of common occurrence in Christian art. They may be associated with virgin martyrs, as mentioned by G. M. Rushforth;[14] or, they may be placed round the coffin of a martyr like St. Stephen as in the French tapestry series, "The Legend of St. Stephen."[15] Emblem writers also made use of them. Philipp Galle, for instance, a Flemish emblematist, in a curious work called *Prosopographia*, depicts the sixth beatitude, Misericordia, as a semi-nude young woman holding aloft in her right hand a cross surmounted by a pelican, and in her left, three roses on one stem.[16] The pelican, because she was believed to feed her young by piercing her own breast, was taken to be a true emblem of Christ. Hence, some of the Jesuit emblem writers called their Lord "nostro Pelicano." It is significant to find three roses on one stem so intimately associated with such typical emblems of martyrdom and suffering as the Cross and the pelican.

Another distinctive feature of the initial "E" is the attenuated snake which winds round the erect stem of the letter. The snake's head and open mouth are faintly visible just above the two roses in the centre. Eve's temptation, and

the martyrdom and suffering which resulted from her fall, are thus indirectly conveyed. By introducing the snake, Blake justifies his use of the red roses.

The second "E" in the word "Genesis" is placed under the first. This initial is also beautifully tinted in pale gold and spring green. The centre stroke blossoms into a perfect lily, coloured a deep rose. From the base of the flower emerge the head and neck of a small snake, left in as a pencil sketch. The lily is very like the *Lilium Martagon*, or Turk's Cap Lily [Illustration 52]. Among the herbal writers this flower was evidently known as the Lily of Calvary. R. Dodoens, for instance, in his *Pemptades*, describes it as "Lilikens van Calverien."[17] For the sake of the fine woodcuts which illustrate the *Pemptades* Blake may have consulted this work in the library of Sir Joseph Banks where both the 1583 and the 1616 editions lay.[18] On the other hand, Blake may have heard of the Lily of Calvary from his wife who was a gardener's daughter, and though illiterate, may well have been a repository for such choice bits of folklore. Besides, there were only three species of lily widely cultivated in cottage gardens in Blake's day. These were the *Lilium candidum*, or Madonna Lily; the *Lilium Martagon*, or Turk's Cap Lily; and the *bulbiferum croceum*, or orange lily.[19]

Whatever his source, Blake's imagination was fired by this symbol, for he introduces it on page 23 of the *Jerusalem* where it forms an important clue to the meaning of the whole illustration [Illustration 53]. Jerusalem (freedom) lies rooted in a rock-like sepulchre canopied by human intestines, calling to mind the lines on pl. 89:

> But in the midst of a devouring Stomach, Jerusalem
> Hidden within the Covering Cherub, as in a Tabernacle[20]

The wings may belong to the Covering Cherub (false religions), or to Jerusalem. In some copies, such as the

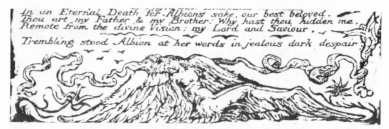

In an Eternal Death for Albions sake, our best beloved.
thou art my Father & my Brother: Why hast thou hidden me.
Remote from the divine Vision: my Lord and Saviour.
Trembling stood Albion at her words in jealous dark despair

53. Blake, *Jerusalem*, pl. 23, detail of a recumbent figure. Keynes & Wolf *Census* copy C.

Hooper copy at Harvard, the tips of the wings bear marked crosses, indicative of the crucifixion of the flesh Jerusalem is undergoing. Above her head, to the left, escape winged joys in the shape of small birds. To the right, from the knotted intestine, escape the Spectre and Emanation of Los, the masculine and feminine aspects respectively of the creative imagination. They reappear in the illustration to page 30. At either end, guarding Jerusalem like sentries, stand the Lily of Calvary and the Star of Bethlehem. Both flowers are stylized, but not beyond recognition. The lily here is full blown,[21] unlike the same flower in the "Genesis" title-page [Illustration 50]. As for the Star of Bethlehem, Blake does not seem to have in mind the six-pointed *Ornithogalum umbellatum*, but the *Stellaria Holostea* or Greater Stitchwort, often mistaken by peasants for the Star of Bethlehem [Illustration 54].[22] The Lily of Calvary stands for the Crucifixion, the Star of Bethlehem for the promise of the Redemption. Christ suffers in the sufferings of Jerusalem, but she is not left comfortless. At her feet is the lowly Star of Bethlehem, the seal of her bodily redemption. Just as the imaginative instincts escape from her intestines, because the imagination is of the spirit and therefore indestructible, even so will her flesh be spiritualized and redeemed. Below the immobilized, recumbent figure of Jerusalem, Blake depicts

humanity blindly groping for a passage out from the caverns of the flesh and the dark abysses of thought.

Turning back to the "Genesis" title-page, it will be seen with what precision Blake once again uses the Lily of Calvary as an emblem of martyrdom and suffering. As in the case of the red roses, he associates this lily with the serpent.

Between the symbols of creation, fertility and the abundance of life, on the one hand, and the symbols of martyrdom and suffering on the other, are found two Y-shaped trees. Although their stylized elegance defies exact identification, they bear some slight resemblance to the *Phoenix dactylifera*, or feathery date palms.[23] Blake himself speaks emblematically of "the Oak Of Weeping & the Palm of Suffering" (*Jerusalem:* 59).[24] Both trees appear in the well-known illustration on page 37 of the *Jerusalem* where Christ receives the fainting Albion (Man) in his arms. In front of him stands the Oak of Weeping, behind him, the Palm of Suffering. One long branch of the palm sweeps down in the same manner as the Y-shaped branches of the "Genesis" title page.[25]

54. Stellaria Holostea, from R. J. Thornton's *British Plants*, 1812.

Doubtless, Blake was aware that to Christians the date palm stood for salvation and victory as well as the martyr's sacrifice.[26] He may also have been familiar with the tenets of the Orphites who looked upon the tree with veneration and considered it immortal.[27] It is not necessary, however, to go further afield than the strictly Christian significance of the date palm to discover Blake's meaning. The creative abundance of life and its sacrifice and suffering are reconciled in an eternal salvation and an eternal victory based on the martyrdom of Christ.

The puzzling fact that there are two trees can also be explained. It was known, from early Babylonian times, that the date palm did not bear the male and female flowers on the same tree.[28] Fertilization was often carried out by hand. By placing the male and female trees of the date palm together as Blake does, he may wish to imply the marriage of salvation and victory in the person of Christ. Or, he may be pointing to the close union in suffering between Christ and Adam, as in *Jerusalem:* 76, where Albion imitates the cruciform position in his adoration of Christ nailed to the tree. Palms were evidently recognized emblems of a happy marriage as the following lines from Webster's *Duchess of Malfy* go to prove:

> That we may imitate the loving Palmes
> (Best Embleme of a peaceful marriage)
> That nev'r bore fruit devided.
> *Duch. of Malfy*, Act I, sc. i, 555 ff.[29]

That Blake attached very great importance to the two Y-shaped trees is clear, for he violates the artistic symmetry of the page by introducing them where he does. If they were meant to be merely decorative, they would have served their purpose better elsewhere on the page. The only justification for the place they occupy lies in their symbolic significance

which explains fully the hidden emblems in the other letters of the word "Genesis."

The remaining initials do not contain obscure symbols. The two "S" initials flank Adam on either side. They are composed of corn and grass, and coloured in gold and green with touches of pink and black. The initial "I" is suspended from Adam's waist and forms his sole piece of clothing. It is streaked with turquoise green.

On the left margin stands Christ in a cruciform attitude, his arms compassionately spread in blessing. From his left hand descends a scroll, presumably the Pledge of the Redemption, to which Adam reaches with his right hand. Christ's body is tinted a pale mauve pink, and is glimpsed through floating drapery touched with turquoise blue. The brooding, half-closed eyes gaze with prophetic earnestness into futurity. The whole countenance is instinct with a noble sorrow. Christ's figure recalls the lines in "The Divine Image" of the *Songs of Innocence:*

> For Mercy has a human heart,
> Pity a human face,
> And Love, the human form divine,
> And Peace, the human dress. [30]

Christ has his left foot forward as he is a celestial being descending to a lower sphere, the earth. [31]

On the right margin stands Jehovah, with a flowing beard and a stern expression on his face. His feet are firmly planted on a black cloud, while a finger of severity points into a black cloud above. His body is tinted a pale pink, and is glimpsed through clinging drapery which falls in folds round his legs. One such fold is held in his left hand. He seems to illustrate the verse in the poem "A Divine Image" of the *Songs of Experience*:

Cruelty has a Human Heart,
And Jealousy a Human Face;
Terror the Human Form Divine
And Secrecy the Human Dress. [32]

He represents the Law; Christ, Mercy and Compassion. Cabbalistically speaking, Jehovah is the Pillar of Severity, Christ the Pillar of Mercy.

Christ stands above the Tree of Life which bears globular, rose-pink fruit. [33] Jehovah stands above the Tree of the Knowledge of Good and Evil which bears blurred fruit, mauve, purple and pink, resembling half-crushed grapes. The trees are left unfinished, but the lower trunks of both are coloured a pale green and pink with touches of yellow, black and blue.

The centre of the page is taken up by Adam who stands, with feet apart, on the green earth. His right foot is forward, the left being slightly raised. His head is framed by a rose-pink circle forming a kind of halo behind which the red dawn of a new day is streaked across the sky. With his right hand he grasps the Pledge of the Redemption from Christ. The left arm is flexed at the elbow, but the hand is unfinished.

At the feet of Adam, between the Tree of Life and the Tree of the Knowledge of Good and Evil, are seated the "four living creatures" of Ezekiel's vision (*Ezek.* i and x, 8 ff.) and the Zoas or "beasts" of *Revelation* iv and v. At first sight, these figures appear to be demoniac versions of the Four Evangelists. Blake, however, is here introducing his own private mythology. They are the Four Zoas of his prophetic books, but depicted in their fall. Blake names them Urthona (the Spirit), Urizen (the Intellect), Luvah (the Passions), and Tharmas (the Body and its Instincts). [34]

That Blake used the conventional symbols of the Four Evangelists for his Four Zoas is clear from the title-page of

the *Four Zoas* manuscript, where, among the figures at the bottom, one can pick out the head of a lion with a forepaw, the bald head of a man with slit eyes and hands like claws, the head of an ox resting on a front hoof, and, on the extreme right, the head of an eagle, open mouthed, gazing up into the sky.[35]

In the "Genesis" title-page, propped against the Tree of Life is the Zoa with the face of a man, corresponding to Blake's Urthona. His left arm is raised, and on his head is the crown of worldly power studded with gems. Both his shoulders are covered with fish scales, always a symbol of degeneracy and corruption in Blake, whose Satanic Spectres are thus represented in his prophetic books. The degeneracy is further emphasized by the bestial tongue which sticks out from the wide gash of the man's mouth. The image is strongly reminiscent of Blake's caricatures of the "Ghost of a Flea." The figure is partially tinted in blue, pink and mauve, with touches of yellow and green. In this presentation of the Zoa, Blake is stressing the complete collapse of the Spirit, revealing the unregenerate condition of man who is "born a Spectre or Satan & is altogether an Evil, & requires a new Selfhood continually, & must continually be changed into his direct Contrary" (*Jerusalem:* 52).

Next to him is the Zoa with the "face of a flying eagle" as St. John describes him. The eagle with Blake is a symbol of genius, according to the proverb in *The Marriage of Heaven and Hell*, "When thou seest an Eagle, thou seest a portion of Genius; lift up thy head!"[36] This Zoa corresponds to Blake's Urizen. A crown of iron spikes is clamped upon his head, while his shoulders are covered with the feathers of an eagle as by a cape. The face and crown alone are tinted, the colours being blue, and pink, with touches of red, yellow and green. The upturned face depicts anxiety and fear, while the

eyes are remarkable for their sinister expression. Blake is here depicting the depraved and tortured intellect of man fettered by the iron bands of its own logic.

The Zoa with the face of a lion is characterized by a profusion of pink locks. His hands are clasped as if in prayer or supplication, while his countenance registers mingled horror and amazement. This Zoa corresponds to Blake's Luvah. According to Blake, in human life the passions are not allowed to "Emanate Uncurbed in their Eternal Glory" but are cast down and governed by the "Various arts of Poverty & Cruelty of all kinds" (*Vision of the Last Judgment*, p. 87).[37] Blake here foreshadows the doom of the passions and affections after the fall of Adam.

Leaning against the Tree of Knowledge of Good and Evil is the fourth Zoa with the face of an ox. A look of resigned patience pervades his features. His hands too are folded, as if in prayer or supplication, yet the dilated pupils and distended nostrils reveal the dread expectation of an approaching terror. The ox denotes the patient, the slow and the stupid. This Zoa corresponds to Blake's Tharmas. In the prophetic books, he is the most oppressed of the four, and the least aware of his own nature and that of the other three. The perversion and repression of the bodily instincts are represented in the depiction of this Zoa.

The Four Zoas in the "Genesis" title page show Blake's conception of the fall of man. He portrays this as a crucifixion of the whole personality: of the spirit, the intellect, the passions and the body. Adam's only hope of salvation lies in his holding fast to the Pledge of the Redemption handed him by Christ.

According to Professor Damon, however,

Blake was not satisfied with this title-page, so he left it unfinished and began another. The Holy Ghost is given more prominence;

Christ emerges from a sphere and points to the Father; and he, in his turn, uplifts the Bow of Spiritual Warfare. All three figures show much more energy, and give a sense of the inner life of the Trinity. The Trees and the Evangelists are replaced by the Twelve Apostles, who are not represented as demons, but who float in ecstasy crested with the Pentecostal flames. [38]

Yet, when the two title-pages are compared, there is no question as to the one here reproduced being the more highly finished and aesthetically satisfying, for the red daubs of the Pentecostal flames, and touches of black, are the only colours in the title page described above by Professor Damon.

Two factors now emerge unifying the intricate symbolism so far explained into an organic whole. To Blake, creation implied conflict, and a liberation of the spirit through suffering. Both these aspects of the Genesis theme are given prominence by antithesis. Christ, the Pillar of Mercy, is placed opposite Jehovah, the Pillar of Severity. The blue lotus blossom, its fruit, and the sheaf of corn, emblems of creation, fertility and abundance of life respectively, are contrasted with the red roses of martyrdom and the lily of Calvary. The Temptation, as yet perceived only in "the shadows of Possibility," [39] is hinted at in the faint sketch of the two snakes, while the promise of the Redemption is shown by the scroll which Christ gives Adam. Between the divergent sets of emblems stand the date palms, symbols of a Christian salvation and a Christian victory achieved through the Crucifixion which unites man with God and God with man in the person of Jesus. The uncorrupted Adam bestrides the green earth in simple majesty. Yet his fall is grimly portrayed in the Four Zoas at his feet. Only through the catharsis of suffering and the mercy of Christ can man liberate his spirit, his intellect, his senses and his body, thus attaining an eternal blessedness. As if to typify this liberation, beyond the conflict and the sacrifice, rides Blake's image of "Eternal Delight." [40]

NOTES

1. Geoffrey Keynes, *A Bibliography of William Blake* (New York: Grolier Club, 1921, reprinted New York: Kraus, 1969), p.48.

2. K 933, E 667.

3. Ed.: Described and reproduced in Martin Butlin, *William Blake: A Complete Catalogue of the Works in the Tate Gallery* (London: Tate Gallery, 1971), p. 33, no. 13.

4. K 149, E 34.

5. I wish to thank Professor Dr. Elisabeth Schiemann, Agnes Arber, and William T. Stearn, Librarian, Royal Horticultural Society, London, for their generous help in plant identification. I am further indebted to Mr. Stearn for placing at my disposal monographs on plant symbolism which enabled me to discover Blake's meaning in the "Genesis" title-page.

6. Robert John Thornton, *New Illustration of the Sexual System of Linnaeus . . . and the Temple of Flora* (London: Dr. Thornton, 1799-1807), Part III, Nymphaea Nelumbo, or Sacred Egyptian Bean (pages unnumbered). For a lively account of the work, see F. M. G. Cardew, "Dr. Thornton and the 'New Illustration' 1799-1807," *Journal of the Royal Horticultural Society*, 72 (July, 1947), 281-85.

7. Thornton, *Temple of Flora*, Part III, description of Nymphaea Nelumbo.

8. *Devises Héroiques* (Lyon: Jan de Tournes, 1557), pp. 201, 210, 244.

9. *A Choice of Emblemes* (Leyden: Plantyn, 1586), p. 23.

10. *A Collection of Emblemes, Ancient and Moderne* (London: R. Milbourne, 1635), pp. 44, 50.

11. *Dialogo dell'imprese militari et amorose* (Lyon: G. Rovillio, 1574), p. 116.

12. *Emblemata* (Metz: I. Aubrii, [1584]), p. 46.

13. *Symbola et Emblemata* (Amsterdam: H. Wetstenium, 1705), p. 139 emblem 412.

14. *Medieval Christian Imagery* (Oxford: Clarendon Press, 1936), p. 263. Cf. pp. 240, 395, 395 note 3.

15. French tapestry series woven for the choir of the Cathedral of Auxerre, *c.* 1488-1500, Cluny Museum, Paris. Displayed at an Exhibition of French Tapestry, Victoria and Albert Museum, London, March 29th to June 8th, 1947, *Catalogue*, No. 32, "Discovery of the Body of St. Stephen and its Removal to a Church in Jerusalem." Twelve red roses are placed round the open coffin in which the body of the martyr was exposed to view.

16. Cornelius Kilianus, *Prosopographia* (Antwerp [?] : P. Galle [?], *c.* 1600), pl. 6. I am indebted to Miss Enriqueta Harris for drawing my attention to this point.

17. Rembert Dodoens, *Stirpium historiae pemptades sex* (Antwerp: Plantin, 1583, revised ed. 1616), II, cap. iii, p. 201.

18. Jonas Dryander, *Catalogus bibliothecae historico-naturalis Josephi Banks* (London, 1797), III, Botanici, p. 55. For a bibliography of eighteenth century publications in which the Lily of Calvary was illustrated, see *Index Londinensis* (Oxford: Clarendon Press, 1930), IV, 102.

19. I am indebted to Mr. W. T. Stearn for this piece of information.

20. K 738 lines 43-4, E 246 lines 43-4.

21. Cf. the full-blown lily in Joseph Jacob Plenck, *Icones Plantarum Medicinalium* (Vienna, 1790), III, pl. 274.

22. J. Britten and R. Holland, *A Dictionary of English Plant Names* (London: Tubner & Co. for the English Dialect Society, 1886), p. 451. See also *Index Londinensis*, IV, 484; VI, 210. For the drawing Blake seems indebted to a plate in Dr. Thornton's *British Plants*. See Robert John Thornton, *The British Flora; or, Genera and Species of British Plants* (London, 1812), IV, pl. 17.

23. L. H. Bailey, *The Standard Cyclopaedia of Horticulture*, new ed. (New York: Macmillan, 1927), III, 2593.

24. K 691 lines 5-6, E 206 lines 5-6.

25. Cf. feathery palms in devices dedicated to the Count of Soriano and the Duke of Urbino in G. Ruscelli, *Le Imprese illustri* (Venice: Trino di Monferrato, 1572), II, iii, 128, 136. Cf. also p. 170.

26. *Revelation* vii:9-10; *John* xii:12-5; *Matthew* xii:1-9. Note also the numerous representations of the martyr's palm in Christian art.

27. Angelo de Gubernatis, *La Mythologie des Plantes* (Paris, 1882), II, 278.

28. I am indebted to Mr. W. T. Stearn for this piece of information.

29. Quoted by Mario Praz, *Studies in Seventeenth-Century Imagery*, second ed. (Rome: Edizioni di Storia e Letteratura, 1964), p. 224. Cf. Albert Flamen, *Devises et Emblèmes d'Amour moralizes* (Paris: Olivier de

Varennes, 1648), p. 57, where two feathery date palms incline towards each other till their branches mingle at the top; the motto, in Latin and French, being "Ivngit Amor," "L'Amour les joint."

30. K 117, E 12.

31. I am indebted to Mr. Joseph Wicksteed for his inter-pretation. See his *Blake's Vision of the Book of Job* (London: Dent, second ed. 1924), Appendix B, p. 218.

32. K 221, E 32.

33. Cf. the globular, rose-pink fruit on the Tree of Life in Blake's illustrations to Edward Young's *Night Thoughts*, Night VII, p. 24 (British Museum Dept. of Prints and Drawings).

34. For the significance of the Zoas in Blake see S. Foster Damon, *William Blake, his Philosophy and Symbols* (New York and London: Houghton Mifflin, 1924), pp. 145-48; D. J. Sloss and J. P. R. Wallis, eds., *The Prophetic Writings of William Blake* (Oxford: Clarendon Press, 1926), II, 256 ff.; Milton O. Percival, *William Blake's Circle of Destiny* (New York: Columbia Univ. Press, 1938), pp. 18-46.

35. Mr. Keynes does not distinquish the Four Zoas in his description of this page, and omits to mention both the snake and the partly rubbed figure with a trumpet on the left margin corresponding to a similar figure on the right. See his *Bibliography*, p. 33, entry la.

Dr. Zofja Ameisenowa of Cracow informs me that the presentation of Blake's Zoas in the "Genesis" title-page is derived from the iconographical tradition depicting the Four Evangelists each wearing the head of his appropriate symbol. Such instances occur in illuminated

manuscripts of the eighth to the twelfth century A.D., and in church frescoes: e.g. The Sacramentary of Gellone, dating from the second half of the eighth century (V. Leroquais, *Les Sacramentaires et les Missels Manuscrits* [Paris, 1934], I, 1-8, pl. III); The Book of Kells, *c.* 800 A.D. (A. M. Friend, Jr., "The Canon Tables of the Book of Kells," in *Medieval Studies in Memory of A. Kingsley Porter* [Cambridge, Mass.: Harvard Univ. Press, 1939], II, 614, 637, pl. I); The Sacramentary of Limoges, twelfth century (Leroquais, II, 213-15, pl. XXXIV); Title-page of the Sponheim Gospels, *c.* 1124 A.D. (Wilhelm Neuss, *Das Buch Ezekiel in Theologie und Kunst* [Munster in Westf., 1912], pp. 251-53, fig. 58); Poitiers Gospel, twelfth century (Friend, p. 632, pl. XXIII); two 13th-century Bibles executed in Bologna (Ameisenowa, "Les Principaux Manuscrits à peintures de la Bibliothèque Jagellonienne de Cracovie," *Bull. Soc. Fran. de Reprod. Man. à Peintures*, no. 17 [1933], 18-9; and "Das messianische Gastmahl der Gerechten in einer hebraischen Bibel aus dem XIII Jahrhundert," *Monatsschrift, f. Geschichte u. Wissenschaft d. Juden-tums*, no. 79 [1935], 419); Dome of the Baptistry in Parma, Èmèlie frescoes in Provence (Ameisenowa, "Les Principaux Manuscrits . . .," p. 22; "Das Messianische Gastmahl . . .," p. 419).

36. K 152 line 15, E 37 line 54.

37. K 615, E 554.

38. Damon, p. 221.

39. *Jerusalem* 92:18 (K 739, E 250).

40. *Marriage of Heaven and Hell* (K 149, E 34).

POETRY AND DESIGN IN WILLIAM BLAKE

by
Northrop Frye

*T*he ability to paint and the ability to write have often belonged to the same person; but it is rare to find them equally developed. Most people so gifted have been either writers who have made a hobby of painting, like D. H. Lawrence, or painters who have made a hobby of writing, like Wyndham Lewis. When the two are combined, one usually predominates. It is not uncommon for poets who can draw to illustrate their poems, like Edward Lear; nor is it uncommon for painters who can write to provide inscriptions to their paintings, like Rossetti. In a world as specialized as ours, concentration on one gift and a rigorous subordination of all others is practically a moral

Ed.: Reprinted by permission of the publisher from *The Journal of Aesthetics and Art Criticism*, 10 (Sept., 1951), 35-42. The footnotes have been added by the editor.

principle. Mr. Eliot uses the word "schizophrenia" even about the attempt to write both poetry and philosopy. Blake, it is clear, had a different attitude, and the reasons for his different attitude are of some interest.

Besides being a poet and painter, Blake was a professional engraver and a tireless and versatile experimenter in a great variety of media. He was an artisan or craftsman who was an expert in an important minor art as well as two major ones. His political sympathies were anarchist and revolutionary. The combination of talents and outlook reminds us of William Morris, and as the French Revolution wore on into Napoleonic imperialism, Blake came more and more to anticipate Morris in his view of the social function of art. Like Morris, he felt that revolutionary action would only go from one kind of slavery to another unless it were directed toward the goal of a free and equal working society. Like Morris, he believed that real work and creative activity were the same thing, and that as long as society supported a class of parasites, work for the great majority of people would be perverted into drudgery. And so, like Morris, he came to feel that the essential revolutionary act was in the revolt of the creative artist who is also a manufacturer, in the original sense of one who works with his hands instead of with automata. And as the tendency of a class-ridden society is to produce expensive luxuries for the rich and shoddy ugliness for the poor, the true manufacturer should present his work as cheaply and as independently of commerce and patronage alike as possible.

The creative producer, then, has to imitate, on a necessarily limited scale, the mass-producing methods of commerce. Also, a revolutionary break with both patronage and commercial exploitation is only possible if some revolutionary new method of production is discovered. Blake made

at least three attempts to develop his own means of production. First, and most important to students of literature, was his discovery of the engraving process which he used for most of his poems. It is clear that Blake expected this process to be more efficient and less laborious than it was: he expected, in short, that it would make him independent of publishers as well as of patrons, so that he could achieve personal independence as both poet and painter at a single blow. A character in his early satire, *An Island in the Moon*, speaks of printing off two thousand copies of engraved works in three volumes folio, and selling them for £100 apiece.[1] Next came an attempt at large-scale reproduction of prints by means of a millboard, but the millboard proved too fragile for more than a few copies, and the variety of results it produced was too unpredictable. He was still dependent on patrons and connoisseurs to do the work he wanted to do, and on publishers' commissions to keep himself alive the rest of the time. Finally Blake turned to another idea on a much bigger scale: he thought he might gain government support for the arts if he could start a revival of fresco-painting on the walls of public buildings. The chief commercial disadvantage of fresco, Blake thought, was that the original painting had to remain as long as the wall it was painted on did, and he proposed that frescoes should be painted, not directly on the plaster, but on canvas stretched over the plaster, so that they could be taken off and changed. After he had worked out what he thought was a practicable method of painting such "portable frescoes," he held the one exhibition of his life in 1809, to introduce it to the public. The fate of this exhibition is well known, though it is seldom realized that its primary object was to advertise, not Blake, but a new instrument of production that would initiate a social revolution.

It is natural that Blake, whose main source of income was illustrating books, should at first think of his own poems as constructed on the same principle as the illustrated book, an alternation of text and design. In the passage from *An Island in the Moon* already quoted, he speaks of making every other plate a high finished print. An early prophecy called *Tiriel* survives in a manuscript and a group of twelve separate illustrations, about the same number of plates that would be needed for the text. Fortunately for us, however, Blake began his experiments with aphorisms and lyrics which took only a single plate apiece, and so hit very early on a form in which text and design are simultaneously present and contrapuntally related. From the start Blake avoids all devices that would tend to obscure either text or design at the expense of the other. In illuminated books we often find what we may call the tradition of hieroglyphic, in which the verbal sign itself becomes a picture, such as the ornamental capitals of medieval manuscripts or the tortuous decorations of the Book of Kells. There is nothing of this in Blake: occasionally the shoots and tendrils of the design are entangled with the longer letters of the text, but that is all. The words are left alone to do their own work. The only exception I can think of is the heading to *The Book of Los,* where Urizen is shown wrapped up in a net inside the letter O of "Los," and even this is intended as a joke.

More surprising than the independence of the words from the design is the independence of the design from the words. Blake's age, after all, was the age of the pictorial Slough of Despond known as "historical painting," in which the painter was praised for his grasp of archaeology and the history of costume and for the number of literary points he could make. Again, the *Songs of Innocence and Experience* are in the direct tradition of the emblem-books: they are by

far the finest emblem-books in English literature. But the typical emblem is a literary idea to begin with: its design takes its form, not from pictorial laws, but from the demands of the verbal commentary, and it is allegorical in a way that Blake's lyrics never are. In Blake the poem does not point to the picture, as it regularly does in the emblem. On the other hand, the design is not, like most illustrations, an attempt to simplify the verbal meaning. The *Songs of Innocence* are not difficult poems to read, and one might expect them to be made even easier, at least for children, by being put into a picture-book. Perhaps even Blake expected this. But when we contemplate the great spiral sweep that encircles "The Divine Image," or the passionate red flower that explodes over "Infant Joy," or the marching horizontal lines of "Holy Thursday," we can see that, so far from simplifying the text, the design has added a new dimension of subtlety and power.

In the earliest prophecies, *The Book of Thel* and *Visions of the Daughters of Albion,* text and design approach one another rather tentatively. In *Thel* the design is always at the bottom or the top of the page, but in the *Visions* the text is occasionally broken in the middle, and an important step has been taken toward the free interpenetration of the two which belongs to Blake's mature period. In the early prophecies there is often an unequal balance between the amount Blake has to say in each of the two arts. Thus *The Marriage of Heaven and Hell* is in literature one of Blake's best known and most explicit works, but for that very reason it is less successful pictorially. The text predominates too much, and what design there is follows the text closely and obviously. So much so, in fact, that some of the marginal decorations become a rather irritating form of punctuation. Thus on Plate 11 the words "whatever their enlarged & numerous senses could perceive" are followed by a little drawing of a bird; the

words "thus began Priesthood" are followed by a black serpentine spiral, and the words "at length they pronounc'd that the Gods had order'd such things" are followed by tiny kneeling figures. On the other hand, *The Book of Urizen* is pictorially one of Blake's greatest works: here there is no plate without a major design on it, and there are ten plates without text. Blake here seems to be trying to forget about the poem, which with its short lines sits awkwardly on the plate in double columns. It is clear that there were pictorial as well as poetic reasons for the long seven-beat line of Blake's prophecies.

The finest of the earlier prophecies, as far as the balance between verbal and pictorial elements is concerned, are undoubtedly the "continent" poems, *America, Euorpe,* and *The Song of Los,* the last of these divided into two parts called "Africa" and "Asia." After 1795 Blake began to meditate a prophecy of epic proportions, and between then and 1800 he undertook two colossal projects which enabled him to work out the archetypes of his verbal and pictorial systems respectively, on an epic scale. Each of these was a dream of nine nights: one was the great unfinished poem, *The Four Zoas,* which never reached the engraving process, but was left in a manuscript full of extraordinary sketches; the other was his illustrated edition of Young's *Night Thoughts.* The fascination that Young's poem clearly had for Blake was not due to Young so much as to the fact that Young's poem was based, like Blake's own symbolism, on the Bible. Throughout Blake's illustrations we can see how he infallibly goes to the Biblical archetype which gives what point and direction there is to Young's narrative. It was from his work on Young that Blake gained a coordinated vision of the leviathan, the four "Zoas" of Ezekiel, the Great Whore with the beast, and the other essential elements of his later

symbolism. The final fruits of his effort were the two great poems *Milton* and *Jerusalem,* in fifty and one hundred plates respectively, after which Blake turned his main attention away from poetry.

It is difficult to convey adequately the sense of the uniqueness of Blake's achievement in these engraved poems. In the Preface to *Jerusalem* Blake speaks with pride of having developed a free and unfettered verse,[2] but he hardly seems to notice that he had at the same time perfected a far more difficult and radical form of mixed art, for which there is hardly a parallel in the history of modern culture. The union of musical and poetic ideas in a Wagner opera is a remote analogy; but the poetry is not independent of the music in Wagner as it is of the painting in Blake. Blake seems to have worked on his text and his pictorial ideas simultaneously: this is clear from the manuscript of *The Four Zoas,* where the pencil sketches in the margins indicate that Blake did not think in terms of a poem to be written first and decorated afterward, but, from the beginning, in terms of a narrative sequence of plates.

Blake felt that his conception of outline was one which held all the arts together, and his engraving technique does a great deal to prove his case. The stamped designs produced by a relief etching on metal, in which the details stand out from surrounding blank space, give us something of the three-dimensional quality of sculpture. On the other hand, the tremendous energy of Blake's drawings with their swirling human figures makes them of particular interest to dancers and students of ballet, even if more sedentary observers merely find them out of proportion. About the color it is more difficult to speak. After reading what Blake has to say about the subordinating of color to outline in painting, we are not surprised to find that there is no fixed color

symbolism in the designs: every copy is colored differently. At the same time, as he developed confidence and scope, he began to move toward the luminous splendors of the golden city that was the end of his vision. "A word fitly spoken," says the Book of Proverbs, "is like apples of gold in pictures of silver." Such ideas were entirely unbefitting to Blake's station in life. The text of the only surviving colored copy of *Jerusalem* is in a strong orange which looks like a poor man's substitute for the golden letters he doubtless dreamed of.

The designs play a great variety of roles in relation to the words, besides that of direct illustration. The natural symbols lend themselves admirably to pictorial meta-morphosis, and the process is simplified by the fact that the symbols of experience are often direct parodies of those of innocence. Vines with grapes, ears of wheat, and a profusion of green leaves sprout from the tree of life; brambles, thorns, thistles, dead trees, and tangles of roots belong to the tree of mystery. In Illustration 75 of *Jerusalem* a row of angels, with haloes around their bodies, make a line of intersecting circles, the "wheels within wheels" of Ezekiel's vision. At the bottom of the page the same rhythm is picked up and parodied by a picture of Rahab and Tirzah caught in the rolling coils of serpents.

I have spoken of the analogy between Wagner and Blake, and some of Blake's pictorial symbols incorporate ideas in a way that reminds one of Wagner's technique of the leitmotif. Thus it is one of Blake's doctrines that we see the sky as a huge concave vault because we see it with eyes that are imprisoned in a concave vault of bone. The title page of *The Book of Urizen* depicts Urizen himself, the fallen reason of man, and it therefore endeavors to give a concentrated impression of befuddled stupidity. The picture is built up in a

series of rounded arches. Urizen sits crouching in the foetus posture that Blake regularly uses for mental cowardice, and two great knees loom out of the foreground. His skull and bushy eyebrows are above; behind his head are the two tables of the law, each with a rounded top; behind them is the arch of a cave, the traditional symbol since Plato of blinded vision, and over the cave droops a dismal willow branch, an imp of the tree of mystery.

Occasionally, though rarely, the design comments ironically on the text, if an ironic touch in the text permits it. Thus the seventh illustration of *America* contains the speech of the terrified reactionary angel of Albion denouncing the rebellious Orc as "Blasphemous Demon, Antichrist, hater of Dignities," and so on.[3] The design shows a graceful spreading tree with birds of paradise sitting on its branches; underneath is a ram and some children asleep, sunk in the profound peace of the state of innocence. A much more frequent type of comment, and one which also is sometimes ironic, is a pictorial reference or quotation, generally to the Bible. *The Marriage of Heaven and Hell* concludes with a portrait of Nebuchadnezzar going on all fours. Nebuchadnezzar is not mentioned in the text, but the prophecy deals with the overthrow of senile tyranny, and Nebuchadnezzar, the tyrant of Babylon who becomes a monstrous animal, first cousin to behemoth and leviathan, is for Blake a central symbol of the kind of thing he is attacking. The great picture of Albion before the cross of Christ, which concludes the third part of *Jerusalem,* is a more familiar example. It is more common, however, to have the designs focus and sharpen the verbal symbolism. Thus the poem *Europe,* if we had only the text, would seem an almost perversely intellectualized treatment of the theme of tyranny and superstition. It is when we look at the plates depicting

famine, war, and pestilence that we realize how acutely aware of human misery Blake always is.

In the longer poems there is, of course, a good deal of syncopation between design and narrative. At the bottom of Illustration 8 of *Jerusalem* is a female figure harnessed to the moon: the symbol is not mentioned in the text until Illustration 63. The effect of such devices is to bind the whole poem together tightly in a single unit of meaning. And here, perhaps, we come closest to the center of the aesthetic problem that Blake's achievement raises. The words of a poem form rhythms which approach those of music at one boundary of literature, and form patterns which approach those of painting at the other boundary. To the rhythmical movement of poetry we may give the general name of narrative; the pattern we may call the meaning or significance. The Renaissance maxim *ut pictura poesis* thus refers primarily to the integrity of meaning which is built up in a poem out of a pattern of interlocking images. When Spenser begins the last canto of the Legend of Temperance with the words "Now gins the goodly frame of Temperance fairly to rise," he means that, in addition to the narrative, a unified structure of meaning has been built up which can be apprehended simultaneously, like a painting, or, to follow Spenser's image, like a building. Such a passage shows the principle of *ut pictura poesis* in action.

When we think of "meaning" we usually think of something to be expressed in general propositions. But the units of poetry are images rather than ideas, and a poem's total meaning is therefore a total image, a single visualizable picture. Not many rhetorical critics pursue their image-linking to this ultimate point. They usually remain close to the texture of the poem, engaged in the detailed study of the poetic equivalents of the technique of brush and palette

knife. The critic who can only express meaning in terms of propositions has to stop his interpretation of the poem at the point of fitting it into the background of a history of ideas.

But it is possible to go further, and it is only when literary critics stand back far enough to see the imagery as one pattern that they are in a position to solve the problems of structure, of genre, and of archetype. The meaning of, for instance, Spenser's *Mutabilitie Cantoes* is not the conflict of being and becoming, which is only an aspect of its content. Its meaning is the total structure of its imagery, and this structure is a spherical, luminous, ordered background with a dark mass thrusting up defiantly in the central foreground: the same structural archetype that we find at the opening of *The Book of Job*. The propositional content of Blake's *Europe* could be expressed somewhat as follows: the root of evil and suffering is the fallen nature of man; this fallen nature is a part of physical nature; hence the basis of superstition and tyranny is the deification of physical nature; this deification has polluted Western culture from the sky-gods of Greece and Rome to the gravitational universe of Newton. But its poetic meaning, its total image, is given us by Blake himself in his frontispiece to the poem, the famous picture of the Ancient of Days, the bearded god whose sharp cruel compasses etch the circumference of the human skull and of the spherical universe which is its objective shadow.

Blake's prophecies are in the tradition of the Christian epic, and the meaning or total image of the Christian epic is the apocalypse, the vision of reality separated into its eternal constituents of heaven and hell. At the time that he was completing his epic prophecies, Blake was preoccupied by the pictorial vision of the Last Judgement. He has left us the magnificent picture reproduced as Illustration 7 of Darrell Figgis's book on Blake's paintings,[4] and an elaborate

commentary for a still larger design of which nothing else remains. After this, Blake tended to make the picture the unit of a new kind of non-verbal narrative, and so turned from poetry to the sequences of his Milton, Bunyan, Dante, and Job illustrations.

The only complete edition of Blake's engraved prophecies is in the third volume of *The Works of William Blake* edited by Ellis and Yeats and published by Bernard Quaritch in 1893. This edition was a heroic publishing effort, and it showed the true spirit of scholarship, as it must have lost a great deal of money. But it is increasingly difficult to obtain, and the reproductions, which are in black and white and done from lithographs, a rather greasy medium that failed to interest Blake himself, are not very satisfactory, to put it mildly. There are passable color reproductions of the lyrics and a few of the shorter prophecies, but so far as I know there has been no good edition, with or without color, of *America, Europe, Milton,* or *Jerusalem.*[5] There are even editions of the lyrics which have been illustrated by other people. For one reason or another, many literary students of Blake have only the vaguest notion of what sort of pictorial basis underlies his poetry. A good many foolish ideas about Blake have resulted from staring at the naked text. The notion that he was an automatic writer is perhaps the most absurd of these; the notion that his prophecies offer only the dry bones of a vision that died within him runs it a close second. We spoke at the beginning of the specialized nature of modern culture; and a man who possesses so much interest for students of religion, philosophy, history, politics, poetry, and painting will be chopped by his critics into as many pieces as Osiris. It is all the more necessary to correct the tendency to identify blinkered vision with directed vision by trying to expose oneself to the whole impact of Blake at once.

NOTES

1. K 62, E 456.

2. K 621, E 144.

3. K 198, E 52.

4. Ed.: *The Paintings of William Blake* (London: Ernest Benn, 1925), pl. 7, "The Last Judgment," Lord Leconfield-Petworth House version. See also Geoffrey Keynes, *William Blake's Illustrations to the Bible* (Clairvaux: Trianon Press for the Blake Trust, 1957), p. 38, no. 131c. For one of Blake's drawings of "The Last Judgment," see Illustration 55 and the essay on this design by Albert S. Roe reprinted here.

5. Ed.: During the years since this essay was originally published, color facsimiles of these works have been published by the Trianon Press for the William Blake Trust.

THE DATING OF WILLIAM BLAKE'S ENGRAVINGS

by

David V. Erdman

*U*ntil recently every attempt to trace Blake's development as a graphic artist has relied more or less unsteadily—and sometimes with an appeal to the reader's belief in genial miracles—upon what prove to be erroneous dates for certain landmarks in his career as an engraver. The matter of a year's error in the dates of his apprenticeship, not a source of any momentous confusion, has been cleared up.[1] But errors of from seven to forty years continue to be made in the dating of three of Blake's major original engravings and continue to stand in the way of

Ed.: Reprinted by permission of the author and publisher from *Philological Quarterly*, 31 (1952), 337-43. The notes have been revised by Prof. Erdman for this reprint. On the dating of Blake's engravings, and for reproductions of the prints referred to in this essay, see also Geoffrey Keynes, *Engravings by William Blake: The Separate Plates* (Dublin: Emery Walker, 1956).

accurate biography and of critical appraisal of the three works themselves, rich as they are in allusive symbolism.

These pivotal engravings are: (1) Blake's supposedly earliest work, *Joseph of Arimathea*; (2) his most famous single print, *Albion rose* (commonly called *Glad Day*, and now, by Mr. Geoffrey Keynes, *The Dance of Albion*); and (3) his obscure prophetic engraving, *Our End is Come* (or *The Accusers*). Mr. Keynes, in his *Blake Studies* of 1949 and in the introduction of his valuable 1950 collection of *Blake's Engravings*, has upset the traditional dating of these three works and has brought forward evidence making it possible for us to work out a consistent chronology.[2] But he has not worked out one himself, and while he has overthrown the old bibliographic assumptions, he has not managed to establish firmer ones in their place. In one instance he does not even hold to the same date for two pages running.[3] These inadequacies, let me hasten to say, Mr. Keynes has recognized in subsequent correspondence, and he has graciously acknowledged the substantial accuracy of the ensuing remarks, submitted to him in rough draft. An itemized analysis of the evidence for dating the three dislodged engravings, in their various states, will I trust make clear the nature of the problem and some of its more immediate implications.

I. Joseph of Arimathea. Extant in two states: A, B.

O. [Drawing. None extant, perhaps none made by Blake: see A.]

A. Line engraving, apprentice work [Illustration 153]. Extant print is inscribed in ink in Blake's handwriting: "Engraved when I was a beginner at Basires, / from a drawing by Salviati after Michael Angelo." No engraved inscription. [*Blake Studies*, plate 14.] *Date.* Engraved in 1773, as we know from inscription of B. This print made

then or later.[4] Keynes' discovery and reproduction of this print affords ocular demonstration that Blake's early work was *not*, as commonly supposed, the highly finished engraving, B.

B. Line engraving, mature work, a thorough refurbishing of A, with engraved inscription: "Joseph of Arimathea among The Rocks of Albion / Engraved by W Blake 1773 from an old Italian Drawing / This is One of the Gothic Artists who Built the Cathedrals in what we call the Dark Ages / Wandering about in sheep skins & goat skins of whom the World was not Worthy / Such were the Christians in all Ages / Michael Angelo Pinxit"

Date. Obviously it was the crude original (A) and not this finished version that was "Engraved by W Blake 1773." The lettering of the inscription is of a late style, and its theme suggests a date well after 1800. Though Blake's interest in Gothic Artists began early, he did not write this way about them until after his Lambeth period. The closest parallels in idea and phrasing are in his *Descriptive Catalogue* (1809) and *Jerusalem* (1804-1818) — and the inscriptions of *Laocoön* (1815-1820). This is the time when Blake was concerned to declare the oneness of Artists and Christians, and in such spirit he refurbished and inscribed his early plate. Most unhappy guesses are Mr. Keynes' (in 1949) of "twenty years later [1793] or more" and (in 1950) of "1790 or soon after" (p. 9) or "1788-90" (p. 10). Almost certainly Blake did *not* write of "the Christians in all Ages" in this manner in the years when he was writing the diabolical *Marriage of Heaven and Hell*. I should put the probable date: 1809-1820.

Implications. With B in its proper date and A as the apprentice work, we can see that Blake was not miraculously born with full mastery;[5] on the other hand, as mature work B is not exceptionally fine engraving: we should now be less inclined to overrate Blake's technical skill. As to Blake's practice in dating, we see that here his date did not mark the final version but commemorated the first draft of some thirty or forty years earlier. The implication for other dated works is far-reaching. Consider our next example.

II. Albion rose ... [Gilchrist's title: *Glad Day*; Keynes': *The Dance of Albion*]. Extant in four states, O, A, B, C.

O. Pencil drawing. n.d. Probably 1780: see B. [*Pencil Drawings*, plate 1.]

A. Color print. n.d. [Illustration 11] Printed from the plate used for all extant engravings (B and C) but from a simpler and therefore probably earlier state of the plate. Girth and lines of waist and legs are closer to O than B. According to Binyon the plate surface used is 3/4" higher and slightly wider than B and bears no trace of any engraved inscription.[6] On the other hand the plate could have been modified after the printing of B and C, though this seems less likely. Keynes affirms that there are certainly not two plates, as Binyon's account might imply.

Date. Keynes: ca. 1794, from the similarity to other color experiments of the period. A very flexible date *beyond* 1794.

B. Line engraving [Illustration 10]. Engraved inscription: "WB inv[enit] 1780 / Albion rose from where he labourd at the Mill with Slaves / Giving himself for the Nations he

danc'd the dance of Eternal Death." [Often incorrectly transcribed "Albion arose etc."] A development of A with some body lines changed and with the addition of lines of radiation above and to the left of the figure of Albion. Two other lines, used in A for color guides (compare similar lines in the "Argument" of *Visions of the Daughters of Albion*) reappear here with differences of shading added to take the place of color differences. If B preceded A, that is if the radial lines had already been on the plate, Blake could have used them as color guides; but this area is differently organized in A.

Date. The inscription dates the drawing or "invention"—"WB inv[enit] 1780"—but not the engraving. Keynes' conjectures have ranged from 1800 to 1780, but he now accepts my contention for a date in the late '90s. The language of the inscription is that of *Vala* (dated in MS "1797," i.e. begun then): "at the Mill with Slaves" comes from *America* (and ultimately *Samson Agonistes*), but the apocalyptic irony of "Eternal Death" belongs to the *Vala* period, and Albion's *dance* comes from Burke's *Letter to a Noble Lord* (1796) read in an infernal sense. There Burke recalled the riots of 1780 and shuddered to think how close the "savage" multitude of England had come to "leading up the death-dance of democratic revolution" at that time. Blake commemorates the date, "1780," and says in effect that the people of England rose in insurrection, sacrificing themselves to save the "Nations," his word in *America* for the Colonies.[7] Conclusion: a date of 1796 or later.

Implications. The assumption that "1780" dated B (and C) has pied all accounts of Blake's development as

engraver. For *if* this engraving was "drawn effortlessly upon the copper" in 1780, then later work such as *Our End* is pushed back into the '80s (see this happen in Keynes' 1950 volume). But actually there is no work of comparable freedom before the line etching of the Lambeth books of the '90s, and the technique of this plate is close to that of the 1796 engravings for Young's *Night Thoughts* (cf. the ruled background).

C. Line engraving, identical to B but without inscription, except "WB inv 1780." According to Keynes, all known copies have some trace of the B inscription.

 Date. All copies of C are not necessarily later than all copies of B. The inscription may simply have been covered by a slip of paper (as was done in the printing of some copies of the second "Preludium" page of *America*).

 III. Our End is Come, or ***The Accusers***. Extant in five states: O, A, B, C, D

O. Pencil drawing, undated. [Plate 10 in *Pencil Drawings*, with title suggested by Keynes: *War.*]

 Date. Precedes A; hence earlier than June, 1793. Probably not earlier than February, 1793, because on the same sheet are sketches used for *Europe*, a poem with the engraved date "1794" which deals with events leading up to the war with France begun in February, 1793.[8]

A. Line engraving, with engraved inscription: "Our End is Come / Publish'd June 5, 1793 by W. Blake, Lambeth." Crowned king and two armed henchmen agonize on a flaming threshold.[9] Inscription applies to them the prophecy of *America* ("1793") warning the "Angels &

weak men" who govern England that "their end should come" twelve years after the American War (1781 + 12 = 1793).

B. Line engraving, with engraved inscription: "When the senses are shaken / And the soul is driven to madness. Page 56 / Publish'd June 5, 1793 by W. Blake, Lambeth."

The quotation is from the "Prologue, intended for a Dramatic Piece of King Edward the Fourth" on page 56 of Blake's *Poetical Sketches* (1783). Inscriptions A and B point to the same thesis: a judgment for the mad king and weak angels who govern England and have been "shaken" by the civil war of the American Revolution. The "Prologue," written during that revolution, implies a parallel in the civil war that shook the throne of Edward IV. B makes sense to a reader of the *Sketches*; A to a reader of *America.*

Date. Since the engraved date is retained, B was probably issued not long after A. B follows A, since the B inscription shows traces in D.

C. Color print. Several copies extant. One on paper with the watermark 1794. Printed from A or B before the additions found in D. Color extends beyond engraved area, some lines of which are clearly visible. [Query: whether traces of inscription may be visible under the heavily colored surface at the base?]

D. Line engraving, considerably reworked with addition of laurel wreath etc. Engraved inscription at top: "The Accusers of / Theft Adultery Murder"; at bottom: "W Blake inv & sculp / A Scene in the Last Judgment / Satans' [sic] holy Trinity The Accuser The Judge & The Executioner." Traces of inscription B remain. No inscribed date.

Date. In *Blake's Engravings* Keynes suggests that this "final dramatic form" of the plate "must be of about the same date as 'Joseph of Arimathea,' that is 1788-1790." But of course it must be at least some time *later* than the verions dated June 5, 1793. This observation was impelled, however, by an important consideration—that the inscriptions of *Joseph* B and *The Accusers* D are close in style and symbolism. The period they both belong to is nearer 1810 than 1790.

Deletion of the 1793 date implies a time lapse, and the inscription fits the post-1804, post-1809 persecutions. The diabolism of the Lambeth period is gone; the evil rulers are not angels now but devils; and the poet has moved on from the strictly political applications of *America* as reflected in inscriptions A and B to the more general—and more personal—applications of *Jerusalem*. The Accusers are not simply the war-making king and councillors of 1793 but the Satanic trinity of Hyle, Hand, and Coban; or Schofield, Hunt, and Cromek. [These are related, but not identical trinities.]

Implications. Again the failure to attend closely to the language of the inscriptions has meant a failure to observe the wide separation of early and late issues, and of course a failure to observe the differing allusive contexts. The absence of symbolic language in the 1793 captions (A and B) also argues for a much later date for the highly symbolic captions of I B, II B, and III D.

Summary

Attention to the implications noted above should ultimately clear up much of the confusion in the whole chronology of Blake's engraved works. As for the particular

works examined here, the evidence points to the following conclusions.

The *drawings* were made in this order:
> *Joseph of Arimathea* [1773]
> *Albion rose* 1780
> *Our End is Come* 1793

The first engravings:
> *Joseph of Arimathea* 1773 (though the extant print may be later)
> *Our End is Come* June 5, 1793
> *Albion rose* 1794-1797 (color print)*

The final inscriptions:
> *Albion rose* 1796 or later*
> *The Accusers* ca. 1810 (1804-1820)
> *Joseph of Arimathea* ca. 1810 (1804-1820)

A demonstration of the evolution of Blake's styles of lettering would, I believe, reinforce this ascription of a very late date to the inscribed *Accusers* and *Joseph*.

*Postscript, 1972: See "Dating Blake's Script," *Blake Newsletter*, 3 (1969), 8-13. There a date of ca. 1800-1803 is argued for *Albion rose* and a date of 1803 or earlier for *The Accusers*, and reasons are given for my having been guilty of moving about the date of *Albion rose* in the meantime. D.V.E.

NOTES

1. See "William Blake's Exactness in Dates," *PQ*, XXVIII (1949), 466-467.

2. *Blake Studies* (London: Rupert Hart-Davis, 1949), p. 46; *William Blake's Engravings* (London: Faber & Faber, 1950), introduction.

3. See below, I. B. *Date*.

4. "Blake must have kept a pull from the plate in his portfolio," reasons Keynes, "and many years later he wrote at the bottom, 'Engraved when I was a beginner. . .' " But it is equally possible that Blake kept only the plate and made this pull years later just before refurbishing the plate to create state B.

5. In 1773 Blake was in the second year of his apprenticeship to Basire which began August 4, 1772; but he may have begun to learn engraving in the middle of his previous four-year term at Pars's Drawing School. In 1809-1810 Blake wrote of "having from early Youth cultivated the two Arts, Painting & Engraving, & during a Period of forty Years [i.e. since 1769-1770] never suspended his Labours on Copper for a single day. . . ." *Blake's Chaucer*, Notebook p. 117 (K 587, E 557).

6. Laurence Binyon, *The Engraved Designs of William Blake* (London: Ernest Benn and New York: Charles Scribner's Sons, 1926).

7. See *America*, lines 180 ff. (K 200-01, E 54) for the explanation; but there the naked multitude is not called Albion and does not dance. I have shown elsewhere that Blake often builds his meaning on the inversion of Burkean images.

8. For this reading of *Europe* see my article "Blake: the Historical Approach," in *English Institute Essays 1950*, ed. Alan S. Downer (New York: Columbia Univ. Press, 1951), pp. 197-223. For some of the larger implications

of all these matters see my *Blake: Prophet Against Empire: A Poet's Interpretation of the History of His Own Times* (Princeton: Princeton Univ. Press, 1954, revised ed. 1969).

9. The flames do not occur in state A but are added by further engraving for state B.

THE BLAKEAN AESTHETIC
by
Hazard Adams

*W*illiam Blake's theory of art is difficult to formulate. Blake considered it an "Image of truth new born," but for most of us it is only a further complication of the same "endless maze" from which he would deliver us. Blake tells us that our difficulty in perceiving truth is simply that we are unable to formulate the perception of our "maze" in any new way. Our words entangle us in the same old roots. Our words are no longer our slaves; they act as tyrants over our abilities to ask new questions and to overthrow old orientations.

Blake is almost always on the attack, and almost all of his attacks have at their roots an important semantic disagreement with some intellectual "villain." He was a man peculiarly sensitive to the total meaning of a word. He

Ed.: Reprinted by permission of the publisher from *Journal of Aesthetics and Art Criticism*, 13 (1954), 233-48.

believed that the terms chosen by a writer impose or at least reveal the limitations of that writer's view of reality. Often it is simply what his terms imply by connotation that chains a writer to some false epistemology and therefore to some false theory of art. Among Blake's most cherished "villains" were "Bacon, Newton, Locke" and Sir Joshua Reynolds with "his Gang of Cunning Hired Knaves."

Recently in this magazine Walter J. Hipple has endeavored with considerable success to show that some of the supposed inconsistencies for which Blake and others attacked Reynolds are not inconsistencies at all.[1] Lest Mr. Hipple's closely reasoned argument be taken as a complete vindication of Reynolds—I am sure that the author did not intend it as such—let it be said that Blake's disagreement with Reynolds is far more deeply seated than his attack on "inconsistency" would immediately reveal. He was dissatisfied with basic assumptions as they revealed themselves in Reynolds' expression. Even if Reynolds was consistent, to Blake he was downright wrong.

In an issue previous to the one containing Mr. Hipple's article, there appeared an article by Marcia Brown Bowman on Blake's doctrine of art. Mrs. Bowman suggested therein that Blake's symbolic method "naturally emphasized the abstract as opposed to the concrete aspects of the sensory world."[2] This is strange to the Blakean because for Blake the term "abstraction" carries with it an extremely derogatory connotation: "I labour incessantly & accomplish not one half of what I intend, because my Abstract folly hurries me often away while I am at work, carrying me over Mountains & Valleys, Which are not Real, in a Land of Abstraction where Spectres of the Dead wander."[3] It is strange too because the emphasis suggested by Mrs. Bowman is the very emphasis to which Blake objects in Reynolds' aesthetics. And yet Mrs.

Bowman employs the term "abstraction" in a sense accept-
able to many aestheticians.

Here we have a semantic muddle—Blake's "tangled
roots"—from which we must extract ourselves without doing
violence to Blake's thought. I propose therefore that it is now
time to re-examine Blake's aesthetic, especially in the light of
his sensitivity to the full meaning of words. Such a
re-examination may well serve as a kind of footnote to
Haskell M. Block's illuminating article, "Cultural Anthro-
pology and Contemporary Literary Criticism",[4] for Blake's
aesthetic, in truth his whole literary and artistic production,
is strongly related to developments in the kind of criticism
Mr. Block discusses.

1. *Epistemology of Vision*

For a man of the late eighteenth and early nineteenth
centuries Blake employed a somewhat unique vocabulary. In
revolt against a certain kind of rationalism, he objected to the
connotations of words commonly used by the philosophers
and poets of his time—nature, memory, abstraction, for
instance. They implied an epistemology with which he could
not agree. We must approach Blake's own theory of
knowledge knowing that he would not subject himself to the
tyranny of what seemed to him a materialistic vocabulary, its
conceptual boundaries trapping the thinker in "nets and
gins." Blake has been looked upon as an eccentric, as a
madman, and—both honorifically and derogatorily—as a
mystic. When the string has been wound into a ball, Blake's
thought emerges in a rational system, as much a logical
extension of the thought of his time as, for instance,
Berkeley's, but an extension contrived to move man out and
beyond the eighteenth century "endless maze" of "dark

disputes and artful teazing." True, Blake's system is based upon intuition or imagination, but it is not therefore dissolved anarchically in logical inconsistency.

A major point in Blake's theory of art lies behind a distinction between "Allegory" and "Vision." Blake did not always draw the distinction in the same way, for in one letter he speaks of a higher and a lower allegory: "Allegory address'd to the Intellectual powers, while it is altogether hidden from the Corporeal Understanding, is My Definition of the Most Sublime Poetry; it is also somewhat in the same manner defin'd by Plato."[5] But the less confusing and later distinction is this one: "The Last Judgment [a painting by Blake] is not Fable or Allegory, but Vision. Fable or Allegory are a totally distinct & inferior kind of Poetry."[6] There is a shifting of terms here. "Allegory address'd to the Intellectual powers" becomes "Vision." Allegory addressed to, or not hidden from, the "Corporeal Understanding" corresponds to the "Allegory or Fable" of the second quotation. If we have unraveled this semantic problem, our understanding of Blake's thought still depends upon the meanings we assign to the terms "Intellectual powers" and "Corporeal Understanding." If we simplify the Blakean language, the following sets of warring contraries appear:

Allegory	Vision
Fable	
Corporeal Understanding	Intellect

To the left-hand column we may add, as symbol, the name of Locke, and to the right the name of Berkeley.

Blake raises the name of Locke to the status of symbol for the thinking of a whole age, and then he attacks that thinking. He follows closely Berkeley's *reductio ad absurdum* of the hypothesis of primary and secondary qualities. For

Blake the mental image, form—the very act which creates the image—is the single reality. The world is a world of mental acts: ". . . what is call'd Corporeal, Nobody Knows of its Dwelling Place: it is in Fallacy, & its Existence an Imposture. Where is the Existence Out of Mind or Thought? Where is it but in the Mind of a Fool?"[7] The fool is Locke himself, who abstracted the subjective qualities of an experience from the objective, hard material facts. A visionary truth is the concrete apprehension of an object as it is created in the act of apprehension, not in the impingement of an outer material object upon a passive subject. We may therefore add the following to our contending word columns:

Abstraction	Concretion
Passive	Active

Blake objects to the Lockeian epistemology in the following comment upon one of Lavater's *Aphorisms:* "Deduct from a rose its redness, from a lilly its whiteness, from a diamond its hardness, from a spunge its softness, from an oak its heighth, from a daisy its lowness, & rectify everything in Nature as the Philosophers do, & then we shall return to Chaos. . . ."[8]

Blake summarized his theory of knowledge in the single phrase, "Strictly Speaking All Knowledge is Particular."[9] This statement follows directly from his attempt to heal or, better, disregard the Lockeian gap between inanimate object and passive subject, between nature and mind. It is no surprise to discover that in the Blakean myth the Fall from the visionary state of Eden, where harmony exists free of nature, is manifested by the creation of Lockeian matter. But it is Blake's faith that man's true state is visionary; that is, his state is potentially above the delusion which is the bifurcated natural world.

It is clear that Blake is not merely quibbling in his criticism of Wordsworth:

(Wordsworth): How exquisitely the individual Mind
 (And the progressive powers perhaps no less
 Of the whole species) to the external World
 Is fitted;–& how exquisitely, too,
 Theme this but little heard of among Men,
 The external World is fitted to the Mind.
(Blake): You shall not bring me down to believe such fitting
 & fitted.[10]

To Blake, Wordsworth's unification of subject and object is tenuous and strained, dependent upon a temporary clutching or an artificial series of connecting links. The very connotations of "fitting" and "fitted" suggest an outer material reality. Blake on the other hand sees reality only in the mental experience, the concrete perceptual act:

(Wordsworth): Influence of Natural Objects
 In calling forth and strengthening the
 Imagination
 In Boyhood and early Youth.
(Blake): Natural Objects always did & now do weaken,
 deaden & obliterate Imagination in Me.
 Wordsworth must know that what he Writes
 Valuable is not to be found in Nature.[11]

Blake abhors the epistemology Wordsworth implies. Again he objects to the material connotation of "nature." From Blake's point of view Wordsworth is unsuccessfully struggling to escape "Bacon, Newton, Locke." He has become the pawn of Blake's mythical goddess Rahab, symbol in the Prophetic Books of feminine will and of nature separate from and inaccessible to man; he attempts to embrace a Rahab who continually rebukes him but ever beckons. If we follow Blake's argument carefully, we discover that he was quite consistent in saying, with characteristic but meaningful overemphasis, "I see in Wordsworth the Natural Man rising up against the Spiritual Man Continually, & then

he is No Poet but a Heathen Philosopher in Enmity against all true Poetry or Inspiration."[12] The vituperative attack upon Sir Joshua Reynolds and his Lockeian principles of painting in the *Discourse* is based upon the same general distinction between the natural and the spiritual man. Blake thought, of course, that Reynolds was in far greater error than Wordsworth was.

It might be well to borrow a page here from Mr. Northrop Frye, who allows Blake to speak the following words: "Every eye sees differently, As the Eye Such the Object."[13] and: ". . . all of us on earth are united in thought, for it is impossible to think without images of somewhat on earth."[14] Mr. Frye then comments:

> . . . but the reality of the landscape [Blake's "earth" above] even so consists in its relation to the imaginative pattern of the farmer's mind, or of the painter's mind. To get an "inherent" reality in the landscape by isolating the common factors, that is, by eliminating the agricultural qualities from the farmer's perception and the artistic ones from the painter's is not possible, and would not be worth doing if it were. Add more people and this least common denominator of perception steadily decreases.[15]

Mr. Frye's least common denominator is very much like the photograph. The photo has sought to isolate the object from the subject. It begins with the Lockeian assumption, but, as Mr. C. Day Lewis has pointed out, it eliminates half of what is contained by the poetic image or as Blake would call it, the "vision."[16] Furthermore, to look at the situation another way, even to generalize from a series of these "visions" or to depend upon the memory in order to make these generalizations leads away from the act in which reality momentarily exists: "To Generalize is to be an Idiot. To Particularize is the Alone Distinction of Merit. General Knowledges are those Knowledges that Idiots possess."[17] The argument against Reynolds is rooted in the belief that a

generalization is as delusory as the natural world. If one is to employ a generalization one should assume that it is merely a useful fiction.

Blake makes one of his most revealing comments upon the following statement by Reynolds:

> (Reynolds): Thus it is from a reiterated experience and a close comparison of the objects in nature, that an artist becomes possessed of the idea of that central form . . . from which every deviation is deformity.
>
> (Blake): One Central Form composed of all other Forms being Granted, it does not therefore follow that all other Forms are Deformity.
> All Forms are Perfect in the Poet's Mind, but these are not Abstracted nor Compounded from Nature, but are from Imagination.[18]

It is quite clear that Blake and Reynolds are talking about two totally distinct "central forms." Reynolds conceives "central form" as a generalization, but a generalization is as meaningless to Blake as the modern American "average voter" or "Mrs. Housewife" should be to us.[19] Blake thought that Reynolds' conception, followed out in art, gives rise to personification and, as in Rubens, to painting in which by allegory and abstraction the "rattle traps of Mythology" degrade the imaginative expression.[20] In literature also, Reynolds' conception leads to allegory, which is addressed to the "Corporeal Understanding." But "central form" in Blake is of an entirely different nature. It has nothing to do with generalization and abstraction. It is in fact the very opposite. There is a "central form" available to the visionary imagination, but it is immediately available. All imaginative forms are microcosms of "central form." One need not employ the memory in order to build up a set of artifical forms. Blake's "central form" is the mental or human structure of the world, not the impingement of nature upon a *tabula rasa.*

But how can Blake convince the materialist that "all other Forms" are essentially one with "central form," that the microcosm may stand for the macrocosm—in fact *is* the macrocosm? It is here that he affirms the importance of the artist as a religious force in society and especially the importance of the artist's conceptual tool, the poetic symbol. To this affirmation I shall soon return.

Now any discussion which links Blake's idea of the poetic symbol with abstraction seems to me unacceptable in the light of his own vocabulary.[21] Simply because Blake denied Lockeian material nature as the objective reality, there is no reason to assume that his only alternative was to emphasize the abstract rather than the concrete. In fact to do so is to begin unknowingly in the very pit of Ulro to which Blake consigned Locke and the mythical figure Urizen. It is to do what Blake accused Reynolds of doing.

If we bring the word "symbol" into the study of Blake and link it with the word "abstraction," we find ourselves in the semantic muddle already mentioned. It is downright impossible, as Susanne K. Langer has recently pointed out, to use the word "symbol" in any sense acceptable to a majority of writers on the arts. Blake does not use the term, but nearly all writers on Blake, beginning with Yeats and Ellis, who at least let the reader know what they meant by it, have used it. In *Feeling and Form* Mrs. Langer uses "symbol" to mean "any device whereby we are enabled to make an abstraction."[22] Unfortunately we cannot adopt such a definition, since Mrs. Langer and Blake use the word "abstraction" in crucially different senses. Mrs. Langer says:

> All forms in art, then, are abstracted forms; their content is only a semblance, a pure appearance, whose function is to make them, too, apparent—more freely and wholly apparent than they would be if they were exemplified in a context of real circumstance and anxious interest. It is in this elementary sense that all art is abstract.

Its very substance, quality without practical significance, is an abstraction from material existence.[23]

But Blake uses "abstraction" to mean not only the action of Locke in separating the primary from the secondary qualities—the "bifurcation of nature," as Whitehead puts it—but also "generalization." Blake would call the building up in poetry of a composite image by selecting the common qualities from a group of objects "abstraction." What we call "generalization" is simply the logical extension of the Lockeian way of thinking. Blake would argue that Mrs. Langer allows objects material existence; but, he would go on, material existence is delusion. Thus, what Mrs. Langer calls "material experience" is simply the old "finite organical perception" of the scientist. The infinite perception—the vision of Ezekiel, for example—expressed as symbol is not an abstraction from material existence at all. It never existed materially in the first place. Nor does the vision of a more "realistic" cat or tiger.

Blake never uses the term "abstraction" to mean the act of the artist in transforming experience into expression. Blake's view in the light of recent epistemology may be put this way: The negation of material does not necessitate the negation of spatial or temporal vision. Such vision, however, is greatly metamorphosed, becomes something else to us. Our intuitions of the one reality—the world infinite—are, it is true, "symbolic transformations": "it is impossible to think without images of somewhat on earth." We see the infinite all around us symbolized in the forms of space-time. Yet these visions, if read correctly, tell us paradoxically that they are not material forms.

Blake's argument then is that the term "abstraction," carrying along past meanings, cannot but imply material. Thus the word is a symbol of the basic error in modern

thought, the "bifurcation of nature." We do not abstract *from* material experience. We intuit *through* visionary forms.

If we follow out Blake's epistemology the solid, material world falls away, and the terms "abstraction" and "concretion" cease to be useful with their old connotations. The term "concretion" could be admitted into the Blakean world only if it were to lose its hard materiality. It could then be a symbol of immediate perception, the only reality. But there is no possibility of the word's losing its aura, so we are wise to substitute at the beginning a word like "immediate." In the Blakean world there are immediate symbols, produced by the mind, which give reality, and there are abstractions produced by the generalizing memory, which give only a "lowest common denominator." As Northrop Frye has aptly put it, "In Blake the criterion or standard of reality is the genius; in Locke it is the mediocrity."[2 4]

To the abstractions as they appear in art, Blake gives the name "Allegory" addressed to the "Corporeal Understanding." The immediate symbols he dignifies with the word "Vision."

2. *The True Vision and the Debased Vision*

Blake made no distinction between poet and prophet, poetry and religious prophecy. Both present an intuition of the "central form" of life. Both Isaiah and Ezekiel simply assume that this correspondence exists when they speak to Blake in "The Marriage of Heaven and Hell":

> The Prophets Isaiah and Ezekiel dined with me, and I asked them how they dared so roundly to assert that God spoke to them; and whether they did not think at the time that they would be misunderstood, & so be the cause of imposition.
>
> Isaiah answer'd: "I saw no God, nor heard any, in a finite organical perception; but my senses discover'd the infinite in everything, and as I was then perswaded, & remain confirm'd, that the voice of

honest indignation is the voice of God, I cared not for conse-
quences, but wrote."

. .

Then Ezekiel said: "The philosophy of the east taught the first
principles of human perception: some nations held one principle for
the origin, & some another: we of Israel taught that the Poetic
Genius (as you now call it) was the first principle and all the others
merely derivative, which was the cause of our despising the Priests &
Philosophers of other countries, and prophecying that all Gods
would at last be proved to originate in ours & to be the tributaries
of the Poetic Genius."[25]

These remarks are packed with significance. First let us
explore the implied relationship between poetry and proph-
ecy. The infinite quality of the poetic or prophetic percep-
tion is by its perfect material nothingness not a process which
may be divided up into sections any more than the human
body, the *fallen* material manifestation of perception, can be
divided into portions capable of separate life.

I have heard many People say, "Give me the Ideas. It is no matter
what Words you put them into," & others say, "Give me the Design,
it is no matter for the Execution." These People know Enough of
Artifice, but Nothing of Art. Ideas cannot be Given but in their
minutely Appropriate Words, nor Can a Design be made without its
minutely Appropriate Execution.[26]

The execution of a work of art is not the imposition of an
arbitrary form upon the mental experience as it is recollected
in tranquillity. It is the immediate apprehension and holding
back from time of the central form of that experience.

In Blake's Edenic realm God and Man were one. And
they still are, except that corporeal illusion now often
prevents us from the realization of that Unity. The visionary
instinctively knows the fact of Unity, and the great works of
art are assertions of it. The Poetic Genius may overthrow the
bonds of "finite organical perception." The artist in society
strives to regain Eden for all men, to leave behind that state
of delusion characterized by Lockeian nature and spiritual

forms fallen into material. Art is thus prophetic in the religious sense. It does not predict, but it does disclose the true central form, the pattern of human life. And it does this not by viewing the grain of sand, and then by means of abstract reason considering its relation to a greater controlling deity, but by visualizing that grain of sand as symbol of the deity itself, as the central form in microcosm.

Unfortunately, in Blake's fallen world of "finite organical perception," instead of the timeless and spaceless unification of the microcosm which is man, or the grain of sand, and the macrocosm, the central form which is God, there is a delusory chain of being in which God, angels, men, animals, and plants are forever separated from one another. To Blake the chain of being is only another aspect of the Lockeian dilemma and of the abstract rationalization of the true Christian vision. Without the material delusion which gives more than symbolic reality to matter and time—the chains of Blake's Ulro—the chain of being would cease to exist. Blake writes:

> I give you the end of a gold string,
> Only wind it into a ball,
> It will lead you in at Heaven's gate
> Built in Jerusalem's wall.[27]

So long as the ball exists as a string, it exists as a symbol of linear progression in time and in space. When wound into a sphere it becomes the traditional symbol of perfection. Unlike Blake's mythical figure Urizen, who traps himself inside the sphere in nets and gins, the reader rolling it carefully and finally examining its perfection sees the chain gone, time ended, and space brought back to itself, the immediate symbol of heaven remaining. The reader has slipped out of Plato's cave, the sphere of Urizen, into Vision:

If the doors of perception were cleansed every thing would appear
to man as it is, infinite.
For man has closed himself up, till he sees all things thro' narrow
chinks of his cavern.[28]

The visionary sees the large in the small because he understands the delusion of taking largeness and smallness literally. The poetic vision is therefore a vision of apocalypse, *total resolution*, the return of all things to unity. It begins with a grain of sand and ends with God, but ideally it begins where it ends and achieves a single image of reality, shifting by fallen analogy into other images.

If we are to accept Blake's view of experience we must also see that Blake's analogies are not abstractions from a basic material reality but symbolic assertions of the unity of a reality into which material is simply never admitted. Blake's world is a world of hypostasis; Locke's is a world of tenuous correspondences or allegories.

Thus it is at all times to the immediate that Blake turns:

(Swedenborg): The Gentiles, particularly the Africans ... enter-
 tain an Idea of God as of a Man, and say that no
 one can have any other Idea of God: When they
 hear that many form an Idea of God as existing in
 the midst of a Cloud, they ask where such are ...
(Blake): Think of a white cloud as being holy, you cannot
 love it; but think of a holy man within the cloud,
 love springs up in your thoughts, for to think of
 holiness distinct from man is impossible to the
 affections. Thought alone can make monsters but
 the affections cannot.[29]

Blake is trying to show by example that there is a distinct and unbreakable identity between God and Man which transcends any barrier raised by nature, that the habit of primitive animation has its own logic. To the human imagination all things grasped and held are microcosms of a single mythic pattern, which Blake found primarily in the Bible but also in other great bodies of mythology and in the

greatest works of art. All things grasped in this manner, as we invest the cloud with human life, are "momentary gods," intimations of reality, personal flashes of intuition which move beyond the illusion of nature into a human, living world; for nature is dead.[30]

Thus, when Blake says, "A Spirit and a Vision are not, as the modern philosophy supposes, a cloudy vapour," he is not substituting a new cloud of nothingness. He is advancing his theory of imagination to its absolute refinement:

> A Spirit and Vision are not, as the modern philosophy supposes, a cloudy vapour, or a nothing: they are organized and minutely articulated beyond all that the mortal and perishing nature can produce. He who does not imagine in stronger and better lineaments, and in stronger and better light than his perishing, mortal eye can see, does not imagine at all.[31]

The modern philosophy begins with the wrong assumptions. It assumes but cannot prove the existence of a material reality out there beyond the mind. It then stretches this assumption illogically and declares that all things which do not seem to have this material reality are by analogy "cloudy vapours."[32]

Yet if we have come this far with Blake we may foresee a difficult problem looming both for the artist and the reader. Is the visionary, having escaped from Plato's cave, able upon his return to communicate a truth so different from the accepted delusion? Will he merely be talking a sign language to the blind? Blake was aware of this problem, for he asks the prophets Isaiah and Ezekiel this very question: "I asked them ... did they not think at the time that they would be misunderstood, & so be the cause of imposition."[33] But Isaiah simply implies that truth cannot compromise with falsehood and maintain its own nature. The Blakean artist must sacrifice himself to Ulro, must howl like Los and stick to his task.

Blake fully understood the risks and proceeded with faith in that thing he called man's Universal Poetic Genius. Blake believed each man capable of spiritual regeneration through the power of this Genius. When he states that "all had originally one language, and one religion" he does not hypothesize the original Indo-European language of the philologists.[34] He means that the vision of all people is of the same pure form. That one pure form is eternally "Imagination," pitted against the mundane form called "Memory," which is a product of the delusory finite world of Generation and Vegetation, which builds up an opaque experience of nature: "There Exist in that Eternal World the Permanent Realities of Every Thing which we see reflected in this Vegetable Glass of Nature." [35]

The mundane world, the world built by nature and memory, is a crazy house of false mirrors, cunningly distorted. If we come into this world with a *tabula rasa*, as Blake thought both Locke and Reynolds believed, then it is the memory alone upon which we depend. Our experiences are multiple, diverse; we are hurled out alone into a world where separate entities jostle about without single purpose and form. Blake could not accept this view. Against Reynolds he defended innate ideas: "Reynolds thinks that Man Learns all that he knows. I say on the Contrary that Man Brings All that he has or can have Into the World with him. Man is Born Like a Garden ready Planted & Sown. This World is too poor to produce one Seed." [36] There is a human form of experience and ideation which is common to us all and in which we are conceived. It is not learned; it is part and parcel of our very existence. We have spiritual form, symbolized in space and time but unrestricted by them. Blake's form denies the careening, soundless, scentless world of matter.

But even the productions of the Poetic Genius have been debased. Greek myth as we know it, once pure vision, is an example:

> Reality was Forgot, & the Vanities of Time & Space only Remember'd & call'd Reality. Such is the Mighty difference between Allegoric Fable & Spiritual Mystery. Let it here be Noted that the Greek Fables originated in Spiritual Mystery & Real Visions, which are lost & clouded in Fable & Allegory, while the Hebrew Bible & the Greek Gospel are Genuine, Preserv'd by the Saviour's Mercy. The Nature of my Work is Visionary or Imaginative; it is an Endeavour to Restore what the Ancients call'd the Golden Age.[37]

The Blakean "Golden Age" is no more a past period than it is a future period. It is simply the timeless reality. To Blake then, the Apocalypse is the ultimate communal assertion of spiritual reality, of "central form."

The act of visionary debasement is usually illustrated by a tendency toward moral allegorization, or allegorical interpretation, the turning of mythic vision into moral law. Interpreters of the Bible have therefore lost the true Biblical significance, though "by the Saviour's Mercy" the truth remains for the intellectually active reader. How the death-like process of abstraction occurred is visualized by Blake in "The Marriage of Heaven and Hell":

> The Ancient Poets animated all sensible objects with Gods or Geniuses, calling them by the names and adorning them with the properties of woods, rivers, mountains, lakes, cities, nations, and whatever their enlarged & numerous senses could perceive.
>
> And particularly they studied the genius of each city & country, placing it under its mental deity;
>
> Till a system was formed, which some took advantage of, & enslav'd the vulgar by attempting to realize or abstract the mental deities from their objects: thus began Priesthood;
>
> Choosing forms of worship from poetic tales.
>
> And at length they pronounc'd that the Gods had order'd such things,
>
> Thus man forgot that All deities reside in the human breast.[38]

It is now a short step to the "Proverbs of Hell": *The apple tree never asks the beech how he shall grow; nor the lion, the horse, how he shall take his prey.*[39] Everything should act according to its own form.

Yet here Blake must face up to the "contrary" nature of the fallen world. If every eye sees according to its own form, can there be any communally acceptable standard of truth, can there be any true "central form?" Blake answers "yes," but he denies that the truth must be an artificial abstraction of the common qualities perceived by every eye. The first step toward the communal apprehension of true "central form" is for each individual to comprehend the delusory nature of matter, projection, all the tricks of "this world." The second step is to visualize the world, relieved of these encumbrances, as a timeless reality in which entities are no longer separated, because spatial and temporal configurations have disappeared; the world has moved toward unity: the great is the small, the old the young, microcosm is macrocosm.

To the materialist Blake's vision is merely symbolical (in the materialist's sense of the word), an assertion of possibility which might be achieved through the supernatural intervention of a great controlling deity, but to Blake that which is symbolical is a door opening upon the real world. In fact that real world is evoked only by poetic symbols, which may escape the chains of time and space. The poetic symbol is an image of unity shining through to the fallen world and apprehendable as such by all souls if only read correctly.

We should not dignify with the word "symbol" the abstraction Blake calls "Allegory." Such an "Allegory" is totally inconsistent with Blake's epistemology. It tends to break into pieces the human life pattern, which to the intellectual powers remains unified and complete. It presents

an arbitrary system of analogies. Any value can be assigned to the term "x".

> The Last Judgment is not Fable or Allegory, but Vision. Fable or Allegory are a totally distinct & inferior kind of Poetry. Vision or Imagination is a Representation of what Eternally Exists, Really & Unchangeably. Fable or Allegory is Form'd by the daughters of Memory. Imagination is surrounded by the daughters of Inspiration, who in the aggregate are call'd Jerusalem. Fable is allegory, but what Critics call The Fable, is Vision itself. The Hebrew Bible & the Gospel of Jesus are not Allegory, but Eternal Vision or Imagination of All that Exists. Note here that Fable or Allegory is seldom without some Vision. Pilgrim's Progress is full of it, the Greek Poets the same; but Allegory & Vision ought to be known as Two Distinct Things, & so call'd for the Sake of Eternal Life.[40]

Blake believed that there may be *some* vision in allegory and that there is a partial truth in Greek myth as we know it today. He believed that each human being may strive against corporeality and achieve varying degrees of success. Each human is a microcosm of the great dialectic: "Without contraries is no progression." The dialectical battle resounds through Blake's poetry, "The Mental Traveller," "My Spectre Round Me ... ," the great prophecies. It is the battle of Devils and Angels in "The Marriage of Heaven and Hell," the battle of Urizen and Orc; it is the problem which Los must solve.

In the bulk of Blake's writing there are at least three places where he implies that a battle has occurred within an artist and has led to a peculiar contradiction within his work. One of these artists is Reynolds, who is upbraided, not without a diabolic humor, for inconsistencies: "The Contradictions in Reynolds's Discourses are Strong Presumptions that they are the Work of Several Hands, But this is no Proof that Reynolds did not Write them. The Man, Either Painter or Philosopher, who Learns or Acquires all he knows from Others, Must be full of Contradictions."[41] Another, as a

previous quotation has shown, is Wordsworth: "I do not
know who wrote these Prefaces: they are very mischievous &
direct contrary to Wordsworth's own Practise." [42]

The third is Milton: "The reason Milton wrote in fetters
when he wrote of Angels & God, and at liberty when of
Devils & Hell, is because he was a true Poet and of the Devil's
party without knowing it." [43] Blake implies that the god of
abstraction, symbolized in the Blakean myth as Urizen, the
giver of law, restrains the true poetic genius. When Urizen is
at work, the poet is forcibly separated from the prophet.
Both art and religion suffer. Vision perishes. Those who write
in a violently Urizenic age sometimes come very near the
completely mundane view of life. It does not take a great
deal of imagination to decide what Blake must have thought
of Pope's work. We know very well his view of Rubens's.
Blake applies to Rubens the very criticism which he levels at
Greek mythology; for when the mythical figures of a now
abstract mythology become accoutrements of painting, the
result can only be a subjugation of vision to allegory, and
probably bad allegory. Blake's antagonism toward Rubens is
immense. His attack is characteristically excessive in
vehemence; but his objection, with violence discounted, is
significant:

> Ruben's Luxembourg Gallary is Confessed on all hands to be the
> work of a Blockhead: it bears this Evidence in its face; how can its
> Execution be any other than the Work of a Blockhead? Bloated
> Gods, Mercury, Juno, Venus, & the rattle traps of Mythology & the
> lumber of an awkward French Palace are thrown together around
> Clumsy & Ricketty Princes & Princesses higgledy piggledy. [44]

Others, who have the prophetic temperament, un-
consciously revolt and join the "Devil's party," since in an
Urizenic age the Devils are the upholders of "Vision." In
"The Marriage of Heaven and Hell" Blake speaks of an
"Angel" who has been defending the materialist view of life

and whom Blake has finally converted: "This Angel, who is now become a Devil, is my particular friend; we often read the Bible together in its infernal or diabolical sense, which the world shall have if they behave well."[45]

Although Blake thought of a poet as a visionary, he saw him also as a human, in whom the "contraries battle." Blake himself was subject to fluctuation between the visionary and the mundane, the traditional Western duality. ". . . I am under the direction of Messengers from Heaven, Daily & Nightly; but the nature of such things is not, as some suppose, without trouble or care. Temptations are on the right hand & left; behind, the sea of time & space roars & follows swiftly; he who keeps not right onwards is lost. . . ."[46] As a visionary the poet must evade time and space and see into the Edenic realm of harmony.

Blake not only condemned (1) the gradual allegorization of Greek myth into abstraction and (2) the tendency to interpret "Vision" allegorically; he also made clear the depths to which a debased vision might fall: "Allegories are things that Relate to Moral Virtues. Moral Virtues do not Exist; they are Allegories & dissimulations."[47] According to the Blakean premise, the fundamental visionary form of a poem is violated by an allegory which proposes an artificial morality. Blakean "perfect unity" breaks down. The writer's imagination—Blake's Los in his mythology—is locked in battle with his tendency toward the assumption of an abstract morality—Blake's "Spectre." These two, hero and Spectre, work at cross-purposes; the poet finds himself caught between revelation rationalized and a new imaginative reason revealed. If he is pulled toward the former, as Blake admitted that he sometimes was, he becomes lost in a "Land of Abstraction" where all form is dead form, where, in the words of Messrs. Sloss and Wallis, "the 'spectre of the dead' is

apparently the abstract idea for which the artist cannot, save
by inspiration, find the living form. . . ."[48] This is the maze
from which the Ancient Bard in *Songs of Experience* seeks to
lead men:

> Youth of delight, come hither,
> And see the opening morn,
> Image of truth new born.
> Doubt is fled, & clouds of reason,
> Dark disputes & artful teazing.
> Folly is an endless maze,
> Tangled roots perplex her ways.
> How many have fallen there!
> They stumble all night over bones of the dead,
> And feel they know not what but care,
> And wish to lead others, when they should be led.[49]

Folly here is female, for she is really the goddess of Nature,
Rahab. More men are chained by the spectre than are not;
the tangled roots of nature take a sorry toll:

> Each man is in his Spectre's power
> Untill the arrival of that hour,
> When his humanity awake
> And cast his own Spectre into the Lake.[50]

In Blake's fallen world all things are bifurcated, all
images divided. The spectre of Blake's evil is good; the
spectre of his good is evil. In the real world—the materialist's
symbolic world—the abstract ideas of good and evil disappear
even as all spectres disappear. All things are one. The genius,
free of his spectre—or better, unified with it so that it ceases
to exist as entity—recognizes this situation: "He who can be
bound down is No Genius. Genius cannot be Bound."[51] The
forms of memory, of time, of space are the chains of the
spectral life, of nature, of reason triumphed over faith:

> The Negation is the Spectre, the Reasoning Power in Man:
> This is a false Body, an Incrustation over my Immortal
> Spirit, a Selfhood which must be put off & annihilated alway.
> To cleanse the Face of my Spirit by Self-examination,

> To bathe in the waters of Life, to wash off the Not Human
> I come in Self-annihilation & the grandeur of Inspiration,
> To cast off Rational Demonstration by Faith in the Saviour.[52]

These are the words of Blake's symbolical Milton in the prophecy named for that great poet. In another place, where Blake is not speaking of the symbolical Milton, but presumably of that Milton who walked our fallen natural earth, he attacks Dryden's "improving" of Milton as the chaining of human imagination by the mundane and opaque: "Now let Dryden's Fall & Milton's Paradise be read, & I will assert that every Body of Understanding must cry out Shame on such Niggling & Poco-Pen as Dryden has degraded Milton with."[53] We may then, in a sense, imagine Dryden as Milton's symbolical spectre. For Blake to have used him thus—he used "Bacon, Newton, Locke" in a similar way—would not be surprising.

For another poet, Spenser, the perfect symbolical spectre could be a spitting, hermaphroditic, double-mouthed creature much like his own blatant beast. One mouth would serve to represent a composite image of Spenser's allegorical interpreters, who dismantled the *Faerie Queene* as if it were a great machine, interpreted the pieces independently with strict rationality, and then frustrated themselves over and over by their inability to put the pieces back into a rational whole. They overlooked the organic unity of a work of art; they violated the Blakean premises. The second mouth would represent Spenser's personal difficulty in dealing with an ecclesiastical moral doctrine where rational consistency— itself based originally on faith and imagination—was sacrificed for political expediency. Thus a compromising mundane, abstract, opaque morality was forcibly grafted on a Los-like imagination. W. B. Yeats, a student of Blake, was aware of this tendency toward the rationalized imagination in

Spenser when he dubbed him "The first salaried moralist among poets" and found himself bored by Spenser's allegory. [54]

The important principles of Blake's thought are these: He finds reality in the immediate mental experience, not in the passive joining of an inanimate object with a chained subject. "Where man is not, nature is barren." The "corporeal" world is delusion caused by the passive reception of an inanimate, non-existent nature by a race of the spectral dead. "Active Evil is better than Passive Good." All abstraction from sense data is unreal and must be considered as such. "Bacon's philosophy has ruin'd England." God and man are identical in the sense that macrocosm and microcosm are identical. "All deities reside in the human breast." The symbolical world is the real world. "One thought fills immensity."

In great art the vision of apocalypse, *total resolution*, is available. The Bible, preserved by "the saviour's mercy" is the greatest receptacle of the "Poetic Genius," but it has been subjected to perverse, corporeal interpretation. Greek myth, on the other hand, became distorted as it was handed down through centuries; but originally it was evolved from pure vision.

3. *The Archetypal Vision*

Blake based his hope for the communication of his vision on the truth of his theory of "The Poetic Genius." He based this theory upon a carefully thought epistemology. He saw in mythology an archetypal religious vision created again and again through traditional poetic symbols forming a single pattern of human experience, the one thought which "fills immensity." This to Blake was the true "central form."

Blake's poetry combined with his painting is an attempt to bring alive that archetypal vision, free of debasement by false interpretation and allegorical presentation, for the edification of a debased world: "The Religions of all Nations are derived from each Nation's different reception of the Poetic Genius, which is every where call'd the Spirit of Prophecy."[55]

Although Blake's theory of the Poetic Genius is a logical extension from his theory of knowledge, it appears that it was either evolved simultaneously with or, at least, substantiated inductively by a rather extensive study of comparative mythology. Blake had read the great mythologies and the awkward and inaccurate works of contemporary mythologists. He discovered in all myths statements of "central form."

Blake was one of the first modern artists not only to articulate fully man's loss of spiritual community but also to seek an answer both in the communal myths of the past and the personal poetic symbols of the present. He sought to recreate for men out of a *personal* vision a *communal* vision both new and old. That vision anticipates by nearly a century the development of psychological and anthropological theories of literary criticism discussed by Mr. Block.[56] His vision can contain them all, and in its way is greater than them all. Blake's faith in art led him to a form of reality which denied the final truth of nature and abstraction. It led him to express that form as a pattern of symbolism distilled from the debased visions of past mythologies, cleansed and unified in his own imagination.

NOTES

1. "General and particular in the Discourses of Sir Joshua Reynolds: A Study in Method," *JAAC*, 11 (March 1953), 231-247.

2. "William Blake, A Study of His Doctrine of Art," *JAAC*, 10 (September 1951), 53-66.

3. Letter to Thomas Butts, September 11, 1801 (K 809, E 685).

4. *JAAC*, 11 (September 1952), 46-54.

5. Letter to Thomas Butts, July 6, 1803 (K 825).

6. "A Vision of the Last Judgment" (K 604, E 544).

7. Ibid. (K 617, E 555).

8. Marginalia to Lavater's *Aphorisms* (K 81, E 584-5).

9. Marginalia to Reynolds' *Discourses* (K 459, E 637).

10. Annotations to Wordsworth's *Excursion* (K 784, E 656).

11. Annotations to Poems by William Wordsworth (K 783, E 654-5).

12. Ibid. (K 782, E 654).

13. Quoted in *Fearful Symmetry* (Princeton: Princeton Univ. Press, 1947), p. 19.

14. Ibid., p. 20.

15. *Fearful Symmetry*, p. 20.

16. *The Poetic Image* (London: J. Cape [1947]), pp. 23-4.

17. Marginalia to Reynolds' *Discourses* (K 451, E 630).

18. Ibid. (K 459, E 637).

19. As we shall see, Blake calls what we term "generalization" "abstraction."

20. "Public Address" (K 599, E 568).

21. See Bowman, *op. cit.*

22. *Feeling and Form* (New York: Scribner's, 1953), p. xi.

23. Ibid., pp. 50-1.

24. *Op. cit.*, pp. 21-2.

25. *The Marriage of Heaven and Hell* (K 153, E 37-8).

26. "Public Address" (K 596, E 565).

27. *Jerusalem,* pl. 77 (K 716, E 229).

28. *The Marriage of Heaven and Hell* (K 154, E 39).

29. Annotations to Swedenborg's *Divine Love* (K 90, E 593).

30. The term "momentary gods" has been suggested to me by Susanne K. Langer's translation of Ernst Cassirer's *Language and Myth* (New York, 1946), 62: "According to Usener the lowest level to which we can trace back the origin of religious conceptions is that of 'momentary gods,' as he calls those images which are born from the need or the specific feeling of a critical moment, sprung from the excitation of mythico-religious fantasy."

31. "A Descriptive Catalogue" (K 576, E 532).

32. Take as a peculiarly apt example Hartley's study of the mind and his attempt to bring it and its actions into the "real" material world by explaining them totally in terms of material and movement in extension. He sought to bring thought back into good, solid repute by giving it material reality.

33. *The Marriage of Heaven and Hell* (K 153, E 37).

34. "A Descriptive Catalogue" (K 579, E 534).

35. "Vision of the Last Judgment" (K 605, E 545).

36. Marginalia to Reynolds' *Discourses* (K 471, E 645-6).

37. "Vision of the Last Judgment" (K 605, E 545).

38. *The Marriage of Heaven and Hell* (K 153, E 37).

39. Ibid. (K 152, E 36).

40. "Vision of the Last Judgment" (K 604-5, E 544).

41. Marginalia to Reynolds' *Discourses* (K 449, E 628).

42. Annotations to Wordsworth's "Poems" (K 783, E 655).

43. *The Marriage of Heaven and Hell* (K 150, E 35).

44. "Public Address" (K 599, E 568).

45. *The Marriage of Heaven and Hell* (K 158, E 43).

46. Letter to Thomas Butts, January 10, 1802 (K 812-3, E 688).

47. "Vision of the Last Judgment" (K 614, E 553).

48. *The Prophetic Writings of William Blake* (Oxford: Clarendon Press, 1926), II, 227.

49. K 126, E 31-2.

50. K 421. See also *Jerusalem* 37:32-5.

51. Marginalia to Reynolds' *Discourses* (K 472, E 647).

52. *Milton* 40:34-7 & 41:1-3 (K 533, E 141).

53. "Public Address" (K 600, E 570).

54. "Edmund Spenser," *The Cutting of an Agate* (London: Macmillan, 1919), p. 220.

55. *All Religions are One* (K 98, E 2).

56. *Op. cit.*

A DRAWING OF THE LAST JUDGMENT

by

Albert S. Roe

*T*he Last Judgment is a theme which stands at the very center of William Blake's thought. In one of his prose writings, with which we shall be here much concerned, Blake says, "Whenever any Individual Rejects Error & Embraces Truth, a Last Judgment passes upon that Individual."[1] Blake in this passage states the belief, fundamental to an understanding of his thought, that man may, while in this life, become through imagination capable as an individual of comprehending the eternal order, where all things exist outside of the bounds of time and space as we know them in this world. The essence of Blake's doctrine is that man is created in the image of God. In the Fallen World of our present life, man is, however, under the domination not of the divine potentiality within him, but of his selfhood,

Ed.: Reprinted by permission of the publisher from the *Huntington Library Quarterly*, 21 (1957-58), 37-55.

or to use Blake's own terminology, of his "spectre." It is important to remember that Blake had no belief in any eternal damnation of the individual. Mankind in the Fallen World is by that very fact in what Blake terms a "state" of error—"states" being phases of experience into which all men may enter, but which must be distinguished from traits which are peculiar to the individual. Eventually, through the mercy of God, some sooner and some later, every man will recognize the error of selfhood, and when he does so will reject his present state and be saved. To phrase it in Blake's own words, as given in *Jerusalem,* his most important prophetic work: "Each Man is in his Spectre's power/Untill [sic] the arrival of that hour,/When his Humanity awake/And cast his Spectre into the Lake."[2] Ultimately the sum total of error will be cast out, and then the Created or Fallen World will disappear. This for Blake is the Universal Last Judgment, and it is this that he represented in his drawings of the theme.

> The Last Judgment is not Fable or Allegory, but Vision. . . . Vision or Imagination is a Representation of what Eternally Exists, Really & Unchangeably. . . . The Nature of My Work is Visionary or Imaginative. . . . This world of Imagination is the world of Eternity . . . There Exist in that Eternal World the Permanent Realities of Every Thing which we see reflected in this Vegetable Glass of Nature.

> When Imagination, Art & Science & all Intellectual Gifts, all the Gifts of the Holy Ghost are look'd upon as of no use & only Contention remains to Man, then the Last Judgment begins, & its Vision is seen by the Imaginative Eye of Every one according to the situation he holds. . . . I have represented it as I saw it.[3]

Blake represented what he saw on a number of occasions: in poetry, in several of his prophetic writings;[4] in prose, in his letters and in his notebook; and as a full-scale vision in a tempera painting, several drawings, and an engraving.[5] The tempera painting was a work of monumental

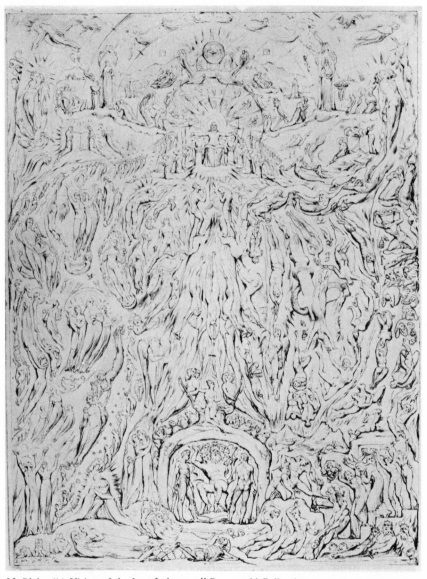

55. Blake, "A Vision of the Last Judgment." Rosenwald Collection.

scale; by the time that Alexander Gilchrist wrote his *Life of Blake*[6] in 1863, it had already disappeared. As it has not since come to light, we must presume that it has most tragically perished, and with it one of the most remarkable productions of religious art of modern times. We know of it from a description in a biographical sketch of Blake appended by John Thomas Smith, Keeper of Prints and Drawings in the British Museum, to his life of the sculptor, Joseph Nollekens, which appeared in 1828, the year following Blake's death. "Had he fortunately lived till the next year's exhibition at Somerset House, the public would then have been astonished at his exquisite finishing of a Fresco picture of the Last Judgment, containing upwards of one thousand figures, many of them wonderfully conceived and grandly drawn."[7] Gilchrist, who knew it only from hearsay, speaks of it as "one of the most important of the culminating productions of Blake's life," and gives us some further information, including the fact that "Nobody could be found to give twenty-five guineas for it then."[8]

We can, however, gain some further idea of this remarkable work from a description which clearly refers to it, and which is found in scattered form on a number of pages of Blake's personal notebook, now in the British Museum, the gift of the late Mrs. William Emerson of Cambridge, Massachusetts.[9] This is the notebook which, in 1847, Dante Gabriel Rossetti bought for ten shillings from a brother of Samuel Palmer, the artist who was one of the youthful disciples of Blake's last years. It was Rossetti who gave to this account the title by which it is known among Blake's works, *A Vision of the Last Judgment.*

In addition to this detailed prose account, clearly specified by Blake as the *"description of* [a] *Picture,"* [10] there exist, as noted above, several visual representations by

him of the Last Judgment. One of these is an engraving which appeared as one of the illustrations to an edition of Robert Blair's poem, *The Grave;* engraved after Blake's design by Louis Schiavonetti, it was first published in 1808.[11] The remaining versions are drawings in various stages of completion. These can be divided into four main categories, according to different representations of the theme. It is with the most finished drawing of the last of these groups that we shall be here concerned.[12]

This is the remarkable pencil, India ink, and wash drawing which is included in the collection which Lessing J. Rosenwald has presented to the National Gallery of Art in Washington [Illustration 55].[13] A great masterpiece of design and linear draftsmanship, with an amazing feeling for delicate and swift movement which weaves through the wonderfully organized multitiude of figures, preserving complete clarity amidst complexity, this drawing ranks as one of the outstanding achievements of Blake's life, and gives a striking indication of the loss which English art has suffered through the disappearance of the full-scale tempera version.

Comparison of the drawing with the text of *A Vision of the Last Judgment* makes it possible to identify most of the figures, and gives numerous clues as to their significance to Blake. Before discussing this aspect of the drawing, however, it will be well to say something concerning Blake's employment of traditional literary and artistic sources. With another artist, this might very well constitute the major interest of such a study as this, but with Blake, even when treating a theme involving so many traditional connotations as the Last Judgment, his approach to it is essentially personal.

As a literary source, he went directly to the Book of Revelation, and the major features of this drawing follow the

Biblical account closely. The throne set in the midst of heaven, surrounded by the four and twenty elders, the creatures with wings full of eyes, the angel with the key and the chain, the harlot and the beast, the "woman clothed with the sun, and the moon under her feet, and upon her head a crown of twelve stars," Gog and Magog—all these features, as well as numerous others, are taken quite literally from the Apocalypse. While Blake was a student of Dante, his version—unlike that of Michelangelo—is not related directly to the *Divine Comedy*. [14] Similarly, while his rendition of certain features, as in his placing of Gog and Magog within a cavern, may suggest familiarity with St. Augustine's *City of God*, such is merely incidental. [15] When he wishes a wider vocabulary, he turns to the Old Testament—and hence Moses, Noah, and Abraham occupy central positions, as do less familiar characters such as Og, King of Bashan, Hazael the Syrian, Araunah the Jebusite, and the like. Ultimately, as we shall see, all of these are interpreted in terms of Blake's own mythological system, so that—apart from the Bible—the basic literary source is that of Blake's own prophetic writings.

Likewise, Blake's dependence upon visual tradition in the rendition of the theme, while revealing influence from various sources, never approaches in the slightest that of a close copying of earlier works. The general scheme of the composition, with its light upward movement on Christ's right circling across to become swift downward motion on His left, all against a background of limited space in depth, was probably suggested by the "Last Judgment" of Michelangelo, for whom, as is well known, Blake had immense admiration. When, however, we turn to the details of treatment, the two works could not be more unlike. Michelangelo's emphasis on the physical, his representation of Christ as the stern judge instead of as the merciful Lord of

forgiveness, his direct dependence upon Dante, all combine to make his rendition altogether different from that of Blake. And so it happens that, while Blake's first known work, the engraving "Joseph of Arimathea among the Rocks of Albion" of 1773, [16] derives directly from a figure in Michelangelo's Pauline Chapel frescoes, as Blake states in the inscription, there is not one figure in any of his versions of the Last Judgment which is copied directly from Michelangelo— although, as usual with him, the modeling of male figures has Michelangelesque reminiscences. The nearest he comes to adopting something directly from the Michelangelo fresco is the cavern-like mound which appears at the bottom of the drawing; however, the figures within the cavern are quite different and, furthermore, human forms enclosed within caves have a very specialized meaning in Blake's symbolism. [17]

In point of fact, in spirit and even in detail, it is to works of medieval art that Blake's treatment of the Last Judgment most nearly approaches. Of all of his contemporaries of the period of the Gothic Revival, Blake most fully appreciated the true quality of the original. During his apprenticeship, Blake's master sent him, as part of his training, to make drawings of the Gothic tombs of Westminster Abbey, these later serving as studies for engravings. Thereafter, the art of the Middle Ages always had a special significance for Blake, representing to him the forms of the spiritual world as contrasted with those of the material world; thus in his later years we find him saying, "Grecian is Mathematic Form: Gothic is Living Form." [18] It will be noted that some of the figures in the foreground of the Rosenwald drawing distinctly recall Gothic funereal monuments of a type reminiscent of those in Westminster Abbey with which Blake was in such intimate contact during the

years of his apprenticeship to James Basire between 1772 and 1779. [19]

When we turn to actual medieval renditions of the theme, however, we do not find Blake basing himself directly upon any identifiable and specific prototypes. An interesting case in point is the figure of Christ upon the throne. In Blake's other versions of the Last Judgment, Christ's hands rest upon the scroll or book which lies upon His lap. The group of drawings, however, of which the Rosenwald drawing is the most finished example show His hands outstretched in a manner clearly intended to call to mind the Crucifixion. Now, this is not the usual way in which Christ is represented on the throne in medieval tradition, where He either holds His hands down by His sides with palms outward to display His wounds, or else holds His right hand raised in blessing while His left is lowered in a gesture of judgment on the damned. [20]

We do, however, find the motif of the Christ figure with arms extended employed by Blake himself on a number of occasions. The most notable example, and the key to the significance of this symbol, is plate 76 of *Jerusalem*, first published about 1818. [21] Christ, crucified on the tree of the Fallen World, faces the reawakening Albion, who stands before Him making the identical gesture of extended arms. Christ's redeeming love, as exemplified by His sacrifice, makes possible the salvation of Fallen Man, and after the dark night of Albion's sleep the first traces of dawn are appearing. The same gesture occurs in a water color in the Tate Gallery, "David Delivered Out of Many Waters." [22] Christ hovers over the waters, symbol of the Fallen World, and His saving gesture is repeated by the enmeshed form below Him; the surrounding seraphim represent the seven

eyes of God, symbolizing God's continuing love of man, even in the fallen state. The figure of the Lord repeats the gesture in the fine thirteenth engraving of the Book of Job series, "Then the Lord answered Job out of the Whirlwind," the plate which illustrates the beginning of Job's emergence from error; the motif appears again in Blake's most famous work, the fourteenth Job engraving, "When the morning Stars sang together," which we shall consider later.[23]

It is thus clear that, consistent with the entire trend of his beliefs, as previously stated, Blake does not stress the terrors of everlasting damnation in this, his final preserved version of the Last Judgment. In this he differs from Michelangelo. Rather, he shows the ultimate casting out of error, when, through God's mercy freed from their spectres (those "states" which are here shown as forever rejected), all created souls arise to the universal salvation. Christ's gesture emerges, therefore, not as the perpetuation of an iconographic archetype, but as an essentially Blakean symbol, and the key to the fundamental meaning of this drawing.

In speaking of the figure of Christ, we should mention the pillars of the throne. Blake identifies these in his notebook as Jachin and Boaz, the pillars of Solomon's temple.[24] As he chooses to mention them specifically in this connection, it is probable that Blake attached a special significance to them. Jachin and Boaz have from early times been regarded as possessed of magic properties, being as they are the guardians of the doorway leading to inner mysteries. They figure prominently in the symbolism of alchemy, whence their appearance as the pillars of the throne in the tarot cards;[25] they have symbolic significance also in the rites of Freemasonry.[26] The ultimate source from which this tradition derived would seem to be traceable to cabalistic

doctrine, in which the pillars signify redemption, as well as symbolizing the two sexes.[27] Blake, as has been demonstrated on a number of occasions, was clearly familiar with many points of cabalistic lore, which influenced his own symbolism in a number of important ways.[28] In Blake's system, he conceives the essential harmony of creation to be the vital balance between the creative imagination, which he characterizes as masculine, and its reflection in the feminine world of material existence. These are the basic contraries of Blake's sysmbolism, and he views their eternal interaction as producing the dynamic tension and ebb and flow which is the essential for arriving at truth. Blake sums up this theory in an important passage at the beginning of one of his earliest prophetic books, *The Marriage of Heaven and Hell,* of ca. 1793: "Energy is Eternal Delight . . . Without Contraries is no progression. Attraction and Repulsion, Reason and Energy, Love and Hate, are necessary to Human existence."[29] This concept of the basic nature of the interaction of the masculine and feminine contraries remains a fundamental element in all of Blake's thought, and is doubtless here symbolized by Jachin and Boaz. The placing of the pillars of the throne immediately above the figures of Adam and Eve adds emphasis to this connotation. Here, at the very seat of judgment, Christ maintains the balance of the essential vital harmony, enthroned between the masculine Jachin and the feminine Boaz.

While on the subject of Blake's symbolism of masculine and feminine, it is of interest to note that Blake does not give a distinctive place to the Virgin in any of his representations of the Last Judgment. Although referring to her in *A Vision of the Last Judgment* as "ignorant of crime in the midst of a corrupted Age,"[30] Blake does not follow the almost universal tradition of giving her an important position beside the

throne. This is because Blake was convinced that the emphasis placed by organized religion upon the Madonna cult tended to identify the Virgin with the Female Will, Blake's own name for the materialistic Goddess of Nature, characteristically identified as feminine in his system. This idea is strikingly presented in one of the most remarkable of his illustrations to the *Divine Comedy*. We recall that at the climax of the *Paradiso* Dante is vouchsafed a vision of the Court of Heaven opening in the form of a great celestial rose, and enthroned within the rose he beholds the Virgin. In Blake's representation of this episode, however, he makes some startling but characteristic changes. The rose becomes a sunflower, symbol of lover perverted in a Fallen World, and seated in its center Mary appears as the Goddess of Materialism, bearing the scepter and the looking glass. It must be understood that Blake does not here reflect upon Mary as an individual, but upon Dante's orthodoxy.[31] In his own vision, however, the Virgin is significantly absent.

To the point of greatest prominence before the throne, as noted above, Blake has elevated Adam and Eve. Adam raises his hands in petition and looks upward in hope; Eve bows her head in humiliation. Adam, the representative of the masculine imaginative faculty as it exists in fallen humanity, at the final judgment appears at the head of the host of the redeemed.[32] Eve, who first persuaded him to yield to that feminine materialism which brought on the Fall, now is abject at the moment of the recognition and admission of the fundamental error. Behind her the "spectres," representing rationalistic self-interest—man's basic sin and the cause of his fall—are cast out and plunge headlong into the pit. Closest to Eve falls Cain, "with the flint in his hand with which he slew his brother," while behind Adam

kneels the transfigured form of Abel, "surrounded by innocents."

Beneath Abel we find Abraham, founder of the chosen race, hovering "above his posterity, which appear as Multitudes of Children ascending from the Earth, surrounded by Stars, as it was said: 'As the Stars of Heaven for Multitude'." Opposite to Abraham, Moses appears, "casting his tables of stone into the deeps."[33] Now, with man's final rejection of error, the law is revealed to Moses for what it is. Opposed to Christ's compassionate gospel of forgiveness of sins, stands the tyrannical law of vengeance, based not upon divine love but upon human reason. This, therefore, in Blake's eyes, is the law not of God but of Satan. He speaks of this very clearly in the prose introduction to the third chapter of *Jerusalem.* "Every Religion that Preaches Vengeance for Sin is the Religion of the Enemy & Avenger and not of the Forgiver of Sin, and their God is Satan, Named by the Divine Name. . . . The Glory of Christianity is To Conquer by Forgiveness."[34] The Tables of the Law appear strikingly in this aspect in the eleventh engraving of the Job series, "With Dreams upon my bed thou scarest me & affrightest me with Visions." Now, at the moment of universal enlightenment, they are cast into the pit of hell, together with their master, Satan, who appears bound around with the tail of the serpent and dragged down by the Angel of Revelation, who holds a book. Beside Satan, the serpent of the Fallen World is seen falling headlong, nailed to the cross. Nearby are others of Satan's retinue. These include Death, who appears just in front of the serpent on the cross, and who is dragged downward by a demon crowned with laurel; this demon with his other hand grasps another figure by the hair, this form representing Time. Just above Time is seen another demon with a key, in whose grasp falls Sin. Close beside the demon

with the key appears Og, King of Bashan, whom the Lord utterly destroyed, [35] falling into the pit, bearing the sword and balances of human justice. Beside him, at the margin of the drawing, Araunah the Jebusite, master of the threshing floor, [36] is seen emptying the chaff of worldly vanities into the abyss. Prominent among them may be discerned a rosary, the triple diadem, and a crown. Directly beneath Araunah are "three fiery fiends with grey beards and scourges of fire: they represent Cruel Laws." [37] These are the Three Accusers who figure prominently in Blake's writings. Identified with Theft, Adultery, and Murder, they are personified as the judges who condemned Socrates, or in more contemporary terms as the rational philosophers, Bacon, Newton, and Locke. [38] We find them portrayed much as here, but in a triple grouping, in Blake's illustration to the seventh canto of the *Inferno* which shows the Ireful Sinners fighting beneath the surface of the Stygian Lake. [39]

Turning now to the bottom corner of the design, Blake describes very fully what is depicted here. Let us quote again and at some length from *A Vision of the Last Judgment.* [40]

On the rock & above the Gate a fiend with wings urges [them *del.*] the wicked onwards with fiery darts; he [represents the Assyrian *del.*] is Hazael, the Syrian, who drives abroad all those who rebell against their Saviour; [41] beneath the steps [is] Babylon, represented by a King crowned, Grasping his Sword & his Sceptre: he is just awaken'd out of his Grave; around him are other Kingdoms arising to Judgment, represented in this Picture [as in the Prophets *del.*] as Single Personages according to the descriptions in the Prophets. The Figure dragging up a Woman by her hair represents the Inquisition, as do those contending on the sides of the Pit, & in Particular the Man strangling two women represents a Cruel Church.

Two persons, one in Purple, the other in Scarlet, are descending [into Hell *del.*] down steps into the Pit; these are Caiaphas & Pilate—Two States where all those reside who Calumniate & Murder under Pretence of Holiness & Justice. Caiaphas has a Blue Flame like a Miter on his head. Pilate has bloody hands that can never be cleansed. . . . Those figures that descend into the Flames before

Caiaphas & Pilate are Judas & those of his Class. Achitophel is also
here with the cord in his hand.

Achitophel, it will be recalled, represents the archetype of
the false counselor and the suicide.[42] He appears just behind
Pilate, holding the cord with both hands above his head.

The most striking group among those in hell is to be
found at the bottom center. Here is the Goddess of Nature,
the Vala-Rahab of Blake's prophetic books, enthroned upon
the cave of the Fallen World. Blake identifies her with the
Harlot of the Book of Revelation, and as the trumpets sound
she is seized upon her throne, stripped naked, and burned
with fire as foretold in Revelation xvii.16. Within the cavern,
Gog and Magog hold the seven-headed beast in chains, before
whom on the ground lies "Satan's book of Accusations." [43]
It will be recalled that the cave is one of Blake's most
frequent symbols for the Fallen World, that world where
"Thought is clos'd in Caves," and where, until the final
judgment, "The Beast & the Whore rule without control." [44]
Gog and Magog, with their hammer and tongs, have bound
the forces of oppression. It is with the same tools that Blake
portrays Los, the spirit of prophecy who maintains the vision
of God in the Fallen World, and who strives endlessly to
overcome the spectre of tyranny.[45] Now, at the Last
Judgment, the subjugation of the powers of violence in the
Fallen World is complete.

Blake gives likewise a long account of those on the side
of the blessed, among whom we have already identified
Adam, Abel, and Abraham. One of the most prominent
features of this section of the drawing is the group of three
figures surmounted by a rainbow. These are identified by a
particularly interesting and important description. "Noah is
seen in the Midst of these, Canopied by a Rainbow, on his
right hand Shem & on his Left Japhet; these three Persons

represent Poetry, Painting & Music, the three Powers in Man of conversing with Paradise, which the flood did not Sweep away."[46] Blake here states his belief that creative art represents a direct avenue of communication whereby man, even when in the fallen state, may apprehend directly in moments of imaginative vision the Eternal World from which he has fallen and to which at the Last Judgment he will return. This is the same faith which Blake expressed in more personal terms in the ninety-eighth Dante illustration, "Dante Drinking at the River of Light," in which Blake undoubtedly intended the figure of Dante to be taken as a self-portrait, and in the background of which he has shown a view of his studio with his easel and another representation of himself at work at his engraver's press.[47]

Just above Noah and his sons appears the Woman Clothed with the Sun, with the moon under her feet, and a crown of stars, whom Blake identifies as "the Church Universal," and describes as the state of those who "having not the Law, do by Nature the things contain'd in the Law." The single bending figure just above the woman represents Elijah, while the man and woman nearby with arms raised are to be identified as Seth and his wife. The group of the woman leading two children by the hand, seen between Seth and Elijah, signifies "Learning & Science, which accompanied Adam out of Eden."[48] They are given a characteristically elevated position in accordance with Blake's creed as set forth in the preface to the fourth chapter of *Jerusalem:* "What are the Treasures of Heaven which we are to lay up for ourselves, are they any other then Mental Studies and Performances? . . . What is the Life of Man but Art & Science? . . . to Labour in Knowledge is to Build up Jerusalem."[49]

Turning finally to the top portion of the design, we find
that here a considerable difference exists between the
Rosenwald drawing and the arrangement found in the other
versions. It is interesting to note too that, while in the lower
portion the relationship between the Rosenwald drawing and
the text of *A Vision of the Last Judgment* is very close
indeed, and much closer than in the case of the other
renditions, now the situation is reversed and the other
versions more closely follow the text.[50] To be sure, many of
the same features are to be found in almost all—for instance,
the sacraments, the angels with the books of life and of
death, the ark with the shewbread, the candles, and the
hovering angels, the beasts with wings full of eyes of
Revelation and of Ezekiel's vision; however, the arrangement
of these and the details of their representation are quite
different. The scheme of the Rosenwald drawing reveals a
considerable expansion from that of the other versions and is
the most interesting of the group, for Blake here diagrams his
vision concerning the entire spiritual life of man.

In *A Vision of the Last Judgment* Blake gives the
following description of this portion of his design: "Around
the Throne Heaven is open'd & the Nature of Eternal Things
Display'd, All Springing from the Divine Humanity. All
beams from him [& (Because *del.*) as he himself has said, All
dwells in him *del.*]. He is the Bread & the Wine; he is the
Water of Life; accordingly on Each Side of the opening
Heaven appears an Apostle; [one *del.*] that on the Right
Represents Baptism, [& the Other *del.*] that on the Left
Represents the Lord's Supper."[51]

It will be observed in the Rosenwald drawing that,
immediately adjacent to Christ's halo, which is pure light, is a
concentric ring of small forms. These represent souls at the
moment of creation and are a striking visualization of

another passage from *A Vision of the Last Judgment:* "Jesus is surrounded by Beams of Glory in which are seen all around him Infants emanating from him; these represent the Eternal Births of Intellect from the divine Humanity." In the next circles light becomes manifest in the form of rays, and the souls as infants are born into the created world, where young mothers accompanied by children wait to receive them. In the circle where infants are being received into families, the ark is represented to remind us that, as Blake says, "Man is the ark of God."[52] In the next circle aged men approach the sacrament of Holy Communion. The circle of the sacraments marks another transition beyond which appear the Gothic spires of the fields of the blessed, for here, as Blake tells us, are shown the "Spirits of the Just made perfect." The architecture serves to remind us, as noted earlier, that "Gothic is Living Form."[53] Those seated on the ground to the right of the figure administering the Last Supper, Blake further informs us, represent the Holy Family.

When we reach the outermost circles into which this upper portion of the drawing is divided, we find that man's passage through the Fallen World is completed by Redemption. Man here assumes the "Giant forms"[54] of his eternal stature, the divided forms become one, and the fourfold aspects of human personality—Blake's "Zoas," signifying the imaginative, intellectual, emotional, and sensory aspects of man's nature—reassemble in the perfect harmony of man's transfigured stature, here symbolized by the forms of the living creatures of Revelation, now blended into a single giant form, dominated by the human, which bears the aspect of Christ.

The Zoas are the principal characters of Blake's drama of human psychology as set forth in his major prophetic works.

Personifying the basic contrary forces which together form the
character of every individual, in the eternal state they manage to
combine intense energy with complete harmony, preserving a
dynamic balance in much the same way as does the atom with its
nucleus and swiftly-moving electrons. As soon, however, as man
becomes inclined towards the development of his selfhood, the
harmony is disrupted. Reason, desire, or the sensory aspects of
man's nature strive for dominion, upsetting the proper control
which must be exercised by the divine power of imagination. The
Fall occurs, and eternity cannot be regained until, through
experience, man once again learns to bring the Zoas into their
proper relationship.[55]

In the great eighty-eighth design for the *Divine Comedy,*
"Beatrice Addressing Dante from the Car," Blake shows us
the divided Zoas of Fallen Man, represented by the beasts
with wings full of eyes, dominated by the Female Will
signifying man's fallen estate, and enthroned upon the
whirlpool of chaos.[56] Now, at the Last Judgment, we see the
Zoas reassembled in the perfect harmony of one individual,
and crowned with light. This is the same theme, though now
even more fully elaborated, as that of Blake's most famous
work, the fifteenth engraving to the Book of Job, "When the
morning Stars sang together, & all the Sons of God shouted
for joy." There the figure of the Lord, with arms out-
stretched in the same gesture as that of Christ on the throne
in the Rosenwald drawing, maintains the universal harmony
of the Zoas within the divine world of His creation.

It is the further unification and integration of its
symbolism with respect even to this Job design that, together
with other evidence, permits us to deduce a probable date for
the Rosenwald drawing. While other versions are dated 1806
or 1808, this design appears to be somewhat later.[57] *A
Vision of the Last Judgment* must stand somewhere in
between, its description of the upper portion of the picture
largely coinciding with the water color of 1808 at Petworth
House, but being otherwise more clearly linked with the

Rosenwald drawing. The section of the Rosenwald drawing about and above the figure of Christ on the throne thus represents a further development beyond that of this account in Blake's notebook; these notes may, therefore, have served as a first outline of what Blake intended to do in his proposed large-scale tempera. When, however, he translated these words into the sketches, of which the most developed is the Rosenwald drawing, his ideas concerning the heavenly vision surrounding the throne of Christ at once expanded and crystallized.[58] This would suggest that the Rosenwald drawing represents the closest approximation to Blake's lost tempera. Now, we know from Smith's account that Blake was just finishing the tempera at the time of his death in 1827.[59] Also, we have seen that the symbolism of the Rosenwald drawing is a further development of that of the Job design, the first water-color version of which was completed about 1820.[60] This would suggest a date of somewhere between 1820 and 1825 for the Rosenwald version of the Last Judgment.

Stylistic considerations tend to corroborate this conclusion. When, for instance, one compares the figures of the Zoas in the Rosenwald drawing—particularly that on the side of the Lord's Supper—with such works as Blake's pencil drawings for the Book of Enoch [see Illustrations 37-41], one notices a striking similarity. This manner is indicative of the greater boldness of handling of Blake's later years, as found for example in the Dante drawings of 1824 to 1827.[61] Now, the book of Enoch designs can be dated, and this date fits in with the other evidence. The first English translation of the Book of Enoch, by Richard Laurence, afterwards Anglican Archbishop of Cashel, did not appear until 1821, six years before Blake's death. Hence the Enoch drawings are

likewise late works, and fortify our belief that the Rosenwald drawing is a work of the early twenties.[62]

In closing this discussion of the most developed of Blake's Last Judgment drawings, we cannot do better than to quote his own words in one of his most striking passages of prose, the final paragraph of *A Vision of the Last Judgment,* which well sums up the whole significance of the theme to him:

> Forgiveness of Sin is only at the Judgment Seat of Jesus the Saviour.... The Last Judgment is an Overwhelming of Bad Art & Science. Mental Things are alone Real; what is call'd Corporeal, Nobody Knows of its Dwelling Place.... Error is Created. Truth is Eternal. Error, or Creation, will be Burned up, & then, & not till Then, Truth or Eternity will appear.... I assert for My Self that I do not behold the Outward Creation ... "What," it will be Question'd, "When the Sun rises, do you not see a round disk of fire somewhat like a Guinea?" O no, no, I see an Innumerable company of the Heavenly host crying, "Holy, Holy, Holy is the Lord God Almighty!" [63]

NOTES

1. *A Vision of the Last Judgment* (hereafter abbreviated *V. L. J.*), K 613, E 551.

2. Inscription in reversed writing which forms part of the design at the bottom of pl. 41 of *Jerusalem*, K 669, E 182. See note 21 below.

3. *V. L. J.*, K 604-05, E 544-45.

4. The important long prophetic poem by Blake, which was unpublished and is preserved today in the Department of Manuscripts at the British Museum (Add. Ms. 39764), *The Four Zoas* or *Vala*, has as the title of its final book, "Night the Ninth being The Last Judgment." The two major prophetic poems published by Blake

himself in his own process of "illuminated printing," *Milton* and *Jerusalem*, also end with visions of an apocalyptic character. For *The Four Zoas* MS, see Herschel M. Margoliouth, *William Blake's "Vala"* (Oxford: Clarendon Press, 1956). Ed.: For a reproduction of the manuscript, see William Blake, *Vala or The Four Zoas*, ed. G. E. Bentley, Jr. (Oxford: Clarendon Press, 1963).

5. William Michael Rossetti, in his catalogue of Blake's works in the second volume of Alexander Gilchrist's *Life of William Blake*, lists eight versions of the theme, one being described as a "tracing." I am familiar with five extant versions, three of which can be identified with those listed by Rossetti, and one of which may well be the original of Rossetti's tracing. See notes 8 and 12 below.

6. *Life of William Blake, "Pictor Ignotus"* (London and Cambridge: Macmillan, 1863). All page references to Gilchrist given herewith are to the second edition (London: Macmillan, 1880).

7. Quoted from Arthur Symons, *William Blake* (London: Dutton, 1907), pp. 373-74.

8. Gilchrist, I, 262-63, 401-02. See Rossetti's List No. 1, No. 110, in Gilchrist, II, 223, where the dimensions of this tempera are given as seven feet by five (but note that in List No. 2, No. 25, p. 258, they are referred to as *six* feet by five).

9. *The Note-Book of William Blake Called the Rossetti Manuscript*, ed. Geoffrey Keynes (London: Nonesuch Press, 1935).

10. *V. L. J.*, K 606, E 545.

11. For a full account of the various editions of this poem with plates engraved after Blake's designs, see Geoffrey Keynes, *A Bibliography of William Blake* (New York: Grolier Club, 1921), pp. 219-22, 377. Ed.: See also G. E. Bentley, Jr. and Martin K Nurmi, *A Blake Bibliography* (Minneapolis, Minn.: Univ. of Minnesota Press, 1964), pp. 96-101 and Bentley, *Blake Records* (Oxford: Clarendon Press, 1969), pp. 166 ff.

12. The four main treatments of the theme may be divided as follows:

(i) The engraving in Blair's *Grave*. Rossetti in his catalogue, List No. 2, Nos. 113, 114, 115, p. 267, mentions three drawings as related to this version. These are unknown to me. Ed.: These may be three of the drawings listed below, (iv).

(ii) A water color until recently in the collection of the late Sir John Stirling-Maxwell, Bart. To be identified with No. 84 of Rossetti's List No. 1, p. 218. Signed and dated 1806. See *Burlington Fine Arts Club Catalogue: Blake Centenary Exhibition* (London: Burlington Club, 1927), pp. 37-39, no. 40, and pl. XXIX. Ed.: This water color is now in the Stirling Maxwell Collection, Pollock House, Glascow Museum and Art Galleries. See also Keynes, *William Blake's Illustrations to the Bible* (Clairvaux: Trianon Press for the Blake Trust, 1957), p. 38, no. 131b.

(iii) A water color in the collection at Petworth House, Sussex, signed and dated 1808. Reproduced in color in Darrell Figgis, *The Paintings of William Blake* (London: Ernest Benn, 1925), pl. 7; also in monochrome in *The Writings of William Blake*, ed.

Keynes (London: Nonesuch Press, 1925), III, facing p. 2, and in *The Letters of William Blake*, ed. Keynes (London: Rupert Hart-Davis, 1956 and second ed., 1968), pl. XI, and in C. H. Collins Baker, *Catalogue of the Petworth Collection of Pictures in the Possession of Lord Leconfield* (London, 1920), No. 454, pp. 6-7. This is the version described in Blake's letter to Ozias Humphry, dated Jan. 18, 1808. (For the most accurate text of this letter and of the second draft dated Feb., 1808, see *Letters*, ed. Keynes, pp. 165-170 in first ed., pp. 128-130 in second ed.). It is catalogued by Rossetti as No. 89 in his List No. 1, p. 218, but Rossetti there makes the mistake of describing it as a "tempera." See also Gilchrist, I, 260-62. Ed.: See also Keynes, *Blake's Illustrations to the Bible*, p. 38, no. 131c.

(iv) (a) A very slight pencil sketch formerly in the collection of W. Graham Robertson, now in an anonymous private collection in London. Inscribed in ink, "William Blake for his Last Judgment. Frederick Tatham."

(b) A more developed, but still quite unfinished version of the same design in pencil, India ink, and wash, now in the collection of T. Edward Hanley, Bradford, Pennsylvania. Reproduced in E. J. Ellis, *The Real Blake* (New York: MacClure, Phillips, 1907), facing p. 271. Rossetti's List No. 2, No. 24, pp. 257-58. Ed.: Now in the collection of the University of Texas, Austin, Texas. Reproduced in *Blake Newsletter*, IV (Spring, 1971), 138.

(c) The fully developed pencil, India ink, and wash drawing which is in the collection which Lessing J. Rosenwald of Jenkintown, Pennsylvania, has presented to the National Gallery of Art. It is the subject of this article and is illustrated herewith [Illustration 55]. See note 13 following.

Ed.: There is a fourth pencil sketch in the collection of Gregory Bateson, Honolulu, Hawaii, reproduced in Keynes, ed., *Writings of Blake* (1925), III, pl. LII.

13. 17½ by 13¼ inches. No watermark. Not signed or dated. Collections: Thomas Butts (?), J. Marsden Perry, W. A. White, William Bateson. Rossetti, List No. 2, No. 25, p. 258, describes a "tracing" from a similar drawing; however, if this is so, the date given by Rossetti (1807) would appear improbable, as brought out in the course of this article. The drawing has been reproduced in Keynes, *Writings*, III, facing p. 148, and in Keynes, *Pencil Drawings of William Blake* (London: Nonesuch Press, 1956), pl. 27.

Ed.: As noted above, the drawing reproduced in Keynes, ed., *Writings* is the Bateson sketch, not the Rosenwald version reproduced here. William Bateson should not be included in the provenance of the Rosenwald version given here by Roe.

14. But see note 61 below.

15. "They [i.e. Gog and Magog] are therefore the nations in which we find the devil was shut up as in an abyss." *City of God*, Bk. XX, ch. 11. (Bk. XX treats of the Last Judgment and ch. 11, of Gog and Magog.)

16. For this state of the plate, see Keynes, *Blake Studies* (London: Rupert Hart-Davis, 1949), pp. 47-47 and pl. 14. Keynes has shown that the familiar state of this engraving, although dated 1773, must be considerably later.

 Ed.: See also Keynes, *Engravings by William Blake: The Separate Plates* (Dublin: Emergy Walker, 1956), pp. 3-5 and pls. 1-3, and the essay by David V. Erdman reprinted in this volume.

17. The limited perceptions of the Natural Man in the Fallen World are frequently symbolized by Blake as human figures struggling to free themselves from a cave which encloses them tightly. See, for instance, pl. 3 to *The Gates of Paradise* (reproduced in K 762, E 258), and compare the following passage from *The Marriage of Heaven and Hell* (K 154, E 39): "Man has closed himself up, till he sees all things thro' narrow chinks of his cavern."

18. K 778, E 267 (written ca. 1820).

19. The Westminster Abbey sculpture was published in Richard Gough's *Sepulchral Monuments in Great Britain* (London: T. Payne, 1786). See Keynes, *Bibliography*, pp. 197-198, and *Blake Studies*, pp. 41-42, pl. 13 and second ed. (Oxford: Clarendon Press, 1971), pp. 14-19 and pls. 5-7. The influence of this medieval sculpture is especially apparent in Blake's designs for Blair's *Grave*. It will be noted that quite a number of groups in the foreground of the Rosenwald drawing on the side of the blessed are derived from various of the *Grave* illustrations; this is even more the case with respect to some of the other Last Judgment drawings, notably that at

Petworth House, which is dated in the same year as the *Grave* designs were published (1808).

20. Emile Mâle, *L'Art religieux du XIIe siècle en France* (Paris: A Colin, 1953), p. 178.

21. Facsimile editions of *Jerusalem* have been issued by the William Blake Trust both in color (from the unique hand-colored copy, now on loan from Paul Mellon to the Yale University Library) and in black and white. This plate is also reproduced in color in Keynes, *Bibliography*, facing p. 166.

22. Laurence Binyon, *The Drawings and Engravings of William Blake* (London: Studio, 1922), pl. 9. See also the tempera, "The Agony in the Garden," pl. 55.

 Ed.: For these paintings, see also Martin Butlin, *William Blake: A Complete Catalogue of the Works in the Tate Gallery* (London: Tate Gallery, 1971), p. 44 no. 27 and p. 46 no. 30.

23. For reproductions of the water colors, pencil sketches, and engravings of the Job series, and for the history of the designs, see Binyon and Keynes, *Illustrations of the Book of Job by William Blake* (New York: Pierpont Morgan Library, 1935). The standard work of interpretation is Joseph H. Wicksteed, *Blake's Vision of the Book of Job* (London: Dent and New York: Dutton, 1910, second ed. 1924).

24. K 606, E 545. I Kings vii.13-22; II Chron. iii.15-17; Jer. lii.21-23. For an attempted reconstruction of these brazen pillars, following the Biblical account and archaeological evidence, see Georges Perrot and Charles Chipiez, *History of Art in Sardinia, Judaea, Syria, and Asia Minor* (London: Chapman and Hall, 1890), I,

250-257, pls. vi and vii. Jachin and Boaz have recently been associated with the Romanesque columns in the Friedsam Annunciation in the Metropolitan Museum, New York (attributed to Hubert van Eyck), and seen there as symbolic of the Old Dispensation (Erwin Panofsky, *Early Netherlandish Painting* [Cambridge, Mass.: Harvard Univ. Press, 1953], I, 133).

25. For Jachin and Boaz in the eighth card of the tarot pack, "Justice," and for their masculine and feminine significance in the symbolism of alchemy, see Oswald Wirth, *Le Symbolisme Hermétique* (Paris, 1931).

26. The origins of Freemasonry are often popularly traced back to the building of Solomon's temple, and hence the significance in the Masonic rite of the objects of temple furniture. For Jachin and Boaz, see George F. Fort, *The Early History and Antiquities of Freemasonry* (Philadelphia: Putnam, 1877), pp. 332-334. Arthur Edward Waite, *A New Encyclopaedia of Freemasonry* (London, 1921), II, 279-281, brings out the cabalistic connections of Jachin and Boaz. A number of editions of a work with the significant title, *Jachin and Boaz; or, an Authentic Key to the Door of Freemasonry*, were issued in London during Blake's lifetime (e.g., 3rd ed., 1763; another new and enlarged ed., 1780).

27. See, for example, *Kabbala Denudata, seu Doctrina Hebraeorum Transcendentalis et Metaphysica atque Theologica* (Salzburg: Abraham Lichtenthaler, 1677), pp. 186-89, 433-34.

28. For Blake and the cabala, see especially S. Foster Damon, *William Blake, His Philosophy and Symbols* (Boston and New York: Houghton Mifflin, 1924), pp.

446-7; also Milton O. Percival, *William Blake's Circle of Destiny* (New York: Columbia Univ. Press, 1938), and Northrop Frye, *Fearful Symmetry, A Study of William Blake* (Princeton: Princeton Univ. Press, 1947).

29. K 149, E 34.

30. K 610, E 549.

31. For a full discussion of the symbolism of this drawing, and for a reproduction, see Albert S. Roe, *Blake's Illustrations to the Divine Comedy* (Princeton: Princeton Univ. Press, 1953), pp. 193-96, pl. 99.

32. In Blake's symbolism, Adam is identified as the "Limit of Contraction," signifying that portion of imaginative life which remains even to the Fallen Man. See Roe, *Blake's Illustrations to the Divine Comedy*, p. 15.

33. This section of the drawing is described in *V. L. J.*, K 606-07, E 545-46.

34. *Jerusalem*, pl. 52 (K 682-83, E 199).

35. Deut. iii.16-23. Blake doubtless gives Araunah this function due to the connotation of separating the wheat from the chaff. Rossetti, List No. 1, No. 152, p. 237, describes a tempera entitled "The Plague stayed at the Threshing-floor of Araunah the Jebusite."

 Ed.: This tempera may actually be the "St. Luke" (see Keynes, *Blake's Illustrations to the Bible*, p. 26 no. 88).

37. For this section of the drawing, see *V. L. J.*, K 607-08, E 546-47.

38. See the design to pl. 93 of *Jerusalem*. Note that the well-known print usually referred to as "The Accusers of Theft, Adultery, Murder," which in the first state bore the caption "Our End is Come," in the late state is

entitled, "A Scene in the Last Judgment." (Archibald G. B. Russell, *The Engravings of William Blake* [Boston and New York: Houghton Mifflin, 1912], No. 10, pp. 66-67; David V. Erdman, *Blake, Prophet Against Empire* [Princeton: Princeton Univ. Press, 1954], pp. 189-91, pl. iv.) "Locke, along with Bacon and Newton, is constantly in Blake's poetry a symbol of every kind of evil, superstition, and tyranny" (Frye, *Fearful Symmetry*, p. 14).

39. Roe, *Blake's Illustrations to the Divine Comedy*, pp. 69-70, pl. 15.

40. K 608, E 547-48.

41. II Kings viii.7-15; xiii.3.

42. II Sam. xvii.1-23.

43. *V. L. J.*, K 609, E 548. Blake made a number of designs showing the Harlot of Revelation. For a discussion of these and her identification with Vala-Rahab, see the account of the Dante illustration, "The Harlot and the Giant," in Roe, *Blake's Illustrations to the Divine Comedy*, pp. 171-74, pl. 89.

44. Quotations are from *Four Zoas*, "Night the Fifth," line 241 (K 311, E 337) and from Blake's annotations to Watson's *Apology for the Bible* (K 383, E 601). For the cave, see note 17 above.

45. Los Appears thus in the designs of pls. 6 and 100 of *Jerusalem*.

46. This section of the drawing is as described in *V. L. J.*, K 609, E 548. Poetry, Painting, and Music are represented prominently in Blake's only lithograph, "Enoch," where the figure of the painter is clearly a self-portrait of Blake

as a young man. (Reproduced in Russell, facing p. 91, where it is incorrectly entitled "Job in Prosperity"—cf. Keynes, *Blake Studies*, p. 122, second ed. p. 178.)

Ed.: For "Enoch," see also Keynes, *Engravings by Blake: The Separate Plates*, pp. 43-44 and pl. 26.

47. See Roe, *Blake's Illustrations to the Divine Comedy*, pp. 189-93, pl. 98.

48. *V. L. J.*, K 610, E 549 and K 611, E 550. A horse's head may be discerned within the curve of Elijah's body.

49. *Jerusalem*, pl. 77 (K 717, E 229).

50. This is particularly true of the water color in the collection of Petworth House.

51. For the upper portion of the drawing, see especially *V. L. J.*, K 612-13, E 551-52. Also significant here, although referring specifically to the Petworth water color, is the description of the figures surrounding the throne in Blake's letter of Jan. 18, 1808, to Ozias Humphry (Keynes, ed., *Letters,* p. 167 in first ed., p. 130 in second ed.).

52. From Blake's annotations to Lavater's *Aphorisms on Man* (K 82, E 585). For a discussion of the ark in Blake's symbolism, see the commentary on the *Purgatorio* drawing, "The Rock Sculptured with the Recovery of the Ark and the Annunciation," in Roe, *Blake's Illustrations to the Divine Comedy*, pp. 150-53, pl. 80.

53. See note 18 above.

54. *Jerusalem*, pl. 3 (K 620, E 143).

55. Roe, *Blake's Illustrations to the Divine Comedy*, p. 29. Those not familiar with Blake's symbolism may find

convenient the succinct account given of it here on pp. 8-29.

56. Roe, *Blake's Illustrations to the Divine Comedy*, pp. 164-71, pl. 88. It will be noted in the Dante drawing that the beast with the human head also bears the features of Christ.

57. Two of Blake's drawings of the Last Judgment are dated, those in the Sterling-Maxwell collection (1806) and at Petworth House (1808). The engraved version was first published in 1808. See note 12 above. Keynes, in *Pencil Drawings* (1956), suggests a date of 1810 for the Rosenwald drawing, with which I do not agree for the reasons here given.

58. The upper portions of each of the three versions listed under (iv) in note 12 above are essentially the same; the Rosenwald drawing represents a more complete working out of a scheme sketched tentatively in the drawing in an anonymous collection in London and more fully in that in the Hanley (Ed.: now University of Texas) collection.

59. See note 7 above.

60. Keynes, *Blake Studies*, pp. 119-134, second ed. pp. 176-86.

61. It is of interest to note that the upper portion of the Rosenwald drawing is divided into nine concentric circles, counting Christ's halo as the first. Perhaps this was suggested to Blake by the nine spheres of Dante's *Paradiso*, as illustrated by him in the drawing, "The Deity, from Whom Proceed the Nine Spheres" (Roe, *Blake's Illustrations to the Divine Comedy*, pp. 186-88,

pl. 97). If so, we have another argument for the late date of the Rosenwald drawing.

62. Keynes, *Pencil Drawings* (1956), text facing pls. 45-49. See also [Wolf and Mongan, compilers], *Blake 1757-1827: A Descriptive Catalogue*, pp. 151-54.

63. K 616-17, E 555.

BLAKE'S SHAKESPEARE

by

W. Moelwyn Merchant

*T*he most persuasive quality in Blake's visionary art is its precision and particularity, a matter-of-fact directness which he shares with all the mystics. The quiet effrontery of Henry Vaughan's 'I saw Eternity the other night' is of a piece with the cultivated simplicity in expressing profundities which Blake shared with Wordsworth, though with a revolutionary directness which Wordsworth never reached. In examining Blake's elaboration of images and concepts in Shakespeare, we must reckon on the constant irony of his unorthodoxy, the bitter irony of a poem, which in its title commands the theological overtones of *A Divine Image*, and then proceeds:

> Cruelty has a Human Heart,
> And Jealousy a Human Face;

Ed.: Reprinted by permission of the author and publisher from *Apollo*, new series 79 (April, 1964), 318-24.

> Terror the Human Form Divine.
> And Secrecy the Human Dress;

and, a century and a half before our present analysis of personal relationships, we must reckon equally on a statement like this:

> In a wife I would desire
> What in whores is always found—
> The lineaments of Gratified desire.

This is no comfortable commentator on any theme.

A great proportion of Blake's imaginings, visual and verbal, appear undisciplined and rootless: they are too private for our ease and we frequently move disorientated in the world of *Los, Urizen* or *The Four Zoas*. But a great deal of his work is grounded in the classical expression of central themes in our tradition: of the pastoral mode, in the wood engravings of Thornton's *Virgil*; in the exploration of the theology and images of the Fall of Man in his studies of Milton; of humiliation and suffering in the *Job* series;

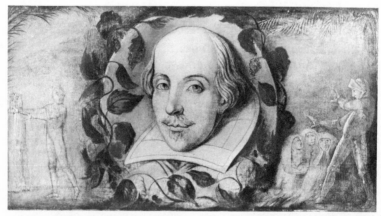

56. Blake, Portrait of Shakespeare, one of the eighteen panels painted for William Hayley's house at Felpham. 41 x 79.5 cm. City Art Gallery, Manchester.

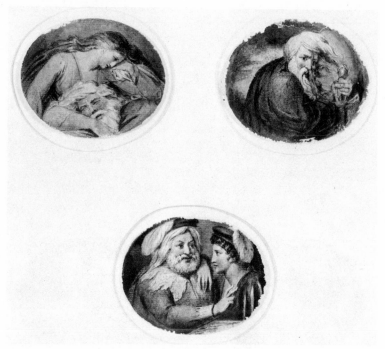

57-59. Shakespeare character-heads. (57, top left) Lear and Cordelia, (58, top right) King Lear, (59, bottom) Falstaff and Prince Hal. Museum of Fine Arts, Boston.

and—the climax of his work—those illustrations, running to more than a hundred, interpreting Dante.

Each of these projects, however extensive or complex, had the unity imposed by the original work and the single technique—of wood-engraving, drawing or 'colour-print'—in which Blake chose to elaborate the poet's verbal images. He succeeds, within this unity, in scaling his work to the limited artifice of Thornton's pastoral temper, or to the epic movement of the *Divine Comedy*. There is no such single direction or technical form in Blake's works which are derived from Shakespeare; they spanned a considerable

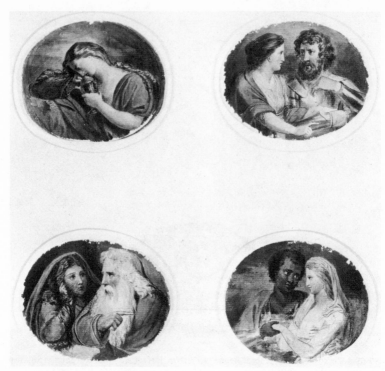

60-63. Shakespeare character-heads. (60, top left) Juliet and the Sleeping
Draught, (61, top right) Macbeth and Lady Macbeth, (62, bottom left) Lear and
Cordelia, (63, bottom right) Othello and Desdemona. Museum of Fine Arts,
Boston.

period in his working life, they involved more than a dozen
plays and, most important, they employed most of his
methods and techniques of working. For good measure, in
addition to their highly personal comment on Shakespeare's
thinking, they form a quite substantial comment on certain
aspects of Blake's private mythology.

The natural starting-point is with the illustrations
proper, those drawings which follow the text with a
minimum of personal interpretation. The *Lear and Cordelia*
[Tate Gallery, London, Illustration 64], a small water-colour

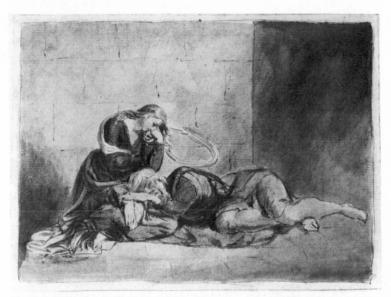

64. Blake, "Lear and Cordelia in Prison," perhaps *c.* 1780. Water color, 13.2 x 18.2 cm. Tate Gallery.

study, has two interesting relationships. It is not directly from Shakespeare's *Lear* but from Nahum Tate's Restoration version, in which Cordelia's imprisonment with her father was elaborated in a scene on stage; and, since this and similar handlings of *Lear* ousted Shakespeare's play from the stage until its revival by Macready in 1837, it was a scene which Blake could have seen. It has a further interest. In manner it resembles the rather larger pen and wash drawing, *The Penance of Jane Shore* (also in the Tate Gallery) and is thus placed as a primitive moment in a series of drawings for a projected *History of England*, announced in 1793: an unusual and perceptive placing of *Lear* in the dark ages of our history.

Associated with these historical drawings are the seven character heads, now in the Boston Museum of Fine Arts [Illustrations 57-63], and two further studies, a Glendower and a Hotspur of which Rossetti wrote warmly. They have some affinity with the later and more mature visionary heads, in that they attempt interpretation beyond the immediate appearance, recalling Samuel Palmer's phrase:

> They [the Virgil engravings] are like all that wonderful artist's works, the drawing aside of the fleshy curtain.

—though Gilchrist greatly disapproved of all these early historical subjects as being too much in the manner of J. H. Mortimer ('the historical painter') and his contemporaries:

> what mannerism there is is a timid one, such as reappears in William Hamilton always, in Stothard often.

We are, however, quickly taken to a more characteristic quality of his art in those engravings and drawings which adopt a phrase or a single moment in a Shakespearian scene and assimilate it to Blake's own mythology. The most remote and teasing is *Jocund Day* [in the version in the Rosenwald Collection, National Gallery, Washington, Illustration 10, known as *The Dance of Albion*]. The verbal suggestion comes from *Romeo and Juliet* (Act III sc. v):

> Nights Candles are burnt out, and Jocond day
> Stands tipto on the mistie Mountaines tops

The posture of the figure echoes the words of Romeo and, with the dark suggestions of the moth and the caterpillar creeping away, extends the ambiguity of light and darkness in this scene of the lovers' parting at the dawn.

> More light and light—more dark and dark our woes.

Blake, of course, explicitly relates this theme to his mythic figure of Albion, with his overtones of Miltonic ascendancy

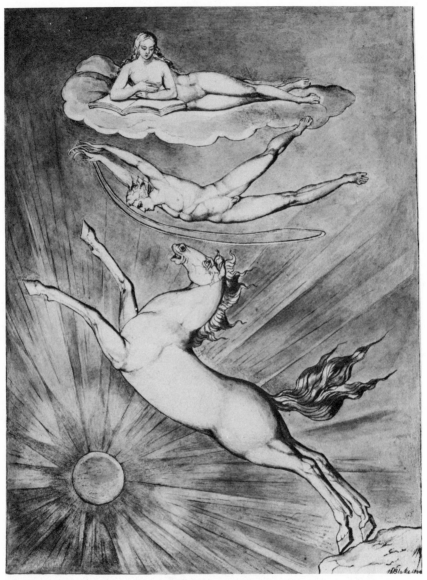

65. Blake, "Fiery Pegasus." Pen, ink and water color, 22.5 x 17 cm. One of a group of six drawings for the extra-illustrated *Second Folio* in the British Museum.

over dark tyranny; the words are engraved below the
illustration:

> Albion arose from where he labour'd at the Mill with slaves,
> Giving himself for the Nations he danced the dance of Eternal
> Death.

An analogous method is found in one of the drawings
included in an extra-illustrated copy of the *Second Folio* in
the British Museum Print Room, the *Fiery Pegasus* [Illustra-
tion 65]. Again the verbal source is Shakespeare—the moment
of Prince Hal's regeneration expressed in terms of skill in
horsemanship: an analogy with the control of the natural
passions and at the same time of skill in manoeuvre, with its
tacit reference to affairs of state:

> [Harry] vaulted with such ease into his seat
> As if an angel dropp'd down from the clouds
> To turn and wind a fiery Pegasus,
> And witch the world with noble horsemanship.

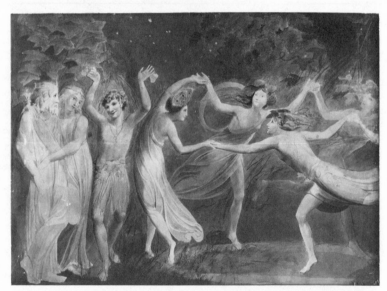

66. Blake, "Oberon, Titania, and Puck with Fairies Dancing." Water color, 47.5 x
62.5 cm. Tate Gallery.

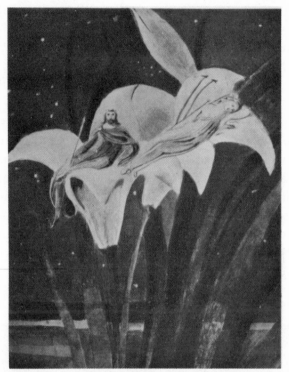

67. Blake, "Oberon and Titania." Collection of Mr. Philip Hofer.

Blake calls the drawing 'A spirit vaulting from a cloud to turn and wind a fiery Pegasus', to which he adds a gloss which weds the Shakespearian theme to his own mythology:

> The Horse of Intellect is leaping from the cliffs of Memory: it is a barren Rock: it is also called the Barren Waste of Locke and Newton.

Here the spontaneity and the creative wit of Prince Henry, which develops into the regenerate king of *Henry the Fifth*, are contrasted with the barren reason which Blake rejected.

We are in the same context of reference with the next two related works, the *Oberon and Titania* from Mr Philip Hofer's collection [Illustration 67] and *Oberon, Titania and*

Puck with *Fairies dancing,* Tate Gallery [Illustration 66]. The
first is a striking exercise in scale: the grace of the lily design
containing the tiny, yet majestic figures of the fairy rulers.
Titania has the innocent grace of posture with which Blake
drew Eve asleep in Eden in his *Paradise Lost*; Oberon,
bearded, crowned and sceptred, has an alert, mature regality.
If these are to be interpreted, in Binyon's phrase, as 'natural
joys', they play their proper part in the pattern of intellect,
reason and instinctive passion which was at the centre of
Blake's anthropology. This is extended in the more elaborate
and complex water-colour drawing in the Tate. This is quite
substantial in size (47.6 x 67.3 cm.) and, within its night
setting, contrasts two moods of the beneficent supernatural,
turning upon the poised and ambiguous figure of Puck. On

68. Blake, "Hecate," 1795. Color-printed monotype, 43.9 x 58.1 cm. Tate
Gallery.

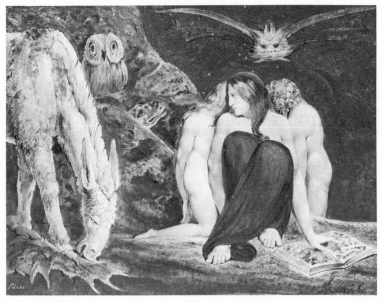

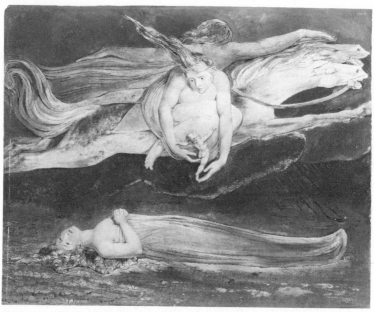

69. Blake, "Pity," 1795. Color-printed monotype, 42.5 x 53.9 cm. Tate Gallery.

the one side stand, in rhythmic repose and concord, the two royal figures, Oberon carrying suggestions in his figure and face of both the Oberon of Illustration 67 and the old shepherd in the *Virgil* woodcuts; on the other side the rhythmic passion is in rapid movement, divided from the contemplative figures by Puck, whose frozen posture assimilates him to both elements in the study. He has something of grace, something of the sinister infant Puck of Reynold's painting for the Boydell Gallery, now in the collection of Earl Fitzwilliam.

The equivocal nature of Puck relates this drawing to the colour-print *Hecate* [Illustration 68]; both the drawing in the British Museum and the three versions of the print focus the closing speech of Puck in *A Midsummer Night's Dream:*

> And we Fairies that do runne,
> By the triple *Hecates* teame,
> From the presence of the Sunne,
> Following darknesse like a dreame.

Here the darker overtones of this fairy world link Puck, who
is Hecate's servant, to the brooding Hecate of the evil
supernatural in *Macbeth*, who is, in turn, invoked in Lear's
curse and in the murderous potion of the inset play in
Hamlet. If Martin Butlin's suggestion has force (in the notes
to the Blake Exhibition at the Tate in 1957) that this subject
and the related *Pity* [Illustration 69]

> were probably chosen to show two aspects of the place of woman in
> the Fall

since

> the triple representation of the Infernal Goddess Hecate is a
> traditional symbol of the three phases of the moon, crescent, full
> and waning,

Blake has again related his own mythology to the four
disquieting references to Hecate's evil in Shakespeare. In the
colour-print the triple figure is surrounded by 'familiars', as
the witches are in *Macbeth*.

Though Butlin has established both the formal and
thematic connexion between *Pity* and *Hecate* (in the 1957
Catalogue, p. 43), the formal relation of *Pity* to the
Shakespeare text is quite different and indeed unique in
Blake's work. *Hecate* relates into one group within the
drawing the scattered references to the triple goddess in
Shakespeare, establishing the visual form of a recurrent image
in the plays. *Pity* proceeds not by conflation but by analysis.
In the first act Macbeth is meditating on the consequences of
his regicide: because of the relation of the king to his subject,
this is more than murder, for the impiety in the act
outweighs even its violence. This is stated in a linked series of
images:

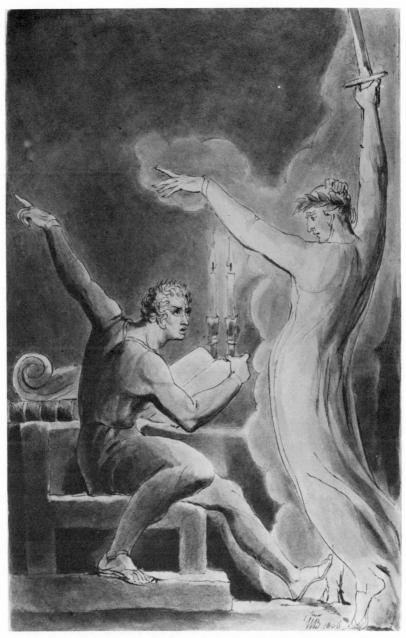

70. Blake, "Brutus and Caesar's Ghost." Ink and water color, 22 x 16 cm. One of a group of six drawings for the extra-illustrated *Second Folio* in the British Museum.

71. Blake, "Hamlet Administering the Oath." Pencil, 14 x 16 cm. No. 43 in a sketchbook presented by John Deffert Francis to the British Museum.

> And Pitty, like a naked new-borne Babe
> Striding the blast or Heaven's Cherubim, hors'd
> Upon the sightlesse Couriers of the Ayre,
> Shall blow the horrid deed in every eye,
> That teares shall drowne the winde.

It will be seen from the colour-print that each of these images is faithfully realized in detail, teasing out the image-cluster into its several parts and holding them within the sole unity of the composition.

From these highly personal readings of Shakespeare Blake returned periodically to a manner which can more properly be called illustration in the humbler sense. In a sketch-book in the British Museum we have three subjects, *Hamlet administering the Oath, Lady Macbeth with Candle &*

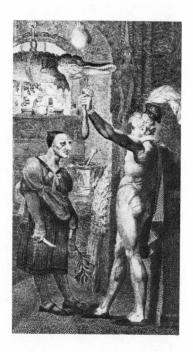

72. "Romeo and the Apothecary."
Mixed engraving, 17 x 9 cm., engraved
by Blake after Fuseli for the Rivington
edition of Shakespeare, 1805. Essick
Collection.

Dagger and *Hamlet and the Ghost*, the last perhaps by Robert
Blake but related to the illustration at the head of this article.
The first of these is much the best [Illustration 71] and is
clearly influenced by Fuseli (Rossetti in his *Catalogue*
describes it as 'of an Ossianic or Fuseli-like tendency').
Among Blake's few essays in engraving Shakespeare we have
two after Fuseli drawings in the Rivington edition of the
Works in 1805. The first of these, *Queen Katherine's Dream*,
we shall be considering with Blake's finer works on the same
subject; the second is a rather rigid little engraving of *Romeo
and the Apothecary* [Illustration 72] where the figure of
Romeo, of characteristic Fuseli stature and stance, is sur-
rounded by the conventional paraphernalia of alchemy.

A group of six drawings by Blake in the extra-illustrated
Second Folio in the British Museum constitutes a rough

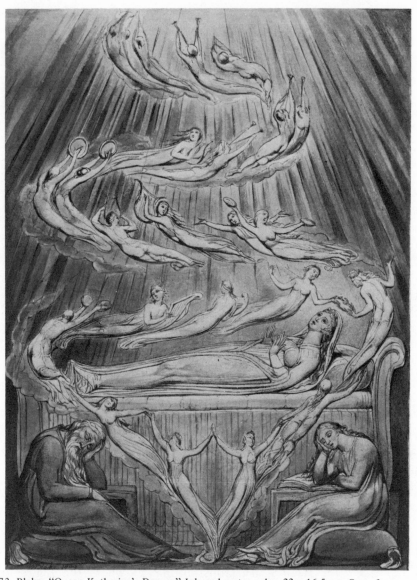

73. Blake, "Queen Katherine's Dream." Ink and water color, 22 x 16.5 cm. One of a group of six drawings for the extra-illustrated *Second Folio* in the British Museum.

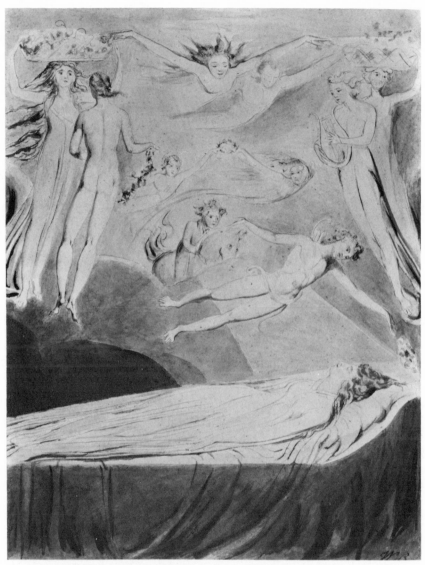

74. Blake, "Queen Katherine's Dream." India ink, grey wash, and water color over some pencil, 20.3 x 16.1 cm. From the Stopford A. Brooke Collection, now Fitzwilliam Museum.

cross-section of Blake's art as an interpreter of Shakespeare. They range from the relatively factual and straight-forward *Brutus and Caesar's Ghost* [Illustration 70] to the allusive *Fiery Pegasus* we have already examined. Another of these drawings, *Richard III and the Ghosts*, is almost alone in Blake's work on Shakespeare as being directly influenced by recollections of the stage: Richard is enveloped by the lines of a characteristic eighteenth-century stage pavilion and it is either a survival of the stage tradition of the 'starting from sleep' or a reminiscence of Hogarth's record of Garrick in this scene, probably a union of both. A *Hamlet* and a *Jaques and the Stag* have no interest beyond their rather unconvincing allusions to former eighteenth-century engravings of the same subjects.

The sixth subject, *Queen Katherine's Dream*, is quite another matter. A comparison of Illustrations 73, 74, 75, 76 shows a close organic relationship between Blake's engraving after Fuseli in the Rivington edition [Illustration 76] and the three original studies by Blake himself. The Fuseli drawing, it is true, is in the 'historical' manner of the Boydell engravings and there is also an uncomfortable suggestion of Fuseli's courtesan figures in Patience, the waiting-woman. For the rest, Blake has conveyed something of the visionary quality which he develops through his other studies. There is considerable diversity in the composition of the vision in the three major studies. The first of the two drawings in the Fitzwilliam Museum, Cambridge [Illustration 74], conveys, in its symmetry, the descent of the vision upon Queen Katherine, the quality of beneficence in the stage direction in *Henry the Eighth:*

> They first Conge unto her, then Dance: and, at certaine changes, the first two hold a spare Garland over her Head, at which the other foure make reverend Curtsies.

76. "Queen Katherine's Dream." Mixed engraving, 16 x 9.5 cm., engraved by Blake after Fuseli for the Rivington edition of Shakespeare, 1805. Essick Collection.

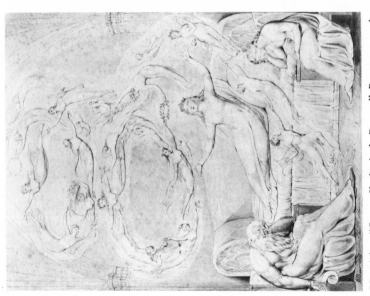

75. Blake, "Queen Katherine's Dream." Pen, grey wash, traces of pencil underdrawing, touched with color, 39.9 x 31.4 cm. From the Dilke Collection, now Fitzwilliam Museum.

The illustration from the *Second Folio* [73] anticipates, in a simplified form, the final elaboration of the second Fitzwilliam drawing [Illustration 75]. The Queen is no longer asleep and the great spiral of figures carrying harps and cymbals shift the interest from the descending vision to the words of the waking Katherine:

> Saw you not even now a blessed Troope
> Invite me to a Banquet, whose bright faces
> Cast a thousand beams upon me, like the Sun.

The drawing in the Fitzwilliam Museum is almost identical with another in the Rosenwald Collection, National Gallery, Washington. It was drawn in 1807 and echoes, both in temper and in the soaring ascent of supernatural figures, Blake's *Assumption of our Lady* in the Royal Collection, Windsor Castle. Formally, the vision of Katherine is now at its most developed. The intricate double spiral of angels, held within a Gothic arch, bear garlands, trumpets, harps and cymbals; and the three drawings, together, move through the complete span of the vision as Shakespeare pursues the tragic end of Queen Katherine.

In the whole complex range of Blake's handling of Shakespeare, this is the only group which gives us any conception of the interpretation we might have been given had Blake been moved or commissioned to treat a Shakespearian play with a series of drawings like those which illuminate his *Job* or Dante. This is a fragmentary, sporadic inspiration, one scene from Shakespeare moving Blake to a simple translation into direct visual imagery; another finding its fullest significance in its manifold comment on both the text of Shakespeare and the visionary universe of Blake himself. But even in this fragmentary form, it is the richest, most penetrating comment by any artist on the work of Shakespeare.

THE EIDETIC AND THE BORROWED IMAGE:
AN INTERPRETATION OF
BLAKE'S THEORY AND PRACTICE OF ART

by
Joseph Burke

*T*he questions, 'Was Pope a poet?' and 'Was Blake mad?' seem at first to have little connexion. They were in fact debated by romantic critics from the same year, 1806;[1] almost every major writer of the time was sooner or later involved in expressing an opinion on one or other case; and each controversy was revived by the publication of biographical studies in the second half of the century.[2] Echoes of these debates that run chronologically parallel can be detected today. For Pope as rationalist poet and Blake as visionary artist were, as complementary extremes, test cases for the romantic symposium on the nature of genius, and thus raise fundamental and related problems with which modern criticism is still deeply concerned.

Ed.: Reprinted by permission of the author and publisher from *In Honour of Daryl Lindsay: Essays and Studies*, ed. Franz Philipp and June Stewart (Melbourne: Oxford Univ. Press, 1964), pp. 110-27.

Bowles's attack on Pope takes up the challenge with which Dr Johnson concluded his famous critique:

> After all this, it is surely superfluous to answer the question that has once been raised, whether Pope was a poet; otherwise than by asking in return, if Pope be not a poet, where is poetry to be found?[3]

However objectionable Pope's theory may have been to the romantics, many of the leading figures of the movement took the keenest delight in his poetry. Wordsworth, Coleridge and Southey all admired Pope's poetical genius and admitted the poetical excellence of many of his poems. According to Hazlitt, Charles Lamb defended his enthusiasm for Pope by quoting from his 'friendly' epistles and compliments, thus stressing the generosity of personal feeling and the equally romantic value of wonder.[4] Byron became his leading champion. A comparable collection of encomiums on Racine, the test case of classicism for French romantic writers, could be readily prepared from contemporary sources of no less distinction. But in the absence of a Gallic counterpart to Blake attention was never focused so sharply on the irrational principle in creative activity, and for this reason the parallel English controversies have an unique interest for the student of romantic ideas.

Each debate was directly concerned with imagery. Bowles insisted that 'images drawn from what is beautiful or sublime in nature are more sublime and beautiful than images drawn from art, and that they are therefore *per se* more poetical', thus earning the title of 'the restorer of natural poetry'.[5] Blake, on the other hand, had stated that 'Mental Things are alone Real',[6] that true artistic images were not copies of natural ones, and that 'To learn the Language of Art, "Copy for Ever" is My Rule.'[7] Bowles demanded elaborate naturalistic detail in description, the fidelity to

'every rock, every leaf, every diversity of hue in nature's variety', against which Campbell had protested. Blake's unequivocal opposition to the doctrine of natural imagery partly explains the ambivalent attitude of the Pre-Raphaelites when Blake was being discussed both as madman and as artist in their circle.[8]

In 1806, the year of Bowles's editorial attack on Pope, Dr Benjamin Heath Malkin published a biographical sketch of Blake in the dedicatory epistle to Johnes of Hafod, translator of Froissart, which serves as introduction to *A Father's Memoirs of his Child.* Although the book had a limited circulation, its author was sufficiently known in antiquarian circles for his championship of a controversial poet to attract attention. Blake was then fifty-nine, had been taken up by Hayley and talked about as an eccentric genius. Unlike Capel Loft, who introduced Robert Bloomfield as an untutored prodigy at the somewhat belated age of thirty-two, Malkin was not launching a proprietary phenomenon. His tone is one of romantic reverence for the power of imagination so conspicuously lacking in Bloomfield's conventional verse; Blake's poetry is at once enhanced by its early and spontaneous manifestation, and excused for its oddity and technical defects. The artist-poet, according to Malkin, wrote the lyric 'How sweet I roam'd from field to field' 'before the age of fourteen, in the heat of youthful fancy, unchastised by judgment'.[9] 'Unchastised by judgment' can be read, and was no doubt intended to be read, in a partly praiseworthy sense.

Malkin as a friend of Blake certainly did not regard him as mad. Tortured by grief at the loss of his only and precocious son, whose artistic promise Blake had admired, he may have been dismissed as a prejudiced and unbalanced critic by the reviewers, whose notice of Blake's poetry is

tartly unfavourable. The question, 'Was Blake mad?' had not yet been formulated, but Malkin's publication undoubtedly prompted it. For Crabb Robinson, with his keen nose for literary gossip, scented in Malkin's biographical sketch the possibility of an *avant-garde* criticism, which he published four years later in a German periodical, the *Vaterländisches Museum:*

> Of all the conditions which arouse the interest of the psychologist, none assuredly is more attractive than the union of genius and madness in single remarkable minds, which, while on the one hand they compel our admiration by their great mental powers, yet on the other move our pity by their claims to supernatural gifts. Of such is the whole race of ecstatics, mystics, seers of visions and dreamers of dreams, and to their list we have now to add another name, that of William Blake! [10]

Crabb Robinson, who as an ambitious student at Jena and Weimar had met many of the leading spirits of German romanticism, was consciously playing on the sympathies of an audience prepared for the idea of insane genius by the *Sturm und Drang* and its aftermath; he was also writing in a foreign periodical, which perhaps explains his apparent callousness in implying that the living Blake was mad and deserving of pity. It is noteworthy that his views on the artist's mental condition were formed long before their first meeting; Hayley, who had by far the stronger personal ground in view of his trying intimacy, avoided the charge while Blake was living at Felpham, although in a letter to Lady Hesketh, dated 15 July 1802, he expressed the fear that:

> the common rough treatment which true genius often receives from *ordinary minds* in the commerce of the world, might not only wound him *more than it should do*, but really reduce Him to the Incapacity of an Ideot, without the consolatory support of a considerate Friend . . . [11]

What is no less significant, Crabb Robinson admits the possibility of doubt *after* talking at length with Blake, whom he first met in 1825: 'Shall I call him artist or genius—or mystic or madman? Probably he is all.'[12]

Probably is not certainly. The underlining in his *Reminiscences*, 'There was nothing *wild* about his look', [13] again suggests the reluctant surprise of a rationalist critic prepared to modify his judgement in the light of experience. He continued to use the epithets 'mad', 'wild' and 'insane', and in 1855, after hearing Gilchrist's plea for considering Blake 'as an enthusiast, not as an *insane* man', wrote in his diary, 'such a question, whether he were or not insane, is a mere question of words . . .'[14]

Robinson's ubiquity in the literary world, and the romantic cult of *mirabilia*, must have greatly promoted the currency of his original view that Blake was a living example of 'the union of genius and madness'. He quotes the famous dictum of Wordsworth after reading the *Songs of Innocence and Experience* (and, one is tempted to add, after talking to the diarist as well) that there was something in the madness of Blake that interested him more than the sanity of Byron and Scott.[15] The poet's reputation, outside his small circle of loyal partisans, was to remain for some time that of a curiosity of literature, but capable of fine things.

A full account of the romantic and post-romantic debate on Blake's madness is outside the scope of this essay. It may be appropriately resumed from the 1863 two-volume *Life of William Blake* by Alexander Gilchrist. When as an undergraduate I asked a tutor to authorize its purchase for the College library, he scribbled a note to the librarian and handed it to me with the comment, 'I'm ashamed to say I have never read it, but I understand it's the worst biography in the English language.' This was at least less authoritative

than the considered verdict of Gilchrist's editor, Mr Ruthven Todd: 'much of the value of Gilchrist's *Life* lies in its irritant power'. [16]

If Gilchrist had been less irritating, he would scarcely have written a biography which has deservedly become a minor classic. For he had the rare virtue of collecting every scrap of evidence on those aspects of Blake which he least understood, and nevertheless admired. His comments on this evidence are those of a scrupulously honest Victorian, and unconsciously but admirably throw into relief the essential character of Blake's genius. All portraiture expresses a situation between two characters, and some of the finest biographies have been written by those who, naturally like Gilchrist, or artfully like Boswell, perform the role of Dr Watson to their hero.

By far the most important source quoted by Gilchrist, and indeed the *locus classicus* for any discussion of the visions, was John Varley. [17] Varley had two great advantages as a witness in Blake's case: he admired the visionary faculty, and he was credulous. He had what has been described as 'a passion for the dubious sciences', and enjoyed as a palmist and astrologer 'the remarkable luck of predicting truly his own misfortunes and those of his friends'. [18] He was completely without any desire to rationalize Blake in order to defend his sanity, a desire which sometimes led the artist's other partisan friends to misinterpret the evidence. Because he believed in Blake's world of spirits, but was not personally visited by them, he records the *ipsissima verba* with the literal fidelity of a true believer in the real presence that he himself has not been permitted to glimpse. Linnell remarks: 'Varley believed in the reality of Blake's visions more than even Blake himself.' [19] As Mona Wilson has pointed out, this implies that

Varley's belief was not fully shared, or shared in the same sense, by the poet. [20]

Varley's evidence reached Gilchrist, as is well known, from two sources. The first was the report published in Varley's lifetime by his friend Alan Cunningham. [21] The former had employed Blake to draw 'the portraits of those who appeared to him in visions', and when he discovered that the artist's visionary power responded to suggestion, he seized the opportunity to collect the images of those historical personages—mainly kings, prophets, heroes and assassins—in whom he was interested as a student of horoscopes. Sometimes the image is linked with an historical event.

The second source is Varley's own account in *A Treatise on Zodiacal Physiognomy* published in 1828. The description of the 'Ghost of a Flea' is one of the most quoted passages in the literature on Blake, but is so essential to this discussion that it must be given in full:

> With respect to the vision of the Ghost of the Flea, seen by Blake, it agrees in countenance with one class of people under Gemini, which sign is the significator of the Flea; whose brown colour is appropriate to the colour of the eyes in some full-toned Gemini persons. And the neatness, elasticity, and tenseness of the Flea are significate of the elegant dancing and fencing sign Gemini. This spirit visited his imagination in such a figure as he never anticipated in an insect. As I was anxious to make the most correct investigation in my power, of the truth of these visions, on hearing of this spiritual apparition of a Flea, I asked him if he could draw for me the resemblance of what he saw: he instantly said, 'I see him now before me.' I therefore gave him paper and pencil, with which he drew the portrait, of which a facsimile is given in this number. I felt convinced by his mode of proceeding that he had a real image before him, for he left off and began on another part of the paper to make a separate drawing of the mouth of the Flea, which the spirit having opened, he was prevented from proceeding with the first sketch, till he had closed it. During the time occupied in completing the drawing, the Flea told him that all fleas were inhabited by the souls of such men as were by nature blood-thirsty to excess, and

were therefore providentially confined to the size and form of
insects; otherwise, were he himself, for instance, the size of a horse,
he would depopulate a great portion of the country. He added, that
if in attempting to leap from one island to another, he should fall
into the sea, he could swim, and should not be lost. This spirit
afterwards appeared to Blake, and afforded him a view of his whole
figure; an engraving of which I shall give in this work. [22]

The main features in Varley's account of the visions can
be corroborated from many contemporary sources. Two
differences, the first of treatment, the second of interpre-
tation, may be noted. The romantic love of *mirabilia* was still
tempered with the gusto and relish, sometimes carried to
humorous lengths, of the eighteenth-century cult of Gothic
horror. The *anecdota* of Blake naturally lent themselves to
this mixture of humour and seriousness, so artfully combined
by Lamb in a passage which recalls Walpole's vivacity in
writing about the marvellous:

Blake is a real name, I assure you, and a most extraordinary man he
is if he be still living. ... He has *seen* the old Welsh bards on
Snowden—he has seen the Beautifullest, the Strongest, and the
Ugliest man left alone from the Massacre of the Britons by the
Romans, and has painted them from memory (I have seen these
paintings), and asserts them to be as good as the figures of Raphael
and Angelo, but not better, as they had precisely the same
retro-visions and prophetic visions with themself [himself]. The
painters in Oil (which he will have it neither of them practised) he
affirms to have been the ruin of art; and affirms that all the while he
was engaged in his Water-paintings, Titian was disturbing him,
Titian, the Ill Genius of Oil-Painting.

His poems have been sold hitherto only in manuscript ... There is
one to a Tiger, which I have heard recited, beginning:

'Tiger tiger, burning bright
Thro' the desarts of the night'

which is glorious. But alas! I have not the book, for the man is
flown, whither I know not—to Hades or a Mad House. But I must
look on him as one of the most extraordinary persons of the age. [23]

The stories circulating as romantic *mirabilia* about Blake
are rich in transitions from the sublime to the ridiculous, and

from the ridiculous to the sublime, also characteristic of contemporary tales of mystery and horror, in which the joke is quickly given a grisly twist, or the macabre a relieving stroke of irony. The difference of interpretation, however, is what concerns us here. Scientific rationalism played a greater part in the romantic movement than is commonly allowed for. Those who knew Blake intimately were deeply convinced of his sanity, and this led them to seek a rational explanation of his visions by attributing them to his 'power of visualising his conceptions for practical purposes'. [24] The likely originator of this theory is John Linnell, who does not record his own opinion of the visionary heads, but does criticize Varley for believing that Blake actually summoned the spirits of the dead to sit for their portraits, in spite of the artist's repeated declaration 'that both Varley and I could see the same visions as he saw—making it evident to me that Blake claimed the possession of some powers, only in a greater degree than all men possessed . . .' [25] Because Linnell obviously did not believe in the power of all men to summon the spirits of the dead, what explanation could he fall back upon other than Blake's heightened power of imaginary visualization, shared, to a greater or lesser degree, by every human being?

Cunningham, who applied to Linnell for assistance in his memoir and knew Tatham, first formulated the theory of imagination in excess. Blake's fancy, he tells us, 'over-mastered him—until he at length confounded the "mind's eye" with the corporeal organ, and dreamed himself out of the sympathies of actual life'. [26] The readiness with which this theory was accepted is a striking instance of romantic rationalism. For the romantic movement, it may be mentioned, produced very few mystics, certainly none of the influential stature of the eighteenth-century Swedenborg. With the immense advance of pure and applied science,

rationalism is even more pronounced in the second half of the nineteenth century.

Gilchrist, in his Chapter XXV, 'Mad or Not Mad?', goes to considerable lengths to defend Cunningham's explanation of Blake's visions, and quotes the opinion of a respectable Swedenborgian acquaintance of the artist, Francis Oliver Finch: 'he was not mad, but perverse and wilful'. [27] Swinburne, who knew Linnell in the latter's old age, devoted a masterpiece of abusive rhetoric to scarifying the doubters of Blake's sanity. [28] But by far the most remarkable rationalist explanation was to come from the heart of the Pre-Raphaelite circle. Dante Gabriel Rossetti had contributed a supplementary chapter to Gilchrist's *Life*; his brother William Michael published twenty-five years later a long and important introduction to the Aldine edition of Blake's *Poetical Works*, dedicated to Lucy Rossetti (Mrs Madox Brown). [29] With considerable independence, in view of Gilchrist's accumulation of personal testimony and his judicial summing-up, and Swinburne's intimidating war-dance, William Michael Rossetti came down cautiously but clearly on the side of insanity. What he described as 'the mad clink of Blake's genius' he found conclusively demonstrated by the apparent rhapsodical incoherence of the prophetic books:

> When I find a man pouring forth conceptions and images . . . into words where congruent sequence and significance of expression or of analogy, are not to be found, then I cannot resist a strong presumption that that man was in some true sense of the word mad. [30]

But Rossetti did not find evidence of insanity in the most likely source, the visions. On the contrary, he supports Blake by asserting their optical reality:

> Blake had a mental intuition, inspiration, or revelation–call it what we will; it was as real to his spiritual eye as a material object could be to his bodily eye: and no doubt his bodily eye, the eye of a designer and painter with a great gift of invention and composition, was far more than normally ready at following the dictate of the spiritual eye, and seeing, with an almost instantaneous creative and fashioning act, the visual semblance of the visionary essence. Blake thus, in a certain not solely metaphysical sense, inevitably *saw* the vision. . . .

> But in fact I have understated it in saying that the mental intuition 'was *as* real to his spiritual eye as a material object could be to his bodily eye'. It was much more real. To Blake . . . the spiritual was the reality, and the physical was the phantom . . . That he had held converse with Milton . . . this was a mental truth, therefore, in the full sense of the word, a *truth*. [31]

Rossetti was prepared to leave open 'the exact degree in which, according to his personal impression and convictions at least, the appearances presented themselves to him spontaneously and unbidden, apart from any self-conscious exercise of imagination or formative power'. [32] With the same caution he records the environmental and physiological conditions which may or may not have favoured the visionary tendency: Blake's peculiar mode of life, his nocturnal industry, the abstemious habits 'to which poverty as well as inclination conduced', his shortsightedness and reluctance to wear glasses, the prominent and brilliant eyes, the lips 'quivering with feeling'.

With one exception, the assumption of a 'spiritual eye' which dictates the optical image, this explanation corresponds with the account of eidetic images given by E. R. Jaensch in his pioneer treatise. [33] Rossetti lists at least three properties claimed for eidetic images by Jaensch: their optical reality, sharpness of retinal definition, and involuntary appearance. Like Jaensch, he admits auto-suggestion under conditions of nervous excitement. Moreover, he comes very close to suggesting a physiological basis.

His careful account of Blake's eyes recalls a passage by the modern psychologist:

> One of the characteristics of this type (with Eidetic Images like Memory Images) are the large eyes. According to the particular personality, they may be lustrous or dreamily veiled; but we can find a continuous transition into those protuberant eyes known as 'protusio bulbi', which are one of the most striking symptoms of Basedow's or Graves' disease. . . .
>
> Individuals of this type are predominantly gracefully built, and have a soft, satin or silky skin with a low resistance to electric currents. The thyroid gland is often enlarged. All these symptoms, or rather their exaggeration, belong to the basedowoid condition. [34]

According to Jaensch, 'optical perceptual or eidetic images are phenomena that take up an intermediate position between sensations and images. . . . Like ordinary physiological after-images, they are always *seen* in the literal sense.' [35] My colleague Professor Oeser, who attended Jaensch's lectures, informs me that on one occasion a student who frequently saw eidetic images was 'visited' by one during the lecture, and applied to a neighbour for materials with which to draw it. Eidetic images may disappear if the attention of the eye is distracted by real objects. More than one anecdote of Blake refers to his calling for materials, which were handed to him by others. In the nocturnal sessions attended by Varley and sometimes Linnell, 'he sat with his pencil and paper ready', which suggests that the image might have been lost by his looking for them. [36] Again, eidetic images sometimes change; so Blake was on at least two recorded occasions forced to abandon a sketch he had begun, and start another.

A full collation of the traits recorded by Blake's 'friends and observers', and those recorded by Jaensch in his clinical investigations, would be outside the scope of this study. Nor is it easy for a layman to determine into which of Jaensch's classifications of eidetic types Blake would most appro-

priately fit. If it is the S-type, then we should at least have a ready-made explanation of what Rossetti regarded as egocentric obscurity:

> The analysis of the S-type brings to light a particularly strong 'artistic' mode of experience, which gives a picture of the world valid only for the individual himself. [37]

Sir John Eccles, F.R.S., has kindly given me some comments on the application of Jaensch's findings to Blake's particular case:

> There is something undoubtedly in the stories that Blake had great power of visual imagery with the curious eidetic ability actually to 'see' these images. I would, however, be cautious about relating this to exophthalmic goitre ... I am prepared to believe that there are great differences in the power of visual imagery apart from thyrotoxicosis and tetany.

> To me there seems to be no real mystery about eidetic imagery from the neurophysiological point of view. All that is required is that the spatio-temporal patterns of activity in the cortex corresponding to some visual experience can be continued after the original picture is no longer being impressed upon the retina; and this we must postulate in relation to any recall of a visual experience. In eidetic imagination this experience is, presumably, more vivid than with ordinary subjects. Hence their statement that they actually 'see' the images. I would imagine that all accomplished pictorial artists had unusual powers of this kind, but Blake would rank as somebody particularly highly endowed in this respect.

Leaving further discussion to the scientifically qualified, we may more profitably return to that memorable phrase of Rossetti which so directly concerns the art historian: 'the bodily eye, and eye of a designer and painter with a great gift of invention and composition'. For whether or not Blake is accepted as an eidetic type in one or other of Jaensch's categories, there can be no doubt that he saw his visions, and saw them in the forms not of nature, but of art. None of the visionary heads could possibly be mistaken for a life-drawing. They have every stylistic attribute of an invention, to a far

greater degree than would be possible in a study of the living model, which was anathema to the artist. Because Blake's visions came to him in the forms of art, not nature, we must now consider briefly the artistic influences to which he was subjected during his boyhood training and early years as an original engraver.

At Par's Academy he was grounded in the academic tradition of linear draughtsmanship. He was next apprenticed to James Basire, who also belonged to the old linear school and was already branded as a conservative by contemporary engravers who were exploiting the painterly style of mezzotint. Basire set Blake to work on drawing Gothic tombs in London and its environs, and used these drawings for his engravings for the antiquary Richard Gough's *Sepulchral Monuments in Great Britain* (1786-96). The linearism of Gothic art is too well known to need comment. During the same period he came under the influence of Michelangelo and the Mannerists, not through paintings, but engravings. Thus the main artistic traditions, including contemporary neoclassicism, that converged on him during his most impressionable years, combined to stock his visual memory with sharply defined linear forms.

The optical reality of the visions involved no act of credence on Blake's part, because the eidetic image is actually seen. Nor did he confuse his visions with the appearance of material objects. But he did believe wholeheartedly that they were revelations of the spiritual world—that is, true images of eternally living spirits. Such spiritual images appeared to him, and he believed could also appear to others, in a linear form which was clearer than the images projected on the retina of the eye by natural objects. The accepted style for representing such phenomena modified by light and shade and the atmospheric envelope was the painterly. But it was no

business of the artist to depict the 'vegetable' world, indeed this was a betrayal of his spiritual mission. The great masters of the painterly style were thus viewed as renegade agents of materialism, which it was the true artist's duty to expose and attack.

Blake, like Hogarth, had been trained as an engraver at a time when one of the chief functions of engraving was to record paintings. Like Hogarth, he had an excellent visual memory, with this difference, that he exercised it, not on nature and art, but almost exclusively on art. He thus acquired an unusually comprehensive knowledge of the historical development of western painting after the invention of engraving. This historical sense, notable also in his other writings, explains the curious and striking way in which his artistic judgements and *obiter dicta* anticipate some of Wölfflin's description of the well-known five sets of perceptual categories elaborated in his *Kunstgeschichtliche Grundbegriffe* (first edition 1915).

According to Wölfflin, the change from the linear to the painterly mode of perception, prepared for in the sixteenth century, was accomplished in the seventeenth. Blake too dates the decisive and, from his point of view, disastrous change from the same epoch. Wölfflin sees in Correggio and Titian foreshadowings of the painterly style which is to culminate in Rubens and Rembrandt. Blake casts Titian, Correggio, Rembrandt and Rubens in the role of the 'outrageous demons' of art history. But by far the most remarkable correspondence is with Wölfflin's concepts of perceptual development. It is scarcely an exaggeration to say that three of his five concepts can be paralleled in Blake's writings on art. It would be hard to demonstrate more convincingly the artist's power of accurate observation and rational analysis than by illustrating this correspondence.

In his introduction and general observations on the first concept of change, Wölfflin prepares the ground and announces the themes that he later elaborates. The key to the correspondence is that when Blake and Wölfflin discuss the linear style, they speak from the common standpoint of appreciation. Later, as Wölfflin progressively unfolds the merits of the painterly style, their value judgements come into conflict.

'Occidental painting,' writes Wölfflin, 'which was draughtsmanly in the sixteenth century, developed especially on the painterly side in the seventeenth century.'[38] 'Painting,' according to Blake, 'is drawing on Canvas,'[39] and later, in denunciation of the painterly Reynolds, he writes, 'What's the first Part of Painting? he'll say: "a Paint Brush".'[40]

> The evenly firm and clear boundaries of solid objects give the spectator a feeling of security, as if he could move along them with his fingers, and all the modelling shadows follow the form so completely that the sense of touch is actually challenged. Representation and thing are, so to speak, identical.[41]

So Wölfflin. Blake describes his own method, and that of the Old Masters before the seventeenth century, as follows:

> Clearness and precision have been the chief objects in painting these Pictures. Clear colours unmuddied by oil, and firm and determinate lineaments unbroken by shadows, which ought to display and not to hide form, as is the practice of the latter schools of Italy and Flanders.[42]

'Firm and determinate lineaments' are opposed to a style where 'All is Chiaro Scuro' and 'there's no such thing' as outline, just as '*die Linearität in ihrer vollen Bestimmtheit*' is contrasted with the painterly style by which '*die tastbaren Flächen sind zerstört*'.[43]

The idea that colour and shadow are used to define form in the linear style, and to obscure it in the painterly, is repeatedly stressed by both writers. According to Wölfflin,

'there is in the classic style no impression of colour which is not bound to an impression of form'. [44] 'The disposition of forms,' writes Blake, 'always directs colouring in works of true art.' [45] In the painterly style, on the other hand, 'a painterly illumination ... will glide over the form and partially veil it'. [46] So Blake attacks Correggio's love of 'soft and even tints without boundaries' and Rubens's 'Swell'd limbs, with no outline that you can descry'. [47]

According to the fourth concept of change, multiplicity or distinctness of parts becomes unity: in the linear style 'the component part ... is still felt as an independently functioning member', whereas in the painterly style there is 'nothing separable, nothing that could be isolated'. [48] Blake writes: 'For Real Effect is Making out the Parts, & it is Nothing Else but That.' [49] *'Das plastische und konturierende Sehen isoliert die Dinge, für das malerisch sehende Auge schliessen sie sich zusammen.'* [50] So far from such merging of multiple objects being a valid effect for the painter to strive for,

> These are the Idiot's chiefest arts,
> To blend & not define the Parts.[51]

By the fifth concept, absolute clarity becomes relative clarity: 'The more tonal relation there is,' writes Wölfflin, 'the more easily will the process [of the combination of colours detached from things] be accomplished.' [52] 'One species of General Hue over all,' writes Blake, 'is the Cursed Thing call'd Harmony; it is like the Smile of a Fool.' [53]

Now it is Wölfflin, now Blake who uses the emphatic phrase in describing the painterly revolution. *'Zertrümmer-ung der Linie'* [54] is more forceful than Blake's 'broken lines' [55] or the translator's 'break-up of line'; whereas the artist's censorious description 'the unorganized Blots & Blurs of Rubens & Titain,' [56] if compared with *'lauter Flecken'* and

'unzusammenhängende Zeichnung'[57] is—if not stronger—characteristic in its passionate rejection.

Blake's judgements of artists are extraordinarily consistent. They are based exclusively on perceptual approach and on style, never on the artist's religious or political ideas, or his personal conduct, except in the case of the living. No less consistent is his denunciation of the painterly style. He may cast doubts on its efficacy in depicting nature, but he accepts the accurate representation of natural appearance as its aim. Whether they succeed or not, all painterly artists are damned by their intention.

If there is an Old Master by whom we would expect him to be attracted on ideological or personal grounds, it is surely Rembrandt. But Rembrandt's greatness as a religious painter is for Blake completely obscured by his natural vision.

To proceed from the concrete judgements to general theory is to enter the heart of Blake's theology. Apart from the complexity of his theological views, there are certain limits to any rationalization of mystical experience. It is only claimed for the following remarks that they may help to clarify a single aspect of his theory of art, namely, the strictly limited extent to which it is based on the eidetic image, without reference to the debatable ground of its physiological conditions and categories.

Stress has been laid on the historical conditioning of the artist to the linear mode of perception. According to Sir Herbert Read, the first to draw attention to the importance of Jaensch for the student of Blake, the 'intuitive introvert' expresses himself in art by emphasizing 'structural form', more precisely defined as 'a "stylisation" of a theme, a perception of pattern *in* the natural object'.[58] This conclusion is not incompatible with the foregoing explanation, which it supports by implying that Blake would have rejected

the contemporary version of the painterly style even if he had been brought up in it. Natural phenomena may be accepted as an indirect source of his visual imagination. He himself practised something like the famous exercise recommended by Leonardo, by which natural forms are used to suggest images. But this is not quite the same thing as 'the perception of pattern in the natural object', which implies a greater degree of fidelity to the model and is contrary to his doctrine of emancipation from the vegetable world. Blake is first and foremost an artist of 'abstract imaginings'—abstract, that is, in the sense of apart from concrete material phenomena; after leaving Par's Academy he separated himself from the overwhelming majority of contemporary figure-painters by ceasing altogether to draw from the model or the world of external reality.

The vision, and not vision, becomes the artistic pre-occupation of his life. According to the valuable analysis by Schorer, Blake distinguished between several varieties of vision, of which four main categories may be deduced from his writings.[59] The first is natural vision, that is, simple sensation, which he uniformly condemned in a work of art and identified with 'Newton's single vision'. The second is twofold vision, the perception of spiritual forms in material objects:

> With my inward Eye 'tis an old Man grey;
> With my outward, a Thistle across my way.

The third order of vision resembles hallucination. The fourth is 'an extremely vivid mental impression that had no external representation at all'. Schorer follows the romantic rationalists in deriving most of Blake's poetry and pictures from this kind of vision. 'Most important,' he adds, 'it was the vividness of his mental conceptions that gave the poet the

conviction of revelation, which laid upon him the obligation of working as a "literalist of the imagination".' [60]

There is undoubted justification of this analysis in the quotations that Schorer assembles. Nor need we quarrel with the statement that most of the paintings derive from the fourth category. But it is the third category that surely gave 'the conviction of revelation' which he carried over to the second and fourth. However much the eidetic image may have later responded to auto-suggestion, or to the promptings of others, the visions that appeared to him in his childhood were involuntary. They were generally associated with moments of ecstatic happiness, and they came to him in the form of angelic revelations. He accepted them as such at the time, and never deviated from this simple faith. The stylistic language of the imaginary visualizations was the same as that of the visions, as may be seen by comparing the Visionary Heads with his illustrations. We have already demonstrated that style was for Blake an essential and absolute test of spiritual truth, overriding any other evidence to the contrary, even in the case of an artist of Rembrandt's profound spiritual insight.

The central role of style in Blake's theory of art is logically defensible from his own premisses. It explains his consistent denunciation of artists as different as Rembrandt and Reynolds. It is enough for a painter simply to fall within Wölfflin's second great stylistic division for him to stand revealed as an outrageous demon. It also explains the wide range of his visual interests within the linear tradition, and their influence on his art. Sculptures from Persepolis and the works illustrated in Edward Moor's *Hindu Pantheon* (1810), no less than Gothic tombs and Mannerist engravings, bear for him the unmistakable imprint of spiritual revelation, for their authors too were 'literalists of the imagination'. Nothing can

be less mystic than the conventional art of late eighteenth century neo-classicism, but Blake is prepared to accept its most fashionable exponents, until Flaxman and Stothard appear on personal grounds in their true light as 'false friends'.

Unlike the Visionary Heads, the inventive compositions were often finalized after careful revision; many tentative drawings survive, and tremulous pencil outlines may be detected behind some of his most finished work in ink or water-colour. Nor does he always remain faithful to his first conception. But the final image was so powerfully visualized that it too was accepted as an inspiration.

Sir Anthony Blunt in two masterly studies [61] and (more recently) Dr Ursula Hoff in her succinct and penetrating introduction to a publication of the Melbourne illustrations to Dante [62] have elucidated the sources of Blake's pictorial imagination. In the first, Blunt's starting point is Blake's borrowings: 'It is a peculiar testimony to the immense power of his invention that when he borrows from others he invariably makes of what he takes something wholly his own.' [63] It is sometimes profitable in reading or writing about a dead artist to ask oneself the question: What would he say if he were alive and could criticize this statement? Blake would have been hostile to any rationalist interpretation of his art; but he would not, I think, have objected to the extraordinarily apt illustrations that Blunt has grouped round some of his masterpieces. It is conceivable that he might tell us that he had never seen Cranach's woodcut of the Were-Wolf, and that his memory would not have been at fault. He might have seen a figure deriving from Cranach, or simply an old man playing parlour games on his hands and knees. But he could only have approved the selection of artists with whom his name is linked, and so far from denying

the resemblances would possibly have regarded them as further evidence of the communion of saints.

In so far as the term 'borrowing' might suggest the conscious use of a source in the hands of a less cautious writer than Blunt, it could be very misleading. Blake did not advocate the practice of copying in order to appropriate the inventions of others; he was acutely sensitive to the charge of plagiarism, and never takes over an entire or unaltered image. There are in fact very few borrowings so close that they must have been deliberate. In general his attitude is the opposite to that of Reynolds, who consciously borrowed attitudes either to elevate his composition or to play wittily on a pictorial or sculptural association. [64]

The student of Blake's sources must therefore be prepared to allow for the unconscious influence of his visual experience on invention, even when the resemblances are striking. The 'Ancient of Days' combines two stock motives that he probably knew from Mannerist sources; but the result of their combination is so different from the two engravings by Pellegrini Tibaldi reproduced by Blunt that it is difficult to believe that his invention would not have been hampered by having the originals, or drawings from them, before him. The same unconscious alchemy may be seen at work in the 'Angels Hovering over the Body of Jesus' [Illustration 77]. The general conception is not unlike that of the tomb of Aveline, Countess of Lancaster and widow of Edmund Crouchback, in Westminster Abbey [Illustration 78]. In each case the recumbent figure is surmounted by an arch which frames a stark recess.

> . . . Hovering high over his head
> Two winged immortal shapes . . .
> . . . they bent over the dead corse like an arch. [65]

To realize the image of the arch in the opposing curve of the angels' wings Blake has drawn on the pointed trefoil, of

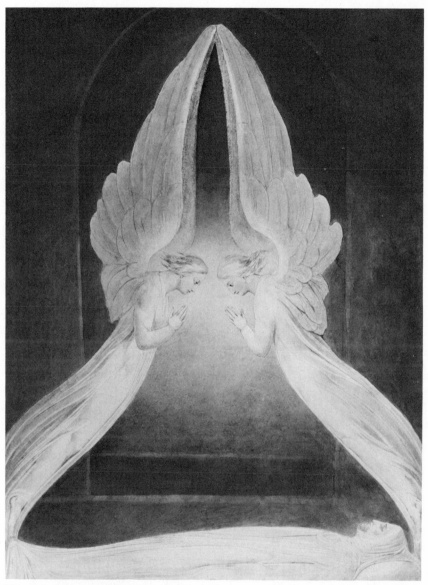

77. Blake, ⁰ "Angels Hovering over the Body of Jesus." Mr. and Mrs. Esmond Morse
Collection.

79. Gough, *Sepulchral Monuments*, detail of the tomb of Bishop Aquablanc of Hereford (engraving).

78. Monument of Aveline, Countess of Lancaster, in Westminster Abbey.

80. Gough, *Sepulchral Monuments*, detail of the tomb of Aymer de Valence in Westminster Abbey (engraving).

which he had seen both steep and ogee examples in the Abbey and Gough's *Sepulchral Monuments* [Illustrations 79, 80].[66] The horizontal body of Christ, with its linear sweep of drapery and head raised on a pillow but not tilted by it, similarly recalls a well-known type of recumbent effigy on Gothic tombs, again common in London [Illustrations 81, 82].

Because the fusion of images may be part of an unconscious process, it is dangerous to identify a particular source where many possibilities may be adduced. But the synthesis of Gothic forms is here unmistakable, and how astonishingly beautiful is their transformation into the 'fearful symmetry' of Blake's own moment of vision!

A paper commenced in Melbourne during the centenary year of Blake's birth and in Sir Daryl Lindsay's honour would be incomplete without some illustrations taken from the great Dante series. No one has done more than Lindsay to spread Blake's reputation in Australia; indeed, during his period as Director, the Dante illustrations became a symbol of his belief in the aristocratic nature of art, and were used

on more than one occasion to silence trustees who dared to oppose a costly purchase as 'lacking in popular appeal'.

As is well known, the National Gallery of Victoria acquired the largest single share (thirty-six) when the one hundred and two water colour drawings were sold in London in 1918.[67] The Felton Adviser who recommended their purchase was Robert Ross, who died on 5 October, a few months after their purchase and before the criticism occasioned by their first exhibition in Melbourne, although the price, £3,000 sterling, was hardly as excessive as the public was led to believe. The drawings have never been exhibited continuously and their exposure to light has been cautiously controlled, so that the colours are exceptionally well preserved. The Curator of Prints, Dr Ursula Hoff, is well known among students of Blake for her vigilant care and for the unselfish way in which she is ready to place her researches into these masterpieces at their disposal. Although I have tried to acknowledge specific indebtedness, it is harder to estimate the benefit gained from discussion of Blake problems over a number of years, and in particular for the encouragement and advice received in writing this paper.

Besides seeing visions, Blake also heard voices. An English novelist whom no one could describe as insane has recently used in fictional form his own experience of hearing voices after taking a powerful sedative of chloral and bromide

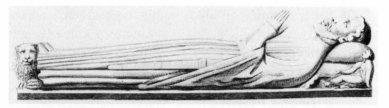

81. Gough, *Sepulchral Monuments*, detail of the monument of the Oteswick Family (engraving).

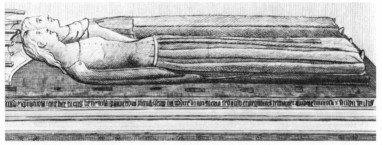

82. Gough, *Sepulchral Monuments*, detail of the monument of Richard II and Queen Anne (engraving).

over a long period. To quote the publisher, 'the reason remains strenuously active but the information on which it acts is delusory'. [68] To Blake, voice and images were equally the record of revelation. His literary faculty was as highly developed as the artistic, and few artists have turned from one medium of expression to the other more naturally or with a stronger sense of their complementary role. To the 'literalist of the imagination' in both spheres Dante's text was so sacred that in his old age Blake learned Italian rather as a biblical scholar might learn Hebrew.

Dr Hoff has published a revealing instance of the way in which his visual imagination was stimulated by his reading. [69] In the *Inferno*, Canto XXXI, 136-45, Dante uses two metaphors: 'he refers to the giant Antaeus as a tower when a cloud is going over it, and also as the mast of a ship':

> *Qual pare a riguardar la Garisenda*
> *sotto 'l chinato, quando un nuvol vada*
> *sovr'essa si, che ella incontro penda;*
> *tal parve Anteo a me che stava a bada*
> *di vederlo chinare, e fu tal ora*
> *ch' i' avrei voluto ir per altra strada.*
> *Ma lievemente al fondo che divora*
> *Lucifero con Giuda, ci sposò;*
> *né, si chinato, li fece dimora,*
> *e come albero in nave si levò.* [70]

Of these three images—the tower, the cloud and the mast—only the cloud is represented in the illustration of 'Antaeus setting down Dante and Virgil in the Lowest Ring of the Inferno' [Illustration 83]. But the other two also influenced the visual realization. The mast-like vertical of the outstretched arm, from which curves have been almost eliminated, dominates the composition. The most curious feature of the illustration is the attitude of the giant. He does not kneel or stoop, but leans sideways. What is the explanation of this leaning posture, which is both against nature and without any iconographical precedent? The answer is to be found in Dante's text, including the commentary: the tower of the Garisenda is the *leaning* tower of Bologna.

The spectator is forced to turn sideways to read the awe-inspiring countenance of Antaeus, and in doing so we see from a second base line his massive torso and head partly circumscribed by the sailing cloud, which seems to gather speed as it moves from left to right (or from bottom to top if we return to the original base line). According to Dante's combination of images, the leaning tower then 'rose, as in a bark the stately mast' and the whole form finally assumes the verticality of the arm.

The device by which Blake forces us to see the composition from two base lines, namely, the vertical arm and the horizontal head with the cloud on the same axis, powerfully reinforces the idea of movement by making the onlooker go through the same motion as the giant.

It is to be hoped that an art historian who has attempted to master Blake's wide reading and visual experience of works of art will one day attempt the exegesis that his illustrations to Dante deserve. [71] I have suggested that the artistic derivations should not be studied in isolation from the literary ones. But there is one purely stylistic

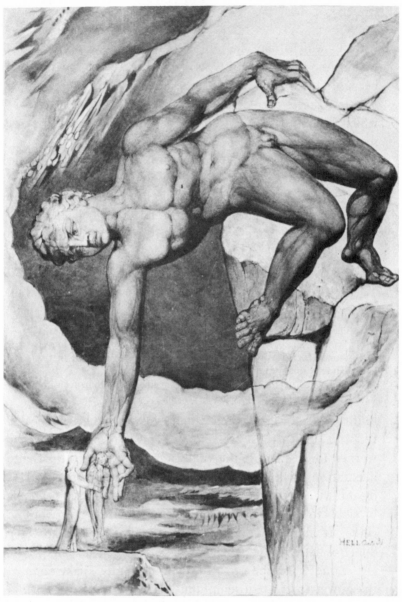

83. Blake, "Antaeus Setting Down Dante and Virgil." Watercolor, 52.5 x 37 cm.
Melbourne, National Gallery of Victoria, Felton Bequest.

feature which may be noted here, both because it distinguishes these illustrations from his earlier work and because it may be related to one of his most memorable eidetic images, the 'Ghost of a Flea'. This is the extent to which his latest work was influenced by the direct study of sculpture.

G. K. Chesterton is seldom quoted by students who have worked in one or other of the many fields to which he gave his somewhat superficial attention. But he had been trained as an artist, and in his little book on Blake there is a passage in which the gold of observation may be detected beneath the purple of his rhetoric:

> A figure, naked and gigantic, is walking with a high-shouldered and somewhat stealthy stride. In one hand the creature has a peculiar curved knife of a cruel shape; in the other he has a sort of stone basin. The most striking line in the composition is the hard curve of the spine, which goes up without a single flicker to the back of the brutal head, as if the whole back view were built like a tower of stone. The face is in no sense human. It has something that is aquiline and also something that is swinish; the eyes are alive with a moony glitter that is entirely akin to madness. The thing seems to be passing a curtain and entering a room. [72]

'Built like a tower of stone': the image would have appealed to Blake. His earliest commission, and the one on which he worked longest before the kindly Linnell suggested the Dante illustrations, had been to make drawings from sculpture. This meant that when he came to study classical sculpture he brought to it an eye already trained in the properties of stone. It also meant that he was better able to read three dimensionally Mannerist engravings after Michelangelo.

Long before he came to illustrate Dante, Blake revealed the power to create a sculptural image. He retains to the end the Gothic and neo-classical conventions of the linear silhouette and frontality. But within the circumscribing line, his treatment of the third dimension can be astonishingly

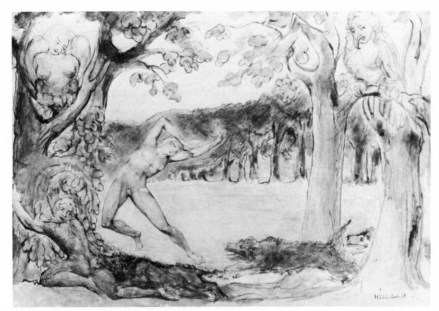

84. Blake, "The Hell Hounds Hunting the Destroyers of Their Own Goods in the Forest of Harpies." Watercolor, 37 x 52.5 cm. Melbourne, National Gallery of Victoria, Felton Bequest.

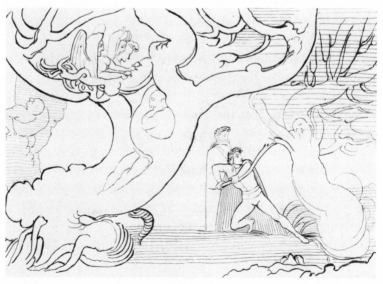

85. John Flaxman, "The Forest of Harpies," from *Compositions from the Hell, Pergatory and Paradise of Dante Alighieri.*

monumental. Flaxman was a sculptor. If we compare two scenes from Dante rendered by both Flaxman and Blake [Illustrations 84-87], Blake reveals at least as plastic an imagination.

It is understandable that art historians should have been attracted first by the pictorial sources of Blake's art, although sculptural ones have not been overlooked by Blunt. Engravings provide the most obvious and indeed the richest field for investigation. His treatment of the anatomical figure is strongly influenced by Mannerist and neo-classical models which he must have known from engravings. But the sheer monumental impact of the 'Ghost of a Flea' remains to be accounted for. How did he learn to render the bulk of flesh and muscle between the Herculean shoulders? Why was Chesterton prompted to describe the whole back view as 'built like a tower of stone'?

There is something that suggests Oriental influence about the 'high-shouldered and somewhat stealthy stride' of the monster. It is known that Blake studied engravings after Persian reliefs, and he may well have seen originals as well. The model for the head was probably a pictorial one. But the monster is a Hercules figure in some essential points of structure, and the rendering of mass is more classical than anything else.

An eidetic image, then, appeared to Blake, not merely as a kind of living sculpture, but in a shape suggested by antiquity. If we accept the argument that he was predisposed to the direct influence of classical sculpture by his early training, then we have at least one guiding thread through the labyrinthine course of his artistic evolution. The formula that Blake begins as a Gothic artist and ends as a classical one would be an over-simplification. The two strands are interwoven from the outset, and many others—contemporary,

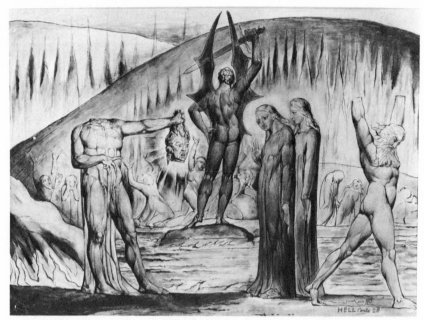

86. Blake, "The Schismatics and Sowers of Discord." Watercolor, 37 x 52.5 cm. Melbourne, National Gallery of Victoria, Felton Bequest.

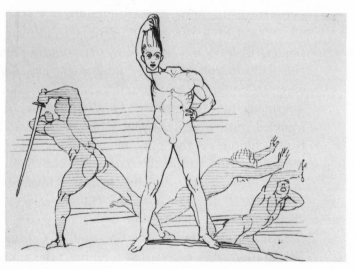

87. John Flaxman, "The Schismatics and Sowers of Discord," from *Compositions from the Hell, Purgatory and Paradise of Dante Alighieri.*

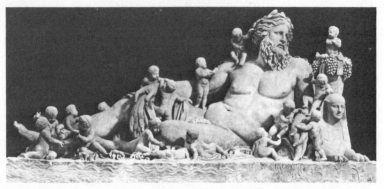

88. "Personification of the River Nile." Statue in the Vatican, Braccio Nuovo.

Mannerist and Oriental—must be taken into account. More-
over, he never surrenders himself completely to the classical
tradition. But the Dante illustrations have always been
recognized as standing in a separate category from the rest of
his work, and it is precisely at this point that we find the
richest evidence of his debt to antiquity.

The debt is particularly noticeable in his monumental
figures. Blake could have known the Vatican statue of the
Nile [Illustration 88] both from engravings and a marble
copy, to say nothing of countless baroque versions. His own
'Capaneus the Blasphemer' [Illustration 89] cuts off the
rounded outline as decisively as a pair of scissors. But how
truly sculptural is the immobile body, and the gravity of the
third dimension within the outline! [73] The 'Symbolic Figure
of the Course of Human History' [Illustration 90] is
conceived as an Apollo Helios [Illustration 91], in which
Michelangelesque inspiration is blended with that of the
Colossus of Rhodes. [74] The She-wolf of Canto 1, verse 49
[Illustration 92] similarly combines the image of the
Capitoline Wolf [Illustration 93] with other classical proto-
types, all of which he could have seen in the Townley

Collection. Today only a part of this immensely influential collection can be exhibited in the British Museum; to gain an adequate idea of its range we must turn to the early illustrated catalogue. [75] Here we find many prototypes of Blake's spiritual bestiary, notably the lion and the griffin. In his first illustration to Dante [Illustration 92] the head of the lion [Illustration 94] may be instructively compared with two engravings from the Townley catalogue [Illustrations 95, 96]. Blake, who was illustrating the lines:

> *ma non sì, che paura non mi desse*
> *la vista, che m'apparve, d'un leone*

required a frightening image. As the Dante scholar Omero Schiassi once pointed out to me, Dante's *terribilità* was alien to the English mystic's Miltonic demonology. Nevertheless in this instance the expressive eyes, characteristic of many of

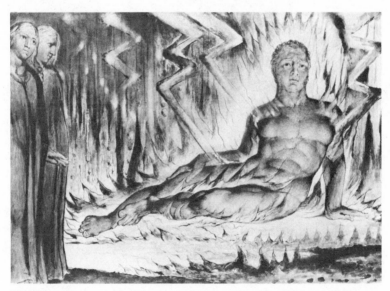

89. Blake, "Capaneus the Blasphemer." Watercolor, 37 x 52.5 cm. Melbourne, National Gallery of Victoria, Felton Bequest.

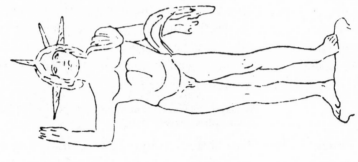

91. "Apollo Helios," from Reinach, *Répertoire de la statuaire.*

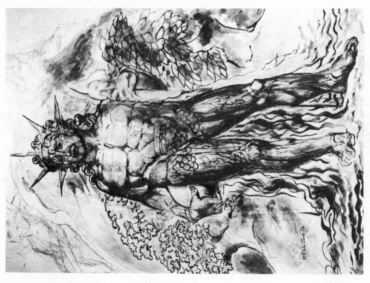

90. Blake, "The Symbolic Figure of the Course of Human History." Watercolor, 52.5 x 37 cm. Melbourne, National Gallery of Victoria, Felton Bequest.

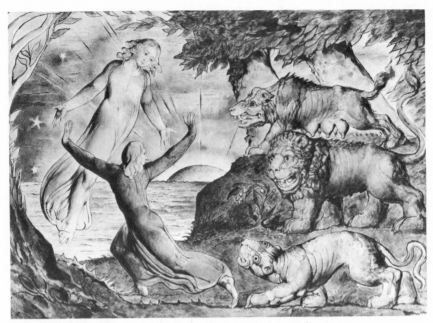

92. Blake, "Dante Running from the Three Beasts." Watercolor, 37 x 52.5 cm. Melbourne, National Gallery of Victoria, Felton Bequest.

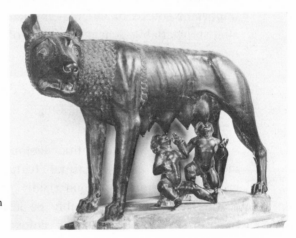

93. Statue of the Roman she-wolf. Rome, Museo Capitolino.

Blake's animals, recall the latter example, while the physical features are closer to the former.

The warning against seeking to identify a precise source needs to be repeated, for he could have known similar examples outside the Townley Collection, or from engravings. Whatever the sources, the monumental rendering can only be explained by the direct impact of classical sculptures, and may be further illustrated by the parallels between Blake's 'Cacus' [Illustration 97] and the Hellenistic Centaur [Illustration 98], and his 'Simoniac Pope' and the Egyptian Tumbler in the Townley Collection [Illustrations 99, 100]. Doubtless in many cases the iconographic motive was fixed in his memory by an engraving. If so, the addition of rigidly monumental gravity becomes even more remarkable.

One further detail, and I shall have finished with the attempt to demonstrate this point. The line engravings that illustrate Moor's *Hindu Pantheon*, which is a particularly important source of Oriental influence on his later art, are almost invariably schematic. One of the most terrifyingly memorable images is that of the Hindu goddess Durga, consort of Siva, who stands frontally against a geometric background [Illustration 101]. The demoniac motif of bared teeth, beneath which a long tongue extends, recurs in Blake's 'Lucifer' [Illustration 102].

The classical and Gothic versions of this motif lack the most startling and unnatural feature of Durga's fearful grimace, the horizontal and rigidly geometric row of front teeth. Here one may possibly be justified in pointing to a precise source. But Blake's colossal image assumes the monumental forms of a classical god, not an Oriental one.

The romantic discussion of genius in its relation to nature constantly recurs to the theme of the image. Neither

94. Blake, "Dante Running from the Three Beasts," detail. Melbourne, National Gallery of Victoria, Felton Bequest.

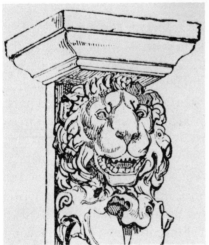

95. Head of a lion, from Ellis, *The Townley Gallery*.

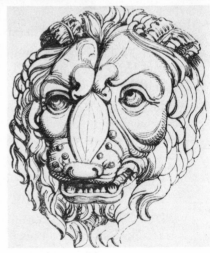

96. Head of a lion, from Ellis, *The Townley Gallery*.

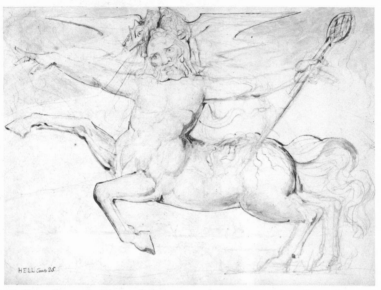

97. Blake, "Cacus." British Museum.

the Platonic idea of the divine archetype nor the Aristotelian view of nature as aesthetic norm satisfied the impulses on the one hand to idealism and on the other to observation. Blake's spiritual imagery is never naturalistic. If Bowles had directed his strictures against the living artist instead of the dead poet, he would at least have been arguing a clear-cut case for, as Byron pointed out so effectively, the poetry of Pope is rich in images drawn from daily visual experience of the natural world and society.[76] Proto-romanticism may be defined as the early expression of romantic attitudes within the stylistic conventions that the romantic artist later felt committed to attack. Blake, for all his formal inventiveness, drew widely on contemporary neo-classicism and the occidental and oriental traditions of linear art. Similarly, Phoebus frequently fired

his vocal rage in accents of which Pope would have cordially approved.

The aura of madness may perhaps have served to protect the visionary's reputation in a century which rediscovered Smart and admired Clare. [77] But the new subjective humanism was tinged with a noble agony of doubt alien to Blake's theology. Wordsworth, who at least preferred mythical paganism to pessimistic doubt, worked out his creed in solitary communion with nature. The artist who saw a world in a grain of sand, and heaven in a wild flower, led the renaissance of wonder from the vanguard of the great tradition in art. 'To Reynolds' Aristotelian view of nature Blake opposes a purely neo-Platonic doctrine.' [78] Perhaps no artist of major stature has moved with greater range, intensity and exclusiveness in the world of ideal imagery. For this reason, the full appreciation of his art is the consummate reward of study in the wide fields of which he was visual master.

98. Statue of a young centaur. Rome, Museo Capitolino.

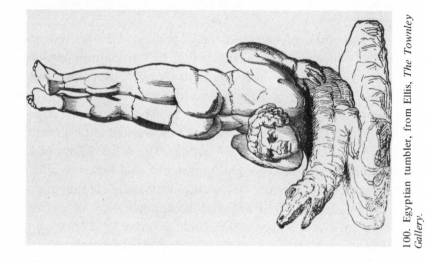

100. Egyptian tumbler, from Ellis, *The Townley Gallery.*

99. Blake, "The Simoniac Pope." Tate Gallery.

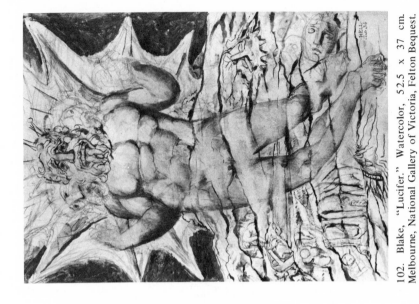

102. Blake, "Lucifer." Watercolor, 52.5 × 37 cm. Melbourne, National Gallery of Victoria, Felton Bequest.

101. Durga, consort of Siva, from Moor, *The Hindu Pantheon.*

NOTES

1. By W. L. Bowles in the life prefixed to *The Works of Alexander Pope* (London: J. Johnson, 1806), I, [xiv]-cxxxiv, and Dr. B. H. Malkin in the Dedicatory Epistle to Thomas Johnes of Hafod prefixed to Malkin, *A Father's Memoirs of his Child* (London: Longman, Hurst, Rees, and Orme, 1806), p. xxiv.

2. Alexander Gilchrist, *Life of William Blake* (London and Cambridge: Macmillan, 1863), 2 vols., and the studies of Dilke, Croker, Elwin and Courthope.

3. *Lives of the English Poets*, ed. George Birkbeck Hill (Oxford: Clarendon Press, 1905), III, 251.

4. In the eulogy of Mr. B— (Charles Lamb) in the Imaginary Conversation "Of persons one would wish to have seen" in the *New Monthly Magazine*, 20 (Jan., 1826), in *Collected Works of William Hazlitt*, ed. A. R. Waller and Arnold Glover (London: Dent, 1904), XII, 31-32.

5. Both the *Dictionary of National Biography* and *Chambers's Cyclopaedia of English Literature*, ed. David Patrick (London and Edinburgh: Chambers, 1902), II, 721 give a considerable proportion of space to the controversy, which the latter describes as having "a profound historic significance and influence." Many later writers on Pope have touched on the romantic debate, but good general accounts are still those in W. Elwin and W. J. Courthope, *The Works of Alexander Pope* (London: John Murray, 1871-1889), V, Chap. 16, "Pope's place in English literature," and H. A. Beers, *History of English Romanticism in the Nineteenth Century* (New York: H. Holt, 1926), pp. 48-89.

6. "A Vision of the Last Judgment" (K 617, E 555).

7. "Annotations to Reynolds" (K 446, E 626).

8. D. G. Rossetti, in his supplementary chapter to Gilchrist, *Life of Blake*, I, 368-384, strongly criticizes Blake's refusal to draw from nature.

9. Quoted by Mona Wilson, *Life of William Blake* (London: Rupert Hart-Davis, 1948), p. 8.

10. Quoted by Wilson, pp. 286-89, from K. M. Esdaile's translation and article "An Early Appreciation of William Blake," with interesting comments on Blake's early reputation in Germany, in *The Library*, 4 (July, 1914), 229-56. Crabb Robinson's article was published anonymously "Aus dem Englischen" under the title "William Blake, Künstler, Dichter und religiöser Schwärmer" in the *Vaterländisches Museum*, Erster Band, 1 (Jan., 1811), 107-31. In the *Diary, Reminiscences, and Correspondence of Henry Crabb Robinson*, ed. Thomas Sadler (London: Macmillan, 1869), I, 299 Crabb Robinson states that the article was prompted by Malkin's account, was written in the spring of 1810, and that the translator was Dr. Julius (cf. Geoffrey Keynes, *A Bibliography of William Blake* [New York: Grolier Club, 1921], p. 371).

11. Morchard Bishop, *Blake's Hayley* (London: Gollancz, 1951), p. 278.

12. *Henry Crabb Robinson on Books and their Writers*, ed. Edith J. Morley (London: Dent, 1938), I, 325.

13. Quoted by Wilson, p. 288.

14. Morley, II, 752.

15. Quoted by Wilson, p. 288, from *Blake, Wordsworth, Lamb, etc. being Selections from the Remains of Henry Crabb Robinson*, ed. Morley (London: Dent, 1922), p. 18.

16. Gilchrist, *Life of Blake*, ed. Ruthven Todd (London: Everyman's Library, 1942, revised ed., 1945), p. ix. All references are to the edition of 1945.

17. Gilchrist, *Life of Blake*, ed. Todd, Chap. XXVIII, "John Varley and the Visionary Heads."

18. Wilson, p. 270.

19. Wilson, p. 274, quoting from Alfred T. Story, *The Life of John Linnell* (London: Richard Bentley, 1892), I, 160.

20. Wilson, p. 274.

21. *Lives of the Most Eminent British Painters, Sculptors and Architects* (London: John Murray, 1829-1833), 6 vols. The account of Blake appeared in vol. II, 1830, pp. 142-79, and was revised and expanded in the second ed., 1830-1833, II, pp. 143-188.

22. Quoted in full by Wilson, p. 344.

23. Letter to Bernard Barton, 15 May 1824, in *The Works of Charles and Mary Lamb*, ed. E. V. Lucas (London: Methuen, 1905), VII, 642.

24. Wilson, p. 275.

25. Wilson, p. 274.

26. Cunningham, II, 178.

27. *Life of Blake*, ed. Todd, p. 320.

28. Algernon Charles Swinburne, *William Blake, a Critical Study* (London: John Camden Hotten, 1868).

29. *The Poetical Works of William Blake*, ed. with a prefatory memoir by W. M. Rossetti (London: Bell and Sons, 1874), pp. ix-cxxxiii.

30. *Works of Blake*, ed. W. M. Rossetti, p. lxxxix; see also p. xciv.

31. *Works of Blake*, ed. W. M. Rossetti, pp. lxii-lxiii.

32. *Works of Blake*, ed. W. M. Rossetti, pp. lxiv-lxv.

33. *Eidetic Imagery and Typological Methods of Investigation*, trans. O. Oeser (London: Kegan Paul, 1930).

34. Jaensch, p. 32.

35. Jaensch, p. 1.

36. Cunningham, II, 168.

37. Jaensch, p. 113.

38. P. 18. Quotations in English are from Heinrich Wölfflin, *Principles of Art History*, trans. M. D. Hottinger (New York: G. P. Putman's Sons, 1929); in German from the *Kunstgeschichtliche Grundbegriffe*, Zehnte Auflage (Basel, 1947-1948).

39. "Public Address" (K 594, E 563).

40. From the *Notebook* (K 553, E 507).

41. Wölfflin, p. 21.

42. *A Descriptive Catalogue* (K 564, E 521).

43. "To Venitian Artists" from the *Notebook* (K 554, E 507); Wölfflin, pp. 65, 34.

44. Wölfflin, p. 53.

45. *A Descriptive Catalogue* (K 580-81, E 536).

46. Wölfflin, p. 20.

47. *A Descriptive Catalogue* (K 583, E 538); from the *Notebook* (K 546, E 505).

48. Wölfflin, pp. 161, 156.

49. "Annotations to Reynolds" (K 450, E 629).

50. Wölfflin, p. 25.

51. From the *Notebook* (K 547, E 505).

52. Wölfflin, p. 203.

53. "Annotations to Reynolds" (K 478, E 651).

54. Wölfflin, p. 45, in translation p. 32.

55. "Annotations to Reynolds" (K 464, E 641).

56. "Public Address" (K 596, E 565).

57. Wölfflin, p. 34.

58. *Education through Art* (London: Faber and Faber, 1949), pp. 139, 145. For a discussion of Jaensch, Hogarth, and Blake see pp. 42-49. Read was also the first to discuss (in the same work) the theories of Victor Löwenfeld, later accepted by Leonard Adam, *Primitive Art* (London: Penguin, 1954), as particularly relevant to the art of primitive peoples.

59. Mark Schorer, *William Blake: the Politics of Vision* (New York: Henry Holt, 1945), pp. 5ff.

60. Schorer, p. 7.

61. "Blake's Pictorial Imagination," *Journal of the Warburg and Courtauld Institutes*, 6 (1943), 190-[facing] 212, and *The Art of William Blake* (New York: Columbia Univ. Press, 1959).

62. Ursula Hoff, *William Blake's Illustrations to Dante's Divine Comedy*, Special Bulletin for the Centenary

Year, 1961 (Melbourne: The National Gallery of Victoria, 1961).

63. "Blake's Pictorial Imagination," p. 190. The first writer to point to the various models used by Blake was C. H. Collins Baker, "The Sources of Blake's Pictorial Expression," *Huntington Library Quarterly*, 4 (1940-1941), 359-367.
Ed.: The essay by Baker is reprinted in this volume.

64. "Humanitätsidee und heroisiertes Porträt in der Englischen Kultur des 18. Jahrhunderts," *Vorträge der Bibliothek Warburg*, 1930-1931 (Leipzig and Berlin: B. G. Teubner, 1932), pp. 156-229.

65. *The Four Zoas*, Night 8, lines 6-7, 13 (K 341, E 357).

66. (London: T. Payne and G. G. and J. Robinson, 1796), III, 85, pl. 2.

67. Inventory Stock Book of National Gallery of Victoria, Book 3, Nos. 988-1023. See also A. S. Roe, *Blake's Illustrations to the Divine Comedy* (Princeton: Princeton Univ. Press, 1953), p. 5.

68. Evelyn Waugh, *The Ordeal of Gilbert Pinfold* (London: Chapman and Hall, 1957), publisher's note.

69. *Masterpieces of the National Gallery of Victoria* (Melbourne: National Gallery of Victoria, 1949), p. 93.

70. *La Divina Commedia*, testo critico della Societa Dantesca Italiana Riveduto (Milan: Hoepli, 1929), *Inferno*, Canto XXXI, lines 136-45.

71. A. S. Roe's learned study concentrates on literary rather than iconographic sources.

72. G. K. Chesterton, *William Blake*, Popular Library of Art (London: Duckworth and New York: Dutton, [1910]), p. 153.

73. For a "pictorial" source to Blake's "Capaneus" see Hoff, *Blake's Illustrations to Dante's Divine Comedy*, p. 2, note 27.

74. See Hoff, *Blake's Illustrations to Dante's Divine Comedy*, p. 2, note 23.

75. Sir Henry Ellis, *The Townley Gallery of Classical Sculpture in the British Museum* (London: British Museum, 1836), 2 vols.

76. *Works of Lord Byron*, ed. Thomas Moore (London: John Murray, 1832), VII, 230-31.

77. Cf. Laurence Binyon, "The Case of Christopher Smart," *English Association Pamphlet No. 90* (London: Oxford Univ. Press, 1934), and John and Anne Tibble, *John Clare, his Life and Poetry* (London: Heinemann, 1956).

78. Blunt, "Blake's Pictorial Imagination," p. 208.

BLAKE'S "GOD JUDGING ADAM" REDISCOVERED
by
Martin Butlin

*T*here are two particular problems concerning William Blake's large colour-prints of 1795: first, whether their at first sight disparate subjects can be related to a single unifying theme, and, secondly, whether there was originally a thirteenth design to supplement the twelve which can be traced at present. A recent discovery at the Tate Gallery seems to answer the second question and may help to clarify the first.

That the twelve designs known today, usually in more than one version, represent the full extent of Blake's scheme is supported by a letter of 9th June 1818, in which he offered Dawson Turner '12 Large Prints, Size of Each about 2 feet by 1 & ½, Historical & Poetical, Printed in Colours'.[1] Another set had already been sold by Blake to his great

Ed.: Reprinted by permission of the publisher from *The Burlington Magazine*, 107 (1965), 86, 89.

patron Thomas Butts, eight titles being recorded in a debtor-creditor account between them under 5th July and 7th September 1805,[2] while examples of eleven of the twelve known designs can be traced back to the Butts Collection. These include three of the four titles noted under 5th July 1805, 'Good & Evil Angels', 'House of Death' and 'Lamech', all now in the Tate Gallery, and the four titles listed under 7th September 1805, 'Nebuchadnezzar', 'Newton', 'God Creating Adam', and 'Christ Appearing', of which the first three are in the Tate while the fourth seems to be the version in the Yale Gallery of Fine Arts. Three further works in the Tate, *Hecate, Pity*, and the print hitherto known as *Elijah*, also come from the Butts Collection, as does the version of *Satan exculting over Eve* now belonging to John Craxton. Butts may not, however, have had a print of the twelfth known design, *Naomi entreating Ruth and Orpah to return to the land of Moab*, as he had already bought a water-colour of this subject in 1803.[3]

There remains the fourth title listed in Blake's account with Thomas Butts under 5th July 1805, 'God Judging Adam'. No work of this title can be traced to the Butts Collection nor does it appear in any of the Butts sales, and, though it is mentioned by William Rossetti in the first edition of Alexander Gilchrist's *Life of William Blake*, 1863, the fact that it is listed as 'From Mr Butts' with a reference to the 1805 account suggests that Rossetti's source was the account rather than any direct knowledge of the print.[4]

Although many of the large colour-prints have been trimmed all the prints from the Butts Collection in the Tate Gallery retain much if not all of the original margin of the paper on which the design was printed. This can be as much as five inches wide in some cases and usually bears a title, written in pencil in an early hand, almost certainly Blake's

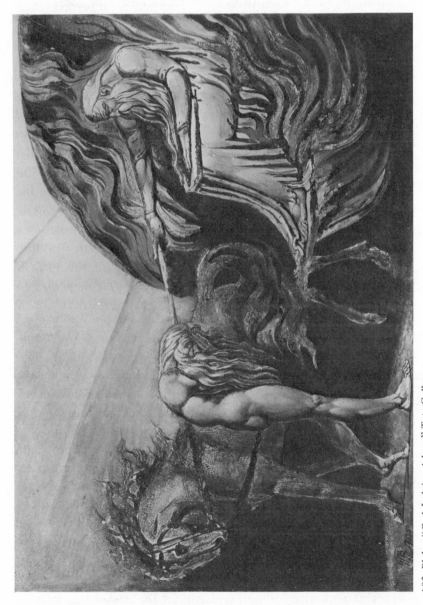

103. Blake, "God Judging Adam." Tate Gallery.

own. Six such inscriptions have been known for some time[5] but a seventh, very indistinct and possibly at one time erased, has only just been recognized. This is on the print usually known as *Elijah* and consists of four words. The first is 'God', the last 'Adam', and the third almost as clearly 'to'. The second word, taking into account the grammatical context as well as the apparent formation of the letters, seems to read 'speaking'.[6] 'God speaking to Adam'—this lacks the pungency of 'God Judging Adam' in the 1805 account, but a similar disparity, though working in the opposite sense in point of emphasis, occurs between the 'God Creating Adam' of the 1805 account and the title 'Elohim creating Adam' written on the margin of that design.

The title *Elijah* does not appear in the 1805 account, nor does it occur until nearly sixty years later, when it was used almost simultaneously in a Sotheby's sale catalogue of 29th April 1862 and in Rossetti's lists. The sale, anonymous but almost certainly of works from the collection of Blake's executor Frederick Tatham, included as lot 189 'Elijah about to ascend in his Chariot, *a large design in colour'*. This title was canonized by William Rossetti in his lists published the following year, the version then in the possession of Mrs Alexander Gilchrist being catalogued as 'Elijah mounted in the Fiery Chariot'.[7]

Once given this title was superficially appropriate enough and it is impossible to think of the inscription 'God speaking to Adam' having been made after it came into common usage in 1862-3. Even if not written by Blake, which seems most probable, the inscription must therefore reflect the opinion of its first owners, the Butts family.

Moreover once recognized this original title, particularly in the stronger form of the 1805 account, accords much better with the forbidding mood of the design [Illustration

103]. Sir Anthony Blunt, who has come closest to a convincing interpretation of the series of prints and their interrelationships, was forced to confess that 'The relation of the *Elijah* to the whole group is slightly different', seeing in it a modicum of optimism and hope as the portrayal of the continuity of the poetic tradition, handed on by Elijah to Elisha.[8] Unlike others of the series for which a visual parallel can be found among the characters of Blake's own mythology there is no resemblance between the supposed figure of Elijah and Los, Blake's embodiment of the Poetic Genius.

But, as *God Judging Adam*, the parallel becomes obvious: Urizen, whom Blake associated with the unillumined Jehovah of the Old Testament, imposes his law on Adam who stands before him transformed into his own image. The scene, and in particular the flames hitherto identified as belonging to Elijah's chariot, echoes the text of chapters II and III of *Urizen*, of which the first copies were made in 1794, the year before the date inscribed on the print.[9] Here the voice of Urizen is heard declaiming the message of 'the Book of eternal brass':

> 'Laws of peace, of love, of unity,
> of pity, compassion, forgiveness;
>
>
>
> One command, one joy, one desire,
> One curse, one weight, one measure,
> One King, one God, one Law';

whereupon 'All the seven deadly sins of the soul' appear 'In the flames of eternal fury'. The version of the print in the collection of Mrs William T. Tonner, in which the flames burn darkly against the black sky, echoes the passage a few lines later:

> 'But no light from the fires: all was darkness
> In the flames of Eternal fury.'

There is even a pictorial parallel in the illustration at the head of the page containing these last lines. This shows Urizen, surrounded by flames, holding the book of eternal brass, a design contrasted to that of the flame-girt youthful figure, possibly Orc, at the head of chapter I. [10]

There is an earlier form of the composition of the large colour-prints, the somewhat tentative water-colour in the collection of Mr George Goyder which can be dated to the early 1790's. [11] In this the so-called Elijah is seated in a chariot of clouds, only a red glow overhead anticipating the flames of the colour-prints. This would seem to offer conclusive proof that the flames in the prints are not those of inspiration, transmitted by the Prophets of the Old Testament, but those of 'eternal fury', introduced by Blake into the colour-printed version of the design to reinforce his depiction of Urizen's imposition of a rigid moral code. The print thus takes its place as one of a series in which Blake chose various subjects from the Bible, literature, and his own imagination to illustrate his very individual views on the Fall and Salvation, deliberately finding in these subjects parallels to the events and characters of his own writings.

NOTES

1. K 867.

2. Geoffrey Keynes, ed., *The Writings of William Blake* (London: Nonesuch Press, 1925), II, 298.

3. K 824, 826; E 698.

4. (London and Cambridge: Macmillan, 1863), II, 208, "List No. 1. Works in Colour," No. 66. Rossetti also lists, II, 232, List No. 1, No. 203, a "Judgment.

Colour-printed. Presumably to be a '*Last* Judgment'; or, possibly, the 'Judgment of Paris,' [Rossetti's] No. 89 (?)." This entry, under which Rossetti makes no mention of ownership, may reflect a faint memory of the existence of the colour-printed "God Judging Adam," a memory sufficiently imprecise for Rossetti to fail to equate it with the item in the 1805 account; this failure was made easier by the fact that, as will be shown below, the print was by 1863 masquerading under another title.

5. "Elohim creating Adam," "Nebuchadnezzar," "New-ton," "Lamech and his two Wives," "The Good and Evil Angels," and "House of Death Milton." See Martin Butlin, *William Blake: A Complete Catalogue of the Works in the Tate Gallery* (London: Tate Gallery, 1971), pp. 34-41, Nos. 14, 16, 17, 18, 23, and 22. The Tate's copies of "Hecate" and "Pity" are definitely not inscribed with titles while the Tate's "Christ appearing to the Apostles after the Resurrection," which is not from the Butts Collection, has had its margin trimmed.

6. I am grateful to Mr. G. E. Bentley, Jr. for confirming this tentative reading. The other two versions of the print, in the Metropolitan Museum, New York [Illustration 2], and the collection of Mrs. William T. Tonner, have been trimmed (reproduced in *Burlington Magazine*, 100 [1958], 45, Illustrations 4 and 5 respectively).

7. II, 203, List 1, No. 21. Rossetti's entry also mentions the version in the Butts Collection and a third, presumably that sold by Tatham the year before.

8. Anthony Blunt, *The Art of William Blake* (New York: Columbia Univ. Press, 1959), p. 61.

9. K 224-25, E 71-72.

10. Both designs are reproduced in the Blake Trust's facsimile of the copy of *Urizen* in the Lessing J. Rosenwald Collection, but this copy, like three others of the known seven copies, omits plate 4 with most of the text referred to above.

11. Reproduced in Geoffrey Keynes, *William Blake's Illustrations to the Bible* (Clairvaux: Trianon Press for the Blake Trust, 1957), No. 64.

"A MOST OUTRAGEOUS DEMON":
BLAKE'S CASE AGAINST RUBENS

by

Edward J. Rose

Most critical studies of Blake make some brief reference to his opinions of Rubens and Venetian and Flemish artists, but very little is said in detail about why Blake reacted as he did. It is not the purpose of this essay to justify Blake's opinions or to defend Rubens, but to organize these opinions and show how they are related to Blake's poetic theory and his vision of the artist. As a critic Blake often indulges in overstatement. For him criticism is not an objective or scholarly discipline, but instead the means by which he can assert the point of view, often frustrated through lack of a public, which moved him as a creative being. His opinions of other artists are essentially independent of the paintings that were immediately available to him; the habit of many of his critics and commentators,

Ed.: Reprinted by permission of the author and publisher from *Bucknell Review*, 17 (March, 1969), 35-54.

who go out of their way to show that Blake had little firsthand knowledge of the work of many of the painters he admired or disliked misses the point. Blake's opinions about painters are not based on purely aesthetic considerations. For Blake "True" art, and *True* is his word, cannot be concerned with trivia or with self-seeking; it cannot lack prophetic vision. A "true" or "real" artist who creates true and real art must be himself true and real. Rubens did not measure up to Blake's view of the artist any more than Dryden and Pope measured up to his idea of the poet, or Locke, Newton, and Bacon to his conception of the wise man. By attacking Rubens and what Rubens represented, Blake attacked what he considered the pictorial equivalent of Augustan poetry and English empiricism.

Rubens became for Blake the chief symbol of that "class of artists, whose whole art and science is fabricated for the purpose of destroying art."[1] Much more than Reynolds or Rembrandt, Rubens came to represent all in art that Blake most loathed, for Rubens was everything, as a man and as an artist, that Blake was not. His case against Rubens, therefore, is as important to his work as his case against Locke.[2] Rubens the man as well as Rubens the artist was suspect to Blake. In his *Note-Book*, he first wrote:

> Rubens had been a Statesman or a Saint
> He mix'd them both, & so he Learn'd to Paint.

Revising the lines by changing the speaker of the verses to Rubens himself, Blake then wrote:

> I, Rubens, am a Statesman & a Saint.
> Deceptions? O no—so I'll learn to Paint.[3]

The revisions are interesting because they indicate that Blake was convinced Rubens was a conscious manipulator, who with cold calculation chose the career of a painter to better

his place in this world. In a word—"Deceptions?"—Blake implies that Rubens was incapable of commitment either to his nation or to art.

Blake's case against Rubens is built in part on his reading of Reynolds' "Discourses," his resentment of Reynolds' praise of Rubens, his suspicions about Rubens' motives, his objections to Rubens' influence (especially in England), and his belief that Rubens was a conscious adversary of the Roman and Florentine schools of painting:

> You must agree that Rubens was a Fool,
> And yet you make him master of your School
> And give more money for his slobberings
> Than you will give for Rafael's finest Things.[4]

This broadside "To English Connoisseurs" which Blake ends with a neat parallelism about Christ being a carpenter and not a "Brewer's Servant" sums up briefly his distaste for what he calls "Venetian & Flemish ooze." As I have already said, this kind of criticism is not altogether a matter of aesthetics.[5]

Throughout Blake's criticism Rubens is the artistic opposite of Raphael. Raphael was "Sublime, Majestic, Graceful, Wise" and Rubens "Low, Vulgar, Stupid, Ignorant."[6] Rubens is not only bad and a dangerous painter, he is a professional sycophant. From what Blake knew of both Rubens' work and his life, he came to believe that Rubens *sacrificed* (a more Blakean word than prostituted) his art by offering himself on the altar of Empire. If there was any doubt about Rubens' motives, so far as Blake was concerned, it was only necessary to look at his paintings for the damning evidence of artistic prostitution. To Blake, Rubens was a "Slobbering Joe" and the head of a "Slobbering School"[7] not only because of his stylistic excesses, but also because he was a deceiver and pretender who sought patronage and satisfied patrons with excessive flattery. Rubens' florid style,

his "wet" drawing, and his questionable reputation (so far as Blake was concerned) as a colorist, made him an obstacle to "all power of individual thought"[8]; he had sold out to Empire and induced any artist influenced by his work to imitate him. Rubens was, therefore, ironically as well as literally, a "Statesman"—a willing tool of the political oppressors of Europe—and a "Saint"—a hypocritical supporter of the Establishment. Rubens' "pretence" like Reynolds' was an abomination of the holy and his painting a kind of harlotry. Rubens was, again like Reynolds, "at all times Hired by the Satans for the Depression of Art—A Pretence of Art, To destroy Art." Whether either man, the Flemish courtier or his English imitator, "knew what he was doing" meant little to Blake: "the Mischief is the same whether a Man does it Ignorantly or Knowingly."[9] Rubens belonged to the same party as Reynolds, the party of Burke, Bacon, Newton, and Locke,[10] hence Reynolds' praise.

The cycle of twenty-one paintings, huge canvases, now in the Louvre, celebrating the life of Marie de Medici, at whose invitation Rubens visited Paris from 1622 to 1625, bears out Blake's mistrust of Rubens' motives and the inevitable sacrifice of his art to the hiring Satans of Europe's commercial and political empires. If we once look at Rubens, the man and his work, especially the Marie de Medici cycle, through Blake's eyes, it is difficult to disagree with his sharp critical rebuke of the combination of artistic cliché, dead allegory, and swollen flattery in Rubens' painting. Even the most impartial judge cannot but agree that Rubens' work is often servile. Blake was hardly impartial:

> Rubens's Luxembourg Gallery is Confessed on all hands to be the work of a Blockhead: it bears this Evidence in its face; how can its Execution be any other than the Work of a Blockhead? Bloated Gods, Mercury, Juno, Venus, & the rattle traps of Mythology & the lumber of an awkward French Palace are thrown together around

Clumsy & Ricketty Princes & Princesses higgledy piggledy. . . . If all
the Princes in Europe, like Louis XIV & Charles the first, were to
Patronize such Blockheads, I, William Blake, a Mental Prince, should
decollate & Hang their Souls as Guilty of Mental High Treason. [11]

Blake's description of Rubens' work is not unlike his
description of those demonic "Swell'd & bloated General
Forms" which he says in *Jerusalem* (43[38]:91) are "repug-
nant to the Divine-Humanity who is the Only General and
Universal Form," those swelled and bloated forms that are
also contrasted with "Minute Particulars." Rubens' flattery
of the kings and princes of empire and his reliance upon a
dead and hackneyed one-dimensional allegory are enough
singly to earn Blake's censure. When yoked together they
roused Blake to speak in his harshest tone. Rubens' "Bloated
Gods" and "Clumsy & Ricketty Princes & Princesses"
combine to destroy and depress by a "Pretence of Art" not
only art but also liberty and religion (*Jerusalem* 43[38]).
About the worshippers of bloated gods or bloated forms or
bloated empires, Blake can only ask, "Can I speak with too
great Contempt of such Contemptible fellows?"

Charles the First knighted Rubens when the painter
visited England in 1629-30, at which time he was also given
an honorary M.A. by Cambridge University and com-
missioned to paint the ceiling of the Banquet Hall in
Whitehall. [12] In less than forty years, Rubens produced about
3,000 paints, which is why Frye briefly calls attention to
Rubens as a symbol for a factory in Blake's poetry. "The
output of Rubens is explained by the fact that he employed
'Journeymen': that is, 'Rubens' means a factory rather than
an individual artist." [13] Blake's case against Rubens, however,
is based on all that he takes Rubens to stand for as an artist
and as a man. Rubens is seen as a chosen emissary of
Empire. [14] All his life Rubens was a court painter, and when

he was appointed painter to the court of the Archduke
Albert, Rubens instituted Titian's system and employed a
great body of students and assistants to help produce those
3,000 paintings. This "Prince of Painters and fine gentle-
man," as his contemporary, Sir Dudley Carleton, character-
ized him, was also a multi-lingual diplomat, who as a
"statesman" on missions to Spain in 1628, gained additional
commissions for paintings.

 In addition to his dislike of Rubens the courtier and
flatterer, Blake, who held a very modern and certainly
Romantic view of the artist as an inspired individual, could
never come to accept the work of any artist who employed
subordinates to mass produce works of art in order to satisfy
the demands of moneyed and political interests. Besides
lacking originality and uniqueness, such work, Blake felt, was
not suitable for copying by young artists.[15] Rubens was,
therefore, only the Venetian all over again, and stands
condemned with Titian, Correggio, Veronese, and the entire
Venetian school: "The Labour'd Works of Journeymen
employ'd by Correggio, Titian, Veronese & all the Venetians,
ought not to be shewn to the Young Artist as the works of
original Composition any more than the Engravings of
Strange, Bartolozzi, or Woollett. They are Works of Manual
Labour."[16] These "Labour'd Works," therefore, are equiva-
lent to the industrial slavery of eighteenth-century England
which is repeatedly condemned in Blake's long prophetic
poems.[17] "All Rubens's Pictures are Painted by Journeymen
& so far from being all of a Piece, are The most wretched
Bungles."[18] Besides being the products of wage-slavery and
lacking originality and uniqueness, Rubens' paintings also
lack unity.

 Blake's dislike of Rubens, Rembrandt, or the Flemish
and Venetian schools arises in part from his reaction to

Reynolds' unwillingness to separate subject from design and drawing from coloring. It is not that the Venetian "does not understand Drawing," but that "he does not understand Colouring. How should he? he who does not know how to draw a hand or a foot, know how to colour it?"[19] This is a rather tricky argument since it implies more than it says.

> Nature & Art in this together Suit:
> What is Most Grand is always most Minute.
> Rubens thinks Tables, Chairs & Stools are Grand,
> But Rafael thinks A Head, a foot, a hand.[20]

Rubens does not draw the right things the right way because he does not think the right things:

> Colouring does not depend on where the Colours are put, but on where the lights and darks are put, and all depends on Form or Outline, on where that is put; where that is wrong, the Colouring never can be right; and it is always wrong in Titian and Correggio, Rubens and Rembrandt. Till we get rid of Titian and Correggio, Rubens and Rembrandt, We shall never equal Rafael and Albert Durer, Michael Angelo, and Julio Romano.[21]

Blake accepts Reynolds' summary, "the Flemish school, of which Rubens is the head, was formed upon that of the Venetian. . . ."[22]

When discussing his own painting of "The Ancient Britons," Blake couples Rubens and the Venetians again, saying in one of his most incisive remarks that despite their reputations as colorists, "their men are like leather, and their women like chalk." Blake's criticism here is not simply concerned with the artist's vision of man, which includes his attitude to nature, imagination, and the character of human life and existence; it also betrays Blake's Romantic attitude to the man of modern civilization as compared to the man of the heroic past idealized by many of Blake's contemporaries:

> The flush of health in flesh exposed to the open air, nourished by the spirits of forests and floods in that ancient happy period, which

history has recorded, cannot be like the sickly daubs of Titian or
Rubens. Where will the copier of nature, as it now is, find a civilized
man, who has been accustomed to go naked? Imagination only can
furnish us with colouring appropriate, such as is found in the
Frescos of Rafael and Michael Angelo: the disposition of forms
always directs colouring in works of true art. As to a modern Man,
stripped from his load of cloathing [sic], he is like a dead corpse.
Hence Rubens, Titian, Correggio and all of that class, are like leather
and chalk; their men are like leather, and their women like chalk,
for the disposition of their forms will not admit of grand colouring;
in Mr. B's Britons the blood is seen to circulate in their limbs; he
defies competition in colouring.[23]

Although Blake had occasion to engrave after Rubens as
he did after Raphael, he says quite outright in his annotations
to Reynolds' "Discourses": "I am happy I cannot say that
Rafael Ever was, from my Earliest Childhood, hidden from
Me. I Saw & I Knew immediately the difference between
Rafael & Rubens."

> Some look to see the sweet Outlines
> And beauteous Forms that Love does wear.
> Some look to find out Patches, Paint,
> Bracelets & Stays & Powder'd Hair.[24]

"The Florid Style," he says, "such as the Venetian & the
Flemish, Never Struck Me at Once nor At-All."[25] His reading
of Reynolds' "Discourses" provided him with critical
opinions which strengthened his case against Rubens, for
Reynolds in his fifth "Discourse" chose to contrast Rubens
and Poussin in such a way that he provided Blake with a
twofold summary of the characteristics of the painting of
these two artists that convinced Blake that his own critical
preferences rather than those of Reynolds were correct. Here
was the Flemish school juxtaposed with the Roman, a latter
day version of the differences, as Blake saw them, between
the Venetians and the Florentines or, in literary matters,
between Dryden and Pope on one hand, and Shakespeare and
Milton on the other. Blake's reactions to Reynolds' critical

delineations of Rubens and Poussin are important, but, perhaps, of even more importance are the points which Reynolds raises since they provide us with a clear picture not only of what Reynolds saw but what Blake responded to in the work of the two painters. Reynolds writes that Rubens and Poussin have each gained a reputation for opposite accomplishments and that each possesses a manner entirely his own. Rubens, for instance, is an especially fine example of a painter whose achievements stem from his weaknesses as well as his strengths. In everything he does we see the whole Rubens; whether we examine his paintings in detail and in part or generally and in collections, we see the same mind at work. While complimenting Rubens on his invention, the "richness of his composition," the "Luxuriant harmony and brilliancy of his colouring," Reynolds implies that Rubens' want of "purity and correctness" in drawing is essential to his greatness. "In his Composition his Art is too apparent. His figures have expression, and act with energy but without simplicity or dignity. His colouring, in which he is eminently skilled, is, notwithstanding, too much of what we call tinted." To what Reynolds calls Rubens' "florid, careless, loose and inaccurate style," he contrasts Poussin's "simple, pure and correct style." Like Rubens, Reynolds contends, Poussin is consistent in his art, and although he does not recommend that Poussin be imitated, he does admire him for his "remarkable dryness of manner" which distinguishes his style and lends an air of the antique to his best work. His "favourite subjects . . . were Ancient Fables" and "no painter was ever better qualified to paint such subjects"; he "seemed to think that the style and language in which such stories are told is not the worse for preserving some relish of the old way of painting which seemed to give a general uniformity to the whole, so that the mind was thrown back into antiquity

not only by the subject but the execution." He compliments
Poussin for his ability to personify mythic figures in a
manner unlike, by implication, many of the Greek and
Roman gods in eighteenth-century landscapes. His final point
is of particular importance to Blake: "If the Figures which
people his pictures had a modern air or countenance, if they
appeared like our countrymen, if the draperies were like
cloth or silk of our manufacture, if the landscape had the
appearance of a modern view, how ridiculous would Apollo
appear instead of the Sun; and an Old Man, or a Nymph with
an urn, to represent a River or a Lake."[26]

The contrast established by Reynolds permits Blake to
annotate the fifth "Discourse" according to his own prefer-
ences. While abhorring all that Reynolds admires in Rubens,
Blake is able to use Reynolds' seemingly objective assess-
ments of both painters against what he considers Reynolds'
fundamental position.

Blake's annotations to the fifth "Discourse" are con-
sistent with the drift of his commentary throughout his copy
of Reynolds' work. After stating that "All Rubens's Pic-
tures are Painted by Journeymen & so far from being all
of a Piece, are The most wretched Bungles,"[27] Blake goes on
to record one of his most scathing indictments of Rubens'
painting: "To my Eye Rubens's Colouring is most Contemp-
tible. His Shadows are of a Filthy Brown somewhat of the
Colour of Excrement; these are fill'd with tints & messes of
yellow & red. His lights are all the Colours of the Rainbow,
laid on Indiscriminately & broken one into another. Al-
together his Colouring is Contrary to The Colouring of Real
Art & Science." When Reynolds juxtaposes Poussin with
Rubens, Blake replies: "Opposed to Rubens's Colouring Sr
Joshua has placed Poussin, but he ought to put All Men of
Genius who ever Painted. Rubens & the Venetians are

Opposite in every thing to True Art & they Meant to be so; they were hired for this Purpose."²⁸ This indictment of Rubens ends with reference again to Rubens' conscious and willing effort to destroy and depress art in order to satisfy his employers—the hiring Satans of Empire. Rubens destroyed the rainbow-covenant as surely as Newton.

> Rubens is a most outrageous demon, and by infusing the remembrances of his Pictures and style of execution, hinders all power of individual thought: so that the man who is possessed by this demon loses all admiration of any other Artist but Rubens and those who were his imitators and journeymen; he causes to the Florentine and Roman Artist fear to execute; and though the original conception was all fire and animation, he loads it with hellish brownness, and blocks up all its gates of light except one, and that one he closes with iron bars, till the victim is obliged to give up the Florentine and Roman practice, and adopt the Venetian and Flemish.²⁹

Reynolds' remarks on Poussin earn from Blake three exclaimed single word approvals, "True," and a final summary statement, "These remarks on Poussin are Excellent." In the seventh "Discourse" when Reynolds says Poussin is not to be imitated, a point implied in the fifth "Discourse," Blake retorts, "Reynolds's Eye could not bear Characteristic Colouring or Light & Shade. . . Some Men cannot see a Picture except in a Dark Corner."³¹ In the eighth "Discourse" when Reynolds extends his contrast of Rubens and Poussin to a contrast of Rembrandt and Poussin, saying, "Rembrandt's manner is absolute unity . . . Poussin . . . has scarce any principal mass of light at all . . . ," Blake answers, "Rembrandt was a Generalizer. Poussin was a Particularizer."³² Whereas Reynolds says that Poussin is "distinguished for simplicity" and Rembrandt "for combination," Blake again replies, "Poussin knew better than to make all his Pictures have the same light & shadows. Any fool may concentrate a light in the Middle."³³ Reynolds'

continuing contract of Poussin with Rubens and Rembrandt permits Blake in his annotations to establish his own preferences in a clear and consistent manner. The point of light in Rembrandt goes with the "Excrement" that fills the rest of the canvas in a "Filthy Brown" shadow. Like Rubens, Rembrandt generalizes and his colouring "only promotes Harmony or Blending of Colours one into another." It "takes away the possibility of Variety." As in Titian, "Such Harmony of Colouring is destructive of Art. One species of General Hue over all is the Cursed Thing call'd Harmony: it is like the Smile of a Fool."[34] Opposed to the generalizing power of Rubens and Rembrandt is the particularizing power of Poussin.[35] Poussin's light comes into the painting like the natural light of day. It is not a Satanic "white Dot."[36] It does not artificially light one spot but truly unifies the picture with an antique glow. Poussin's drawing and hence his colouring is not loose or soft. He has Blake's "wirey" and "bounding line." His figures are statuesque and heroic, "ancient" or "antique." They are archetypal and definite, with distinct outline. And all his colors, shade, and background are determinate. Everything in Poussin's work makes his painting seem admirable to Blake and worthy of imitation. The fact that Reynolds contrasts Poussin with both Rubens and Rembrandt only convinces Blake that he was right and Reynolds wrong in their respective comparative assessments of the Roman and Flemish schools. Poussin was a hardworking, self-educated artist, and no court painter. As a contemporary of Rubens, he deliberately chose to go against Rubens and the Venetian tide. His figures, like Blake's, so Blake thought, belong to a heroic age and a view of man that did not create men of leather and women of chalk. Furthermore, he did not celebrate Empire for personal advancement.

Rubens' and Titian's methods (their "Machination") turn art into a "Machine" or "Mill" not only because they mass-produce journeymen paintings, thereby creating an artistic parody of industrial slavery in which the workers "Kept Ignorant" only "view a small portion & think that All" (*Jerusalem* 65), but also because they have invented that "infernal machine called Chiaro Oscuro [sic]":

> These Pictures [numbers 7, 8, and 9 in Blake's exhibition], among numerous others painted for experiment, were the result of temptations and perturbations, labouring to destroy Imaginative power, by means of that infernal machine called Chiaro Oscurio, in the hands of Venetian and Flemish Demons, whose enmity to the Painter himself, and to all Artists who study in the Florentine and Roman Schools, may be removed by an exhibition and exposure of their vile tricks. They cause that every thing in art shall become a Machine. They cause that the execution shall be blocked up with brown shadows. They put the original Artist in fear and doubt of his own original conception ... tormenting the true Artist, till he leaves the Florentine, and adopts the Venetian practice, or does as Mr. B. has done, has the courage to suffer poverty and disgrace, till he ultimately conquers. [37]

Elsewhere Blake writes, "He who makes a design must know the Effect & Colouring Proper to be put to that design & will never take that of Rubens, Rembrandt or Titian to turn that which is Soul & Life into a Mill or Machine." [38]

The point is clearly made: To Blake, Venetian and Flemish painting is mechanical and without vision. Once again, as in *Jerusalem*, Blake directs his attack at Augustan critical dispositions. [39] Rubens' stereotyped combination of allegorical cliché and his flattering portraits of his rickety patrons as exalted beings, stem from the same highly mechanical and artificial aesthetics as do the poems of Dryden and Pope, whose works reveal a kind of literary pandering similar to that of the Venetian and Flemish demons.

I tell how Albion's Sons, by Harmonies of Concords & Discords
Opposed to Melody, and by Lights & shades opposed to Outline,
And by Abstraction opposed to the Visions of Imagination,
By cruel Laws, divided Sixteen into Twelve Divisions. . . .

and thus depress and destroy Jerusalem in Albion and art in
England (*Jerusalem* 74). In *A Vision of The Last Judgment*,
Blake warns that: "We are in a World of Generation & death, &
this world we must cast off if we would be Painters such as
Rafael, Mich. Angelo & the Ancient Sculptors; if we do not cast
off this world we shall be only Venetian Painters, who will be
cast off & Lost from Art."[40] "There is just the same science
in Lebrun or Rubens, or even Vanloo, that there is in Rafael
or Mich. Angelo," there is "not the same Genius. Science is
soon got; the other never can be acquired, but must be
born."[41] Rubens lacks the Poetic Genius as do Pope and
Dryden. The vision and imagination of Milton, the poet-
prophet, is not the "Niggling & Poco-Pen" of Dryden:

> An Example of these Contrary Arts is given us in the Characters of
> Milton & Dryden as they are written in a Poem signed with the
> name Nat Lee, which perhaps he never wrote & perhaps he wrote in
> a paroxysm of insanity, in which it is said that Milton's Poem is a
> rough Unfinish'd Piece & Dryden has finis'd it. Now let Dryden's
> Fall & Milton's Paradise be read, & I will assert that every Body of
> Understanding must cry out Shame on such Niggling & Poco-Pen as
> Dryden has degraded Milton with. But at the same time I will allow
> that Stupidity will Prefer Dryden, Because it is in Rhyme &
> Monotonous Sing Song, Sing Song from beginning to end. Such are
> Bartolozzi, Woolett & Strange.[42]

And such are (by implication) Reynolds, Rembrandt, and
Rubens so far as their opinions on painting are concerned.
The "Monotonous Sing Song" of Dryden is the same
"Monotony" found in the "Pictures of Rubens & Rem-
brandt." Blake's attack is directed equally at the monotony
of color "produced with Rubens' light and shadow, or with
Rembrandt's, or anything Venetian or Flemish. The Venetian
and Flemish practice is broken lines, broken masses, and

broken colours. Mr. B.'s practice is unbroken lines, unbroken masses, and unbroken colours. Their art is to lose form; his art is to find form, and to keep it. His arts are opposite to theirs in all things."[43] Blake's attack on pictorial monotony is related to his criticisms of poetic monotony and the "Monotony" of point-of-light painting in particular.

> There is not, because there cannot be, any difference of Effect in the Pictures of Rubens & Rembrandt: *when you have seen one of their Pictures you have seen all.* It is not so with Rafael, Julio Roman[o], Alb. d[urer], Mich. Ang. Every Picture of theirs has a different & appropriate Effect. . . . Most Englishmen, when they look at a Picture, immediately set about searching for Points of Light & clap the Picture into a dark corner. This, when done by Grand Works, is like looking for Epigrams in Homer. A point of light is a Witticism; many are destructive of all Art. One is an Epigram only & no Grand Work can have them.[44]

The parallel criticism in Blake's rejection of Dryden's and Pope's verse and Rubens' and Rembrandt's paintings is carried over to another characteristic which Blake asserts they have in common—wit. Pictorial wit is as much beneath the great painter as verbal wit is beneath the great poet. Visionary artists and prophets do not aim at "Vulgar" epigrams or any stereotyped trick. Furthermore, "Grand" works do not have them.

"Rafael, Mich. Ang., Alb. d., Jul Rom. are accounted ignorant of the Epigrammatic Wit in Art because they avoid it as a destructive Machine, as it is,"[45] Blake continues, maintaining a remarkably consistent metaphor. "That Vulgar Epigram in Art, Rembrandt's 'Hundred Guelders,' has entirely put an End to all Genuine & Appropriate Effect; all, both Morning & Night, is now a dark cavern. It is the Fashion; they Produce System & Monotony. When you view a Collection of Pictures painted since Venetian Art was the Fashion, or go into a Modern Exhibition, with a very few Exceptions, Every Picture has the same Effect, a Piece of

Machinery of Points of Light to be put into a dark hole."[46]
Blake returns not only to the machine metaphor and the
symbolism of the dark corner or cavern, but also to his
parallel criticism of the English Augustan poets and the
Flemish and Venetian painters:

> I have heard many People say, "Give me the Ideas. It is no matter
> what Words you put them into," & others say, "Give me the Design,
> it is no matter for the Execution." These People know Enough of
> Artifice, but Nothing of Art. Ideas cannot be given but in their
> minute Appropriate Words ["Minute Particulars"] nor Can a Design
> be made without its minutely Appropriate Execution. The un-
> organized Bolts & Blurs of Rubens & Titian [cf. *Jerusalem* 91] are
> not Art, nor can their Method ever express Ideas or Imaginations any
> more than Pope's Metaphysical Jargon of Rhyming.[47]

Blake is often disturbed by the critical success of the writers
and painters to whom he takes exception and by the critical
victimization or neglect of those, including himself, whom he
considers superior: "All is misconceived, and its mis-
execution is equal to its misconception. I have no objection
to Rubens and Rembrandt being employed, or even to their
living in a palace; but it shall not be at the expence [sic] of
Rafael and Michael Angelo living in a cottage, and in
contempt and derision. I have been scorned long enough by
these fellows, who owe to me all that they have; it shall be so
no longer."[48]

Using Correggio as an example, Blake describes the
financial and critical success of a painter he considers
undeserving. He condemns Correggio for his influence and for
his mechanical manufacturing of pictures through the
"manual labour" of "numerous Journeymen." Like Rubens
and Titian, Blake contends, Correggio was rich in money but
poor in art. Any artist who follows Correggio may also be
financially successful but the poorer as an artist for it. Like
Rubens, Correggio is a demon who can possess any other

artist and destroy his art by taking possession of his mind and his vision.

> Correggio is a soft and effeminate, and consequently a most cruel demon, whose whole delight is to cause endless labour to whoever suffers him to enter his mind . . . he was a petty Prince in Italy, and employed numerous Journeymen in manufacturing (as Rubens and Titian did) the Pictures that go under his name. The manual labour in these Pictures of Correggio is immense, and was paid for originally at the immense prices that those who keep manufactories of art always charge to their employers, while they themselves pay their journeymen little enough. [49]

Correggio is therefore a model of the Venetian and Flemish painter who is, in Blake's view, a kind of sweatshop operator exploiting his employees. Like Rubens and Titian, Correggio stands condemned not only as an artist but as a man. Hired by the Satans of Empire, he soon becomes a Satan with his own private empire—a "petty Prince" instead of a "Mental Prince." Correggio "will make any true artist [poor] who permits him to enter his mind, and take possession of his affections." The influence of Correggio as an artist is disastrous because "he infuses a love of soft and even tints without boundaries, and of endless reflected lights that confuse one another, and hinder all correct drawing from appearing to be correct." Like Rubens, Correggio is subject to the vice of hindering, and to so hinder "is a restraint on action both in ourselves & in the person hinder'd, for he who hinders another omits his own duty at the same time." [50] The labored work of art is "pappy, and lumbering, and thick-headed." The "softness and evenness" of Correggio's work wherever it appears is the work of "a drudge and a miserable man," that is, 'the Correggio that the life writers [his biographers] have written of," a man "compelled to softness by poverty"—the proverty of imagination. This is the meaning of Blake's indictment of Correggio, an indictment

employed for the purposes of continuing his condemnation of Rubens and thereby all Venetian and Flemish painting.

Rubens is the Locke of painting—a Urizen of the arts. He is an aesthetic version of Newton because his coloring is a generalizing power. Rubens' "lights are all the Colours of the Rainbow, laid on Indiscriminately & broken one into another," a "General Hue." His mental attitude is wrong and his method is in error in respect to execution. The art of Rubens is too obscure and "Obscurity is Neither the Source of the Sublime nor of any Thing Else."[51] "Broken Colours & Broken Lines & Broken Masses are Equally Subversive of the Sublime."[52] The *Note-Book* verses "To Venetian Artists" summarizes much of Blake's criticism by invoking Newton as a philosophical compatriot of the Venetian painter. His reversal of God and the devil in a matter of aesthetics recalls the similar reversal of the angel and the devil in *The Marriage of Heaven and Hell:*

> That God is colouring Newton does shew,
> And the devil is a Black outline, all of us know.
> Perhaps this little Fable may make us merry:
> A dog went over the water without a wherry;
> A bone which he had stolen he had in his mouth;
> He cared not whether the wind was north or south.
> As he swam he saw the reflection of the bone.
> This is quite Perfection, one Generalizing Tone!
> Outline! There's no outline! There's no such Thing.
> All is Chiaro Scuro [sic], Poco Pen, it's all colouring.
> Snap, Snap! he has lost shadow & substance too.
> He had them both before; now how do ye do?
> A great deal better than I was before.
> Those who taste colouring love it more & more.[53]

These verses proceed from the ironic reversal by which Newton is associated with a Urizenic vision of God and outline with the devil, to theories of reflection in the Enlightenment, to the "one Generalizing Tone," to the chiaroscuro of Venetian and Flemish "dogs," to the Poco Pen

of the Augustan poets, to the loss of true shadow and outline, to the loss of the original substance (the stolen real bone of Raphael and Michaelangelo), to the admiration of the false reality (the reflection) of form and outline, to, finally, a total absorption in coloring—a coloring "Contrary to The Colouring of Real Art & Science." How completely opposed to Blake's own vision of painting this summary is can be seen by comparing these verses to Blake's remarks in his "Descriptive Catalogue":

> If losing and obliterating the outline constitutes a Picture, Mr. B. will never be so foolish as to do one. Such art of losing the outlines is the art of Venice and Flanders; it loses all character, and leaves what some people call expression [that is, it exchanges the bone for the reflection of the bone] ; but this is a false notion of expression; expression cannot exist without character as its stamina; and neither character nor expression can exist without firm and determinate outline... The great and golden rule of art, as well as of life, is this: That the more distinct, sharp, and wirey the bounding line ["the Outline, the Circumference & form" of *Jerusalem 98*], the more perfect the work of art, and the less keen and sharp, the greater is the evidence of weak imitation, plagiarism, and bungling.... The want of this determinate and bounding form evidences the want of idea in the artist's mind, and the pretence of the plagiary in all its branches. [54]

Rubens and the Venetians have no ideas of their own—only stolen bones whose reflections they admire more than the original substance. Their admiration of the indefinite stems, of course, from their inability to know and understand the golden rule of art and life: "What is that distinguishes honesty from knavery, but the hard and wirey line of rectitude and certainty in the actions and intentions? Leave out this line, and you leave out life itself; all is chaos again, and the line of the almighty must be drawn out upon it before man or beast can exist. Talk no more then of Correggio, or Rembrandt, or any other of those plagiaries of Venice or Flanders. They were but the lame imitators of lines drawn by

their predecessors, and their works prove themselves con-
temptible, dis-arranged imitations, and blundering, mis-
applied copies."[55]

Blake's case against Rubens and against the Venetian
and Flemish schools of which Rubens is the head demon is,
for all its vitriol, as much a defense as an offense. Rubens was
everything Blake was not, everything for which Blake held a
lifelong contempt. The analogy by which Blake assumed the
case of the Roman and Florentine schools against the
Flemish and Venetian is parallel to his identification with the
prophet's opposition to the priest or the rebel's oppostion to
the tyrant. The art of which Rubens was the prime symbol is
dictatorial because it "hinders all power of individual
thought" and is as socially and politically suspect as it is
aesthetically suspect. In order to prophesy against empire,
the function which Blake expected the artist to perform, the
prophet who is also a painter cannot serve that empire.
Rubens did, and therefore must be cast off as "a most
outrageous demon."

NOTES

1. "A Descriptive Catalogue" (K 573, E 529).

2. See Northrop Frye, *Fearful Symmetry* (Princeton:
 Princeton Univ. Press, 1947), Chap. 1, "The Case
 Against Locke." See also Chap. 4, "A Literalist of the
 Imagination."

3. *Note-Book*, p. 38 (K 546, E 505 [revised lines only]).
 The point at issue is that Rubens is no more a statesman
 or a saint than he is a painter. Each role is a deception.
 A true statesman does not use his office for private

commercial enterprises and a saint does not exploit others for his personal reputation as a benefactor of mankind. Cf. Annotations to Bacon's "Essays," pp. 1 and xii (K 395, E 610).

4. *Note-Book*, p. 38 (K 546, E 505).

5. See also "A Descriptive Catalogue" (K 583, E 538).

6. *Note-Book*, p. 39 (K 547, E 505).

7. *Note-Book*, p. 43 (K 550, E 506); p. 39 (K 547, E 506).

8. "A Descriptive Catalogue" (K 582-3, E 538).

9. Annotations to Reynolds' "Discourses," I, 2 (K 452, E 631). Cf. Annotations to Bacon's "Essays," p. 3 (K 398, E 610), and *Jerusalem* 43[38]:35-6 (K 672, E 183).

10. Annotations to Reynolds' "Discourses," VIII, 244 (K 476, E 650), Cf. "Public Address" (K 598-9, E 578-9).

11. "Public Address" (K 599, E 568-9).

12. Cf. Blake's desire to "ornament" Westminster Hall with frescos, "The Invention of a Portable Fresco" (K 560-1, E 517-9).

13. *Fearful Symmetry*, p. 102.

14. Cf. the description of Hand's "Emissaries," Hyle (Haley) and Coban (Bacon), *Jerusalem*, pl. 18 (K 641, E 162). Cf. also "King James with Bacon's Primum Mobile," Annotations to Bacon's "Essays," pp. 235-6 (K 410, E 622).

15. On the necessity or importance of copying, see Annotations to Reynolds' "Discourses," II, 23 (K 455, E 633); II, 33 (K 456, E 634). For what to copy, see, for example, "Public Address" (K 594-5, E 563). See also Annotations to Reynolds' "Discourses," p. xix (K 448,

E 628). Cf., also, Blake's opinion of "Rowlandson's caricatures" in his letter to George Cumberland, 28 August 1799 (K 795).

16. Annotations to Reynolds' "Discourses," II, 22 (K 455, E 633).

17. Cf., for example, *Jerusalem* 65:16-28 (K 700, E 214).

18. Annotations to Reynolds' "Discourses," V, 134 (K 468, E 644).

19. "A Descriptive Catalogue" (K 563, E 520). Cf. "Public Address" (K 602-3, E 564).

20. *Note-Book*, p. 38 (K 547, E 505).

21. "A Descriptive Catalogue" (K 563-4, E 520-1). Cf. *A Vision of the Last Judgment* (K 613, E 552). See, also, Annotations to Reynolds' "Discourses," VIII, 275 (K 478, E 651): "Shade is always Cold, & Never, as in Rubens & the Colourists, Hot & Yellowy Brown."

22. Annotations to Reynolds' "Discourses," IV, 103 (K464, E 641).

23. "A Descriptive Catalogue" (K 580-1, E 536). On copying, see "Public Address" (K 594-5, E 563).

24. Annotations to Reynolds' "Discourses," pp. xiv-xv (K 447, E 627). Cf. Annotations to Reynolds' "Discourses," IV, 99 (K 464, E 640); IV, 100 (K 464, E 641).

25. Annotations to Reynolds' "Discourses," pp. xvii-xviii (K 448, E 627-8).

26. Blake's copy of the second edition of Reynolds' "Discourses" is in the British Museum. Blake made notes only in the first volume of Malone's three-volume edition. Blake's admiration for the "simple, careful,

pure and correct style of Poussin," to quote Reynolds' words, is evidence of his predisposition to a style in painting which has the characteristics of his *Songs* and which has more in common with the ideals of classicism than much of the art which Blake disliked because of its artificiality and florid rhetoric (pictorial and verbal). One might say in Blake's manner that Neoclassicism's pretence to classicism was in reality an attempt to destroy classicism. Cf. Blake's desire "to renew the lost Art of the Greeks' (Letter to Dr. Trusler, 16 August 1799 [K792]).

27. Annotations to Reynolds' "Discourses," V, 134 (K 468, E 644).

28. Annotations to Reynolds' "Discourses," V, 135 (K 468-9, E 644). As did Reynolds, Blake knew Vasari, and some of his opinions of the Italians are traceable to his knowledge of Vasari's criticism.

29. "A Descriptive Catalogue" (K 582-3, E 538).

30. Annotations to Reynolds' "Discourses," V, 137-9 (K 469, E 644). One of the passages to which Blake replied, "True," records Reynolds' observation that "Poussin in the latter part of his life changed from his dry manner to one much softer and richer . . . but neither these, nor any of his other pictures in this manner, are at all comparable to many in his dry manner which we have in England."

31. Annotations to Reynolds' "Discourses," VII, 208 (K 475-6, E 649).

32. Annotations to Reynolds' "Discourses," VII, 251 (K 477, E 650).

33. Annotations to Reynolds' "Discourses," VIII, 251 (K477, E 650).

34. Annotations to Reynolds' "Discourses," VIII, 272; 274 (K 478, E 651).

35. Cf. Annotations to Reynolds' "Discourses," IV, 106 (K 564, E 641).

36. Cf. *Jerusalem* 33 [29]:17-20 (K 659, E 173). The point of light is a "white Dot." See my essay, "The Symbolism of the Opened Center and Poetic Theory in Blake's *Jerusalem*," *Studies in English Literature 1500-1900*, 5 (Autumn, 1965), 587-606, esp. 593-4.

37. "A Descriptive Catalogue" (K 582, E 537-8). This "Machine" should be compared with the "Sexual Machine" of the Female Will in *Jerusalem* 44 [39]. The effect of the "Sexual Machine" on its victims is like that of the "infernal machine" of chiaroscuro. Artists who study Rubens, for instance, "become what they behold." Cf. "Public Address" (K 594, E 563).

38. "Public Address" (K 603, E 564). The "Mill" symbol here should be compared to that of the Satanic Mills in *The Four Zoas, Milton,* and *Jerusalem.* Cf., also, "Public Address" (K 603, E 564): "A Machine is not a Man nor a Work of Art; it is destructive of Humanity and of Art; the word Machination."

39. Cf. "The Symbolism of the Opened Center."

40. *A Vision of the Last Judgment* (K 613, E 552). The emphasis upon ancient sculptors should be compared with Blake's opinion of Poussin and Reynolds' "Discourses."

41. "Public Address" (K 602, E 564).

42. "Public Address" (K 600, E 569-70). Cf. "Public Address" (K 595-6, E 564-5), where Blake speaks of "Subservient" art: "While the Works of Pope & Dryden

are look'd upon as the same Art with those of Milton & Shakespeare . . . , there can be no Art in a Nation but such as is Subservient to the nearest of the Monopolizing Trader . . . No Man Can Improve An Original Invention. Nor can an Original Invention Exist without Execution, Organized & minutely delineated & Articulated, Either by God or Man [cf. *Jerusalem,* pl. 91]. I do not mean smooth'd up & Niggled & Poco-Pen'd, and all the beauties pick'd out & blurr'd & blotted, but Drawn with a firm & decided hand at once [with all its Spots & Blemishes which are beauties & not faults *del.*], like Fuseli & Michael Angelo, Shakespeare & Milton."

43. "A Descriptive Catalogue" (K 573, E 529). Cf. *Jerusalem,* pl. 74 (K 715, E 227-8), quoted in part in the previous paragraph. See, also, Annotations to Reynold's "Discourses," IV, 102 (K 464, E 641), for "Broken Colours & Broken Lines & Broken Masses are Equally Subversive of the Sublime." Cf. Annotations to Reynolds' "Discourses," VII, 194 (K 473, E 647).

44. "Public Address" (K 598-9, E 568).

45. "Public Address" (K 599, E 568). Frye's remark in *Fearful Symmetry,* that Blake's "fondness for aphorism and epigram moves steadily through his work from adolescence to old age," p. 5, can be well documented, but it should be compared with his explicit statement here about whether epigrams belong in grand works of art. Like chiaroscuro, "Epigrammatic Wit" is a "destructive Machine." Any stereotyped technique, like any symbolic cliché, is destructive because it is monotonous and thereby interferes with the unique unity of individual works of art. It is a characteristic of the "Generalizer" rather than the "Particularizer."

46. "Public Address" (K 599, E 568). The image of the "cavern" in this passage should be compared to *The Marriage of Heaven and Hell,* pl. 14 (K 154, E 38-9) and to the "Spectre's double Cave" in *Jerusalem,* pl. 64 (K 699, E 213). When the "Eye of Imagination, the Real Man" is thrust into Locke's closet—the skull of generation—Venetian and Flemish art is the result. Such art, Blake implies, is conceived in a dark hole in order to be seen in a dark hole. Besides being the art of Empire, Rubens' pictures are limited by the fallen senses.

47. "Public Address" (K 596, E 565).

48. "A Descriptive Catalogue" (K 575, E 531).

49. "A Descriptive Catalogue" (K 583, E 538).

50. Annotations to Lavater's "Aphorisms on Man," (K 88, E 590).

51. Annotations to Reynolds' "Discourses," VII, 194 (K 473, E 647).

52. Annotations to Reynolds' "Discourses," IV, 102 (K 464, E 641).

53. *Note-Book,* pp. 60-1 (K 554, E 507). The "fable" recalls the Narcissus myth and the psychology of the state of Urizen. Cf. Blake's color-print of Newton [Illustration 29].

54. "A Descriptive Catalogue" (K 585, E 540).

55. "A Descriptive Catalogue" (K 585, E 540). Los draws this "bounding line," the "line of the almighty," in *The Four Zoas* VIIa, lines 467-71 (K 332, E 456):

> And first he drew a line upon the walls of shining heaven,
> And Enitharmon tinctur'd it with beams of blushing love.
> It remain'd permanent, a lovely form, inspir'd, divinely human.
> Dividing into just proportions, Los unwearied labour'd
> The immortal lines upon the heavens, . . .

POETIC AND PICTORIAL IMAGINATION
IN BLAKE'S *THE BOOK OF URIZEN*
by
W. J. T. Mitchell

*T*he live question in Blake
studies is no longer *whether* his illustrations have anything to
do with the text, but *how* the transactions between his two
media occur. The most thorough investigation of the relation-
ship between Blake's poetry and painting[1] places his "com-
posite art" in the tradition and context of *ut pictura poesis*,
the system of analogies between the "sister arts" which was
dogmatized by many early eighteenth-century critics,[2] and
debunked by Lessing in the second half of the century.[3]
Blake, as a professional book illustrator, could hardly have
been ignorant of this tradition, but it is also unlikely that the
man who had to create his own system, lest he be enslaved by

Ed.: Reprinted, with revisions by the author, by permission of The
Regents of the University of California from *Eighteenth-Century
Studies*, 3 (Fall, 1969), 83-107. Copyright 1969 by The Regents of the
University of California.

another's, would have received this or any other neoclassical doctrine with uncritical acceptance.

It is not obvious, for instance, that Blake's poetry conforms to the "pictorial poetizing" nor his compositions to the "poetical painting" which was so popular in the eighteenth century. His poetry seems closer to the non-pictorial visions of the blind Milton than to the "vision-weaving tribe" of the Wartons, Collins, or Thomson, and his paintings suggest a return to a more primitive conception of spatial illusionism, not an affinity with the elaborate techniques of visual narrative developed by Hogarth or William Kent.[4] The idea that Blake's artistic practice is continuous with, rather than critical of, the tradition of *ut pictura poesis*, must contend, it seems to me, with the implications of a design such as the title-page to his *Book of Urizen* [Illustration 104]. The title character is displayed in this plate as an aged patriarch squatting on an open book, writing simultaneously on tablets placed to each side of him. In some versions of this design[5] it is clear that Urizen is holding a quill pen in his right hand, and a burin, or similar engraving tool, in his left, indicating that he is to be seen at least partially as an emblem of a certain kind of relationship between the arts of poetry and engraving. It is clear also that this design presents the relationship in a satiric fashion. Even if we were unaware that Urizen, the poetical personification, is one of Blake's favorite vehicles for satirizing eighteenth-century rationalism, we would be unable to ignore the humorous implications in the fact that the pictorial Urizen pays no attention to the activity of either pen or burin, but keeps his eyes resolutely closed while each hand plies its own course independent of conscious or purposive regard. One of the points of the picture may be that under the control of Urizen, the two arts become mechanical exercises, devoid of

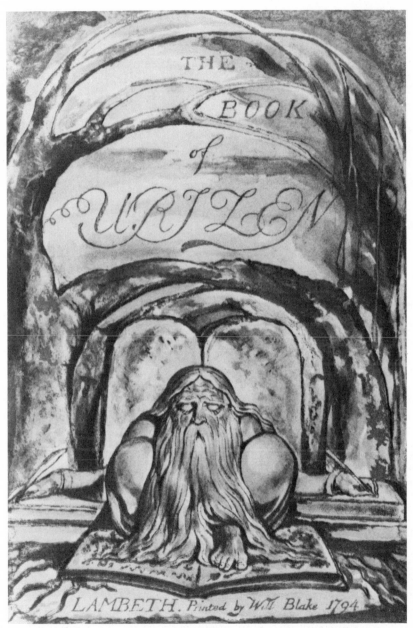

104. Blake, *The Book of Urizen*, title-page. *Census* copy G. Rosenwald Collection.

intellectual purpose. The symmetrical structure of the composition, and the fact that pen and burin are scarcely distinguishable from one another, further suggest that the two arts have become rigid copies of one another. In other words, the design may be a parodic emblem of the "sister arts," depicting a homogeneous, mutually imitative relationship between them (*ut pictura poesis*) as a sterile symmetry. Instead of each art "doing its own thing," as Lessing suggested,[6] they have become (as the stone tablets in the background indicate) mere indistinguishable appendages of Urizen's monolithic world of

> One command, one joy, one desire,
> One curse, one weight, one measure
> One king, one God, one Law.[7]

The Book of Urizen is an appropriate vehicle for investigating Blake's departures from the eighteenth century's preconceptions about the nature of painting, poetry, and the relation between the two, for Urizen is not merely "reason"; he is also the archetypal father, and as such he inevitably becomes a representative of the past, the preceding generation and its ideas, which Blake, like the other romantics, was so eager to depose. *Urizen* the poem is particularly appropriate also because it was probably Blake's first attempt at a major poem, perhaps the *Genesis* of his projected "Bible of Hell," the cosmic poem which was to treat the apocalypse only promised or conjured with in *The Marriage of Heaven and Hell* and other political prophecies.[7]

A good deal of Blake's poetry before 1794 involved a radical critique of the moral, political, and psychological assumptions of the eighteenth century. His turning away from obviously contemporary issues in *Urizen* has been

explained as an act of caution in the face of political dangers,[8] but the move has positive implications as well. It was a movement from the timely to the timeless, from a descriptive cosmology which, in the political prophecies, had comprehended the four "continents" of the world,[9] to a mythic cosmogony which would delineate the beginnings and ends of a cosmos in which Blake's kind of topical prophecy would be coherent. If his previous poetry had been mainly concerned with human issues in a world of space and time, *Urizen* begins his exploration of the metaphysics of that world, and consequently deals primarily with the transition from a "pre-creation" world when "Earth was not: nor globes of attraction" (3:36) into a created world. Blake was faced, therefore, with the traditional paradox of attempting to represent an uncreated (or at least qualitatively different) world in language and imagery which are, by their very nature, post-creation entities. The embodiment of eternity in the temporal confines of language, of infinity in the spatial limitations of two-dimensional composition necessitated not only an art as "criticism of life," but a criticism of the way we come to know life, an exploration of our ways of giving it meaning and form. That the attempt was not wholly successful in Blake's eyes is suggested by his deletion of the word "First" from the title of *The [First] Book of Urizen.*[10] The full development of his mythic cosmogony was to be a long and tortuous process, involving the endless revision and final rejection of his manuscript epic, *The Four Zoas,* and the slow perfecting of *Milton* and *Jerusalem.* But *Urizen* has special interest, first because it marks Blake's first excursion into the problem of embodying his ideas in a long poem, and second, because it is at least a partial failure and hence may indicate what things are to be seen as solutions in the later prophecies.

The primary models for Blake's longer poems are, of course, Milton and the Bible. For *Urizen,* we may narrow the relevent contexts to *Genesis* and Books V and VI of *Paradise Lost* (Raphael's account of the revolt and war in heaven). The setting of the poem is creation, not as the outpouring of a benevolent diety, but as the consequence of superhuman struggle. The poem refers in passing to a previous stage when "Death was not, but eternal life sprung" (3:39), but focuses mainly on the disintegration of this order and its replacement by a universe which is alternately described as a place of monolithic solidity ("A wide world of solid obstruction" [4:23]), and as a world of fragmented multiplicity ("Sund'ring, dark'ning, thund'ring!/ . . . Eternity roll'd wide apart/ . . . Leaving ruinous fragments of life" [5:3,5,9]). The powerful antagonists of this struggle, the Eternals, Los, Urizen, and Orc are reminiscent of the warring angels in *Paradise Lost,* and the action of the poem is rather like that of the war in heaven before the Son enters the fray. The fact that the struggle is accompanied in *Urizen* by the formation of a world of space and time ("Times on times he divided, & Measur'd/ Space by Space" [3:9–10]) is perhaps an allusion to the fact that the war in Milton's heaven necessitates the creation of a sublunary, human world to replenish heaven.

But Blake is clearly thinking of a cosmology radically different from that presented in either Milton or *Genesis.* Blake's titanic warfare does not necessitate a creation; in some sense it *is* the creation of the world. And most important, the superhuman events of his poem are not presided over by any transcendent unmoved mover who weighs the issue in his heavenly scales. The opening statement of theme is subtly misleading in this regard:

> Of the primeval Priests assum'd power,
> When Eternals spurn'd back his religion;

And gave him a place in the north
Obscure, shadowy, void, solitary. (2:1—4)

This "Preludium" seems to promise an account of usurpation and the repulsion of this threat by a superior or at least prior agency of power, a story of rebellious disobedience and the reaction of a superior justice, as in *Paradise Lost*. But the analogy implied between the "Eternals" and Milton's God will not bear scrutiny in the rest of the poem, or even in these lines.[11] When, for instance, did the "primeval Priest" assume power? Was it before or after his spurning by the Eternals? The construction of the first two lines makes these questions unanswerable. The rebellion took place "when" the reaction occurred. Before, after, or concurrently are all equally plausible interpretations of the time sequence described in the opening lines. In *Paradise Lost* the orders of priority in heaven are all gauged as temporal priorities, by both rebels against and defenders of that order. Abdiel argues that God was there first, among other things, and therefore deserves allegiance. Satan's strongest argument against the Son is that his regency will constitute an innovation.[12] In *Urizen* these priorities are evoked only to be dissolved in a world which denies their validity. The Eternals are not Urizen's superiors but his relatives. When Urizen's scholarly researches into the "secrets of dark contemplation" reveal "terrible monsters Sin-bred:/ Which the bosoms of all inhabit;/ Seven deadly Sins of the soul" (4:26, 28—30), the reaction of the Eternal is not the detachment of a superior justice, but an acceptance of Urizen's vision of them: "Rage siez'd the strong/ . . . All the seven deadly sins of the soul" (4:44, 49).

This dissolution of the traditional cosmological temporal hierarchies is paralleled in the opening lines by a similar ambiguity in spatial orientation. The Eternals, we are told,

"gave him [the primeval Priest, Urizen] a place in the north,/ Obscure, shadowy, void, solitary" (2:3–4). This "place" evokes contradictory associations from the world of *Paradise Lost*. Since the Eternals "gave" Urizen this place as part of their repulsion of his usurpation, it calls up the image of Hell, the "place Eternal Justice had prepar'd/ For those rebellious" (*P.L.* I, 70–71). But the "place in the *north,*" as we also know from *Paradise Lost* (V, 690), is not hell; it is the sector of heaven to which Satan and his followers willfully withdraw. The lines blur the distinction between the prison given to the rebel and the place to which he voluntarily retires to muster his rebellion. The purposefulness of this ambiguity becomes more apparent if one asks questions about the origins of this "Obscure, shadowy, void, solitary" place. Since the Eternals have given Urizen this place, there is an implication that they, like Milton's God, created it for him. But the opening lines of Chapter I turn the implications in another direction:

> what Demon
> Hath form'd this abominable void
> This soul-shudd'ring vacuum?–Some said
> "It is Urizen", but unknown, abstracted
> Brooding secret, the dark power hid. (3:3–7)

The specification of the origin of this "void" which has appeared in Eternity is left a matter of conjecture: It can be the product of either Urizen or the Eternals, depending on the choice of perspective and of the context which is employed in interpreting it.

These dislocations of the spatial and temporal hier- archies which inform the world of *Paradise Lost* are amplified further by the Preludium's account of how poetry and painting which describe this world can come into existence. The fifth line, "Eternals I hear your call glady," refers back to

the opening statement of theme and re-casts it as dramatic utterance, the "call" of the muses of the poem, the Eternals. These beings, like the Holy Spirit of *Paradise Lost*, are invoked to "dictate swift winged words" (the verse) and "unfold . . . dark visions of torment" (the illustrations). But these muses, unlike Milton's, can certainly be said to lack the transcendent detachment which we expect from the inspiring agents of a poem about creation. The Eternals do not function in the poem as traditional muses, i.e., as the representatives of some level of being superior to the issues of the poem itself. They are not disinterested observers of the dark visions which they will unfold; they are possessed by those visions, and are implicated as actors, not merely spectators, in the conflict of the poem. It is true that aside from their imitative response to Urizen's unfolding of the "Seven deadly sins," their only real action in the poem is reaction—their retreat from the conflict and separation of themselves from the ensuing creation with the "Tent of Science" in Chapter V. But the poem does not support any implication that they constitute an "unfallen" remnant, superior to the world of Los, Urizen, Orc, and the other characters. In fact, the plate which illustrates their retreat from the created world [Illustration 105: Pl. 16], tends rather to identify them with the actors in that world. Four human figures (in some versions, three) are shown suspended in clouds, one of them reaching down to cast a watery veil over the globe beneath them. The plate probably refers to the lines

> And Los round the dark globe of Urizen,
> Kept watch for Eternals to confine,
> The obscure separation alone;
> For Eternity stood wide apart.

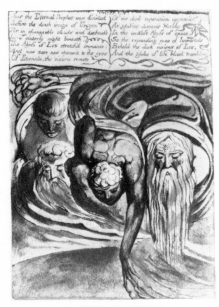

105. Blake, *The Book of Urizen*,
pl. 16. *Census* copy G. Rosenwald
Collection.

The central figure is a curly-haired youth, the typical
appearance of Los, and he is flanked by a group of old men
with white beards, who huddle together and gaze in terror at
the globe beneath them.[13] One implication of the poem is
that Los is the instrument of the Eternals in closing off the
vision of creation. The fact that they are old men ought to
give us pause, for they are presented pictorially just as Urizen
is in other plates. More significant is the posture of the
central figure: His gesture bears a point-for-point resemblance
to that of Urizen in the famous title-page of *Europe*
[Illustrations 105 and 25]. Where Urizen reaches down to
circumscribe the abyss with his golden compasses, Los, as the
instrument of a group of Urizen-figures, reaches down to
enclose the world in an obscuring veil. The design is a kind of
visual metaphor which equates the response of the eternals to
Urizen's world with his initial creation of that world. The
composition may be seen as another variation on the process

of ambiguity we observed in the "Preludium," a process which made distinctions between the roles of the Eternals and Urizen extremely problematic.

Urizen can be endlessly investigated as a parody of traditional Miltonic cosmology. The world of the poem is built with the most traditional materials: a conventional epic opening with a statement of theme, identification of the principal adversaries, and an invocation to the muses. And yet the relations among these basic materials have been systematically adjusted to deny the assumptions by which they were previously seen as intelligible. The theme appears to involve a rebellion and its subsequent punishment, and yet we find the rebel equated with his punishers, and the very sequence of their activities called into question. The muses of the poem, whom we might expect to be disinterested observers of the "dark visions of torment" which they will unfold for the poet, are clearly actors in the poem, tormented by the visions they narrate, and identified with both sides of the conflict they describe. It is all rather like the poem Milton might have written if he had not been concerned with justifying the ways of God to man—a *Paradise Lost* without a transcendent deity to dispense justice and foresee a *Paradise Regained.*

Urizen might also be compared to a world of Homeric deities in which the human level of existence has become a negligible factor: It is a world of super-human entities who lack the absolute moral and spiritual sanctity that theology generally bestows on this level of being. The Greek gods were quickly denied serious theological consideration by thinkers who required more coherent images of the absolute, and were subsequently allegorized as personifications of human emotions and aspirations. The Greek pantheon was returned to its source—the human imagination. Blake may be regarded as

doing the same thing with the whole concept of superhuman modes of being. "All deities reside in the human breast," he tells us in *The Marriage of Heaven and Hell*, and this includes those "absolute" deities which the intellect constructs out of negations ("infinite," "unknowable"). Urizen is the personification of the imagination striving for this illusion of the absolute and the objective: "I have sought for a joy without pain,/ For a solid without fluctuation" (4:10–11).

Blake's symbolism or "allegory address'd to the Intellectual Powers" may be distinguished from allegory like Spenser's or Bunyan's, not because it documents more fully the human dimension of its personifications, but, on the contrary, because it keeps them so abstract. Urizen is not a man "representing" reason, or a man dominated by the faculty of reason: he *is* reason, a particular mode of consciousness. Blake's peculiar genius was not in dramatizing the human behavior associated with mental and emotional states, but in exploring the contours of various modes of consciousness *as such*. The relations among his characters, consequently, are not the complex matrixes of intersubjectivity found in the novel, nor the hierarchical, divinely ordained relations of the epic or romance, but the extremely simple relations possible to different modes of consciousness: they can be united or fragmented, in a loving community or at war, integrated into a whole personality, or split in a cosmic schizophrenia. Most important, the boundaries between their characters is not fixed: unlike people, they are capable of becoming one another, or at least metaphors for one another. We have seen that the Eternals' reaction to Urizen's usurpation is really only an imitation of his activity. They are seized by his "Seven deadly sins of the soul" and begin isolating themselves in an insulated solitude, just as Urizen does in the beginning of the poem. As Blake was to

put it later, they "became what they beheld."[14] This process
of assimilation of various modes of consciousness to the basic
form of Urizenic consciousness is the structural principle of
The Book of Urizen, and explains the contradictions which
occur when we try, as we did with the "Preludium," to
explain the poem's narrative order in terms of an "objective"
spatial-temporal continuum.

If we were to outline the "plot" of *Urizen* as if it were a
traditional narrative, we would probably say that it begins in
some pre-creation state when "Earth was not" with Urizen's
rebellion and a subsequent war in heaven. Los, the champion
of the "unfallen" Eternals, binds down Urizen, but finds
himself bound as well. The remaining Eternals close them-
selves off from this world with the "Tent of Science," and
cease to play any role in the poem, which continues to
describe a world of division, deformity, and monstrous
tortures. As a kind of *Paradise Lost* it is a very unsatisfactory
poem, and would be better described as a paradise destroyed,
never to be regained.

But this description of the poem's narrative line is only
a series of half-truths. We have already seen that Urizen's
rebellion and the Eternals' reaction cannot be explained as
sequentially related events, but as different modifications of
the same event. The creation of Urizen's world is ambig-
uously attributed to both Urizen and the Eternals. A closer
investigation of the later events of the poem reveals that
they, too, are essentially modifications and re-enactments of
the same event, and that they are not to be related in a
causal, linear sequence, but rather as increasingly complex
displacements of a single archetypal action, Urizen's retreat
from and division of the mental universe of the poem. That is
why the typical reading experience of any episode of the
poem involves a sense of *déjà vu*: The same images and

patterns of action appear recurrently, but with variations on the actors and emphasis.

The fundamental pattern of Urizenic activity is established in Chapter I as a set of increasingly radical paradoxes. In the first place, Urizen (or the "dark power") is depicted as the creator of a world, giving form, dividing and measuring space and time, "brooding" like the Holy Spirit of *Genesis*, and producing "beast, bird, fish, serpent & element/ Combustion, blast, vapour and cloud" (3:16–17). And yet this creation is also described as "unprolific" (3:2), as "void" (3:4) and a "vacuum" (3:5). It is simultaneously creation and anti-creation, form and anti-form. Blake pours out visual and aural paradoxes to depict this as a world of fantastic noise, conflict, and prodigious spectacle at the same time that he makes it "silent," "cold," and "unseen." Perhaps his most comprehensive epithet for the nature of Urizen's world is the oxymoron, "petrific ... chaos" (3:26), which fuses the qualities of stasis and death with those of motion and fecund multiplicity.

Urizen explains his motives and methods for creating this world in Chapter II:

> I have sought for a joy without pain.
> For a solid without fluctuation
> Why will you die O Eternals
> Why live in unquenchable burnings?

From this point of view the dynamic life of Eternity when "Earth was not, but Eternal life sprung" (3:39) was an infernal cycle of life and death, and his search for stability and uniformity leads him into an introspective void:

> First I fought with the fire; consum'd
> Inwards into a deep world within:
> A void immense, wild dark & deep,
> Where nothing was; (4:14–17)

In a parody of the Holy Spirit he "stretch'd o'er the void" of his own subjectivity, which has become "Nature's wide womb," and "arose on the waters/ A wide world of solid obstruction" (4:21–22). The subject of "arose" in this sentence is deliberately ambiguous: It can refer either to the "wide world" or "I". That is, Urizen's creation can be seen simultaneously as an "objective" phenomenon, separate from himself, or simply as a new modification of his consciousness. We are not asked to choose between these alternatives, but to accept them as equally true, for "that which seems to be is, to him to whom it seems to be" (J36:51). Urizen thinks he has created a real world within his mind, and since the universe of the poem is totally mental, it *is* a real world. The Eternals and Los confirm the substantiality of his creation by treating it as if it were real, and their behavior toward it repeats the pattern of Urizen's initial activity. They stand "wide apart" (5:41) just as Urizen earlier described himself as "Hidden set apart" in the "eternal abode" of his "holiness" (4:7–8). Urizen was "self-closd, all-repelling" (3:3), and the Eternals ratify this behavior by sending Los (or themselves, for the syntax is again ambiguous) "to confine,/ The obscure separation alone . . ." (5:40). For Los, the result is a re-enactment of Urizen's experience, "a fathomless void for his feet;/ And intense fires for his dwelling" (6:5–6; cf. 4:14–16), and another variation on a creation myth, this time as a parody of the birth of Eve, "for in anguish/ Urizen was rent from his side . . ." (6:3–4).

The basic pattern of Urizen's activity may be described most simply as a paradoxical process of contraction and expansion, unification and fragmentation. His institution of a homogeneous, static order of "One Law" is simultaneously the creation of multiplicity and disorder. Each re-enactment of this central pattern involves the same impulse to retreat

into the self, or confine the other. Both impulses amount to an attempt at unification or solidification, and both imply a division or fragmentation. Blake sets each modification of the pattern in a complex framework of allusions to myths about origins—of the world, the sexes, the body, the animals, and even of "the chosen people." Los's confinement of Urizen in Chapter IVb is described as the "seven ages" of the creation of Urizen's body, and at the end of it, Los is absorbed into the Urizenic mode of consciousness: "A cold solitude & dark void/ The Eternal Prophet & Urizen clos'd" (13:39—40). Los's misguided pity for the Urizenic form he has created divides his soul, an event described as the creation of the sexes, "the first female form now separate" (18:10). The Eternals' response to this phenomenon is virtually identical to their response to Urizen:

> "Spread a tent, with strong curtains around them
> Let cords & stakes bind in the Void
> That Eternals may no more behold them." (19:24)

This creation of the "Tent of Science" both reiterates Urizen's initial retreat, and also foreshadows his envelopment of the world in a similar fabric, the "Web of Religion" in Chapter VIII. Urizen's creation of a universe of "beast, bird, fish serpent & element" (3:16) from his own subjective broodings in Chapter I is re-enacted by Los's "begetting his likeness/ On his own divided image" in Chapter VI, an explicitly sexual version of Urizen's autotelic impregnation of "Nature's wide womb." Enitharmon brings forth a similar world of "fish, bird, & beast" (19:34), but this time the serpent has metamorphosed from a phallic worm, and hence develops further into an "Infant form," Orc. Los, like Urizen, finds that his creation exceeds his control, and adopts the Urizenic role of jealous father-figure, a Jupiter/Abraham *vis-a-vis* Prometheus/Isaac:

> They took Orc to the top of a mountain.
>
>
>
> They chain'd his young limbs to the rock
> With the Chain of Jealousy
> Beneath Urizens deathful Shadow. (20:21, 23–25)

The focus now returns to Urizen himself, who, awakened by the bursting life of his own creation, sets about giving it form. If Urizen was a type of the Holy Spirit in the opening chapters, "brooding" over the abyss, now he becomes a type of the Son in *Paradise Lost*, giving structure to the already fertilized world:

> He form'd a line & a plummet
> To divide the Abyss beneath.
>
>
>
> He formed golden compasses
> And began to explore the abyss. (20:36–37, 39–40)

"And he planted a garden of fruits" (20:41), adopting the role of Jehovah in attempting to enclose his creatures in a realm of obedience to his rule of "One Law." But again the attempt to impose a contracted closed order merely generates its opposite, and "he curs'd/ Both sons & daughters: for he saw that no flesh nor spirit could keep/ His iron laws one moment" (23:23–25). He flees from creation in consternation, enveloping it in the "Web of Religion" which like the Eternals' "Tent of Science" obscures any possible vision of return to Eternity.

The final chapter of *Urizen* adumbrates the mental conflict of the first eight chapters on a strictly human level. The degeneration of man from his visionary state of perfection is depicted, not as a historical consequence of the preceding action, but as another re-enactment of the central creation myth:

> Six days they shrunk up from existence
> And on the seventh day they rested
> And they blessed the seventh day, in sick hope
> And forgot their eternal life. (25:38–41)

The shrinking of mankind is not a post-creation lapse, as it is for the "decay of the world" historiography of Spenser or Donne,[15] but is described *as* a creation itself. Strictly speaking, the conflicts and creations of the first eight chapters do not occur before the fall of man: They are simply alternate performances of the same event. The creation is a metaphor for the historical degeneration of mankind, and vice versa. It is interesting to note that the formation of Urizen's body in Chapter IVb takes seven "Ages"—that is, creation is compared to a historical process of degeneration into "Forgetfulness, dumbness, necessity" (10:24). The degeneration of mankind, on the other hand, a historical process supposed to take ages, is compared to the week of creation. The general implication of these metaphors is that the creative moment, the moment of origin, contains in it all the significance of historical time. As Blake was to put it in *Milton:*

> Every Time less than a pulsation of the artery
> Is equal in its period & value to Six Thousand Years.
>
> For in this Period the Poets Work is Done: and all the Great
> Events of Time start forth & are conceived in such a Period
> Within a Moment: a Pulsation of the Artery. (28: 62-3, 29:1-3)

The narrative order of Urizen, then, does not depend on a sequential, causal conception of temporality. The usurpation of Urizen does not occur before or cause the reaction of the Eternals, the degeneration of Los, the creation of mankind; it is a metaphor for all those events, a mental enactment of the radical, undisplaced action of the poem. The final episode of the poem, the flight of Fuzon (a Moses figure—see 28:19–23) and his followers from the earth, or

"Egypt," portrays the founding of a "chosen people." But it also falls into the same pattern as Urizen's retreat from Eternity and the Eternals retreat from Urizen, and these implications are made explicit in the sequel to *Urizen, The Book of Ahania,* when Fuzon turns on Urizen and usurps his place, declaring himself to be "God, . . . eldest of things!" (3:38) This appropriation of temporal priority immediately results in Fuzon's destruction by his own instrument of authority, the "rock" or decalogue[16] which is his Mosaic version of Urizen's "One Law." The division of mankind into "chosen people" and gentiles is depicted once again as a self-defeating attempt to flee from others while imposing authority on them, another performance of the central action of the poem.

Urizen solved the problem for Blake of how to write at least the beginning and middle of an epic poem about a world defined as a human mind. The apocalypse, however, the comic resolution of mental strife and its physical manifestations in history, continued to elude him for many years. The essential problem he faced is captured in the "Preludium" to *Urizen:* Blake proposes his theme, the epic struggle of eternal beings who exist primarily as modes of consciousness; and yet he must invoke these very beings to give shape and substance to the poem. It is as if Milton had been forced to rely upon Satan and Michael to dictate their respective versions of *Paradise Lost.* Blake is writing a poem about a mind falling into chaos, and he is asking that mind to dictate its own "visions of torment," without any recourse to an "objective" superior position. This problem must have haunted him in a very human as well as artistic sense as he sought a way of making the "One Grand Poem." He probably rejected *The Four Zoas* at least partly out of dissatisfaction with the "Divine Council," or unfallen remnant of Eternity,

because it smacked too much of a Miltonic hierarchy. In *Milton* and *Jerusalem* he centers finally on the figure of Los, the poet-prophet, who also personifies time, and thus can be seen to master history by mastering himself. Los, in spite of his "sun-god" affiliations, never becomes an Appolonian figure, raised above the epic conflict. He "goes to Eternal Death" and submits himself to the fallen world (1) as a Christ-like redemptive sacrifice, and (2) as an artist, not by ignoring or fleeing from the fallen world, but by giving error a form so that it may be cast out.[17] The pessimistic, cyclical view of history of *The Book of Urizen* was to be resolved, not by a quietistic, Urizenic retreat into "a Heaven in which all shall be pure & holy/ In their Own Selfhoods" (J 49:27–28), but by a giving up of the self to its worst fears:

> I will arise and look forth for the morning of the grave.
> I will go down to the sepulcher to see if morning breaks!
> I will go down to self-annihilation and eternal death,
> Lest the Last Judgment come & find me unannihilate
> And I be siez'd & giv'n into the hands of my own Selfhood.
> (M 14:20–24)

The Book of Urizen is a particularly striking example of a work which involves complex interactions between design and text at the same time that it minimizes the dependencies and literal transferences of pictorial scene to poetic episode. The very arrangement of the book militates against any attempt to "read" the illustrations as a narrative parallel to the text. In the seven extant copies the order of the ten full-page designs is never repeated, so there is no "correct" order to be preferred to any other. The coloring, and even the number of figures in some designs, varies widely from one copy to another, producing an over-all effect rather like that of the scores for aleatoric music, which permit rearrangement of the order of the pages by the interpreter, and, conse- quently, a good deal of variation from one performance to

another. Any single copy of *Urizen* may best be understood as *a* performance among several available possibilities, and it is best not to insist upon defining one copy as "better" or "more canonical" than another. Just as the beauty of mobile sculpture depends, not simply on one version of its form, but on its ability to metamorphose through defined, yet infinitely variant forms, so the individual form in Blake's designs, like the individual episode in the text, derives its effect at least partly from its variety of specific incarnations. The title-page of *Urizen* is one example of meaningful interplay between variations on a single design: The fact that pen and burin are scarcely distinguishable in some designs is a visual statement of the degree of homogeneity which Urizen has imposed upon the "sister arts"; Blake permits the distinction in one version only to obscure it in another.

Sometimes the relation between two versions of a design can be seen as a metaphorical equation. Plate 5 of *Urizen* [Illustration 106], for instance, shows the title character unfolding his "book of brass" which contains, we may presume, the "secrets of wisdom" (4:25) which he has found within himself. In copy A of *Urizen* [18] the contents of the book are depicted as a complex and certainly undecipherable set of hieroglyphic forms, particularly the recto page, which contains a circle with a pyramid form and a number of vague cross-hatches. The page represents Urizen's "widsom" as an occult, mysterious language, the appropriate text for a "primeval priest." But in copy D [19] [Illustration 107] the same book contains only a riot of disorganized pigments without any principle of order, mysterious or otherwise. The point is, of course, that Urizen's "order," his mystery religion, is, as we observed in the text, really only a thinly-disguised chaos. His rule of "One Law" does not just beget a disorganizing reaction: It is that reaction. If there is

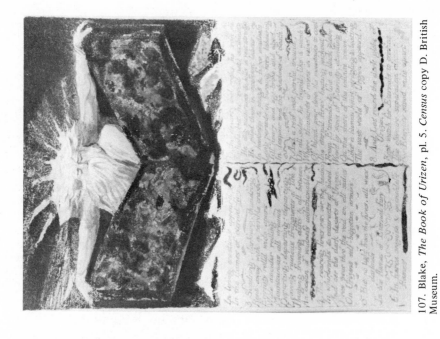

107. Blake, *The Book of Urizen*, pl. 5. *Census* copy D. British Museum.

106. Blake, *The Book of Urizen*, pl. 5. *Census* copy A. Mellon Collection.

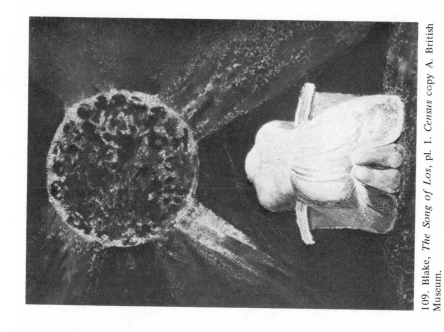

108. Blake, *The Song of Los*, pl. 1. *Census copy D. British Museum.*

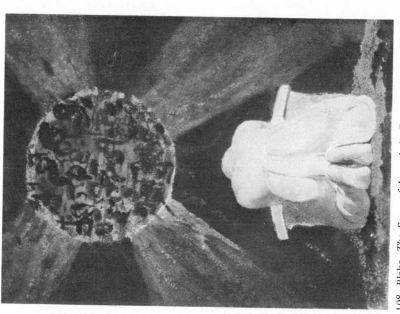

109. Blake, *The Song of Los*, pl. 1. *Census copy A. British Museum.*

any doubt that Blake intended to make this equation, we
need only observe the same technique used even more
dramatically in two versions of the frontispiece to *The Song
of Los* [20] [Illustrations 108 and 109]. In copy D [Illustration
108], Urizen kneels before a rising sun which contains black
hieroglyphics; in copy A [Illustration 109] the sun contains
the same riot of blue, red, and black pigments seen in
Urizen's book. In *The Song of Los* the object of Urizen's
religion is displayed as a thing of mysterious "order" and
obvious chaos; in *Urizen* the product of his religion, his book
of laws, is exposed and satirized in the same way.

Blake was also quite capable of establishing metaphori-
cal correspondences between not only different versions of a
single design, but also plates in widely different contexts.
Sometimes a design will allude to a composition in a different
prophetic work, as, for instance, plate 19 of *Urizen* evokes
plate 6 in *Visions of the Daughters of Albion* [Illustrations
110 and 111]. Both compositions employ a contrast between
a crouched, contracted male figure, and a full-length repre-
sentation of a female figure in a posture of flight. In *Visions,*
the female is Oothoon, who is struggling against the
repression of her sexuality by the male, Theotormon. As his
name suggests, he is a personification of conservative religious
attitudes toward sex, and like a southern Italian husband,
thinks that Oothoon's rape by Bromion makes her a harlot.
The dynamic, liberated eroticism of her flight (accentuated
by the flame-vegetation form in which she rises) expresses her
lack of shame, but her supplicating gesture to Theotormon
and the chain attached to her left ankle remind us of her
entrapment by the repressive categories of her husband,
which are, she reminds us, the categories of Urizen. [21] In
Urizen, the similar composition illustrates a related, but
distinct theme. Enitharmon is the female "Pale as a cloud of

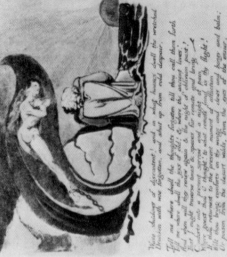

111. Blake, *Visions of the Daughters of Albion*, pl. 6. *Census* copy A. British Museum.

110. Blake, *The Book of Urizen*, pl. 19. *Census* copy G. Rosenwald Collection.

snow/ *Waving* before the face of Los" (18:10–11; my italics)
like the flame which is explicit only in Visions. Enitharmon
personifies Los's own repressed emotional life (as Oothoon
does much more subtly with respect to Theotormon); she
"embodies" quite literally (see 17:52–59) the pity which
Los feels for his own creation, the body of Urizen. Los's
innate impulse to give form to things has been perverted by
the Urizenic desire for confinement and isolation. Instead of
building Jerusalem, he has become the architect of a
prison-house for Urizen. His pity, therefore, is really hypo-
critical self-pity which "divides the soul" because it is a way
of disguising his own disapproval of himself. The reaction of
Los to the embodiment of his suppressed emotions is an
Adamic pursuit of her as a sexual object ("In perverse and
cruel delight/ She fled from his arms, yet he followed"; cf.
P.L. VIII, 500ff.). The stress here is on the male's affliction
by the female, and the composition subtly indicates this shift
from the concerns of plate 6 of *Visions*. In *Urizen* the male is
the anguished suppliant; the female turns away and ignores
him. In *Visions* the male ignores the pleas of the female. And
yet the similar compositional contrasts between movement
and stasis, expansion and contraction in the two designs
indicates the essential identity of the two situations as a
confrontation between the constrictive mentality of Urizen
and the emotional realities which he can only pervert, never
destroy.

Plate 7 of *Urizen* is an example of Blake's ability to
establish not only metaphorical relations between different
designs, but also significant ambiguities within the single
design. The most elaborate versions of this plate show three
figures wrapped in serpents falling into an inferno, a pair of
faces peering through the flames between them [Illustration
112]. The Miltonic overtones of the poem suggest that the

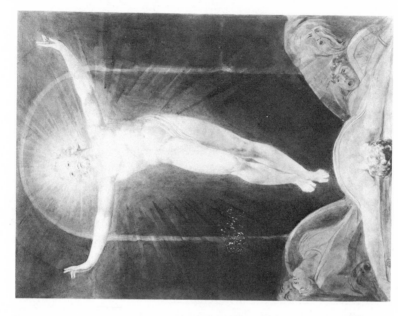

113. Blake, "The Resurrection." Fogg Museum of Art, Cambridge, Massachusetts.

112. Blake, *The Book of Urizen*, pl. 7. *Census* copy G. Rosenwald Collection.

plate is to be seen as some kind of allusion to the fall of the
rebel angels,[22] but the text gives no unequivocal identity to
the figures. On the one hand Urizen is a type of Satan,
usurping the established order of Eternity and retreating to
the Luciferian "place in the north." On the other hand,
Urizen is also presented as a Jehovah-figure, a creator and
law-giver who sees the Eternals' life as a condemnation to
hell: "Why will you die O Eternals,/ Why live in unquench-
able burnings" (4:12–13). From the perspective of the
Eternals, Urizen is a rebel who can be cast into hell; from
Urizen's point of view, the Eternals are already there. The
poem satirizes both of these perspectives by revealing them as
different versions of the Urizenic tendency to assume the
superiority of one's own perspective. The design satirizes
them both by depicting the fall into an inferno as an
upside-down crucifixion with the standard features: a central
cruciform figure in a relaxed posture contrasted with the
contorted struggling of the figures to each side of him. Both
Urizen and the Eternals condemn each other to hell,
appropriating the role of God *vis-a-vis* Satan; Blake's design,
however, reveals this arrogation of authority as the selection
of a scapegoat, a sacrifice for one's own sins. "The modern
church," said Blake, "crucifies Christ with the head down-
wards."[23] That is, the modern church makes the rebels
against its authority into images of both Satan and Christ
simultaneously. Satan is the hero of *Paradise Lost*, and
Milton's Messiah is, for Blake, interchangeable with the Satan
of the Book of Job (see *MHH* 5).

The design does not fuse the imagery of Christ and
Satan, however, simply to satirize two perspectives in the
poem (which are, incidentally, probably represented by the
pair of faces in the flames, an old man and a tiger, repression
and energy)[24] but also to point beyond the poem to a

possible perspective which is only hinted at by the text. The Eternals' view of Urizen as a falling Satan has some point in terms of his behavior in the narrative. But the poem provides no evidence (apart from Urizen's assertion) that the pre-lapsarian life of eternity was in fact a hell; it was rather a world in which "The will of the Immortal expanded/ Or contracted his all flexible senses./ Death was not, but eternal life sprung" (3:37–39). The rationale for Urizen's viewpoint lies outside the poem, in Blake's idea that "the fires of hell ... to Angels look like torment and insanity" (*MHH* 5). From Urizen's "angelic" position of assumed superiority, eternal life seems like hell. But this, of course, is not exactly what he says in the text or what he can see in the design. Both text and design imply that the life of eternity involves willful self-sacrifice, a voluntary submission of the self to a hell as a Christ-like act. But Blake makes precisely the same equation between perdition and crucifixion at the end of *Jerusalem* when Albion throws himself into the "Furnaces of Affliction" in imitation of Jesus' death for him (see J 96:14–35), and he defines his vision of eternal life in terms of this act of continuous self-sacrifice: "if God dieth not for Man & giveth not himself/ Eternally for Man Man could not exist!" (J 96: 25–26) Plate 6 of *Urizen*, then, is a kind of preview of the end of *Jerusalem*, revealing even in Urizen's erroneous perspective Blake's own vision of eternity as a process of self-sacrifice. Blake emphasizes these positive connotations of the design in one version[25] by removing the two side figures, thus minimizing the crucifixion analogies, and replacing them with an inverted image of a resurrection. This association may be confirmed by super-imposing the lineaments of the central figure of plate 6 on Blake's painting of the Resurrection [Illustration 113].[26] The two figures are almost exactly similar in every respect, and their

juxtaposition affords a visual rendition of the paradoxical "life-in-death" quality of true existence that even Urizen can recognize. For Blake, the Resurrection is not a link in a causal chain stemming from the crucifixion; the image of the later event is immanent in the first.

This scene of self-immolation and crucifixion draws its total significance from widely separated areas of Blake's art and thought, but generally his designs seem to interact most extensively with immediate contexts, similar compositional motifs and predominant themes in the same prophetic book. Even those numerous designs which have no corresponding "scene" in the poem, or, like plate 6, only a very ambiguous reference point, tend to reflect the larger thematic issues of both text and illustration. In *Urizen* we saw that the central principle of organization for the particular moment of the narrative (as opposed to its over-all structure) was the paradoxical co-presence of the imagery and activities of contraction and expansion, solidification and fragmentation, unification and division, and that the oxymoron, "petrific . . . chaos," seemed the best description of the nature of this world. A substantial number of the designs in *Urizen* render this tension visually with compositional contrasts between either (1) a contracted human form and its expansive, exploding surroundings (Pls. 9, 11, 13, 14), or (2) an expansive human form struggling against an oppressive surrounding space (Pls. 4, 12, 15).[27] The first group of designs may be seen as variations on the basic Urizenic activity of retreat from the dynamism of eternity; the second group suggests the struggle against the prison-house of the created world. It is doubtful, however, that we are simply to equate the lineaments of expansion with "good" and contraction with "evil"; the point of the contrast is more like that of the similar polarity we observed in plate 19

[Illustration 110] between the expansive female and the contracted male: Expansion connotes desire, the emotional life which, when suppressed, manifests itself as the "Furnaces of Affliction," and contraction connotes the impulse for order and form, which, when perverted, creates a prison.

This visual dialectic between expansion and contraction may be observed not only between separate human figures or between the figure and its setting, but also within a single figure. Plate 8 [Illustration 114] of *Urizen* has no apparent textual reference point, and even the identity of the figure is

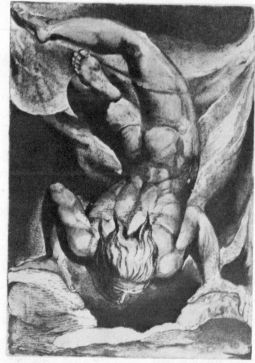

114. Blake, *The Book of Urizen*, pl. 8. *Census* copy G. Rosenwald Collection.

ambiguous, but the formal context that Blake builds around it permits close interpretation. The design shows a muscular nude diving (or doing a hand-stand) in a diaphanous swirl of vapors and clouds. The torso and legs of the figure suggest youth, or Michelangelesque maturity: The limbs seem resilient and elastic, and the upper atmosphere of the composition reinforces this impression in the use of U-shaped curves which re-echo the central compositional feature of the human figure, the long curving leg, and further emphasize the kinesis of the figure by making the atmosphere seem stirred into eddies. As we follow the uninterrupted path of this flight down the long curve of the leg, however, these impressions are arrested by the contractions of the arms and shoulders, and in some copies, by the apparent old age revealed in the head of the figure.[28] We can identify the figure as the aged Urizen in some copies, then, and as Los or perhaps one of the other Eternals in others. The point is, of course, that Blake keeps the specification of identity ambiguous for very good reason: As in the poem, he is not so interested in the activity of Urizen as an "identity," as in the identification of Urizenic activity. The human figure and background in this design both embody the paradoxical fusion of expansion and contraction, movement and stasis which characterize Urizen's world. The figure can be seen with the blink of an eye either as falling freely, or as coming to an abrupt halt. The substance he encounters at the bottom of the design can be either clouds which he parts, or stony obstructions. Their coloring generally suggests that they are of the same substance as the thin vapors in the upper portion of the design, and yet the figure's strained encounter with them suggests a much firmer texture. The figure's hands form flat arches like those on the title-page, conforming to the contours of the space they encounter, and anticipating a

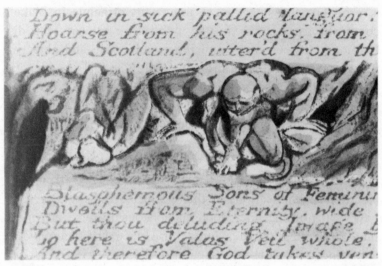

115. Blake, *Jerusalem*, pl. 23 (detail). *Census* copy E. Mellon Collection.

motif Blake was to employ later in *Jerusalem* plate 23
[Illustration 115] to depict a giant being crushed in a cave.
The significance of the contrasts and reverberations in the
linear forms of these designs is, as we have observed, that
Urizenic activity is simultaneously flight and confinement, a
fall through a chaotic void, and an encounter with a petrified
condensation of that void. Urizen and his world are both a
vacuum of introspection and a "solid obstruction." The
co-presence of these qualities is emphasized by fusing them in
a single body, by displaying them as variations on a single
background substance, and, in one version (copy A) the
continuity of the human form with its spatial container is
emphasized by coloring the body with the same spectrum of
pink, blue, and grey hues that make up its vaporous
surroundings.

This kind of significant interaction between human
form and spatial container, by way of contrast or continuity,

is probably the single most important principle in Blake's compositions. Just as in the poetry he subverts the distinctions between outer and inner, subjective and objective realms, so in his designs the body and its spatial envelope are full of mutual reverberations. One could wish for no more obvious declaration of this continuity between figure and background than his illustration of Urizen's creation of the "Net of Religion" [Illustration 116: Pl. 23]. If plate 8 depicted Urizen in search of a "solid without fluctuation" in a mental void, plate 23 shows him fleeing from the paradoxical implications of this world. Urizen's rule of "One Law" has not engendered a homogeneous universe, any more than Los's creation of a body for Urizen has succeeded in confining "The obscure separation alone" (5:40). Urizen finds that "no flesh nor spirit could keep/ His iron laws one moment," and like Los, his hypocritical pity for his own productions divides his soul, creating another "Female in Embrio" (25:18), this time manifested as a web whose meshes are "twisted like to the human brain" (25:21). The conflation of mental and physical descriptions of the web in the poem is translated pictorially as a continuity between Urizen's body and the long, flowing mantle which seems an extension of his flesh. The composition is also an inverted version of the motifs of plate 8, the long curve of the lower body accentuated by the curves of the mantle, opposed to the contracted posture of the upper body and its surroundings, and thus reveals the essential identity of the two activities. Urizen's reaction to his own creatures (an imagistic conflation of the Eternals repudiation of Urizen with the "Tent of Science," and Los's reaction to his finished creation) is simply a more complex re-enactment of the initial Urizenic retreat from eternity into a world of "petrific chaos." If Urizen's "fall" in plate 8 shows him eagerly

117. Blake, *The Book of Urizen*, pl. 6. *Census* copy G. Rosenwald Collection.

116. Blake, *The Book of Urizen*, pl. 23. *Census* copy G. Rosenwald Collection.

searching downward, trying to part the clouds that block his
way, his attempt at an escape from his own world is simply
another version of that fall. The juxtaposition of the two
designs produces a sense, not that Urizen rises in one and falls
in the other, but that up and down have ceased to have any
meaning, and that Urizen's search for the absolute has only
generated a limbo of absolute relativity, a situation which
finds its perfect pictorial representation in plate 6 [Illus-
tration 117].

This principle of continuity and interaction between the
human figure and its spatial container generally manifests
itself in *Urizen* and in Blake's other prophetic books as a
systematic refusal to employ the techniques of three-
dimensional illusionism which had been perfected in Western
art since the Renaissance.[29] There was nothing wrong with
Blake's draughtsmanship: he simply has very little use for
empirical notions of "objective" space. Plate 9 [Illustration
118], for instance, which probably depicts Los after "Urizen
was rent from his side" (6:4), lacks foreshortening, so that
Los's head seems to be directly attached to his waist. The
ambiguity of the illusion permits a strikingly literal rendition
of Los's torment, because it implies that Urizen's separation
has in fact left him without a torso, and compressed his body
into yet another version of Urizenic contraction in a space of
expansion. Perhaps the firmest evidence, however, of Blake's
careful handling of figures in space occurs in a design which
seems quite out of place among the titanic nudes and
phantasmagoric backgrounds of Urizen. Plate 26 [Illustration
119], a starkly simple picture of a boy and dog before a
door seems relatively objective in its mechanical perpendicu-
larity, broken only by the diagonal of light and shadow
across the center. Notice, however, that the figures in the
design do not exist independently of the background: they

119. Blake, *The Book of Urizen*, pl. 26. *Census* copy G. Rosenwald Collection.

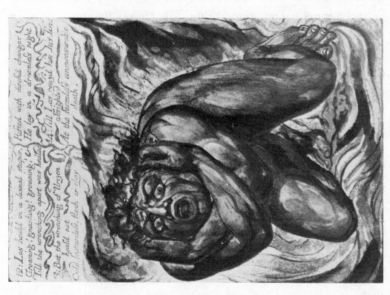

118. Blake, *The Book of Urizen*, pl. 9. *Census* copy G. Rosenwald Collection.

are simply human and animal versions of the austere rigidity
which surrounds them, the boy's vertical lines broken only
by the angles of his arms, which are parallel and perpen-
dicular to the light diagonal, and the horizontal mass of the
dog broken only by the vertical thrust of his head. In this
sense, the design exemplifies the most rigid kind of con-
tinuity between figure and spatial container, and, by impli-
cation, between subjective and objective worlds.

Blake used similar settings in at least three other designs
for his own books: (1) plates 6 and 7 of *Europe* (labelled
"Famine" and "Plague" by George Cumberland) which show
rigid human figures against similarly austere backgrounds; (2)
the illustration to "London" in *The Songs of Experience*,
showing an old man and boy before a doorway with a similar
light-diagonal. The one thing all these designs have in
common is their concern with a contemporary scene—
London in the 1790's. While the flamboyant figures which
dominate the Lambeth books chiefly envision a mental clash
of gigantic psychological forces, the family of plates similar
to *Urizen* plate 26 constitutes Blake's concession to the
"imitation of nature." These are Blake's *genre* pieces, his
look at things "out there" as they are. It is, needless to say, a
very selective look, a focusing on the city which man has
made for himself as a rigid prison-house of "Mathematic
Form."

> I wander thro' each charterd street,
> Near where the charter'd Thames does flow.
> And mark in every face I meet
> Marks of weakness, marks of woe.

Blake is satirizing here the "charter'd liberties" of English-
men,[30] but he is also evoking the geometrical associations of
the word, the graphic "chart-like" perpendicularity which
provides the structural principle of his vision of London. The

hostile sterility of the material city is, for Blake, a metaphor for the imagination which creates it and then accepts it as objectively real.

Space forbids a detailed account of all the illustrations of *Urizen*, but the general principles for their interpretation should be clear. They are readable, not as a sequential narrative, but, like the text, as a series of "epiphanies" or what Blake would call "opened centers." That is, the designs accrue significance, not from their relationships to any verbal or visual temporal sequence, but from their embodiments of recurrent figural motifs. This is not to say that the recurrent abstract linear patterns have any kind of invariable denotation. The contracted forms of Urizenic space may become in another context the protective, maternal contraction of Innocence, the embrace of a mother or the benign shade of a pastoral arbor.[31] The "lineaments," the stylized and abstract dimensions of Blake's art, are like the "is" in a metaphor, a means of linking disparate areas of attention. They are a vision of permanence beneath the changing appearances of color and light.

The "meaning" of the design, then, does not reside simply in the abstract linear skeleton or in the specific representational illusion which it structures, but in the interplay between these two elements, just as in the poem, the meaning of the specific episode depends upon the interplay between the archetypal characteristics of Urizenic behavior and their specific incarnations in historical moments. Each medium is organized as a counterpoint between contrary elements, just as the total design of the illuminated prophecy exists as a counterpoint between the poem and its illustrations. Blake's poetry may be said to have "spatial form" in that it represents time muralistically, as a continuum in which all moments are to be seen as part of a

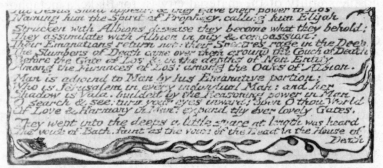

120. Blake, *Jerusalem*, pl. 44 (detail). *Census* copy E. Mellon Collection.

single design (hence, Blake's Bard "Present Past & Future *sees*"), and in which any given moment contains the efficacy and significance of the whole. The painting has a temporal dimension in that any given visual form must be seen as an instance, a version among an infinite number of available possibilities for that form. Blake provides an emblem of this implied dimension in his designs in plate 44 of *Jerusalem* [Illustration 120], which shows a serpent, a vine, and a tongue of flame as metamorphic variants on a single S-curved form. In the painting, as in the poetry, anything can be a metaphor for anything else. When Blake says, then, that his art "copies Imagination,"[32] we need not be disturbed at his apparent confusion of mimetic and expressive goals. His art imitates, not simply the ideal abstraction or the empirical appearance, but the process of interaction between the two, which he defines as imagination. The subject of his poetry is the imagination, presented as consciousness giving shape to itself and to its world, often binding itself down with mental fetters, but always potentially capable of returning to a state of "Intellectual Vision." The subject of his painting is likewise the imagination, presented as the human body ("The Eternal Body of Man is The Imagination"),[33] imprisoned or

tortured by the surroundings to which it gives form, but always capable of rising from its self-imposed slavery. If mind and body are Blake's two essential metaphors for the imagination, it should be clear why he sought an art-form that would unite them, not in some vaguely transcendent realm of idealism, but concretely and immanently in the images of his craft:

> But first the notion that man has a body distinct from his soul, is to be expunged; this I shall do, by printing in the infernal method, by corrosives, which in Hell are salutary and medicinal, melting apparent surfaces away, and displaying the infinite which was hid. (*MHH* 14)

NOTES

1. Jean Hagstrum, *William Blake: Poet and Painter* (Chicago: Chicago Univ. Press, 1964).

2. There is an enormous body of secondary literature on this subject. Recent studies include Hagstrum's *The Sister Arts* (Chicago: Chicago Univ. Press, 1958), Robert J. Clements, *Picta Poesis* (Rome, 1960); part IV of Ralph Cohen's *The Art of Discrimination* (Berkeley: Univ. of Calif. Press, 1964). The best general study is still Rensselaer Lee's *Ut Pictura Poesis* (*Art Bulletin*, 1942; reprinted W. W. Norton Co.: New York, 1967).

3. See *Laocoon: An Essay on the Limits of Painting and Poetry* (1766), trans. Edward A. McCormick (New York, 1962).

4. See Jeffrey Eicholz's "William Kent's Career as Literary Illustrator," *Bulletin of the New York Public Library*, 70 (1966), 620-646, for an analysis of the use of the three-dimensional illusion as a metaphor for the narrative order of the poem. Ronald Paulson's "*The Harlot's Progress* and the Tradition of History Painting," *Eighteenth-Century Studies*, 1 (1967), 69-92, shows the

same kind of technique in Hogarth. Rensselaer Lee's chapter on "The Unity of Action" in history paintings treats the general assumptions of this technique.

5. Especially in copy G, reproduced here [Illustration 104].

6. *Laocoon*, see above, chap. 16, especially pp. 88-91. Since this essay first appeared, Professor Hagstrum has argued in David V. Erdman and John E. Grant, eds., *Blake's Visionary Forms Dramatic* (Princeton: Princeton Univ. Press, 1970), p. 82 that Blake is reviving an older, richer tradition of literary pictorialism than the neoclassical reduction of it which Lessing criticized. I am inclined to agree, but I still think that Blake's return to the older tradition involved a thoroughgoing attack on the newer, neoclassical version of that tradition.

7. See *The Marriage of Heaven and Hell*, pl. 24 (E 43, K 158). All quotations are from Erdman's text. Abbreviations of titles will follow the format in Erdman's text (e.g. "J" = *Jerusalem*).

8. See, for instance, Alicia Ostriker, *Vision and Verse in William Blake* (Madison, Wisconsin: Wisconsin Univ. Press, 1965), p. 163.

9. *Europe* (1794), *America* (1793), and in *The Song of Los* (1795), "Africa" and "Asia."

10. Deleted in two (A and G) of the seven extant copies. The alphabetical listing of copies here is taken from Geoffrey Keynes and Edwin Wolf's *William Blake's Illuminated Books: A Census* (New York: Grolier Club, 1953).

11. D. J. Sloss and J. P. R. Wallis observed that "though the Eternals inspire Blake's prophecy, it is to be noted that

the myth does not represent them as a beneficent providence." *The Prophetic Writings of William Blake* (Oxford: Clarendon Press, 1957), I, 86.

12. See *Paradise Lost*, V, 679-680 and 855.

13. In copy A their expression connotes terror. In copy G, reproduced here [Illustration 105], it is more like gloomy disapproval.

14. There is no question that this phrase reflects the fundamental principle of the relationships among Blake's prophetic characters. He uses it six times in *Jerusalem* (34:4, 14, 15, 50, 54; 36:19) and variations on the idea occur regularly throughout *The Four Zoas* and *Milton.*

15. See for example the "Proem" to Book V of *The Faerie Queene,* and *An Anatomy of the World.*

16. After the rock entered Fuzon's bosom, it "fell upon the Earth/ Mount Sinai, in Arabia" (3:45–46).

17. "To be an Error & to be Cast out is a part of God's Design No Man can Embrace True Art till he has Explord & Cast out False Art" (*A Vision of the Last Judgment*, E 551, K 613).

18. In the collection of Major T. E. Dimsdale. The reproduction here is from the Dent Facsimile of this copy, ed. Dorothy Plowman (London: Dent, 1929).

19. In the Department of Prints and Drawings of the British Museum.

20. Both copies are in the British Museum.

21. See 5:1–6 of *Visions.*

22. Compare also the right side of Blake's "The Last Judgment" in the Petworth Collection, reproduced in

Erdman's edition of Blake. Copies A and B emphasize this allusion by adding four spears or (says Erdman) "arrows from the Almighty's Bow" at the upper right.

23. *A Vision of the Last Judgment* (E 554, K 615).

24. In copies A and B the old man looks more like a bird.

25. Copy D, British Museum.

26. Reproduced from *William Blake's Illustrations to the Bible,* Geoffrey Keynes (Clairvoux, France: Trianon Press, 1957). Ed.: The illustration in this reprint has been made from a photograph of the original.

27. The plate numbers here follow the order of copy G (the Trianon Press Facsimile).

28. In copy G, reproduced here, Urizen's beard is faintly visible.

29. For a general discussion of Blake's treatment of illusion, and its relation to similar Continental movements, see Robert Rosenblum's *Transformations in Late Eighteenth-Century Art* (Princeton: Princeton Univ. Press, 1967), Chap. 4, especially pp. 155-156.

30. Northrop Frye was the first to suggest this implication in *Fearful Symmetry* (Princeton: Princeton Univ. Press, 1947), p. 181.

31. See particularly plates 1, 3, and 6 in *The Book of Thel,* and the Frontispiece, "The Ecchoing Green," "The Lamb," "The Little Black Boy," and "Spring" in *The Songs of Innocence.*

32. "Men think they can Copy Nature as Correctly as I Copy Imagination this they will find Impossible" *(Public Address,* E 563, K 594).

33. Blake's *Laocoön* (E 271, K 776).

BLAKE'S *NIGHT THOUGHTS:*
INTERPRETATIONS OF EDWARD YOUNG
by
Thomas H. Helmstadter

*I*n 1797 Richard Edwards published the first volume of a new edition of Edward Young's *Night Thoughts*, one of many editions of this popular poem in nine parts since its first publication between 1742 and 1745. Edwards issued a prospectus advertising "part the first of a splendid edition of this favourite work, elegantly printed, and illustrated with forty very spirited engravings from original drawings by BLAKE."[1] William Blake had devoted almost two years to the project of illustrating Young's poem and made a marginal water-color design for each page of Young's text, a total of 537

Ed.: Reprinted by permission of the author and publisher, with additional illustrations and the author's revisions, from *Texas Studies in Literature and Language*, 12 (1970), 27-54. Copyright University of Texas Press.

illustrations. Forty-three were engraved for the Edwards edition containing parts one to four of Young's poem. The project was apparently not a commercial success, and subsequent volumes were never printed. Today Blake's *Night Thoughts* illustrations are still largely unpublished and are in the Print Room of the British Museum.

The generality of Young's diction gave Blake considerable freedom in illustrating it, and the fact that Blake supplemented his author's text with ideas of his own is apparent upon even a cursory glance through the *Night Thoughts* series. Sometimes Young's abstract personifications receive a concrete form that would have surprised him. Blake illustrates the lines, "*Ambition, Avarice!* the two *Daemons*, these/ Which goad thro' every Slough our Human Herd," with a picture [Illustration 121] of two men driving a plow pulled by human beings in the traces.[2] One of the men wears a king's crown and the other a miter, thus making the illustration a form of radical social criticism asserting Blake's disapproval of two institutions that he criticized extensively in his writings. This is an easy example of Blake's giving an illustration a meaning Young's text did not possess. Such straightforward expression on the part of the illustrator is obvious enough, but the rich meaning of many of the *Night Thoughts* illustrations does not begin to emerge until we consider them within the context of Blake's own work. The first man to publicize Blake's achievement in the *Night Thoughts* series was J. Comyns Carr, who in 1875 wrote that this fine series of illustrations was Blake's interpretation of Young's poem and that the designs often embodied "germs of ideas employed afterwards in other works."[3] Since then several commentators have found the *Night Thoughts* a valuable pictorial expression of Blake's own mind, and recently scholars have begun to explore this neglected work.[4]

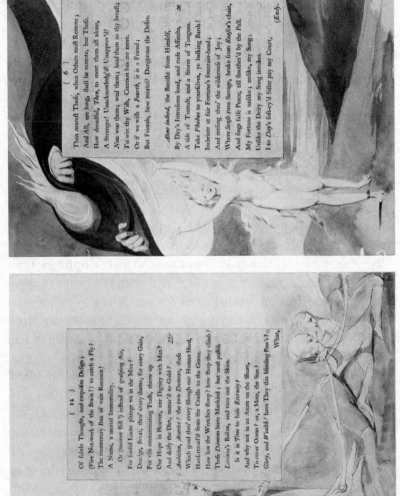

(6)

Then nearest Thefe, when Others moft Remote;
And All, ere long, fhall be remote, but Thefe.
How dreadful, *Then*, to meet them all alone,
A Stranger! Unacknowledg'd! Unapprov'd!
Now woo them; wed them; bind them to thy breaft;
To win thy Wifh, Creation has no more.
Or if we with a *Fourth*, it is a Friend;
But Friends, how mortal? Dangerous the Defire.

Alone indeed, the Banifht from Himfelf,
By Day's Intrufions loud, and rude Affaults,
A tide of Tumult, and a Storm of Tongues.
Take *Phœbus* to yourfelves, ye barking Bards!
Inebriate at fair Fortune's fountain-head;
And reeling thro' the wildernefs of Joy;
Where *Senfe* runs Savage, broke from *Reafon's* chain,
And fings falfe Peace, till fmother'd by the Pall.
My Fortune is unlike; unlike, my Song;
Unlike the Deity my Song invokes.
I to *Day's* foft-ey'd Sifter pay my Court,

(*Endy-*

122. Blake, *Night Thoughts* no. 81. British Museum.

(11)

Of fubtle Thought, and exquifite Defign;
(Fine Net-work of the Brain!) to catch a Fly?
The momentary Bus of vain Renown!
A Name, a mortal Immortality.
Or (meaner ftill!) inftead of grafping Air,
For forbid Lucre plunge we in the Mine?
Drudge, fweat, thro' every flame, for every Gain,
For vile contaminating Trafh, throw up
Our Hope in Heaven, our Dignity with Man?
And deify the Dirt, matur'd to Gold?
Ambition, Avarice! the two *Dæmons*, thefe
Which goad thro' every Slough our Human Herd,
Hard-travell'd from the Cradle to the Grave.
How low the Wretches ftoop? how fteep they climb?
Thefe *Dæmons* burn Mankind; but moft poffefs
Lorenzo's Bofom, and turn out the Skies.
Is it in *Time* to hide *Eternity*?
And why not in an Atom on the Shore,
To cover Ocean? or, a Mote, the Sun?
Glory, and *Wealth!* have They this blinding Pow'r?

What,

121. Blake, *Night Thoughts* no. 233. British Museum.

Like the annotations that Blake made in books he read, these illustrations provide another source of information about him and give us a rare opportunity for seeing Blake reacting to Young's work at the same time that he renders it into picture. Sometimes Blake even corrects or provides an alternative reading for a text with which he disagrees, as we now know that he did in designs for Blair's *Grave*, the Book of Job, and the *Divine Comedy*.[5] At least eighteen of the *Night Thoughts* illustrations depart significantly from the ideas and attitudes of their text and are therefore of special interest for what they tell about Blake.[6] I shall discuss numbers 81, 82, 7, 64, 404, 490, 333, and 349, because they most clearly express Blake's own interpretations of Young's poem. They demonstrate Blake's disagreement with Young on a variety of issues, notably with Young's attitude toward the role of imagination in literature, with his opinion that reason is man's dominant faculty, and with his belief in rigid moral laws providing punishment for sin. When Young wrote the *Night Thoughts* in the middle of the eighteenth century, he considered that he was offering "plain Truths" with which his readers would agree.[7] But when Blake illustrated the *Night Thoughts* at the end of the century, he found ideas with which he was in confirmed opposition.

Three designs challenge Young's pronouncements on literature and by a few years anticipate the reactions of Wordsworth and Coleridge to the Age of Reason. Young invokes his muse and offers advice to other writers in the text for number 81 [Illustration 122], also engraved by Blake for the Edwards edition.[8] Questions about the relationship between design and text arise if we examine the picture carefully, bearing in mind Blake's advice that the spectator discriminate the minute details of the work and that he "attend to the Hands & Feet, to the Lineaments of the

Countenances; they are all descriptive of Character, & not a line is drawn without intention, & that most discriminate & particular. As Poetry admits not a Letter that is Insignificant, so Painting admits not a Grain of Sand or a Blade of Grass Insignificant—much less an Insignificant Blur or Mark."[9]

The immediate basis for Blake's picture is the lines, "Where *Sense* runs Savage, broke from *Reason*'s chain,/ And sings false Peace, till smother'd by the Pall."[10] A naked girl with a manacle on her right ankle walks on a green hill with her arms upraised. The palms of her hands are turned up, and she wears a bracelet with five beads or pearls on each wrist. Blond hair rises up from her head, giving the effect of flame. More hair flames out on each side of her. Her right foot is extended a short distance. Her left heel is raised slightly and her weight is on the ball of her left foot. The girl's erect posture, small step forward, and slightly bent left leg show that she is walking, not "running savage" as in Young's text. Her mouth is open and she is apparently singing, in keeping with the text. An old man with both fists clenching the bottom hem of his black cloak is flying headlong through the air upon her. Although his face is obscured by the pall, his white hair is visible and identifies him as one of the familiar personifications of aged Death with long white hair who appears in many of the *Night Thoughts* illustrations.

Blake's girl personifying Sense is not "running savage," but she does wear the manacle of Reason's chain, appears to be singing, and is about to be smothered by the pall of Death. Her beauty, in contrast to the horror of Death melodramatically swooping down upon her, suggests that Blake's sympathies are for the girl, but in Young's text she is getting what she deserves. The question of whose side Blake is on is of little significance if the girl is only another damsel in distress. As the personification of Sense, she represents a

term sufficiently vague to signify very little in the above lines. But the girl and Blake's attitude toward her become more meaningful if we consider her in Young's context.

The speaker is invoking his muse, and chooses Cynthia because he is suspicious of the inspiration of Apollo, which has misled other bards before him:

> Take *Phoebus* to yourselves, ye basking Bards!
> Inebriate at fair Fortune's fountain-head;
> And reeling thro' the wilderness of Joy;
> *Where *Sense* runs Savage, broke from *Reason*'s chain,
> And sings false Peace, till smother'd by the Pall.
> My Fortune is unlike; unlike, my Song;
> Unlike the Deity my Song invokes.
> I to *Day*'s soft-ey'd Sister pay my Court
> (*Endymion*'s Rival!) and her aid implore.[11]

Seen in this context, Blake's picture begins to embody a conception of literature. Sense now represents the aesthetic pleasure of those poets whose creative or imaginative energy is not bound by Reason's chain. Blake's sympathy for the girl is based on his endorsement of the creative or imaginative energy Young rejects. Young hopes to restrain imaginative energy with Reason's chain, but a central theme of all Blake's work celebrates the liberation of Imagination from domineering Reason. Young is suspicious of Apollo, but Blake asserts that "One Power alone makes a Poet: Imagination, The Divine Vision."[12] Like the Sons of Albion who are "by Abstraction opposed to the Visions of Imagination," Young hopes to check inspiration with Reason's chain.[13] Blake, on the other hand, criticizes even Milton for so submitting to Reason's excessive restraints in parts of *Paradise Lost* that he "wrote in fetters when he wrote of Angels & God."[14] It is not surprising, therefore, that the *Night Thoughts* illustration departs from the spirit of Young's text in order to show Blake's sympathy for Sense, the girl of inspiration, who broke from Reason's chain.[15]

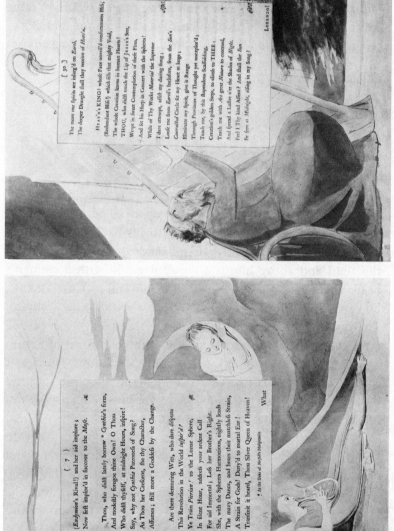

124. Blake, *Night Thoughts* no. 448. British Museum.

123. Blake, *Night Thoughts* no. 82. British Museum.

My interpretation of number 81 is corroborated by 82 [Illustration 123] on the following page, where Young continues to defend his choice of a tame muse and Blake continues to disagree with him in the picture. Young advises all writers to invoke gentle Cynthia as their muse, rather than the stronger inspiration of her brother Apollo:

> Are there demuring Wits, who dare dispute
> This Revolution in the World *inspir'd?*
> *Ye train *Pierian!* to the Lunar Sphere,
> In silent Hour, address your ardent Call
> For aid Immortal; Less her Brother's Right. [16]

The illustration again gives the impression of being straightforward and appropriate to Young's general text. A figure in a blue robe plays a lyre and sits with his back against a tree. Behind him is a curious tentlike backdrop or windbreak. At the right and above him is a crescent moon with a woman's head, the personification of Cynthia. Several pictorial details, however, indicate Blake's reservations about Young's advice. The lyre player leans against a tree without leaves, and trees, especially dead ones, represent the vegetable world of nature as opposed to the world of imaginative vision. The tree's sinister implications for the artist are made more pronounced by the leafless branch that extends over his head, cutting him off from imaginative vision above.

Furthermore, the lady in the moon is curled asleep in the crescent. Her head rests on the moon, her left hand clutches a cover or blanket wrap that grows out of the moon crescent. Not only is this sleeping muse suspect, but the leafless branch from the tree extends over the moon and muse as well as over the lyre player, establishing a barrier that tends to limit both artist and muse to a vision of vegetable nature. The lyre player-artist looking languidly down at the ground with a leafless tree branch hanging over both him and

his sleeping muse contrasts with number 448 [Illustration 124], where the imaginative artist King David plays on his harp and looks up to the golden light of vision at the top of the drawing.[17] Blake reveals the error of Young's advice and is instead true to his own convictions regarding the role of imagination in art.[18]

More direct criticism of Young's writing is delivered in number 7 [Illustration 125], which has no immediate text and provides a marginal design for the blank verso to the title page of Night I. In the upper right corner is a writer wearing a laurel crown, holding a quill pen in his right hand, and leaning over a pedestal. He buries his head in his arms, which in turn rest on the pedestal. He has been writing on a long scroll, which crosses the pedestal and curls over his shoulder. The scroll extends down the left margin of the drawing, held by two young men flying with the scroll down to the lower middle of the drawing. In the lower right corner sits a small old man with a beard, dressed in a gray robe, and observing the scroll as he writes on a tablet in his lap. He leans against a blasted tree trunk whose branches are broken off just above the first fork. He sits on a gray rock, the same color gray as the robe and the tree. A broken branch extends over the head of the man and tends to limit this gray writer to his gray world, like the limiting branch of number 82. A cloud at the right margin above the tree is another limit or barrier.

The round pedestal and laurel crown identify the man at the top of the design as a classical writer, which to Blake represented a limited imagination. One of the means by which Blake rebelled against eighteenth-century neoclassicism was to attack its sources in the classics themselves. He therefore presents the Greek muses as "daughters of Mnemosyne, or Memory, and not of Inspiration or Imagination," and writes that "we do not want either Greek or Roman

Models if we are but just & true to our own Imaginations."[19] Can we, however, be more specific about Blake's criticism of the writer with laurel crown resting on the pedestal, and what is the significance of the old man at the lower right of the design? The meaning of number 7, which has no text of its own, is illuminated if we consider it in relationship to Young's assertions in the Preface, just preceding the design.[20]

The small old man with a beard looking at the scroll and writing resembles Urizen. He is surely a suspect figure, leaning against a dead tree and limited to his gray world by both the branch and cloud. The following passage from the Preface helps to confirm our suspicions. Young explains that his poem differs from *"the common Mode of Poetry, which is from long Narrations to draw short Morals. Here, on the contrary, the Narrative is short, and the Morality arising from it makes the Bulk of the Poem. The Reason of it is, That the Facts mentioned did naturally pour these moral Reflections on the Thought of the Writer."*[21] The old man resembling Urizen represents the "Thought of the Writer" looking at the narration on the scroll. He is the personification of the author's Reason and is thus writing down his moral reflections after observing the narrative events related on the scroll. These events on the scroll were recorded by a classical writer who employed his memory, not his imagination, to give shape to his material. As Young says at the beginning of the Preface, the *"Occasion of this Poem was* Real, *not* Fictitious."

Unlike Blake, who asserted in the "Laocoön that "Art is the Tree of Life," Young disclaims much value in the pursuit of literature: *"This Thing was entered on purely as a Refuge under Uneasiness, when more proper Studies wanted sufficient Relish to detain the Writer's Attention to them. And that Reason (thanks be to Heaven) ceasing, the Writer has no*

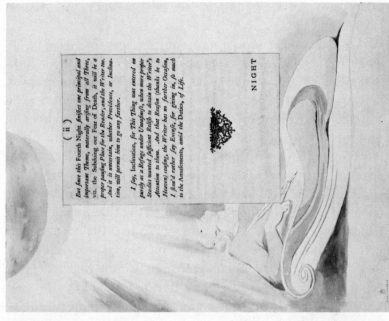

126. Blake, *Night Thoughts* no. 5. British Museum.

125. Blake, *Night Thoughts* no. 7. British Museum.

farther Occasion, I shou'd rather say Excuse, for giving in, so much to the Amusements, amid the Duties, of Life."²² For this page of the Preface, the marginal design, number 5 [Illustration 126], depicts a blond writer in a blue gown with a quill. He writes on a very long scroll, like that of number 7. This writer portrays the writer of the Preface. He resembles the blond writer with quill and laurel crown leaning on the pedestal in number 7, and thus enables us to identify that classical writer as Blake's portrayal of Edward Young. The marginal design for the blank verso to the title page of Night I clearly constitutes a criticism of Young. Blake's classical writer is not a shaper of imagination. He records events for Reason to moralize upon, a Reason whom Blake depicts beneath a dead tree rather than a tree of art and life.

Numbers 81, 82, and 7 are considerably more meaningful, and interesting, when recognized as interpretations of Young that meet his pronouncements on literature and writing with a contrary view of Blake's own. Throughout the *Night Thoughts* Young continues to regard Reason as man's supreme faculty. Blake did not share the confidence of Young's age in Reason, and I find that numbers 64, 404, and 490 contradict their text in order to present Blake's reactions to it.

Several questions concerning the relationship between design and text are raised by number 64 [Illustration 127], also engraved by Blake for the Edwards edition.²³ Young describes the necessity for exchanging ideas in order to keep thought alive. Friends, Young asserts, have this opportunity, just as teacher and students stimulate each other in a healthy exchange of ideas. The following passage would be likely to appeal to Blake's own conviction that a meeting of contrary points of view is useful, for "without contraries is no progression." Several elements in the illustration also suggest

that the passage appealed to Blake's sense of irony:

> Teaching, we learn; and giving, we retain
> The Births of Intellect: when dumb, forgot.
> *Speech ventilates our Intellectual fire;
> Speech burnishes our Mental Magazine:
> Brightens for Ornament; and whets for Use:
> *'Tis Thought's exchange, which like th'alternate Push
> Of waves conflicting, breaks the learned Scum,
> And desecates the Students standing Pool. [24]

An elderly man at the lower left is instructing two children seated before him, while a woman and younger child look on at the right. A youth reclines on a cloud to the right of Young's text, and another plays a lyre at the upper left above the text. Again Blake's illustration seems appropriate and agreeable enough to Young's generalizations. This proves not to be the case, however, if we examine the picture closely, following Blake's advice to heed the minute details and attend to the hands, feet, and countenances.

The elderly instructor with white hair and a beard wears a long white gown that covers his feet. The fingers of his left hand are outspread before him, and he points to the fifth finger of his left hand with the index finger of his right. The viewer can see one side of the instructor's chair, which is turned slightly to reveal part of the back. The back of this chair curves upward from the side to a peak in the middle. Three curious runglike objects are visible on the solid back of the chair.

Two children sit on a low stool before the instructor. One, probably a girl because of the long hair, is dressed in a pink gown and holds up her left hand with index finger extended. On the other side of her is a boy in green. The woman in the lower right wears a long white gown that covers her feet. White hair is visible beneath her hood. She is sitting on a yellow chair, with her hands resting on her knees

and her right hand also partially resting on the shoulder of a small child, younger than the others, dressed in yellow. At the base of the back leg of her chair is curious green foliage with leaves resembling flames. The chair itself resembles a large blossom and seems to grow out of the vegetation. Flaming leaves reappear on the side of the chair as a decoration, confirming a relationship between the blossom-chair and leaves of green flame. A yellow-green vine also grows from the flaming foliage up the margin past the blossom-chair, whereupon it turns and grows in serpentine loops above the head of the woman until it approaches the text.

Several details are at variance with the spirit of intellectual exchange described by Young. The woman's straight lips give her a worried countenance and she leans forward in anxious concern about the young students before her. The sheer size of the instructor in comparison to the students makes him an imposing figure of authority. Attention to the hands gives a more telling indication of the instructor's character. He is counting on his fingers and conducting a memory lesson, not participating in the exchange of thought.[25]

The lyre player and the figure reclining on the cloud suggest imagination and pleasure in contrast to the scene of instruction below, from which they are separated by the block of text, cloud, and vine. The worried countenance of the woman, the domineering instructor, and the separation of education from imagination and pleasure above are pictorial qualifications to the vigorous exchange of thought described by Young. The keys to the illustration, however, are the chairs upon which the woman and instructor sit. The blossom-chair with mother, child, and flaming green leaves represents energy and new life.[26] The back of the

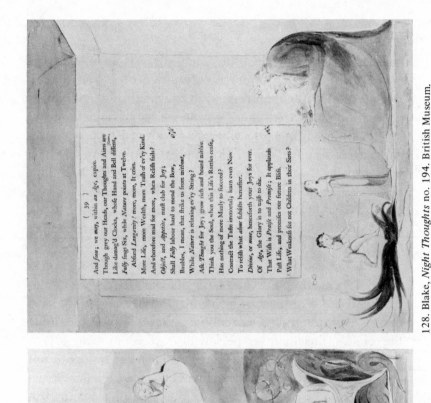

127. Blake, *Night Thoughts* no. 64. British Museum.

128. Blake, *Night Thoughts* no. 194. British Museum.

instructor's chair, on the other hand, suggests small bat wings growing from the instructor, a clear sign of evil in Blake's work.[27] Rather than portraying an exchange of ideas, Blake's illustration dramatizes the fall from energy, imagination, and joy into the adult world where bat-winged Reason imposes patterns of thought upon his students. Appropriately, the vine growing from the foliage trails off into the text in a sickly yellow-green with only three leaves blotched with yellow. The illustration does not show that "teaching, we learn" in "Thought's exchange," but dramatizes instead a fall from innocence into experience.

Blake's pictorial irony cuts through Young's text in order to examine the basis for his glib assertions about teaching and learning. Bernard Blackstone has shown that Blake, a severe critic of education, accused schools of stifling the child's imagination, personality, freedom, and joy. [28] Rigid conformity to inflexible systems of thought, not vitality and growth in intellectual exchange, characterized Blake's schools and universities. [29] One of his manuscript verses thanks God he "never was sent to school/ To be Flog'd into following the Style of a Fool." [30] Like the schoolboy in *Songs of Experience* who spends his day under a "cruel eye outworn" and is separated from the pleasure necessary for his development, the students in Blake's illustration are separated from the figures of pleasure on the cloud and text above them. Blake's illustration challenges Young's glib and disingenuous rhetoric with a sober view of an evil Reason, a Urizenic schoolmaster, imposing his disciplines upon his children.

Number 404 [Illustration 129] presents a much more straightforward challenge to Young's text, describing a model of behavior for Lorenzo to emulate. Young praises the man who is able to keep his appetite and passion firmly under the

control of his reason:

> *He* follows Nature (not like Thee), and shews us
> An uninverted System of a Man:
> His *Appetite* wears *Reason*'s golden Chain,
> And finds, in due Restraint, its Luxury;
> *His *Passion*, like an *Eagle* well-reclaim'd,
> Is taught to fly at nought, but Infinite. [31]

Blake shows a young man holding a sleeping dog on a chain with his left hand, while an eagle is perched upon the index finger of his right hand, raised above his head. Reason's chain keeps Appetite, here portrayed as a subhuman or animal function, under control. The chain is a restraint always suspect in Blake. The hunched back and lowered head make Blake's eagle a thoroughly tamed bird, more likely to fly at nought than at the infinite. The face of the young man is curiously blank and does not suggest that wisdom resides therein. The chain restraining animal appetite, the tame eagle of passion, and the blank face of the young man indicate that Blake disagrees with his author. They recall Blake's opposite assertion that "Men are admitted into Heaven not because they have curbed & govern'd their Passions or have No Passions, but because they have Cultivated their Understandings."[32] The eagle of passion in the illustration has erred in submitting to the restraints of the virtuous young man with Reason's chain.

One would expect Blake to disagree with Young's advice in the text for number 490 [Illustration 130]. Young cites the design and order of Nature as a proof for the existence of the Deity and directs Lorenzo to prepare himself for seeing this design by retiring from the world, by restraining his faculties of sense and passion, and by waking all to reason:

> *Retire*;–The *World* shut out;–Thy Thoughts call Home;–
> **Imagination*'s airy Wing repress;–
> Lock up thy *Senses*;–Let no *Passion* stir;–
> Wake all to *Reason*; Let *her* reign alone. [33]

The illustration seems to be a fairly literal translation of Young into picture, but certain elements make me suspect that Blake has incorporated his own objection to Young's advice into his design.

The illustration portrays Lorenzo lying in a room with personifications of Imagination, Sense, and Passion. Imagination is a winged figure who lies languidly with his head supported by his right hand. His right elbow is bent and rests on a pillow. Sense and Passion are small figures locked up in a cage with five spaces between the bars, suggesting the five senses. Lorenzo leans listlessly on the cage of Sense and Passion and raises his left hand toward a window where a small figure can be seen falling from a cloudy sky with head downward and right arm outstretched. A small flying figure representing the awakener to Reason places his right hand on Lorenzo's left shoulder and points upward and to the right with his extended left arm.

Blake's tired and lifeless figures demonstrate that the awakener has not succeeded. The figure falling outside the window is not explained by Young's text, but in Blake's work the head downward fall represents error.[34] Our eyes are directed to him by Lorenzo's outstretched left arm, which almost meets the outstretched right arm of the falling man. Both Lorenzo and the Imagination are looking at this figure in the upper left rather than looking to the upper right, where the awakener to Reason is pointing. Thus Blake's languid illustration leaves us viewing a fall rather than an awakening.

Sleep and awakening are significant symbols to Blake, who describes his major theme as "the Sleep of Ulro" and the "awaking to Eternal Life."[35] Young's awakening to the Deity is supposed to come when Imagination and Emotion are subordinate to Reason, but Blake's theme is the

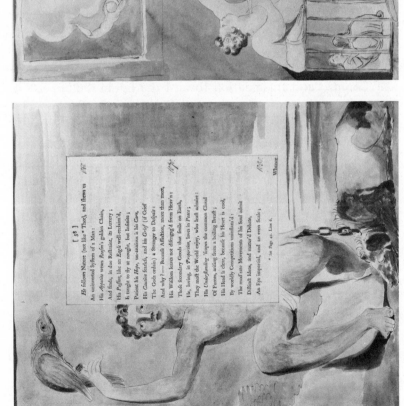

129. Blake, *Night Thoughts* no. 404. British Museum.

130. Blake, *Night Thoughts* no. 490. British Museum.

awakening that comes when Thought, Imagination, and
Emotion work in harmony together to give shape to the deity
residing within:

> I rest not from my great task!
> To open the Eternal Worlds, to open the immortal Eyes
> Of Man inwards into the Worlds of Thought, into
> Eternity
> Ever Expanding in the Bosom of God, the Human
> Imagination.
> O Saviour pour upon me thy Spirit of meekness
> & love! [36]

Blake would have been likely to disagree with Young on
Reason's ability to act alone. His illustration at first seems
appropriate for Young's text, but the cage for Sense and
Passion, the languid Imagination, the passive Lorenzo with
left arm outstretched toward the fall into error, and the gaze
of Lorenzo and Imagination toward the fall in the upper left
rather than toward the upper right where the awakener is
pointing make me suspect that Blake's drawing gives shape to
his own reservations about Young's advice. He does not
portray an awakening, but a fall into division instead.

Young's moral directions are delivered in a didactic,
liturgical tone recalling that Young was himself an Anglican
priest. "Truths, which, at Church, you *might* have heard in
Prose" is his own apt description of the *Night Thoughts*
counsel.[33] Blake's rejection of this counsel in numbers 333
and 349, however, is consistent with his own attacks on the
Church, described by Blake as a cruel institution offering
punishment, not forgiveness, to those who break its rigid
moral laws.

The unprepossessing poetry that number 333
[Illustration 131] represents advises Lorenzo, who is reading
the infidel writer St. Evremont, to read St. Paul instead. St.
Paul understands God's whole system, but St. Evremont sees

only a part. Young concludes with the observation that:

> Parts, like Half-sentences, confound; the Whole
> Conveys the Sense, and God is understood;
> *Who not in Fragments writes to Human Race;
> Read his whole Volume, Sceptic! then, Reply. [38]

In the picture a man in a long white robe with light brown hair and beard stands on a steep mountain slope with both arms raised above his head. At the lower right are several broken stones with "X Command.[ts]" written on the largest one. A soldier in armor, mail, and helmet kneels at the lower left with his hands over his face. The sky in the upper right is a fiery orange-red. Black and blue-purple smoke fills the upper left.

The vague line, "Who not in Fragments writes to Human Race," is illustrated by a biblical scene. The mountain and the broken tablets of the Ten Commandments make it obvious that the figure in white is Moses descending from Mt. Sinai, where God had appeared to him in the smoke and fire still visible at the top of the water color.[39] But who is the soldier kneeling at the left? The broken tablets identify him as Joshua, who had gone up the mountain with Moses and who first heard the noise in the camp below as they descended. When Moses saw the golden calf, he broke the tablets of the commandments in anger.[40]

The design is appropriate to the Night Thoughts text but at the same time gives shape to an independent idea of the illustrator. Young has advised Lorenzo to give up an unorthodox writer who provides only a partial view, a fragment. But what is Blake's attitude toward the Ten Commandments, literal fragments in the above drawing? Is he suggesting that Moses has broken into fragments the whole volume whereby Jehovah might have been understood? Or is he saying that God does not reveal himself in the fragments

of the Mosaic law and that one should turn from these misleading parts or fragments, which "like Half-sentences, confound"? I suspect that Blake is giving shape to the latter alternative. Whereas Young advises Lorenzo to turn from the fragments of an infidel writer and survey the whole, a reading for Blake's illustration is that one should turn from the fragments of the Mosaic law. This interpretation finds support in Blake's consistent use of the Ten Commandments in his own work, which offers several opportunities to illuminate the significance of the above illustration.

The First Book of Urizen and *The Book of Ahania*, for example, tell Blake's story of the Creation and Fall, partly based on the books of Genesis and Exodus. *Urizen* ends with the children of Urizen in Egypt, held in bondage by their father's laws. *Ahania* begins with an exodus. Fuzon, the fiery spirit of passion, revolts and leads some of the sons of Urizen out of Egypt. He hurls a fiery globe at Urizen, which is a "pillar of fire to Egypt/ Five hundred years wand'ring on earth."[41] The revolt, however, is unsuccessful, and Urizen reestablishes his tyranny over his sons by smiting Fuzon with a poison rock, which "fell upon the Earth,/ Mount Sinai in Arabia."[42] The Ten Commandments are Blake's symbol for restraint and tyranny. They are one means by which Urizen gave "his Laws to the Nations" in *The Song of Los*, where "Moses beheld upon Mount Sinai forms of dark delusion."[43] By recounting that Christ broke these Ten Commandments, Blake challenges the authority of inflexible rules for behavior.[44]

In Blake's symbolism the Mosaic law is identified with political as well as religious tyranny. "A Song of Liberty" recounts the fall of the old king who leads "his starry hosts thro' the waste wilderness, he promulgates his ten commands" until the son of fire "stamps the stony law to

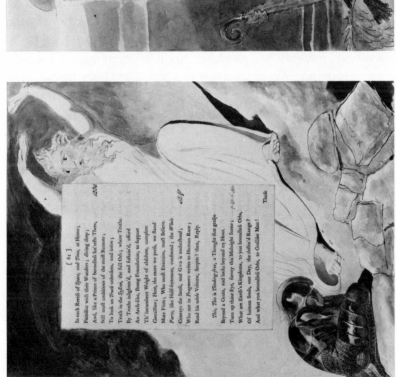

132. Blake, *Night Thoughts* no. 349. British Museum.

131. Blake, *Night Thoughts* no. 333. British Museum.

dust."[45] *America* is a political myth of tyranny and revolution in which King George, agent of the tyrant Urizen, is identified with the arbitrary law of Moses and Jehovah:

> "The times are ended; shadows pass, the morning
> 'gins to break;
> "The fiery joy, that Urizen perverted to ten
> commands,
> "What night he led the starry hosts thro' the
> wide wilderness,
> "That stony law I stamp to dust. [46]

Because Blake's Decalogue has political as well as religious implications, we are now in a position to appreciate more fully the significance of Joshua kneeling before Moses in the illustration. To Blake he represents the unfortunate union of rigid moral laws and military force.[47] In Blake's picture Joshua's hands over his face give the impression that he is weeping, possibly because his stony law lies in fragments.

 Both *The Everlasting Gospel* and *The Gates of Paradise* assert the values of mercy and forgiveness of sin against the values of obedience, judgment, and punishment. In the former work Mary Magdalene is brought to be judged by Christ, who "was sitting in Moses' Chair."[48] Although "Moses commands she be stoned to death," Christ offers her forgiveness, and the earth "On Sinai felt the hand divine/ Putting back the bloody shrine."[49] A symbol of judgment without pity, the Mosaic law has implications for Christians in the present:

> Jehovah's fingers Wrote the Law:
> Then Wept! then rose in Zeal & Awe,
> And in the midst of Sinai's heat
> Hid it beneath his Mercy Seat.
> O Christians, Christians! tell me Why
> You rear it on your Altars high.[50]

 A striking pictorial parallel between the Moses of the *Night Thoughts* illustration and the Moses in one of Blake's

pictures of the Last Judgment gives us an excellent opportunity for realizing what the Young illustration meant to Blake. In the Rosenwald version Moses is standing on a cloud with the two tables of stone raised above his head.[51] His back is arched and he is about to throw down the stones of the law. Jesus is sitting in judgment at the top of the picture, and Blake's notebook commentary on the work observes that "the Just arise on his right & the wicked on his Left hand."[52] Moses is clearly among the wicked on the left, but is shown in the act of casting out error.

Young's admonition that Lorenzo turn from reading the infidel St. Evremont to reading St. Paul, to turn from the fragment to the whole, is a vague and conventional thought for which Blake has made a striking illustration. It is appropriate to Young's poem and at the same time presents a theme of Blake's own. The Ten Commandments are themselves fragments and error that should be cast down. If we look at the *Night Thoughts* illustration in the context provided by Blake's work, we find that he was doing more than illustrating Young's commonplace. Blake had been reading his Bible in its diabolical sense, and he found a special significance and virtue in Moses' casting down the tables of stone.

The Mosaic spirit of judgment and punishment pervades many pages of the *Night Thoughts*, and number 349 [Illustration 132] is an extraordinary rendering of one of them into picture.[53] Advising Lorenzo to turn his thoughts from this world to the contemplation of his heavenly destiny above, Young describes the dread fate that will overtake the man of the world:

> Lorenzo! since *Eternal* is at hand,
> To Swallow *Time*'s Ambitions; as the vast
> *Leviathan*, the Bubbles vain, that ride

High on the foaming Billow; what avail
High Titles, high Descent, Attainments high;
If unattain'd our *Highest?* [54]

A sea serpent with neck coiled twice rises toward three large oval bubbles floating in the waves on the surface of the water. Its mouth is open and is about to swallow the bubble of worldly ambition floating at the upper right of the design. A red crest rises at the top of the leviathan's head. Spikes stand erect on the ridge of its back. Its body is covered with scales, green on the head and upper part of the body, shading to yellow in the lower part of the illustration.

Thus far Blake's design closely corresponds to Young's simile of the leviathan swallowing bubbles of temporal ambition. An extremely interesting addition to the drawing, not suggested by Young's text, is a green man riding on the back of the leviathan. He wears a red conical hat with gold ornamentation and trefoil, which resembles a papal tiara without the triple crown. His right hand holds a red crook with a jagged edge. He is covered with scales, like the sea monster, and has webbed fingers and toes. His left arm extends through the lower coil of the leviathan's body and seems to be directing the leviathan's attention toward the bubble at the upper right. This bestial man is a grotesque clergyman, a primordial bishop with, as Keynes has observed, a crosier and miter. [55] By visualizing the simile of the leviathan swallowing bubbles of ambition, Blake achieves striking images not realized by Young. But in addition to bringing these latent images to life, he also introduces an idea of his own in the form of the grotesque bishop. He is not explained by Young's text, but possibly Blake's own work can reveal his significance.

The subhuman bishop riding on the back of the leviathan recalls another clergyman on the title page to Night

VIII, just four illustrations prior to this one.[56] Here we see the great Whore of Babylon sitting on the back of a seven-headed dragon in one of the best-known and finest of Blake's *Night Thoughts* illustrations. A grotesque clergyman with red hat, this time a triple-crowned papal tiara, is portrayed as the central head of the dragon. He represents one of several institutions corrupted by the whore, who sits on the back of the dragon and controls its monstrous force. Like the pope who is physically a part of the dragon of the Whore of Babylon, the subhuman bishop of 349 is also identified with the monster he directs. Although not physically a part of the leviathan, he is riding on its back and is allied to it by several striking pictorial details. His green scales, webbed hands and feet, and crosier with jagged outline corresponding to the sharp and jagged outline of the leviathan make him a part of the cruel force that he directs up to the bubble of temporal ambition floating on the water.

Young urges Lorenzo to turn his thoughts to heaven or else suffer the fearful vengeance of the leviathan. Blake undercuts this religious admonition based on the threat of fear and punishment by his subtle parody of Young's passage. Blake's illustration reveals that religions based on fear and punishment are themselves cruel and monstrous. The clergyman is a grotesque creature, like the priest on Plate 11 of *Europe*, and dramatically portrays the cruelty of religion based on vengeance. As monstrous as the punishment that he threatens in the form of leviathan, Blake's bishop is not a capricious addition to the illustration, but a means for Blake to give shape to his own interpretation of a passage he disliked.

This explanation of the design finds support in Blake's attacks on the Church for giving more emphasis to laws and punishment than to forgiveness and mercy. "Every Religion

that Preaches Vengenance for Sin is the Religion of the
Enemy & Avenger and not of the Forgiver of Sin, and their
God is Satan, Named by the Divine Name."[57] The wheel of
Religion goes counter to the current of Creation, and the
Church is admonished to " 'Pity the evil, for thou art not
sent/ 'To smite with terror & with punishments/ 'Those that
are sick."[58] *The Marriage of Heaven and Hell* offers several
striking parallels to Young's passage and Blake's design. Blake
describes an encounter between himself and a didactic and
self-righteous Angel who urges him to reform or else suffer
the dire consequences, a meeting similar to that between
Young and Lorenzo. Just as Young confidently informs
Lorenzo of the *"Eternal . . . at hand"* in the form of a
leviathan, so the Angel of *The Marriage of Heaven and Hell*
shows Blake his "eternal lot," also in the form of a leviathan:

> beneath us was nothing now to be seen but a black tempest, till
> looking east between the clouds & the waves, we saw a cataract of
> blood mixed with fire, and not many stones' throw from us
> appear'd and sunk again the scaly fold of a monstrous serpent; at
> last, to the east, distant about three degrees, appear'd a fiery crest
> above the waves; slowly it reared like a ridge of golden rocks, till we
> discover'd two globes of crimson fire, from which the sea fled away
> in clouds of smoke; and now we saw it was the head of Leviathan;
> his forehead was divided into streaks of green & purple like those on
> a tyger's forehead: soon we saw his mouth & red gills hang just
> above the raging foam, tinging the black deep with beams of blood,
> advancing toward us with all the fury of a spiritual existence.
>
> My friend the Angel climb'd up from his station into the mill: I
> remain'd alone; & then this appearance was no more, but I found
> myself sitting on a pleasant bank beside a river by moonlight,
> hearing a harper, who sung to the harp; & his theme was: "The man
> who never alters his opinion is like standing water, & breeds reptiles
> of the mind."[59]

Blake's irony undercuts the reality of the eternal lot offered
by the Angel and proves the Angel's terror to be a "reptile of
the mind" based on the illusions of his metaphysics.

The leviathan of the *Night Thoughts* illustration is another reptile of the mind, an illusion of Young's metaphysics, which uses the threat of fearful destruction to turn Lorenzo's thoughts toward heaven. Its function is identical with that of the Angel's leviathan, which was supposed to give Blake a vision of his eternal lot in order to make him reform. The incongruity of the primordial bishop riding the leviathan gives Blake's illustration a humor that prevents its picture of destruction from being a horrifying event. The agent of destruction promised by Young's speaker is not quite real in Blake's illustration, where we may smile at the grotesque clergyman born in metaphysics of illusion. The clergyman is Blake's own invention, the means by which he interprets Young's advice, at the same time transforming Young's simile into the visual terms that make Blake's illustrations surpass their text.

Illustrations challenging their text provide a valuable record of Blake's reacting to certain ideas of Edward Young. They are ostensibly shapings of the *Night Thoughts* text, to which they do indeed have a general resemblance. But, as Blake reminds us, "it is in Particulars that Wisdom consists & Happiness too. . . . he who enters into & discriminates most minutely the Manners & Intentions, the Characters in all their branches, is the alone Wise or Sensible Man, & on this discrimination All Art is founded."[60] A careful investigation and discrimination of the particular parts of the *Night Thoughts* illustrations can reward the spectator with a view of Blake's reaction to Young's ideas. Young considered that he was imparting "plain Truths," but Blake offered alternative readings for texts that must have reminded him of those Angels of *The Marriage of Heaven and Hell* who "have the vanity to speak of themselves as the only wise." Illustrations challenging Young's authoritative statements on

imagination, reason, and religion reveal a spirit of Urizen in the pages of *Night Thoughts*, taking undue pride in its code of plain truths that dictate rules for others to follow. Blake took his author seriously enough to disagree with him and once asserted that "Opposition is true Friendship." The opposition between Blake's designs and Young's text provides a new source of insight into the mind of Blake and shows how some popular eighteenth-century ideas of Edward Young appeared to a vigorous and independent thinker at the end of that century.

NOTES

1. Geoffrey Keynes, "Blake's Illustrations to Young's 'Night Thoughts,' " *Blake Studies*, second ed. (Oxford: Clarendon Press, 1971), p. 53. Keynes presents the facts of Blake's involvement with this project.

2. "Night the Sixth: The Infidel Reclaim'd," *The Complaint: or, Night-Thoughts on Life, Death, and Immortality* (London, 1744), p. 12, lines 221-2, no. 233. All references to Young are from the pages of *Night Thoughts* inlaid into Blake's drawing paper. Night I has published line numbers, but all other line numbers refer to the numbers written in the text in sepia ink, not to the published line numbers, which were cut away when the margins of Young's pages were reduced before being inlaid into the drawing paper. The illustration number refers to the number found on the border or mat of stiff paper into which Blake's drawing paper was itself inlaid. Keynes and subsequent commentators on Blake's *Night Thoughts* illustrations have cited the text as pages taken from first editions of the *Night Thoughts*, but Nights I

and III are identified as second editions on their title
pages and correspond to copies 1b and 3c in Henry
Pettit, *A Bibliography of Young's* Night Thoughts
(Boulder, Colorado: Colorado Univ. Press, 1954), pp.
16, 22. The other Nights can be identified in Pettit's
bibliography as first editions of Young's poem.

3. "William Blake," *The Cornhill Magazine*, 31 (1875),
721-36.

4. Thomas Wright, *The Life of William Blake* (Olney,
Bucks.: T. Wright, 1929), I, 82-3, observes that Blake's
contemporaries did not recognize that Blake's sym-
bolism in the *Night Thoughts* designs was based on "the
Four Zoas, the Serpent of Materialism, the Mundane
Shell, and other features of his mythological scheme; for
merely to illustrate the placid pages of Young was
remote indeed from his mind." H. M. Margoliouth,
"Blake's Drawings for Young's *Night Thoughts*," *Re-
view of English Studies*, n. s. 5 (1954), 47-54, calls
attention to the neglected *Night Thoughts* drawings and
shows that they "have value not only in themselves or as
helping us to know Blake's mind during these eighteen
months from which we have no poetry, but also because
they reappear with some changes in later or greater
pictures." Jean H. Hagstrum, *William Blake: Poet and
Painter* (Chicago: Univ. of Chicago Press, 1964), pp.
121-3, comments briefly on the *Night Thoughts* illus-
trations and notes that "Blake's illustrations, made
between 1795 and 1797 when he was at the height of
his early prophetic and revolutionary career, constitute
a largely unopened gallery, containing many unsur-
passed masterpieces and always rich in clues to Blake's
symbolism and to the working of his imagination."

Morton D. Paley, "Blake's *Night Thoughts:* An Exploration of the Fallen World," in *William Blake: Essays for S. Foster Damon*, ed. Alvin H. Rosenfeld (Providence, Rhode Island: Brown Univ. Press), pp. 131-157, shows that Blake brought his own symbols and themes to the illustrations for Young and that these designs give shape to a fallen world which shares many characteristics with the fallen world of Blake's own prophetic works. I read this paper after my own study was complete, except for the discussion of number 7, and I am indebted to Paley's observation that Blake satirizes his author in number 7. Articles appearing after the original publication of this paper in *Texas Studies in Literature and Language* are: John E. Grant, "Envisioning the First *Night Thoughts*," in *Blake's Visionary Forms Dramatic*, ed. David V. Erdman and John E. Grant (Princeton: Princeton Univ. Press, 1970), pp. 304-35; and my own studies of "Blake and Religion: Iconographical Themes in the *Night Thoughts*," *Studies in Romanticism*, 10 (1971), 199-212, and "Blake and the Age of Reason: Spectres in the *Night Thoughts*," *Blake Studies*, 5 (1792), 105-139.

5. Several studies of Blake's illustrations to work by others show that he departs from his author's text in order to portray his own vision of that text, most notably: Joseph H. Wicksteed, *Blake's Vision of the Book of Job* (New York: Dutton, 1922); Albert S. Roe, *Blake's Illustrations to the Divine Comedy* (Princeton: Princeton Univ. Press, 1953); S. Foster Damon, *Blake's Grave: A Prophetic Book, Being William Blake's Illustrations for Robert Blair's the Grave, Arranged as Blake Directed* (Providence, Rhode Island: Brown Univ. Press, 1963);

idem, *Blake's Job: William Blake's Illustrations of the Book of Job* (Providence, Rhode Island: Brown Univ. Press, 1966); Irene Taylor, *Blake's Illustrations to the Poems of Gray* (Princeton: Princeton Univ. Press, 1971).

6. The following illustrations challenge Young's text: 7, 61, 64, 81, 82, 119, 151, 222, 293, 303, 333, 349, 360, 387, 416, 444, and 490. These designs are not the only ones providing insight into Blake, but they do most clearly distinguish Blake's opinions from Young's.

7. Night VIII, pp. 68-69, lines 1287-91:

> Thus, in an Age so gay, the Muse plain Truths
> (Truths, which, at Church, you *might* have heard in Prose)
> Has ventur'd into Light; well-pleas'd the Verse
> Should be forgot, if you the Truths retain;
> And crown her with your Welfare, not your Praise.

8. *The Complaint, and The Consolation; or, Night Thoughts*, Printed by R. Noble, for R. Edwards, No. 143 Bond-Street (London, 1797), p. 46. Hereafter cited as Edwards.

9. *A Vision of the Last Judgment* (K 611, E 550).

10. Night III, p. 6, lines 25-26.

11. Night III, pp. 6-7, lines 22-30. An asterisk designates the line Blake marked usually with an "X," to indicate the immediate basis for his picture.

12. Annotations to Wordsworth (K 782, E 654).

13. *Jerusalem* 74:26 (K 715, E 227).

14. *The Marriage of Heaven and Hell*, pl. 6 (K 150, E 35).

15. Five pearls or beads are visible in each of the girl's bracelets in the water-color drawing (Night III, p. 6, no. 81), but seven are visible in each bracelet in the

engraving for the Edward's edition (p. 46). Since the
number five often symbolizes the five senses in Blake's
illustrations, he may have altered the number of beads
so that Sense would not seem to represent sense
perception only.

16. Night III, p. 7, lines 38-42.

17. S. Foster Damon, *A Blake Dictionary* (Providence,
 Rhode Island: Brown Univ. Press, 1965), p. 258,
 observes that "sometimes the lyre is used to contrast the
 lighter song with the grander music of the harp." This
 distinction is observed in numbers 82 and 448 and is in
 keeping with Blake's practice of associating the Greek
 muse with memory and the Hebrew muse with imagi-
 nation: "Jupiter usurped the Throne of his Father,
 Saturn, & brought on an Iron Age & Begat on
 Mnemosyne, or Memory, The Greek Muses, which are
 not Inspiration as the Bible is" (*A Vision of the Last
 Judgment*, K 605, E 545).

18. In *Milton* 41:7-10 and 21-24 (K 533, E 141), Blake
 affirms the value of imagination in poetry and declares
 his purpose to reveal the error of those writers who do
 not utilize their creative power fully:

 > "To cast aside from Poetry all that is not Inspiration,
 > "That it no longer shall dare to mock with the aspersion
 > of Madness
 > "Cast on the Inspired by the tame high finisher of paltry
 > Blots
 > "Indefinite, or paltry Rhymes, or paltry Harmonies,
 >
 > .
 >
 > "These are the destroyers of Jerusalem, these are the murderers
 > "Of Jesus, who deny the Faith & mock at Eternal Life,
 > "Who pretend to Poetry that they may destroy Imagination
 > "By imitation of Nature's Images drawn from Remembrance.

19. *Descriptive Catalogue* (K 565-6, E 522); *Milton*, pl. 1 (K 480, E 94).

20. Preface, pp. i and ii. These pages provide the text for numbers 4 and 5 and are separated from the design under discussion by the title page to Night I. See also Grant's discussion of number 7 in "Envisioning the First *Night Thoughts*," pp. 305-306, 310 et passim.

21. Preface, p. i, no. 4.

22. Preface, p. ii, no. 5.

23. Edwards, p. 35.

24. Night II, p. 31, lines 488-492 and 498-500.

25. A reading in accord with E. J. Rose's thesis that "Blake, a careful student of anatomy, saw that man's hand symbolized his mental life," in "Blake's Hand: Symbol and Design in *Jerusalem*," *Texas Studies in Literature and Language*, 6 (Spring, 1964), 58.

26. Flaming vegetation represents new life, energy, and possibilities for growth in number 194 [Illustration 128], which portrays Young's line, "What Weakness see not Children in their Sires?" (Night V, p. 39, line 652). The picture presents an old man with white beard sitting and counting money in contrast to a naked child beside flaming foliage, extending both hands toward a butter-fly resting on a green flame. A girl in yellow stands between them, critically regarding her father, who closely resembles the elderly instructor of number 64.

27. One of many notable examples of bat-winged villains in Blake is Urizen, the tyrannic lawgiver portrayed with bat wings on plate 11 of *Europe.*

28. *English Blake* (Cambridge, England: Cambridge Univ. Press, 1949), pp. 300-312.

29. A vast machine provides Blake's metaphor for educational institutions in *Jerusalem* 15:14-20 (K 636, E 157):

> I turn my eyes to the Schools & Universities of Europe
> And there behold the Loom of Locke, whose Woof rages dire,
> Wash'd by the Water-wheels of Newton: black the cloth
> In heavy wreathes folds over every Nation: cruel Works
> Of many Wheels I view, wheel without wheel, with cogs tyrannic
> Moving by compulsion each other, not as those in Eden, which,
> Wheel within Wheel, in freedom revolve in harmony & peace.

30. K 550, E 502.

31. Night VIII, p. 58, lines 1060-65.

32. *A Vision of the Last Judgment* (K 615, E 553-54).

33. Night IX, p. 72, lines 1470-73.

34. For comments on Blake's upside down figure symbolizing the fall into error see Albert S. Roe, *Blake's Illustrations to the Divine Comedy*, pp. 74 and 91; Milton O. Percival, *William Blake's Circle of Destiny* (New York: Columbia Univ. Press, 1938), pp. 180-182.

35. *Jerusalem* 4:1-2 (K 622, E 145).

36. *Jerusalem* 5:17-21 (K 623, E 146).

37. Night VIII, p. 68, line 1288.

38. Night VII, p. 61, lines 1239-42.

39. Number 327 shows the same figure holding his rod over the sea in which a crowned head with long brown hair and an effeminate face is still visible above the water. Young's text asks Sinai and the waves that swept Egypt to witness the present God.

40. Exodus 32:15-19. Strikingly similar to the *Night Thoughts* design is Blake's "Moses Indignant at the Golden Calf," described and reproduced in W. Graham Robertson, *The Blake Collection of W. Graham Robertson*, ed. Kerrison Preston (London: Faber & Faber, 1952), p. 126 and pl. 43. Moses, with both hands raised above his head, has just thrown done a stone tablet lying broken at his feet. At the left are two girls dancing, the golden calf, and the fire and smoke of sacrifice.

41. *Ahania* 2:45-46 (K 250, E 84).

42. *Ahania* 3:45-46 (K 251, E 85).

43. *The Song of Los* 3:17 (K 245, E 66).

44. "I tell you, no virtue can exist without breaking these ten commandments. Jesus was all virtue, and acted from impulse, not from rules" (*The Marriage of Heaven and Hell*, pls. 23-24, K 158, E 42).

45. *Marriage*, pls. 26-27 (K 159-160, E 44-45).

46. *America* 8:2-5 (K 198, E 52-53).

47. To Bishop Watson's assertion that the Canaanites were a wicked and depraved people in the time of Moses and were destroyed in accordance with God's justice, Blake makes the following annotation: "the distruction of the Canaanites by Joshua was the Unnatural design of wicked men" (Annotations to Watson, K 388, E 604). To a second assertion that the destruction of the Canaanites proves God's displeasure against sin and is a benevolent warning, Blake replies: "All Penal Laws court Transgression & therefore are cruelty & Murder. The laws of the Jews were (both ceremonial & real) the basest & most oppressive of human codes, & being like all other codes given under pretence of divine command

were what Christ pronounced them, The Abomination
that maketh desolate, *i.e.* State Religion, which is the
source of all Cruelty" (Annotations to Watson, K 393, E
607).

48. *The Everlasting Gospel* (e) 7 (K 753, E 512).

49. *Gospel* (e) 9 and 17-18 (K 754, E 512-513).

50. *The Gates of Paradise* (K 761, E 256).

51. Rosenwald copy of "A Vision of the Last Judgment,"
 reproduced in Damon, *Dictionary*, pl. I, and reproduced
 here, Illustration 55.

52. *A Vision of the Last Judgment* (K 606, E 545).

53. Night VIII, p. 3. Reproduced in color in Geoffrey
 Keynes, *Illustrations to Young's* Night Thoughts, *Done
 in Water-Colour by William Blake* (Cambridge, Mass.:
 Harvard Univ. Press, 1927).

54. Night VIII, p. 3, lines 34-39.

55. "Introductory Essay," *Illustrations to Young's* Night
 Thoughts.

56. Number 345. Also reproduced in color in *Illustrations
 to Young's* Night Thoughts.

57. *Jerusalem*, pl. 52 (K 682, E 199).

58. *Jerusalem* 77:26-28 (K 718, E 230).

59. *Marriage*, pls. 18-19 (K 156, E 40-41).

60. *A Vision of the Last Judgment* (K 611, E 550).

BLAKE'S DESIGNS FOR *L'ALLEGRO* AND *IL PENSEROSO*, WITH SPECIAL ATTENTION TO *L'ALLEGRO* 1, "MIRTH AND HER COMPANIONS": Some Remarks Made and Designs Discussed at MLA Seminar 12: "Illuminated Books by William Blake," 29 December 1970

by

John E. Grant

*T*his version of my remarks has been somewhat tempered, amplified, and polished, though not quite as thoroughly as I should have liked. Because of the paucity of discussion devoted to this series of designs, however, it may be that quick publication of these observations will assist in maintaining dialogue about them. Several people found the diagram by Judith Rhodes, which I distributed at the Seminar and which accompanies my discussion here [see below], to be rather formidable, so she has added an explanation of what she wishes to bring out with this device.

Ed.: Reprinted by permission of the author and publisher from *Blake Newsletter*, 4 (Spring, 1971), 117-34. The informal format of the original discussion essay has been retained in this reprinting. The discussion is continued in *Blake Newsletter*, 5 (Winter, 1971-72), 190-202.

All the watercolors are well-reproduced in color in Adrian Van Sinderen, *Blake, The Mystic Genius* (Syracuse, 1949)—Bentley and Nurmi no. 2086. They are also available in satisfactory color slides from the Pierpont Morgan Library. Black-and-white reproductions are included in John Milton, *Poems in English,* ed. Geoffrey Keynes (London, 1926)— Bentley and Nurmi no. 314. They are also reproduced, much diminished, in E. J. Rose, "Blake's Illustrations for *Paradise Lost, L'Allegro* and *Il Penseroso:* A Thematic Reading," *Hartford Studies in Literature,* 2 (Spring 1970), 40-67, an important article to which I refer. The second installment of my remarks will deal at some length with Blake's first illustration of *L'Allegro,* "Mirth and Her Companions." Both engraved versions of this design are reproduced and discussed in Geoffrey Keynes, ed., *The Engravings of William Blake: The Separate Plates* (Dublin, 1956)—Bentley and Nurmi no. 533.

While this article was in the final state of preparation, *Blake's Visionary Forms Dramatic,* eds. David V. Erdman and John E. Grant (Princeton, 1970) was published. It includes my brief interpretation of the sixth design for *L'Allegro,* entitled "From Fable to Human Vision: A Note on the First Illustration" on pp. xi-xiv, and this design is satisfactorily reproduced in color, while design 12 is reproduced in black-and-white. Below I have also referred the reader to reproductions of some of the *Night Thoughts* designs which are contained in this volume (hereafter abbreviated BVFD). As is customary, the first number after a reference to *Night Thoughts* is to its place in the entire sequence, whereas the material in parenthesis refers to the Night and page number; since not all pages are numbered, letters indicate the place of the picture in the sequence of the Night.

PART I: A SURVEY OF THE DESIGNS

In his suggestive article on "Graphic-Poetic Structuring" that appears in *Blake Studies,* 3 (Fall 1970), Karl Kroeber proposes that we might get farther if we could "kick the habit of labelling" the characters depicted in *Urizen,* or at least "mitigate" it (p. 12). If he means no more than that we ought to be able to enjoy the ballgame without a score card, there is no need to disagree. But after having striven vainly in two letters to persuade the reviewer in the *TLS* in 1967 that the lady depicted at the end of Blake's *Milton* ought to be recognizable as Ololon—or *somebody* mentioned prominently in the epic—I'm not prepared to concede that Blake's art is as peculiar or mysterious as Kroeber seems to imply.

It is true that Blake's repertoire of verbal and pictorial imagery tends to spill over from one work to another and that the student must read or look on further into Blake's later works to find out what to make of the first appearance of, say, Rintrah. But then he discovers that he can't just read backward from a later identification either. How many pictures are going to turn out not to be aligned with any words—even in the canon of illuminated books? It is all very perplexing, and all very simple—but involved.

I'll admit that nothing can be more dismal than the mechanical habit of labelling an old man Urizen, a mature man Los, and a youth Orc—unless it be the habit of attaching to these divine images still more outlandish names found in portentous and occult old books. Even when some kind of correspondence can be established, the careful scholar discovers that, well, yes, Blake meant something like that, but really it was quite a bit different—in fact, you might say it was just the opposite. Blake must not be relegated to his former state of splendid and irrelevant isolation from the

main currents of thought, but he cannot be well represented in the guise of a philosopher, as is suggested by the inconsequential pages in Gillham's intelligent book, *Blake's Contrary States.*

When we come to Blake and Milton, there really is something to talk about. The evidence of the watermarks indicates that the designs for *L'Allegro* and *Il Penseroso* constitute Blake's last thoughts on Milton, save for some stray allusions overheard by Crabb Robinson and the glorious designs from the last fragmentary series for *Paradise Lost.* They are also much more complicated, more dense in particulars, than the other Milton designs and we have the great advantage of possessing a picture-by-picture guide written by the Interpreter himself. I had copies of Blake's commentary mimeographed from the Erdman text and distributed at the Seminar to serve as reminders. Blake doesn't tell us all we need to know about the pictures, but with Milton's help we can see that Blake had a lot to say.

It is not extravagant to declare that systematic published criticism of these designs began in 1970 with the article by E. J. Rose in the Spring issue of *Hartford Studies in Literature.* I have some important reservations about Rose's premises, interpretations, and conclusions, but I wish to make it clear that I believe there are admirable things in this article. *Blake's Visionary Forms Dramatic,* the anthology I co-edited with David Erdman, was not published by Princeton until February 1971; consequently the audience at the Seminar had no opportunity to read my short piece on design 6 for *L'Allegro,* which serves as part of the introduction to the volume. I brought mimeographed copies of the article for distribution at the Seminar for those who wished to read this closely-written piece after the meeting.

I have silently incorporated into my remarks a number of points which Judith Rhodes—a graduate student at the University of Iowa who is writing a thesis on Blake's designs for Milton—first observed, and I have discussed with her many of the ideas I shall put forth. Her diagram of the thematic relationships among Blake's designs for *L'Allegro* and *Il Penseroso* follows my remarks here [see below]. What has proven to be most helpful to me is the imaginative skepticism with which she greeted a number of my plausible but invalid hunches, thus making it clear to me that I had not yet reached an understanding of Blake's meaning. Doubtless errors remain in the interpretations I am advancing and I look forward to their being pointed out by others, but for now I take entire responsibility for them.

We all know that Blake is complicated, but we tend to shy away from geometrical descriptions of his complexities partly because, as Frye has pointed out, Blake himself generally avoided them. At first glance Mrs. Rhodes's diagram seems somewhat bewildering, but after a little study it enables us to recognize some of the pervasive interrelations among these designs. No doubt, after glancing at the diagram, someone will think: "How Urizenic: bring out the compasses in the year of dearth." I would hope to reassure those who are uneasy that all legitimate apprehensions have been anticipated and are shared by Mrs. Rhodes. Certainly not all the relationships indicated are of precisely equal weight. Nor are all the connections indicated equally verifiable: that between designs 2 and 9, for example, is probably a contrastive or contrary relationship, not a connection of similarities. And there is an important connection in symbolism between figures in designs 1 and 9 that the diagram does not call attention to. Doubtless all the designs are somehow connected, but to say this is merely to utter a pre- or post-critical hypothesis: the question is, how?

In the Seminar I showed slides of the whole *L'Allegro* and *Il Penseroso* series fairly rapidly, not pausing for much comment on each. Then I made some more general remarks before turning to a detailed consideration of the first design, "Mirth and Her Companions." This method helps to place Blake's initial premise—his first design—more clearly since we must achieve an awareness of its consequences or its "context" within the rest of the series before we can appreciate the weight of the design itself. Since there are also two engraved versions of this first design, in contrast to the others, an expositor has a great deal of symbolism to work with. We also looked at some other Blake designs that seem relevant or illuminating in one way or another to particulars in the first design.

In a survey of the designs it seems best to point out details of possibly symbolic significance that might not be noticed or would have an uncertain status if one depended entirely on the Morgan Library slides, which tend to turn blue into black, and the reproductions in the Van Sinderen volume, which are done with a fairly crude screen process. One should observe that Blake numbered the designs consecutively in his commentary, the sheets of which have been laid down, thus obscuring some writing on the other sides of the pages. It is also noteworthy that many, if not all, of the original designs have been trimmed, sometimes irregularly, across the bottoms especially, often cropping part of the signatures. This can be observed in the Van Sinderen reproductions which happily reproduce the entirety of each picture, a practice that is too often not respected in the reproductions contained in the art books that are turned out today. These wonderful pictures are not the only ones of Blake's that have been unconscionably trimmed. The great series for "On the Morning for Christ's Nativity," now in the

Whitworth Art Gallery, Manchester, and Blake's greatest undertaking, his designs for Young's *Night Thoughts,* have been similarly trimmed. I gather from an art historian that the edges of pictures were, in former times, commonly trimmed when the paper had become worn or ragged. If this aspect of the drawings is unremarkable, though lamentable, another minutia may be more meaningful. I would be glad to have an explanation of what seems to be the form of the signature, "W. Blake inv.," on one side or the other at the bottoms of all the pictures save the first, where the "inv" precedes the signature. Possibly this variation has some significance; can anyone say for certain what "inv" should be understood to imply with respect to subsequent engraving?

MIRTH [Illustration 133] Of the balanced groups of buildings the one on the right has a distinct area of water in front of it. Most of the figures are significantly altered in the engraved versions. Even without using the altered engraved versions as a standard, the indistinctness of some of the figures is more noteworthy in this than in any other of the designs. The female figure at the right does not have cat whiskers in the watercolor, as she does in the engraved versions, but wears a remarkable twist or cue of hair quite like that of the flyer at two o'clock as he is represented in the watercolor version only. At first he is depicted carrying a wand in his left hand and seems to be controlling four small balls, but in the engraved versions he trails a scroll, being closely related in posture and deed to the figure in the Upcott autograph. There is no figure standing on the upraised left hand of the ass-eared figure in the watercolor and the two flyers above him are uncertainly related, whereas in the engraving the upper flyer fills the goblet of the lower one from a pitcher. The bubble-blowing trumpeter at the top in the watercolor takes off from between the thumb and

forefinger of Mirth, whereas, in the first state Mirth's hand is shifted to support the infant that flies from the outermost to the innermost figure at one o'clock. In the watercolor the outermost figure seems to have her arms crossed over her breasts and to be hugging at least two objects to her, though what they are is not ascertainable. At least five figures (the two at the right are very indistinct) surround the head of Mirth in the watercolor version, whereas they are distinctly figured as two pipers and two tambourinists in the engraved versions. Mirth's rose crown is clear in the watercolor and her unnaturally curved neck is nevertheless pleasingly drawn, though Blake rejected this piece of pictorial Mannerism (as Morton Paley correctly described it) in the second engraved state. The face of "Care" is covered with distinct red wrinkle-lines in the original. Sweet Liberty, the Nymph held daintily at the viewer's left, has no bow in the watercolor version, though a line near her waist indicates that Blake had considered drawing her with a weapon at this early stage. The male figure of "Jest" looks at "Youthful Jollity" in the watercolor version only, evidently behind Mirth's back, since they are not quite in line with her. The five main figures have a suggestive relationship with the mysterious and more sedate five who are lined up in the direction of eternity's sunrise in the Canterbury Pilgrimage picture.

THE LARK [Illustration 134] One cannot disregard Blake's specific identifications of the figures in this beautiful, comparatively simple, picture. The bow being spread above the head of Dawn may be compared to that wielded by the Holy Spirit of Orc in the second version of the Genesis titlepage; she trails red flowers which become an important motif in the designs for *Il Penseroso*. Those who have contended that in Blake's pictures it is dawn invariably which is depicted as occurring on the right and sunset invariably on

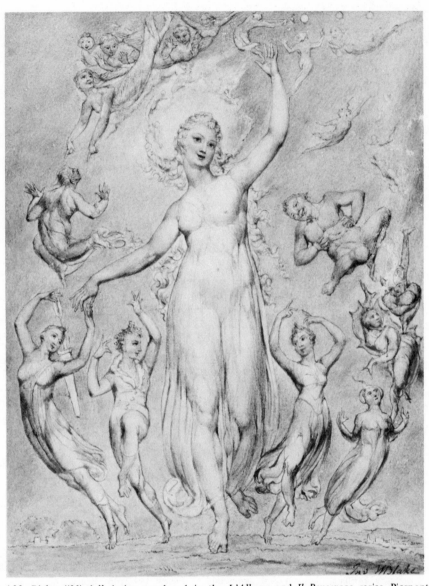

133. Blake, "Mirth," design number 1 in the *L'Allegro* and *Il Penseroso* series. Pierpont Morgan Library.

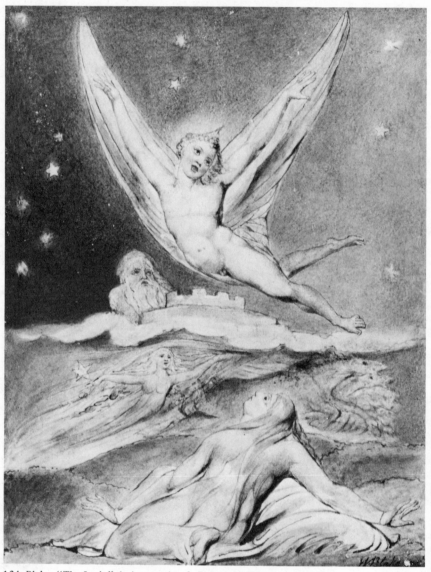

134. Blake, "The Lark," design number 2. Pierpont Morgan Library.

the left must alter their opinion. E. J. Rose declared that the longhaired figure arising in the foreground is Milton himself, but even if Blake had not explicitly told us that she is Earth we should know this from the pictorial analogies. In my opinion there is no critical justification for asserting (to anticipate) that this figure is "both Earth and Milton, depending on how you look at it." The figure of Milton per se only appears once in the designs for *L'Allegro,* the following one.

THE GREAT SUN [Illustration 135] The Eastern Gate is carefully indicated with its threshold just above the central mountain peak, which has a group of buildings on the plain in front of it. The plowman with his ox, the milkmaid with two recumbent cattle, the mower with his scythe over his head, Milton standing looking up, with his back turned from two lovers, are all distinctly delineated between the two framing trees that have fly-people in them. The four distinct trumpeters are accompanied by two less distinct ones within the sun, while two more trumpeters stand in readiness on the threshold. Six clouds empty vials on the left, being directed by the regal sceptre of the Sun. The "clouds unfold" posture of the Great Sun is certainly impressive and is a foretaste of the apocalypse, but the curly flames given off by his head, which is adorned with a very sharply pronged crown, suggest to me that, although Apollo is a force of redemption, he is affecting the means of the Beast. The fact that he does not have his halo on straight and that it gives off long sharp dark beams is also not reassuring. We may at first recall the Spirit of Morning dispelling the creatures of the Night in *Paradise Regained,* illus. 9, but perhaps we should also remember Satan in His Original Glory, whose picture was inscribed as the Covering Cherub. An important prototype for the picture

of Apollo is Flaxman's design of the Triumph of Christ for Dante's *Paradise,* Canto 25.

A SUNSHINE HOLIDAY [Illustration 136] The topography in this, one of the happiest visions in Blake, resembles that of the Arlington Court Picture. Note that Blake has expressly made a composite picture by combining two separate passages in the poem. This is a six-horn occasion: there are two in the middle of the resurrection procession, blowing as they are transcending the material sun, two more at the top left and right of the picture, and two more at the lower right, blowing as they arise from the humanized oak, who gestures upward. Neither the old oak man nor the butterfly spirit were apparent when we first saw this tree in "The Ecchoing Green," the second page of which features a comparable procession, though some of the figures in it are depicted in the titlepage of *Innocence* and in "London." The dancers around the Maypole to the sound of the rebeck recall Apollo and his company in the Gray designs; the church steeple should not pass unremarked because this motif will often appear hereafter. The humanized mountains, however, are in obvious distress, especially the female one who wears the battlemented crown of the Magna Mater and has a city in her lap, quite like the woman in *Vala,* p. 44, and has hair that makes a waterfall, like the woman on the last page of *America.* Her male consort looks like both Old Night in design 2 and the redemptive oak below in this one. The S-Curve composition on both sides of the picture indicate that the vortexes are really working, if not quite as symmetrically as in Job 12. The basket on the head of the leftmost girl in the main vortex stream is a familiar motif (see also design 3 at three o'clock) in Blake; he evidently derived it from Raphael by way of Marcantonio's engraving. I believe the river goddess is quaffing a regenerative dram, but the

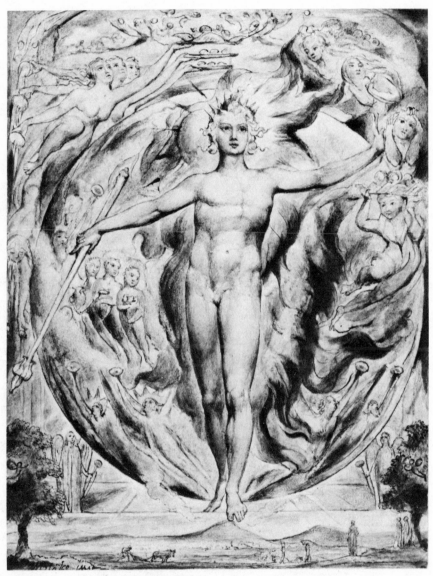

135. Blake, "The Great Sun," design number 3. Pierpont Morgan Library.

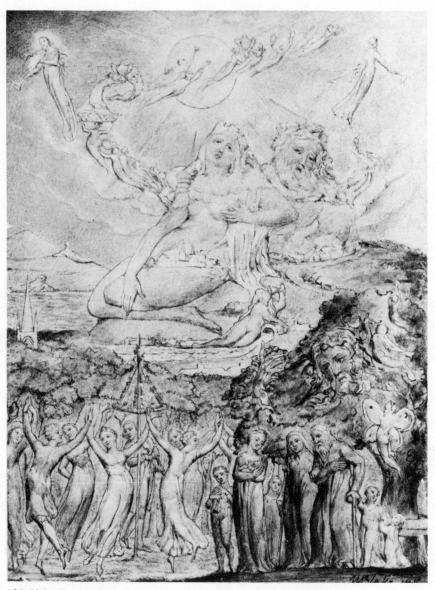

136. Blake, "A Sunshine Holiday," design number 4. Pierpont Morgan Library.

woman and man (he is quite sphinx-like—see "The Virgin and Child in Egypt," *Masters,* pl. viii) on a pyramidal mountain across the water are evidently not participants in the joy.

THE GOBLIN [Illustration 137] The chief spirit in this design resembles Pestilence, the Ghost of a Flea, and the Savage Man in "The Characters in Spenser's *Fairie Queene,"* who also has a flail. Queen Mab evidently enjoys her solitary junkets alone, but "She" is being tormented by three tricky spirits who are about to be joined by another, while a fifth is just climbing out of the ground in order to participate in the fun. But it is the ghost at her feet, much like one in the Gray designs—which have many connections with this series—that especially fascinates her. The adventure "He" is undertaking was not told by Milton, one should observe: "He" is dressed like a Blakean pilgrim, though lacking a stick, as he follows the flame of the ghostly friar, thus becoming an older boy lost, it would appear. Blake introduced the "Convent" (doubtless in the popular sense of a retreat for women) and gave it one tower which is much like that of the church in the previous design. Clearly this night piece interrupts any clock-sense of the diurnal cycle in this series; like the monthly analogy suggested by Rose, the diurnal cycle is merely a conventional standard against which Blake's designs work as counterpoint, as well as accompaniment.

THE YOUTHFUL POET [Illustration 138] At this time there is little more that I want to say about this beautiful picture in addition to what I have said, in perhaps too condensed a way, in my essay in *Blake's Visionary Forms Dramatic.* I do wish to emphasize, however, that the woman in the marriage scene in the main sun carries a huge candle in her right hand and, though I had not noticed it before I studied the original picture again, she wears a distinct transparent veil. The relationship of these figures is much like

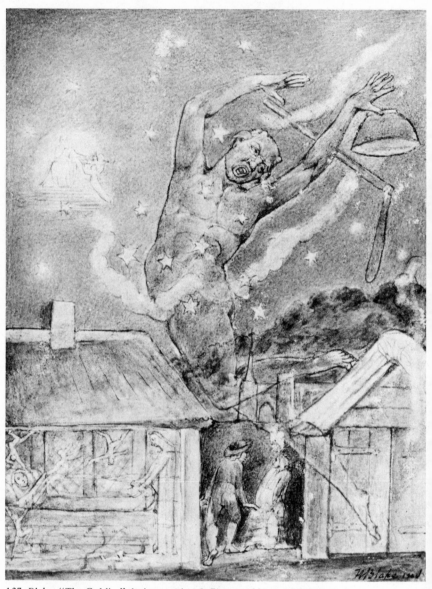

137. Blake, "The Goblin," design number 5. Pierpont Morgan Library.

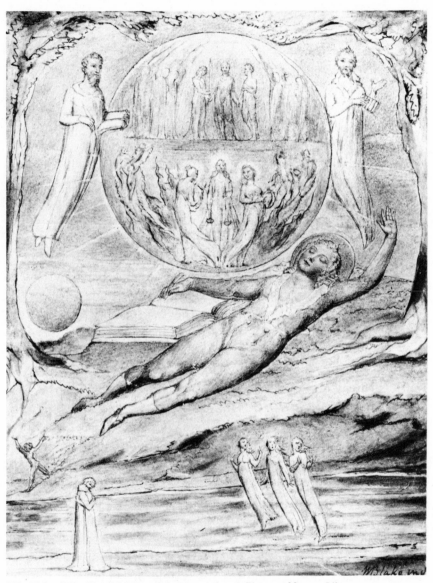

138. Blake, "The Youthful Poet," design number 6. Pierpont Morgan Library.

that of Christ and Adam and Eve in the very great but little-known picture of "The Fall of Man." The chains "of harmony" are not in question in the lower part of this sun, but it is still not certain what the central figure holds; my present opinion is an unblown trumpet in the right hand and a censer in the left, there being no crossbar at the waist such as would occur on a pair of balances, which is what viewers tend to think of first. The overarching oaks on either side enclose even Jonson and Shakespeare and the split in the sun seems rather deflationary than prophetically discriminating. The curious little alarmist, who seems to have a wooden right leg, must be legitimately distressed at the poet's somnolence. The reunion on this side of the water might seem reassuring if it weren't for the horizontal line of the river bank showing through the transparent figure on the right and confirming her to be the half-regained Eurydice. And what the three distressed daughters see is the terrifying source of the river of Darkness, as I am persuaded by an analogy in the *Night Thoughts* designs.

MELANCHOLY [Illustration 139] The companions of Melancholy are, from left to right, Peace, Quiet, and Spare Fast, all of whom are over the curious medial line that separates two distinct ground areas, and retired Leisure, who seems contented with the delicious company of lilies and roses. The varieties and colors of nimbuses are suggestive and challenging, as is the effective separation of the sexes who stand on the ground. I do not at present believe that a strong case can be made against the figure of Melancholy, in spite of her dark clothing and the snaky fold of her gown as it hangs from her left forearm. It is my guess that Blake saw in Durer's "Melencolia," which he kept by his table, a visionary figure, despite her propensity for compasses. But I am confident that those eight or more Muses around Jove's altar

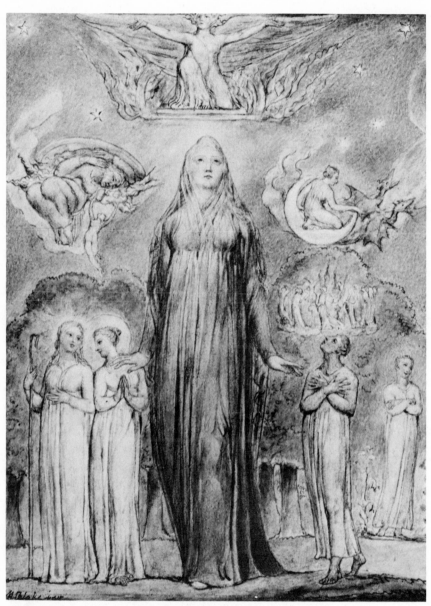

139. Blake, "Melancholy," design number 7. Pierpont Morgan Library.

are the Daughters of Memory, who told Milton that he would
be a better poet if he would cultivate self-denial like Spare
Fast. Cynthia's dragon team has its place in the visionary
economy, but Romantic moon enamorment is for less
strenuous artists than Blake. The fiery cherub Contemplation
is a near relation to the Four Zoas as they come on in
"Ezekiel's Vision," but he also portends the God as central
Man in Job 14. At the left, however, we have not Apollo and
his team but Night, who appears much like Darkness as
depicted in Gray's "Elegy," though she is being roused by the
Nightingale, who also does her best in *Night Thoughts* no. 34.
But Night seems to be sitting on a harp, a distinctly inartistic
gesture which, like the jagged lines on the ground at the
lower right, indicates that there is a distance to go before
visionary order is established.

 MILTON AND THE MOON [Illustration 140] Though
it seemed questionable to some members of the Seminar, I
continue to see the human form of the Moon as a fugitive
from the starry whips beside her and the spear tips of the
cloud beneath her. Cynthia has been disarmed since design 1
(engraving) and no longer is complacently eating, as in design
5, or equipped with imposing dragons, as in Design 7. Again
one notes the continuity of spires from designs 1, 4, 5, and
water from 1, 4, and 6, and the distinct deliberate presence
of the small red flowers at the lower left. Several of the Gray
designs are quite closely connected with this one.

 MILTON AND THE SPIRIT OF PLATO [Illustration
141] The higher things Plato tells of in his book are put in
their proper place at the bottom of the Arlington Court Pic-
ture; that is, the three Fates are the decisive forces of the three
Sun-Worlds of Venus, Mars, and Jupiter respectively. Inter-
estingly, Venus, who is connected by a line to the left toe of
Atropos, is depicted vegetating like Daphne. In her realm man

and woman are tied back-to-back by serpents, like Bromion and Oothoon in *VDA,* or in process of divorce, as in the Notebook drawing "Go and; trouble me no more." Mars sits wearing a plumed helmet, like the Valkyries in Gray, and has a bat-bug familiar, such as tries to escape in the engraving of "Albion rose." At the right Jupiter plays with his compasses, with one leg drooping like the enfeebled God of the Job designs. The darkened sector of the world beneath his footstool may be the smoke-obscured wheel of his chariot (or even a haunted tunnel) but whatever it may be it is benighted because he is unenlightened, though he presumes to rule a sun. The unmentioned man behind him is Vulcan futilely employed (like Sisyphus) with the Shield of Achilles; all this will be straightened out in the last plate of *Jerusalem* when the Spectre carries the sun and the compasses become tongs in the hands of the creatively re-established blacksmith Los. If one should read a real Classicist like Aeschylus he would learn that Hermes, far from being a mere messenger of oppression, can be understood, in effect, as the villain responsible for the crucifixion of Prometheus. For some reason Milton couldn't recognize the consequences of accepting the authority of Hermes the triplicator, but Blake did the best he could to expose it. The confusion and violence that enwreath Milton's head ought to have been a sufficient warning to classicistic partisans, but the elements of fire and water to the left and the right confirm how basically wrong things become under such guidance: the top spirit in fire plies whips to put down pity or resurrection while the finny nymph of water deploys her gin from a clamshell (a stratagem nearly repeated in *J* 45 [31]). Whatever vitality is to be observed is underground, but the six human figures there are variously compromised and will remain so until Milton frees himself from such airy superstitions.

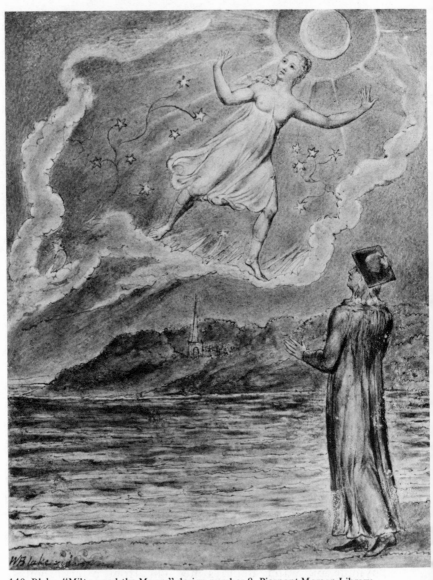

140. Blake, "Milton and the Moon," design number 8. Pierpont Morgan Library.

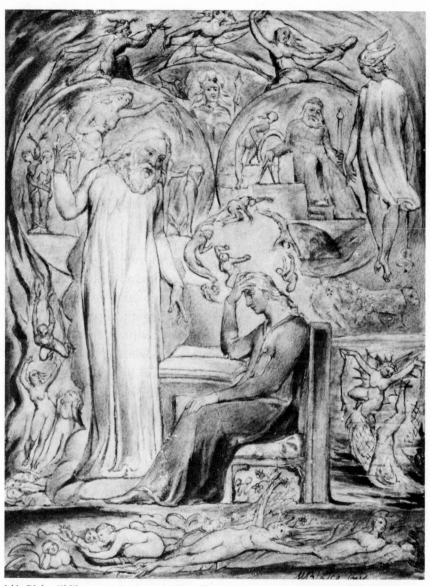

141. Blake, "Milton and the Spirit of Plato," design number 9. Pierpont Morgan Library.

Let me be still more explicit: this picture has been used by Raine as an excuse for Platonizing Blake, and even Damon in the *Dictionary* ("Plato") tends to blur this critique of Platonism. Yet it is impossible to make sense of this design as other than an attack on Hermetic Classicism. Look again at the "Judgment of Paris," whence all that fury came: Hermes was likewise responsible for that seminal disaster, which cannot truthfully be palmed off on triform Discord, unlovely as she is, since Hermes was there to put a prepossessing face on the conspiracy.

MILTON LED BY MELANCHOLY [Illustration 142] Here the poet's regeneration is begun by removal from exposure to the pestilential "Apollonian" arrows (near allied with the arrows of Satan in Job 6) which as yet he cannot bear. Milton has wisely not given up the book, but he has gotten over fasting and is now of equal stature and a fit companion for haloed Melancholy, whose halo renders her impervious to the maddening effects of the noonday sun. The two main trees are animated with spirits as in designs 3, 4, 6, 7, and the earth in 9: being in bondage, none of the dryads are joyful, though perhaps the humanized insects are happy. Despite the malign influence of Apollo, progress is being made again.

MILTON AND HIS DREAM [Illustration 143] Here the Dream, who may be the spiritual form of Melancholy, starts the votexes cooperating again for Milton, partly by the development of scrolls off both wings and partly by sharing its plate-halo with Milton. As Damon has remarked, Milton is still covering up, but he will be released by the music of his emanations. The angel's right wing acts as a suction to draw netted figures (perhaps including an ant!), such as were represented in design 9, out of the river of death. Note that at the lower right there are tiny red dots, indicative of the

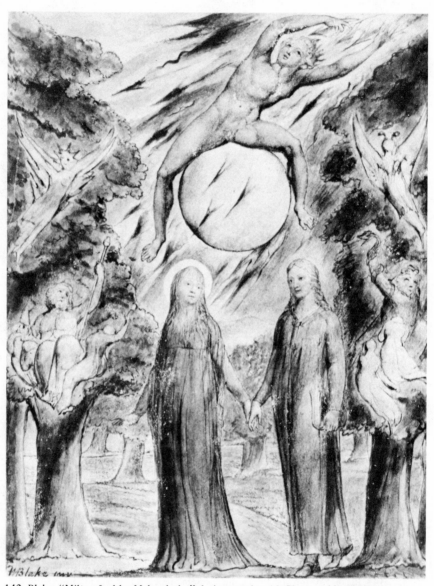

142. Blake, "Milton Led by Melancholy," design number 10. Pierpont Morgan Library.

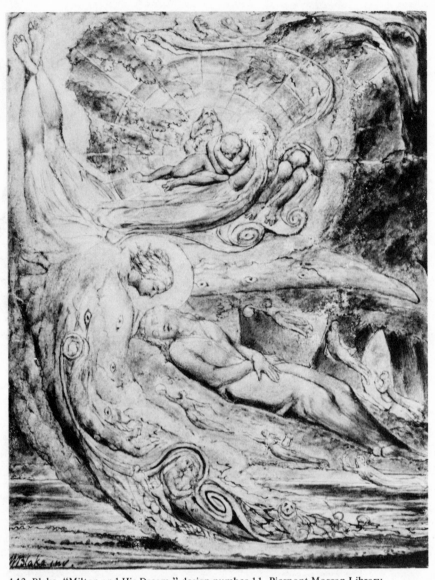

143. Blake, "Milton and His Dream," design number 11. Pierpont Morgan Library.

vital flower, as earlier. The redeemed figures are becoming
lovers, as in Dante 10, "The Whirlwind of Lovers." Those
below are prompted by a Blakean redemptive lady, but those
above are in the keeping of a holy old man, who may not be
as good as he seems despite his red halo and hopeful
surroundings. The spirits that accompany him are comparable
to figures of the errors of Job and his wife who fall in a Last
Judgment with Satan in Job 16. Unless I'm mistaken, the left
wing of the Dream is cracking under the strain of holding this
burden up. This group of three figures is curiously backed by
a fourth, who rides them at the bullseye of the rainbow. He
clutches something which is so woolly that it must be a lamb;
it would be pleasant if he were Esau. In any case, his
mysterious burden recalls that of the little woman at one
o'clock in the watercolor version of design 1. This pod of
figures is comparable to the three groups of Woes in *Night
Thoughts* no. 84 (III, 9) which is reproduced in Damon's
Dictionary. Above this pod of figures a long scroll is attended
by five or more spirits. This is the redemptive counterpart of
the devolution shown in *Night Thoughts* no. 7 (I, b), where
the sleeping Young's imaginings are delivered down to Urizen
beneath a blasted tree. This design has been reproduced in
the important article on the *Night Thoughts* pictures by
Helmstadter published in *TSLL*, 12 (Spring 1970), 27-54 [see
Illustration 125]. It is also reproduced in *BVFD*, pl. 75.

 MILTON AND HIS MOSSY CELL [Illustration 144]
Rose, arguing from the seasonal analogy, concludes that
Milton is here in a wintry plight, but the picture and com-
mentary make it clear that, at last, Blake's Milton has finally
gotten straight. He has still retained his book, which is open
beside a lamp (as in *Night Thoughts* no. 18 [I, 13], *BVFD*,
pl. 85) and he spreads his arms to open a center as he delivers
his prophetic raptures. The flowers in his cell include the

little red ones of designs 8, 9, and 11, and the lillies and roses of Leisure which were shown in design 7. The true lovers dance as the disciples of Venus were unable to do in design 9 attended by putti who have appeared before in designs 1 and 11. The woman and man at the left are effecting a resurrection, the precondition of bliss, though I confess to being a little uneasy about the not-yet-humanized form of her upraised right hand. The fact that the mother at the right is blessed with twins—compare *Night Thoughts* no. 4—is, however, a joyful sequel to the problems of the earth spirits in design 9. Perhaps there is even an incipient third behind this mother, as was observed in the Seminar. Milton's "cell" is half a cave and half a bower made by the entwining of two trees, perhaps to be understood as a continuation of the two-trees motif of earlier designs. It is somewhat like the caves in the Arlington Court Picture and the "Philoctetes," the latter of which is reproduced in color as the cover for *Blake Studies*, 3 (Fall 1970).

The longing female figures above the cell, five on the left, three on the right, are arrested in a futile desire without hope, like those in Limbo, to ascend the sky. If Milton's cell is a bower, they are to be closely related to the forlorn dryads in design 10; if it is a cave, they are related to Blake's Sunflower. Their error is evidently that they pray to the stars rather than celebrate their human forms, as Milton does. The constellations from left to right include: the Crab, with a woman astride it, back to the viewer, and reading; this seems especially odd until one recalls that crabs move backward. The twins in Gemini seem to be having a fight with one another. Taurus is a formidable beast, but Aries has achieved a shepherd form wearing a hat like the benighted figures in designs 5 and 6, and carrying a crook like Peace in design 7. Orion is intervening to neutralize the charge of the Bull;

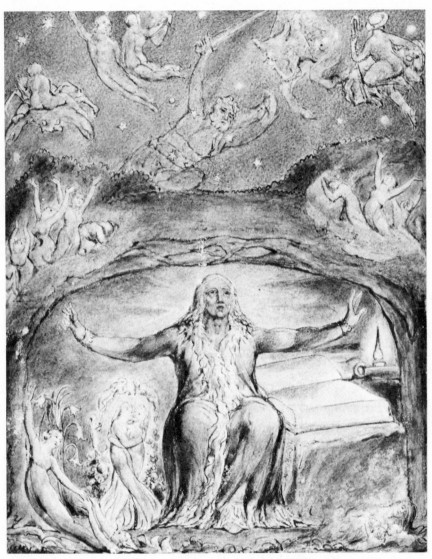

144. Blake, "Milton and His Mossy Cell," design number 12. Pierpont Morgan Library.

Blake greatly respected Orion, depicting the stars of his belt
in the engraving of Job 14 and making a great picture of him
in *Night Thoughts* no. 502 (IX, 84). Indeed, Orion and
Albion are in effect identified in *Jerusalem* 25, as Morton
Paley suggests. The contrast between the redemptive
counter-culture underground and the futile establishment
above ground is one of the distinctive features of Blake's
symbolism, as Frye has explained. The principle is declared
unmistakably in the titlepage of *The Marriage of Heaven and
Hell*, which is why we looked at a slide of this design before
turning again to more general considerations.

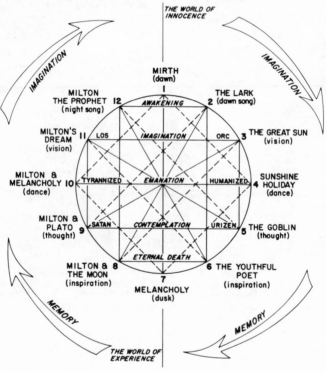

145. The Imagination is not a State: it is the Human Existence itself.
(Milton 32:32)

BLAKE'S DESIGNS FOR
L'ALLEGRO AND IL PENSEROSO:
THEMATIC RELATIONSHIPS IN DIAGRAM

by
Judith Rhodes

*T*his diagram of thematic relationships suggests a direction and level for interpretation of Blake's illustrations. As a descriptive worksheet, it points to specific thematic connections apparent in similar or contrasting motifs (e.g., the motif of light in darkness, 2/12). But primarily the diagram is interpretive. It is a circle of Eternal Identities which I propose are the concerns of the designs singly and as a whole. If, as I suggest, the focus of the designs is the Human Imagination, then it follows that Blake, working by contraries and negations as well as progressions, has created a visual counterpart of the definition in *Milton:* "The Imagination is not a State: it is the Human Existence itself" (*M* 32:32).

Ed.: Reprinted by permission of the author and publisher from *Blake Newsletter*, 4 (Spring, 1971), 135-36. The diagram and explanation should be considered in conjunction with the preceding discussion essay by John E. Grant.

The twelve designs are interrelated so as to define the imagination and to distinguish it from the memory in both the state of innocence and the state of experience. The series is developmental, but not chronological. The first half of the circle (designs 1-6) represents the world of innocence; the second half (designs 7-12) the world of experience. The designs at the four points of the compass (the square within the circle) mark off overlapping quadrants of mental experience, each of which develops out of the previous one.

The first quadrant (1-4) depicts the innocent imaginative world in its dawning and fulfillment with the major themes identified on the horizontal lines: the awakening with a dawn song, the revelation of the imagination as Orc, and the resulting humanized world-emanation. The second quadrant (4-7) shows what happens when the innocent man relies on his memory to account for his experiences. Urizenic contemplation and the sleep of death masquerade as thought and inspiration, resulting in the movement toward Melancholy. In the third quadrant (7-10) the failure of inspiration and the satanic mode of contemplation point to the domination of memory in the world of experience. But the emanation emerging from the tyrannized world in the tenth design reveals the way of liberation. The return of the imagination, now as Los, and the prophetic song which marks the new awakening complete the vision of experience in the fourth quadrant (10-1).

Each design has its opposite in the two worlds, e.g., 1/7, 2/8, 3/9, and these oppositions are much like negations. The horizontal lines connect contrary states of imagination and memory (2/12, 3/11, 4/10, 5/9, 6/8). The vertical lines connect thematic oppositions within each world: song vs. inspiration (2/6, 12/8) and vision vs. thought (3/5, 11/9). Designs 1 and 7 exhibit the Individual in each state while

designs 4 and 10 exhibit the social dimensions of their Emanations. (This aspect of the term is explained in Frye, *Fearful Symmetry,* p. 73.) A fourth relationship appears inevitable, based on the obvious connections between 6 and 11 and the parallels with the sides of the square. This relationship is neither one of contraries or negations, but I do not yet understand it well enough to give it a name.

The diagram, finally, is functional; its symmetry suggests an integrated vision that only careful study of the designs themselves can reveal, for the limitations of mathematical form are well known to students of Blake.

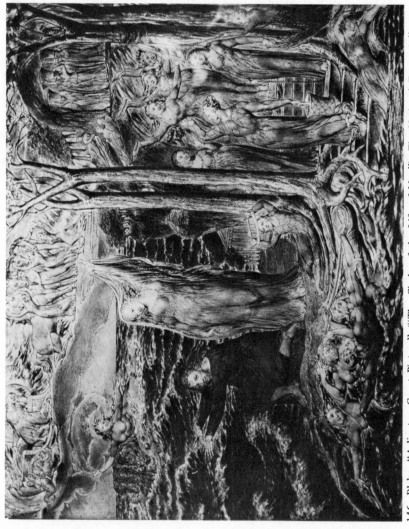

146. Blake, "Arlington Court Picture" ("The Circle of the Life of Man"). The National Trust, Arlington Court.

BLAKE'S *ARLINGTON COURT PICTURE:* THE MOMENT OF TRUTH

by
Robert Simmons and Janet Warner

*I*n 1947 a previously un-known painting by William Blake was discovered at Arlington Court, Devonshire. In the decade following the picture's discovery, Sir Geoffrey Keynes, George Wingfield Digby, and Kathleen Raine each wrote with insight about the painting, attempting interpretations consistent with their knowledge of Blake's art, psychology, and philosophy.[1] Since 1957 there has been little additional critical attention paid to this picture, although S. Foster Damon made sensitive observations in his *Blake Dictionary* (1965) and Raine incorporated her original essay into *Blake and Tradition* (1968).

We suggest here a new interpretation. Basically, what we argue for is an approach to the painting based on the composition and details of the picture itself, rather than

Ed.: Reprinted by permission of the publisher from *Studies in Romanticism*, 10 (Winter, 1971), 3-20.

treating them as illustrating any one literary or historical event. Perhaps you could call it a pictorial rather than a literary approach; different emphases appear when you look within the picture, rather than outside it, for clues to its meaning.

Sometimes called *The Circle of the Life of Man*, the picture [Illustration 146] is a delicately finished watercolor, measuring 16" by 19-1/2", and signed and dated: "W. Blake inventor 1821." It is still in its original gilt frame, which has written on the back the address of James Linnell, frame-maker, father of John Linnell.[2] A pencil sketch in the Pierpont Morgan Library's Blake collection, called *The River of Oblivion* [Illustration 147] is recognized as a preliminary study for the painting.[3] The picture's clarity, the maturity of the work (dated 1821 and probably contemporary with Blake's conception of the Job illustrations), and the possibility that it represents a grand summary or synthesis of Blake's philosophy all combine to make the work of major importance.

As our title indicates, we take this picture to be the moment of truth, the moment when man sees for what it is the fallen, illusory world he has created by separating himself from the divine and balances on the brink of undertaking the long, laborious, dangerous journey to find his eternal self once more. This is not the casting off of mortality, as both Digby and Raine suggest, but the full recognition of it. The way to regeneration is latent in the picture—both eternal and mortal worlds are present—but the painting appears mainly to comment on the illusions (both Greek and Christian) that man has created for himself and that he must overcome. The neoplatonic images are relevant to this picture in about the degree that Christian images are relevant in others of Blake's pictures: he uses them in his own way for his own purposes.

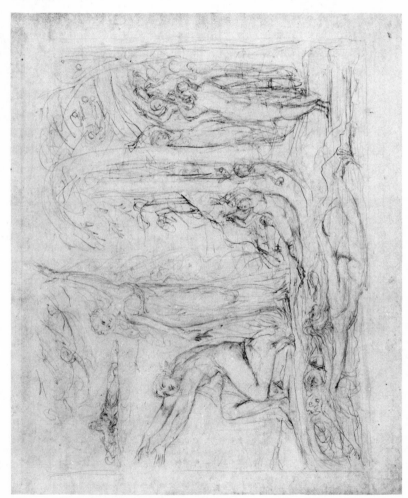

147. Blake, "The River of Oblivion." Pierpont Morgan Library.

Therefore we would not be willing to suggest, as Raine does, that *specific* incidents, such as Ulysses casting his garment into the sea, can be taken as the subject of the painting.[4] We do feel that the meaning of the picture is implied by its form, and for this reason our opinions and the detailed interpretation which follows will be made clearer if we look first at the composition of the picture.

Composition

The *Arlington Court Picture* is made up basically of two geometrical shapes: a triangle and a circle. A line drawn diagonally across the picture from bottom left to upper right follows the line between earth and sea, and earth and sky (running parallel to the roof of the temple), and yields a triangular section including three major groups of figures in the lower right half of the picture. The extreme right lower corner is anchored by a half-submerged, dead or sleeping female [see Illustration 148].

148. Circle and triangle diagram of the "Arlington Court Picture."

The composition of the upper left hand of the picture is based on a circle. This includes the sea and sky sections. The center of this circle is indicated by the pointing index finger of the left hand of the nude woman in the water. To trace the circumference, the eye progresses along the line of rocky cliffs, following the central female's upward gesture, towards the women and horses in the sky; up the stairs they are standing on, and along to the sleeping or dying man in his chariot; down along the line of his drooping right hand and down a cloudy spiral to the woman in the sea; along the line of the horses to the outstretched hands of the central male figure; from him to the female figure via her lower right hand which points at him; and so back up by the left, upward-reaching hand of the woman to the steps again.

The direction in which the eye moves around the circle is, however, equivocal; both clockwise and counter-clockwise movements are possible, with hands, steps, cloudy spiral, all pointing both ways.

The triangular portion of the picture consists of the land area, but beneath the surface of the land lie three caves with which groups of figures are associated: a group of figures writhing in the fiery underground river at lower left; a group of women on the steps; and, at the top right, a group of women with wings, and urns on their heads.

Notice also that movement between the groups in the triangle can go either from lower left to upper right, or vice versa, via the steps which hold both ascending and descending figures. The uppermost right hand group, however, seems rather isolated from the other groups in the triangle.

The circular portion of the picture can also be divided into an upper, sky part with the god and his attendants, and the horses and maidens; and a lower, sea part with the nude woman and the horses with their two attendants. The circle,

then, embraces sea and sky; the triangle, the surface earth, and the three underground caves.

It is important to notice that neither of the two central figures of the picture need be included in this diagram of circle and triangle. They are, in effect, superimposed upon the composition and become the focal point at which circle and triangle meet. While the upper parts of their bodies, especially their arms, become part of the circle, the lower parts are based in the triangle. These two figures, then, can be said to connect the two realms symbolized by circle and triangle.

The half-submerged woman in the extreme lower right corner is almost outside the basic compositional movements of the picture which flow past her up or down the steps. Almost unnoticed, her stillness nevertheless contrasts with the activity of the other groups in the triangle, and mirrors, in calmness and body position, the sprawling god in the upper left corner.

The picture can also be divided in half vertically, by the line made by the whole of the left side of the veiled central woman's garments, from the tip of her upward-reaching hand down to the ground-trailing hem. This line is paralleled by the trees just to the right of the figure. The effect of this vertical movement is to imply the domination of this figure's gesture over the whole right side of the picture. This includes the top two of the three groups in the triangle, but not the struggling figures at bottom left. The effect of this division is to link these latter figures with the nude, sea-borne woman and the tumultuous sea on the left, an effect stressed by the similarity of wild waves and human threshing-about. The vertical line also intersects the group of females unharnessing the horses above, with the result that they are not placed completely in the left side, but rather linked—and the

descending line of the steps helps here—with the angels of the upper right hand corner. The calm angels and the soft womanly forms grooming the horses share a similar mood of tranquil activity.

Interpretation

The two main geometrical forms Blake has employed in this composition are themselves highly significant. The circle here represents what we might call the eternal realm, outside of history. The triangle represents the mortal and rational— men within history. These forms are often used in Blake's art in this symbolic manner: e.g., *The Ancient of Days* (frontispiece to *Europe*—see Illustration 25), showing God creating the world, employs both circle (behind the god) and triangle (the compasses) with much the same meaning. Similarly, the color print, *God Judging Adam* (formerly called *Elijah in his Chariot of Fire*—see Illustrations 2, 103), uses the circle as a symbol of the eternal; and the color print, *Newton* [Illustration 29], uses the triangle as a symbol of the rational. The circle can, of course, in other contexts and even in other parts of this painting, represent eternal recurrence, that is, a repeated cycle, which may be viewed as a fallen-world state. But even in this sense—of the cycles of history—the cycle is seen as a cycle only from a vantage point outside of history, or in eternity. In general terms, therefore, the circular portion of this composition represents the eternal, or what could be the eternal if the sleeping god were revived. The triangle, with its three corners and three sides, and associations, as here, with Greek, Egyptian, or Druid architecture, is clearly in Blake the realm of the fallen world, of history, of mathematical and fixed form.

Thus it is possible to see in the formal structure of the picture an initial statement of its meaning. The two basic

geometrical forms of the painting, the circle and the triangle, represent two central aspects of the red-robed male figure, who kneels by the sea, his arms outstretched. Simultaneously present are his eternal and fallen worlds or capacities.

By this interpretation, all the human figures in the picture are aspects of this man.[5] The whole painting tells us of the state of his mind and existence. He is the most compelling figure in the painting, his importance emphasized by his red robe, a color much more vivid than any other in the picture. His face is turned away from his gesture, towards us, his gaze directed out of the picture into our world and our eyes. This in turn suggests that the picture takes place in that single instant of gesture and eye-contact. The fate of both eternal and mortal worlds, or possibilities, hangs on this instant. The rest of the painting tells us in considerable detail what his choices are.

This interpretation runs counter to other previously published ideas about the picture in its emphasis on the discovery by the man in red of his domination by a world of illusion, a world primarily symbolized by the veiled female standing behind him. Usually the central standing female figure is interpreted as a redemptive symbol—Jerusalem (Digby), or Athena, Divine Wisdom (Raine). But in our view, the picture shows the moment of decision and realization before the long journey to redemption is begun, and the veiled lady represents all that must be rejected. The difficulty of that journey, the fact that it is a night journey, undertaken by the red-robed male without outside help, is underscored by many particulars of the painting.

First, in the "eternal" part of the picture, the horses are being unharnessed—note the comb and towels in the ladies' hands—*after* the trip, suggesting that night is coming, not

day. The horses are descending the steps, not ascending. The sea appears to be rising. Facial expressions tend to be serious and unsmiling. Thus the over-all impression is sombre. But more important, the central woman is veiled, always a significant detail in Blake; and she stands behind the male. The man is seated; she is standing and dominant. She gestures with her left hand and arm, which dominate a triangular, fallen world.

Turning to that world, we find what appears to be a myth of ascent from a lower, cavelike place to an upper, calm, angelic region. Yet the upper region, presumably heaven (Digby) and part of the redemption which the female indicates, is itself contained in a cave. And caves in Blake's poems and other of his pictures are constraining places. A procession of angelic figures in a ritual march is not what is called to mind by poetry which describes the human forms walking to and fro in Eternity as One Man. Raine suggests that some of these "angels" are souls about to leave by the southern entrance of Porphyry's cave, on their way to higher things, or conversely, "the womb by which man enters life" (p. 86). Either way, an endless cycle of generation is implied. In our view, Blake is suggesting that something is wrong about such an idea of heaven.

The clue to what is wrong lies in the central figure, whose realm all this appears to be. We see her as a temptress, associated with nature and the fallen world—the giant, objective, illusory female that man creates when he separates his experience, in consciousness, from himself. That the veiled female is a symbol of nature may be borne out by noting the other pictures where Blake used this figure with this meaning.[6] The source of the figure is probably the Hellenistic statue of *Venus Genetrix* [Illustration 149].[7] Blake adds arms. About 1802 Blake had used the same stance and

149. "Venus Genetrix." Terme, Rome.

gesture for the figure of *Evening* in a tempera picture to
illustrate a passage in Cowper's *Task*. The passage quite
explicitly links the figure to nature.[8] The main female figure
in the pencil drawing for the *Arlington Court Picture*, with its
starry veil, seems to be a close copy of the *Evening* figure
with its left arm raised. Blake also used this figure for Eve in
the painting, *Eve Tempted By The Serpent*. Here the figure is
nude, not veiled, and her right arm is raised, indicating a state
of innocence. She has not yet taken the apple. Thus we may
be fairly certain that a veiled figure in this pose with the left
arm raised is indeed a symbol of the female nature principle,
the fallen, illusory world of time and experience.[9]

The man's hands stretch out in a gesture that combines
sorcery, despair, desire, and the groping of the blind. He is a
creator and Blake has given him the hands he also gave to
Jehovah in *Job* 14, and the Accusers in *Job* 10: one hand is
open, the other makes a pointing gesture. In each of these

examples, an environment is being created or a spell is being cast, events which in Blake's philosophy amount to the same thing: a change in the state of one's mind. [10] The male has the choice of either continuing to support the conjured-up world of the triangle or turning anew to the potential of matter in its eternal aspect, represented by both the rising sea and the nude in its waves. His choice lies between the two women.

The circle world represents the universal, the ideal, the eternal; the triangle shows a particular human manifestation, interpretation, or created form of that ideal. The figures and their clothing and the landscape with its temple indicate that this form is primarily the Greek one, although Christianity enters into it also, as indicated by the "angels" of the upper right cave. Let us call it the form of Western culture. The surface of the land shows the generalized Greek ideal of man reconciled, and adapted, to nature, with its temple to a nature god, its nymphs and bearded, reclining man. Up to this point, the red-robed man has apparently been a part of this culture. The hem of his garment has a Greek key motif, and the drapery of the veiled lady is Hellenic also.

The circle world also takes its imagery from the Greek tradition, and here a specific myth is portrayed: the myth of the sun as a god driving his fiery chariot across the sky each day, and at night descending to rest in the west. Since the god is shown descending at the right of our picture, we must assume we are looking at him from a northern point of view. The sun has moved south, therefore, and we are witnessing not only a daily descent into night, but a seasonal descent into winter.

But Blake adds to this basic myth, portrayed in the top, sky portion of the circle, the concept of the sun's chariot and horses returning once more to the east, as shown in the

lower, water portion of the circle. This second set of four horses is now active and drawing the chariot, whose wheels can be seen dimly under the water on either side of the right foot of the nude female. These horses are contrasted to the first set who are being dried and combed after their journey by the maidens in the sky. The chariot also carries the nude female, apparently uninterested in controlling the horses, in contrast to the god above with his sceptre-like whip. The return, an underwater journey, therefore appears to be quite unlike the daytime progress. It also seems to take place in a darker, cloudier, probably nighttime atmosphere, compared to the blaze of the declining sun's fierce fires above the clouds. [11]

What does this twofold journey described in the circle mean? We would suggest a hypothesis based on Blake's conception of two eternal states: Eden and Beulah. Eden is the day journey, when the sun or creator actively pours out his passionate energy, creating and informing the world. Beulah is the state of rest and receiving back, when the creator rests in his creation, the moon reflecting back the sun's rays, the work of art reflecting back the artist's conception. In this painting the state originally created is the triangle world of the giant female. The god, and all mankind, rest in this creation, the world of Western culture.

However, something seems to be happening to this world. The caves beneath the surface and the seated male's turning away indicate that it is not quite what it appears. The blue ring around the god's head is also ominous. We argue that this veiled lady's world has become, not a good creation, but a delusion. Why has it changed? Because the veiled lady insists on its eternal validity; yet it is a work of time, as all created things are. The notion of a work of art as immortal also has its Greek origins. The seated male has become priest

to a nature goddess, seeing nature as eternity. The veiled lady is not an emanation of the sky god, but a ghostly shadow of one.

When this happens, a second journey begins: the return journey, the underwater journey where new forces are gathered from experience and from the work that has already been created, and the sun's chariot returns to its starting point to wait for the creator to take up the reins once more. The woman in the watery chariot, therefore, is now the true, but lost, cast-out emanation of the god; not the creation itself, but the gathering potential of a new creation. She is cast out, rejected by the already existing world, now fading into illusion, because she is a threat to its validity, and because she has no part in it, being pure potential.

The horses and chariot in both water and air represent the god's body, or physical resources, which are controlled by the blaze of mind during creation, but which are undirected by the god during the return journey. The two tiny figures on either side of the watery horses, apparently a female (far side) and a male, may indicate that the body's only guide during this period is the sexual instinct. The god himself cannot steer the chariot, for this is his time of rest, and he rests within the already created world; yet he will not waken until the chariot has returned to its starting point. His cast-out emanation, passenger of the chariot, cannot direct it, for she must await recognition to exist. Who will volunteer to direct it? We suggest that it is this action that the red-robed male is debating.

Let us examine the state of Beulah, portrayed in the sky portion of the circle, more closely. This state of rest has two components: restoration of the mind, signified by the god himself, and of his body, signified by the horses. Hence, the god has two kinds of attendants: the fairy-like musicians

around his chariot, and the handmaidens engaged in rubbing down the horses. There is a sexual aspect to both groups and their activities; one soothes the mind into dreams, the other the body into relaxation. [12]

The division of mental and physical activity also carries over into other aspects of the painting. The horses of the night journey represent the initial physical need for new stimuli after long or deep sleep; the red-robed male, if he decides to help, could give the necessary mental direction to that endeavor. The triangle world, in turn, seems to have fallen through its placing primary emphasis not just on rest, but on the mere physical aspect of rest. The veiled female indicates the horses and maidens, not the god and his fairies. The surface land shows nymphs and a bearded male reclining in a pastoral world, while the other surface figures, six females grouped around the steps, are all engaged in domestic activities designed to comfort the body, not the mind. Yet, without the guidance of the mind, the body is reduced to a simple state of rest, a static deadness. By contrast the nude maiden of the sea offers a potentially active physical experience.

The red-robed male is between the two. He has been a priest organizing physical experience solely in terms of the best state of rest. He is now debating switching allegiances to the nude lady in the pursuit of an active sensual experience. Both are appropriate aspects of the night, with its sleep and sex components. It is only the attempt of the veiled female to sustain the first forever that entails error. Her world is the Greek surface land which her gesture dominates on the right side of the painting. Her left hand, reaching up into the sky, at the same time seems to indicate that it is from here that the creation comes, from the divine world, and therefore the

seated man should accept it, and live on that plane, as the reclining nymphs and the bearded figure do.

But the seated man instead turns away and reaches out to sea. Why? Because that green, surface, idyllic Greek landscape covers a threefold underground world that tells a very different story. The veiled woman is offering a single cultural explanation for experience, an explanation derived from one of the god's day-journey creations, but an explanation that she claims to be true for all time. With the advent of winter, a sterile time approaches, a time of cultural influence over the ideas of the individual artist. Hence, that artist and individual, the red-robed man (red for rebellion?), turns toward something else. What he turns toward is the night journey, which is the journey of the individual into himself, where he finds and comes to terms with the material which will eventually be formed in the day journey of creation; and where he meets and unites once more with his lovely true emanation—the nude in the water—learning through his essentially sexual experience with her how to redeem his body. Thus he returns to the east of the awakened senses, and redeems the god.

Before turning to the three caves of the triangle world, which illustrate the various errors which undermine the acceptance of the Greek cultural explanation for experience, we should examine some of the relationships between the figures already discussed, and similar figures and ideas elsewhere in Blake's works.

The central myth of the sun god is closely associated with Blake's character, Luvah, who is one of the "four mighty ones" in every man, described in *The Four Zoas*. He can be identified with the senses, the doors of perception, which are opened when the sun glows in the sky. His four horses are the four senses—sight, hearing, smell, and touch

and taste combined—which draw the chariot of the body as the controlling mind expands and contracts them at will. Because he is associated with the Greek Apollo, god of music, the musicians are appropriate as his attendants. During the night journey, his chariot is used for love, and his emanation is sexual desire and experience—Vala. As the feeling or sensation aspect of the Eternal Man, he is one of the four possible symbols or manifestations of him.

The nude female drawn by the horses, as Luvah's emanation, should be Vala, the lovely world of the senses; and indeed she assumes the traditional reclining pose of the bride, or lover, or courtesan. This is one of the traditional poses for Venus or Aphrodite, with whom she is closely associated, and her place in the sea is also appropriate in this context. However, in her relationship with the red-robed male, something seems amiss. Instead of attaining union with her, the red-robed male is dominated by the veiled standing woman, who is far larger than the nude female. The nude female appears to be appealing to her, and an arrow of tiny dots extending from her right foot towards her head, as well as the similarity of their faces, argues for the closeness of their relationship.

The fact that the veiled woman also assumes a traditional Venus pose is again evidence of a connection with the nude female, both of them recalling the Platonic double conception of Aphrodite, or two Venuses, one draped, one nude.[13] Who, then, in Blake's terms, is this veiled lady?

We suggest she is also Vala, but Vala in her demonic, fallen aspect, in which she appears in Blake's *Jerusalem*. In this demonic form, she is associated not with the infinite world of sensual delight, but with a single aspect of that world—Nature. And with her sweeping gesture, and her feet planted squarely on the earth, the triangular portion of the

painting, she insists on the universal validity of that single aspect, an aspect seized on by Western rational-scientific culture as the only "real" fixed fact of existence.

Raine's association of the figure with Athena is interesting, as Blake may have seen the traditional Greek goddess of wisdom as an apt symbol for the rationalist, natural-science basis of Greek thought. Perhaps that is her temple there in the woods. Her other associations with warfare and weaving are also appropriate to Blake's concept of a demonic Vala. The weavers in the second cave may well pick up this latter aspect of Athena, as the struggling figures in the first cave may echo the former. Of this, more later. Athena's maltreatment of Aphrodite in the *Iliad* may also come to mind here, as she dominates the seated male, and rejects the nude female's appeal. There is a neat irony in the notion of a natural Venus becoming a goddess of wisdom that Blake may well have enjoyed. In a somewhat similar way, Blake's god of the senses, Luvah, appears as the Greek god of reason, Apollo.

With the demonic, veiled Vala in charge, the nude female becomes more closely associated with the wandering figure of Jerusalem in Blake's poem of that name—a lost emanation doomed to live in the void, sustained only by Los's works, until her eternal creator once more awakens. Just as Luvah, as one aspect of the Eternal Man, can represent the Eternal Man, so the good Vala, as one aspect of Jerusalem, can represent Jerusalem. The red-robed male's choice is between the two Valas: to seek and support the lost one in her dark, Beulah night; or to live in illusionary daylight with the usurping veiled one.

This, of course, is Los's dilemma in *Jerusalem,* and we suggest that the red-robed male is closely associated with Blake's Los figure, and so with Blake himself as the lonely

artist and rebel. Can we not see the central male as Blake the prophet at the moment when he realizes that he must reject the cultural system and labor in his own way, with all the risks of misunderstanding that go with the rejection of any traditional cultural aesthetic?

Let us now turn to the triangle world, all of which must be seen as Blake's analysis of the fallen world: what's wrong with it; and how it got that way. This world uses myth as history, and illuminates history by myth. It describes the universe of the veiled lady, first, as she sees it and presents it to the red-robed man—on the surface, and second, as it really is, in the three caves. The surface figures are: the red-robed male and the veiled female (already discussed); a group of six females clustered by the steps, one lying half in the waters of a river; three reclining nymphs, letting water fall from spilled jars, and a bearded reclining male. Below ground are: in the first cave, bottom left, three fates and a horned man; in the second cave, three weavers; and in the third cave, top right, a procession of angelic forms, of whom three at least, nearest us, have feminine bodies.

Taking the major group of surface figures first, we suggest that the six females by the steps are all handmaidens of the central veiled woman. If she has associations with Athena, who is the goddess of household skills (and Vala seems to have similar associations), then they portray these skills: on the left, winding yarn from a skein; on the steps, carrying water; and on the right, twisting ropes, perhaps from the bark of the tree, or from the loose material in the two females' hands, using the tree as a support. Each of the central three females, between the two sets of trees, has an assistant outside the trees. The water-carrier's assistant lies half in the water, apparently drowned. The water-carrier seems alarmed at this. [14]

Each of these females and their respective assistants also seem to be associated with the female inhabitants of particular caves. The rope-makers apparently supply the fates below with their rope of life. The yarn-winders supply the weavers. Note their weaving frame, and their feet on the treadle below. Note also the difference between the thick, markedly twisted rope, and the thinner yarn. The water-carrier seems on her way to fill the jars of the jar-bearers in the third cave above. Given that the handmaidens on the surface have their counterparts below ground, the veiled lady's sphere of influence is more pervasive than the surface world alone might suggest.

What does all of this mean? We suggest that the central myth is that of the three graces, given the usual Blakean re-interpretation. The composition of the three females between the trees reflects many traditional paintings of the graces, in particular Botticelli's *Primavera*. The central figure has her back to us (her pose echoing Botticelli's central grace), and all three are subtly differentiated in details, as well as being distinguished by their cultural tasks. The water-carrier has short or bound-up hair, and a note of alarm in her face and gesture. The yarn-winder has long, loose hair, but with some sort of braiding over the brow, and also a somewhat fuller and more relaxed figure. The rope-maker's hair seems completely loose, and she seems somewhat smaller, perhaps more youthful, than the other two, with a less well-developed body. The three are distinguished by their assistants also. The water-carrier's is lying down, motionless, her jar spilled. The yarn-winder's is seated, but her hands are still motionless. The rope-maker's is standing and engaged in twisting the rope.

All of this suggests a progression from one to the other of the three, as is postulated in the neo-platonic reinterpreta-

tion of the figures. The water-carrier, then, would represent procession; the yarn-winder, conversion; and the rope-maker, return.[15] But Blake, we think, via the connections with the caves, is offering a parallel but distinctly different meaning. If we take the third cave, with its angelic figures and water jars (baptism?) to represent heaven and the realm of the soul, then the water-carrying grace is also a symbol for the soul, perhaps here trying to preserve her purity (the water in her pail) during her ascent to the top cave. Similarly, the yarn-winder, with her more voluptuous form and her connection with the female weavers of the second cave, who are Blake's symbol elsewhere for the way the body is woven into the physical world of nature, would represent the body. So far, procession-soul; conversion-body—that which entangles the pure soul on its journey. The third grace is return, or the summarizing conclusion of the other two. And she is connected to the first cave with its rope of life. She is life itself—the only life possible in the fallen world with its divided and therefore forever irreconcilable body and soul.

One should note that though the natural flow of the cave sequence is from bottom left to top right, the sequence derived from the graces would be from top right to bottom left, so that even the water-carrier is deluded as to where she is really going. This idea might be carried further by the suggestive sequence of the lying, sitting, standing assistants from passive to active (from third to first caves). If death has overtaken the first assistant, perhaps the same fate waits for the others; perhaps for the graces themselves; perhaps for Vala herself?

We have still to deal with two male figures—the horned man, and the reclining bearded man. They seem rather out of place amidst this overwhelmingly female world. Indeed, one suddenly notices that there are only five definitely male

figures in the painting, and the fifth is only a tiny figure in
the waves near the four horses of the nude female. We suggest
that the four larger males are all associated with Blake's "four
mighty ones in every man." The god above is similar to
Luvah; the red-robed male is like Los; the horned man below
has associations with Tharmas, as Damon pointed out; and
the beard of the reclining male amidst the nudes leads one to
link him with Urizen. If this is so, then Urizen is appro-
priately placed on the surface. As a god of reason, he is as
naturally part of a nature world, as Athena is. Just as it is
odd, or even difficult to see Athena in the traditional pose of
Venus, so it is odd to find the cold sterile Urizen reclining
somewhat inconspicuously with the naked nymphs. The
figure suggests Pan instead, although it is entirely human, but
again this is appropriate in a world where the only recognized
reality is nature. In that world, nature and reason go together
to form deism or natural religion; in that world, Pan and
Urizen are alike in their response to nature; Venus becomes
Athena; Luvah becomes Apollo.

The true Venus is the nude in the water, cast out and
forced to travel in the underwater world; and similarly, the
true god of the deceptive, surface, bucolic Beulah world is
Tharmas, the horned man struggling in fire below. Notice
that his pose with its outstretched arms and horizontal leg
position mirrors hers. He is the fallen dark aspect, now forced
underground, of the power she represents.[16] As Urizen is
properly placed near the cave of the souls, seeing pure
intellect, or spirit, as the only truth, so Tharmas struggles in
the first cave, trying to integrate the divided reality of
spiritual and physical existence into one body. He is the
whole other, under side of man, of sense and feeling and
passion, which must be repressed to enable Urizen to recline
in his passive ease on the green slope above—though what he

enjoys is really a rather perilous niche in the cliffs. Not to neglect our fifth male entirely, perhaps we can see him as a sign of the direction in which Los, our red-robed man, is about to move.

To finish, let us consider the three caves in their "natural" sequence. Each tells us of an illusion, but behind each illusion lies a divine analogy, mirroring the truth. The illusion is the historical content of each cave's story; the truth lies in the mythic content. The sequence and the time spans are given symbolically by allusions to three zodiacal ages: Aries, Pisces, Aquarius. The ages run opposite to the yearly zodiacal cycle; hence the first cave is oldest. It is identified by the sign of the ram—the horns on the man's head—and tells historically of the battles against fate of the Greek heroic age, as we have them from Homer. But the mythic truth embodied in the tales of Priam and Hector-Helen and Agamemnon and Achilles-Briseis is that one cannot have both body and soul, once divided, in this mortal life. The message is clear; they must be one.

The second cave is the age of Pisces, identified rather more loosely only by the fishy scales on the bucket of the water-carrier, herself a servant of the third cave. But the aspect of futurity implied by this—that the healing waters of Christ are not for the use of that age, but another—underlies the whole history and myth of this age. Historically, it is the age of a fallen world, of an overriding conception of sin and guilt and mortality and growing distaste (with the conscious-ness of its limitations and voracious needs) of the body. The mythic message, however, is again clear; the body separated from the soul *is* mortal. The two must be one.

The third cave is the age of Aquarius, the coming or future age, as we have been reminded so recently by the song from *Hair*. Its sign is the water-carrier. However, in this cave,

as is appropriate when looking into the future, the historical and mythic contents are reversed. The myth derives from, and is part of, the history of the first two caves. It tells of a peaceful, external heaven where man can rest after his mortal life in time. This, paradoxically, is the myth that keeps man going *in* time. The historical projection from the first two ages, however, is more ominous. In the infinite procession of water-bearers we can see merely the cycle of generation repeated over and over again, as it has been in the past. This is the only possible result of attempting to divide the divine oneness into body and soul. The soul apart from the body is not alive, but dead; not eternally fixed, but doomed to inhabit an endless succession of bodies, as in, once more, the Greek (Platonic) myth of the transmigration of souls.

All errors, then, according to Blake, derive from the Greeks. The *Arlington Court Picture* is his biting criticism of the foundations of the Greek culture, and in turn of Western Civilization. The central error is the refusal to recognize the existence of not one, but two eternal states. With the pastoral, passive, Beulah world of nature—of the divided sexes, of man in nature, of subjective as an aspect of objective—being fixed on as the only possible way of existing, man has not only denied himself Eden, the active city world of man, with a united sexuality, and a sense of a world that is limited only by man himself, but also turned Beulah into Ulro. Sleep has become death, as the sleeping god in the top left corner is reflected by the drowned female in the lower right.

Having dealt with the whole picture, some further details become clearer. First, in the triangle world, the trees between which the graces stand, while appearing to be gates through which one passes from the lowest cave to the highest, really link the caves. The roots grow out of the lower

cave, and the branches reach up to the highest. The trunks enclose the central group of graces. Blake's concept of a vegetable universe seems to underlie these details. The steps also change in significance. They appear to lead up the hill, but really lead down from the surface world to the underground world of the second cave. The trees grow out of these steps.

In the circle world, the blue ring behind the sleeping god can now be seen as a summary statement of the whole world of Beulah-become-Ulro. Conceive of the entire world as originally in the Jerusalem state, a fiery ball without regularity, its circumference infinite outwards and inwards. Then the god withdraws into Beulah, towards the center. The flames begin to die, and a finite circumference takes form, as well as a central point—the god's head. Jerusalem, the inner circle of fire, is now contained in Beulah—the blue ring, the blue signifying sky and night, and the round shape their common symbol, the moon. But now the ominous begins to intrude. The double rings containing the blue seem to be hardening into a shell; the sun is entrapped by the moon as the conception of Jerusalem is closed off and a Beulah heaven begins to replace it. So the sleeping god is shut off from the needed outside stimulus which would restore his resources. The flames of Eternity can no longer pass freely into the inner Beulah world; he becomes a prey to a twisted illusionary vision, as do the subjects of sensory deprivation experiments. He begins to dream not dreams, but nightmares.

The somewhat vortical vapor descending from the god's cloud, encircling the sea-nude's head, and ending at her right hand, is also significant. In its vortical aspect it suggests the translation from one kind of existence to another. The nude is the god's emanation, but she has been cast out, or cut off from him. The translation from one kind of existence to

another, together with the sense of separation or loss found in the new existence, seems to be the two most prominent features of Blake's vortical descriptions elsewhere, for example, in "The Mental Traveller," where the old man is cast out and translated from a garden to a desert world.[17] Here, the nude passes from sky to water, from partaker of the sun's rays to distant reflector of his dying light.

Finally, a word about emanations and Zoas. Four Zoas make up the Eternal Man, but the fall of one produces the fall of all. The Zoas here are Luvah, the god in the chariot; Los, the red-robed man; Tharmas, the horned man; and Urizen, the reclining bearded man. Luvah's prolonged sleep has had its effects on the others more than on himself, for a portion of his emanations has stayed with him in the sky, preventing his complete fall into death. These are the fairies and female grooms. Vala, however, has split into two females, one dominating the other three Zoas in a mistaken universe, the other lost to him through the vortex, but providing the way out if the other Zoas will take it. Only Los seems about to take that way. Urizen is supremely happy in that passive, surface universe, because reason is a passive mental faculty; Tharmas is in pain and fighting, but safely put away beneath the ground Urizen sprawls on.

The nude female in the water, then, is the true emanation—Jerusalem—of the Eternal Man; and so the true emanation of all the Zoas who should combine to create her. Instead, each has created false emanations, all of whom are handmaidens of the central veiled lady. Los's false mistresses are the three weavers of the second cave, of the body; Urizen's are the water-carriers in that infinite procession of the third cave, of the soul; Tharmas's are the three fates of the first cave, of fallen divided life: Luvah's are the three graces themselves, and their assistants, of whom one, the

drowned female, symbolizes his own state as she reflects his
body position.

Conclusion

The basic meaning of the *Arlington Court Picture*
essentially needs no other key than the eye of the beholder.
The symbolism is relatively simple and traditional. When the
overall arrangement of the painting is grasped, the message
begins to come clear; and then, when the content of other
Blake concepts is added, a complete and coherent meaning
can be attained. Our use of familiar Blakean terms, such as
Eden and Beulah, as well as references to some of his
best-known characters, has been a convenience rather than a
necessity, mostly useful to indicate quickly to Blake
specialists where we feel the connections between this
painting and other Blake works occur. We think that the
picture describes the philosophical and psychological fall of
man; that it gives a clear, intellectual explanation of the
Greek origin of Western man's neurotic existence as Blake
saw it, as well as the tentative indication of a way out—risky
and laborious as that may be—and that it is a grand and
coherent summary of Blake's thoughts at a period relatively
late in his career.

Note: A version of this paper was presented at the seminar
 on Blake illustrations at the MLA Convention in
 Denver, December 28, 1969. An account of the
 seminar with additional suggestions about Blake's
 iconography and the *Arlington Court Picture* was
 written by John E. Grant for the *Blake Newsletter*,
 May and August, 1970.

NOTES

1. Critical work regarding the painting includes the following: Geoffrey Keynes, "A Newly Discovered Painting by William Blake," *Country Life*, Nov. 11, 1949; Notes to the Arts Council Catalogue of the exhibition of Blake's Tempera Paintings, arranged in 1951 by the William Blake Trust; "Blake's *Vision of the Circle of the Life of Man*," *Studies in Art and Literature for Belle da Costa Greene*, ed. Dorothy Miner (Princeton: Princeton U. Press, 1954), reprinted with revisions in Keynes, *Blake Studies*, second ed. (Oxford: Clarendon Press, 1971), pp. 195-204; George Wingfield Digby, *Symbol and Image in William Blake* (London: Oxford U. Press, 1957); Kathleen Raine, *Blake and Tradition* (Princeton: Princeton U. Press, 1968), ch. 3, originally "The Sea of Time and Space," *Journal of the Warburg and Courtauld Institutes*, 20, 1957; S. Foster Damon, *A Blake Dictionary* (Providence, R.I.: Brown U. Press, 1965), pp. 86-87; John Beer, *Blake's Visionary Universe* (Manchester, England: Manchester U. Press, 1969), pp. 286-94.

2. Keynes, "Blake's *Vision of the Circle*," *Studies in Art and Literature*, p. 204; *Blake Studies*, second ed., p. 197.

3. *Studies in Art and Literature*, p. 202; *Blake Studies*, second ed., pp. 195-196. No one knows who inscribed the title on the back of the drawing.

4. Raine, *Blake and Tradition*, p. 76: "Blake has combined the two accounts of the hero's coming safe to land: from the landing on Ithaca (*Odyssey*, Book XIII) come

Athena and Phorcys and the Cave of Nymphs: from the Phaeacian landing (Book V) the episode of Leucothea's girdle." Raine's case for these specific incidents as the basis of the picture is less convincing when one discovers that neo-platonic accounts of other incidents from the *Odyssey* could fit the picture also. For example, in Thomas Taylor's "On the Wanderings of Ulysses," an appendix to *Select Works of Porphyry* (London, 1823), the account of Calypso could be used:

> For she is represented as dwelling in a cavern, illuminated by a great fire; and this cave is surrounded with a thick wood, is watered by four fountains, and is situated in an island, remote from any habitable place, and environed by the mighty ocean. . . .

Conversely, Taylor, quoting Porphyry, could be said to support our account of the veiled lady if we wanted to suggest that the picture described the Circe incident:

> Homer calls the period and revolution of regeneration in a circle, Circe, the daughter of the Sun, who perpetually connects and combines all corruption with generation, and generation again with corruption. . . . And he also informs us, that Circe ranks among the divinities who preside over generation, or the regions of sense. Homer too, with great propriety, represents Circe, who rules over the realms of generation, as waited on by Nymphs sprung from fountains. . . .

The point is that while the Greek and neo-platonic elements in the picture may suggest Ulysses, they do not necessarily suggest those incidents which make a case for a neo-platonic interpretation of the picture.

5. See Digby, p. 59, for an illuminating psychological interpretation which differs in detail and emphasis from ours.

6. A possible symbolic system for some of Blake's repeated figures is discussed in an essay by Janet Warner, "Blake's Use of Gesture," in *Blake's Visionary Forms Dramatic,* ed. David V. Erdman and John E. grant (Princeton: Princeton U. Press, 1971), pp. 174-95.

7. Kenneth Clark, *The Nude* (New York: Pantheon Press, 1956), notes that this statue (p. 79) is attributed to Kallimachos and exists in several replicas. One, in the Louvre, was discovered in 1650. The replica known in the Renaissance was in the Casa Sassi and drawn by Aspertini and van Heemskerck, and engraved by Fogolino. (Clark, p. 383).

8. From Cowper's *The Task,* Bk. IV, ll. 243 f:

> Come Evening, once again, season of Peace:
> Return, Sweet evening, & continue lone!
> Methinks I see thee in thy streaky west,
> With matron step slow-moving, while the Night
> Treads on thy sweeping train; one hand employed
> In letting fall the curtain of repose
> On bird and beast, the other charged for man
> With sweet oblivion of the cares of day;
> Not sumptuously adorned, nor needing aid,
> Like homely-featured Night, of clustering gems;
> A star or two just twinkling on thy brow
> Suffices thee; save that the moon is thine
> No less than hers, not worn indeed on high
> With ostentatious pageantry, but set
> With modest grandeur in thy purple zone,
> Resplendent less, but of an ampler round.
> Come then, and thou shalt find thy votary calm,
> Or make me so. Composure is thy gift. . . .

9. See Keynes' Notes to the Arts Council Catalogue. Keynes regarded her as Vala (p. 205); Damon also calls her Vala. Digby regarded her as a regenerate figure, Jerusalem, with the female on the waves as Vala. Raine calls her Athena. See also John E. Grant's comments on Blake's iconography and the Veiled Lady in *Blake Newsletter,* August 1970.

10. Kathleen Raine saw this gesture as the act of throwing a girdle or sea-garment into the ocean where it was caught by the goddess on the waves and turned into a spiral cloud, the garment symbolizing the material body. However, this gesture is used by Blake in other pictures, noted in the text, to represent a mental 'casting,' not a physical throwing. Damon saw this gesture as a calming of the seas. Grant drew attention to the similarity of the man's general posture to the figure of Philoctetes in the drawing *Philoctetes and Neoptolemus at Lemnos* (*Blake Newsletter,* May 1970).

11. For further "night" associations of the sea goddess, see Grant, *Blake Newsletter,* May 1970. Both grant and Digby call attention to the lunar horns suggested by her hair. Grant pointed out to us the detail of the chariot wheels.

12. See Digby's illuminating discussion of these attendants as Daughters of Beulah, p. 68.

13. See Edgar Wind, *Pagan Mysteries in the Renaissance* (New Haven: Yale U. Press, 1958).

14. Cf. Damon, p. 87.

15. See Wind, p. 138.

16. The man with the horns has been variously interpreted as the god of generation, Phorcys (Raine, p. 91), Blake's Tharmas (Damon, p. 87), or the unconscious in its most repressed, satanic aspect, bearing the horns of capricorn, the goat (Digby, pp. 85-86).

17. John Sutherland, "Blake's 'Mental Traveler'," *ELH,* 22 (1955), 136-47; reprinted in *Discussions of William Blake* ed. John E. Grant (Boston: D.C. Heath & Co., 1961), p. 86.

REDEMPTIVE ACTION IN BLAKE'S
ARLINGTON COURT PICTURE

by
John E. Grant

*I*t will be clear to the reader that the interpretation of the *Arlington Court Picture (ACP)* which I shall propose is fundamentally different from the Simmons-Warner theory and that, while incidental points in both essays are quite compatible with one another, the discrepancies are too radical for both interpretations to be considered valid. In my opinion their theory could be disproven in a number of crucial particulars, though not in all. Probably the most basic flaw in the Simmons-Warner position is their tendency to shift their ground in explaining what the Man in Red is up to. At first they indicate that he is under the sinister influence of the Veiled Lady and thus unable to respond to the creative influence of the Sea Goddess. But later they imply that the Man in Red has not

Ed.: Reprinted by permission of the publisher from *Studies in Romanticism*, 10 (Winter, 1971), 21-6.

yet made up his mind, that he just might do something redemptive after all and is asking the viewer to help him. This shift does not amount to an outright contradiction but it results in an equivocal theory.

This crucial shortcoming is the consequence of an inadequate conception of the status of the two women in the picture. As I have tried to show before, the case for approving the Sea Goddess and condemning the Veiled Lady cannot be soundly developed, either on the basis of intrinsic or of comparative evidence.

Another serious error is that Simmons-Warner depend too heavily on the latent geometry of the picture as a guide to its meaning. Actually neither "side" of the picture is as symmetrical as they indicate and, even if this were the case, one ought not to base a great deal on such a fact. In a recent article I touched on some theoretical aspects of the problem of the relationship between geometry and meaning in Blake's painting and shall not repeat my rather acerb comments here.[1] It seems to me that Simmons and Warner have been led astray by the kind of thinking expressed by a current slogan in aesthetics, "form is meaning." One need not be a Marxist to see how and why such blatant "formalism" has found favor during our late phase of decadent capitalism. Philosophically one must agree that "form is meaningful," but so, of course, is matter; the assertion: "form is meaning" *period,* is at best a hortative metaphor that serves as a useful antidote to philistine materialism.

Blake himself had little use for diagrams—he said they were the gods of the Greeks—and was never content to let much rest on so abstract a basis. In a noteworthy discussion of the problems of interpretation Northrop Frye once usefully reminded us that the geometry of a (representational) painting is what we attend to last as we back away

from it.[2] And we can never know what to make of such geometry until we have enjoyed an intimate encounter with its more human levels of meaning. It is not even teleological criticism to start at the geometrical end.

But in spite of what I take to be some basic errors of theory and methodology, there are many good things in the Simmons-Warner essay which, I trust, will be appreciated by all Blake scholars. Their ability to attend to minute particulars, such as the Greek key design on the robe of the Man in Red, enables them to recognize how much of the thrust of the picture is anti-Greek, a fundamental problem obscured by Miss Raine's occult Hellenism. And their recognition that the picture is seen from the *north* is also highly suggestive. The frequent occurrence of such sharp observations and their continuous respect for the significance of such details make the Simmons-Warner paper a contribution to scholarship which distinguishes itself from the sort of introductions, explanations, and pronouncements that have added little to our understanding of Blake's iconography.[3]

The Whirlwind of Lovers as a Key to the *Arlington Court Picture*

There are a number of visual similarities between *ACP* and *The Whirlwind of Lovers* (also called *The Circle of the Lustful*), one of Blake's greatest designs for Dante.[4] The topography is much the same insofar as both feature at the left a promontory that juts into the sea, while across the bottom in the foreground a flaming river flows into it. The Nixie on the urn at the lower right on *ACP* is much like the girl at the lower right, reversed, in the *Whirlwind* (especially in the watercolor version). The Horned Shell-Helmeted Man is also like the fourth distinct figure from the right, the first male, in the *Whirlwind*.

The basic motif of two figures on a promontory, one standing, is distinctly similar, especially when we understand the quasi-female role of Virgil (who wears a blue robe, comparable to the Veiled Lady's mauve dress) in Blake's interpretation. The prostrate Dante does not resemble the Conjurer except insofar as he also wears red, but the distinctive kneeling position of Paolo in Dante's solar fantasy is much like that of the conjurer. This "more bright Sun of Imagination"[5] is also symbolically related to the area of the Sun God in *ACP*, and the fact that the Sun God is sleeping relates him to the swooned Dante; ergo Dante is to the Sun God as Paolo is to the Conjurer.

The curve at the bottom of the loop in the engraved version of the *Whirlwind* contains a woman in a horizontal position who, apart from being slightly draped, is almost exactly identical with the Sea Goddess (she is nude in the watercolor, but here the resemblance is less). In the engraved version the hair of the woman in the Whirlwind trails to the right, as in *ACP*; she wears a curious crown of eight or more irregular prongs and has, rising from the middle of her head, two more prongs which might be strands of hair. Her left arm is stretched out toward the action at the right (the crash and the swoon), and her right arm is raised at a slightly higher angle than that of the Sea Goddess, evidently to direct the curve of the Whirlwind. In the engraving she looks almost out at the reader, whereas in the watercolor she looks back, much as in *ACP*. In the Inferno design the Whirlwind has, in effect, drawn the Sea Goddess up into it and has also become articulated with the Storge water depicted across the bottom in the tempera. As one would expect, the flames, which burn mostly against the proper direction of the current in *ACP*, blend into the waterspout of fulfillment that blasts out of Hell.

The figure of Francesca within the tongue of flame, though it is bent distinctly more to the Spectator's left, resembles that of the Veiled Lady, as well as that of Lady Mirth in Blake's later engraved representation of the first design for Milton's *L'Allegro*.[6] The situation of Francesca within the flame also recalls that of Oothoon in the fourth plate of *Visions of the Daughters of Albion*, though she is united with Paolo, whereas Oothoon was divorced from Theotormon.

The fact that the Sea Goddess' hair resembles a crescent connects her with the female devil at 9 o'clock in the Leconfield tempera version of *Satan Calling His Legions*.[7] This nude has a very small crescent on her head[8] and bends to the right, in a posture much like that of Francesca in the flame (though she bends to the left), as she looks up out of her tongue of flame at Satan. Her left forearm is raised and then hidden behind her head and she seems to hold an object in her right hand at her right thigh; it looks like a small spatula or a flat spoon. The crescent, which seems problematic in Figgis, is certain in a photograph of the picture.

One could add that her infernal counterpart at 3 o'clock is the exact prototype of God the Creator, the motif established by Michelangelo and Raphael and used also by George Richmond.[9] When god goes to sleep on the job, as he does in *ACP*, the only creativity to be found is in the flames of rebellion.

These connections are quite suggestive, but it only gradually dawns on the spectator that the *Whirlwind* is essentially a magnification and, as it were, an elucidation of the cloud vortex of *ACP*, one that must be effecting a Resurrection in the perfection of sensual enjoyment. Dante designs nos. 85, 90, and 91 are highly useful at this point to vindicate this Resurrection and distinguish it from the kind

of futility wrought by the *senex* whom Dante at times confuses with God. If the Spirit within the Whirlwind is bringing about the Eternal Salvation of most of those immersed in the River of Death, it can do so because it refuses to be encumbered by the central institution of the Greek temple which is subverting the efforts at redemption that are taking place all around it in *ACP*. And pagan ritual is controlled, either fundamentally or ultimately, by the machinations of the three Fates who command the Classical universe, as shown in the third design for *Il Penseroso*, "Milton and the Spirit of Plato." [10] At least two of this team of malign influences, it is worth noting, are being broken up and elevated at about 7 o'clock in the *Whirlwind*, not being carted off to Hell, as similar pernicious figures are in visions of the Last Judgment.

In this perspective one can see that the River of Death in the foreground of *ACP* is depicted as running ambiguously to the right for a reason: the current of Generation is being arrested and it does not empty into the sea (in contrast to *L'Allegro*, no. 4, "The Sunshine Holiday"). [11] It is highly probable that in the *ACP* the attempt at transcendence up the stairs at the right is being as effectively blocked, just as Dante's first initiative at transcendence in the *Comedy* is blocked by three beasts. Even the bower cavern at the top is too limited for those who make it; not, presumably, because it is necessary to toil there but because there is no male company to produce the delight which penetrates from comfort to Eternity. This conception of the problem depicted, which is keynoted in the arrested progress of the Sun God, must correspond to the moment of crisis in the Vortex of the Whirlwind when disaster overtakes at least two figures. And the figure who restores the proper direction for

the Whirlwind is none other than a prefiguration of Beatrice herself,[12] as well as an avatar of the Sea Goddess in *ACP*.

Clearly her equine strategy in *ACP* was not perfectly effective, since it resulted in the split between woman and man and is connected with the Sun God as derelict deity. What the Conjurer in Red is undoubtedly striving to do is to strengthen her vortex and take control of it so that it can open up the mouth of the River Storge and connect Heaven and Earth again. The extraordinary figure of the Conjurer, whose gesture has only recently been recognized, has been present in Blake's symbolism since the title page of *Visions of the Daughters of Albion*; his task as the Man in Red in *ACP* is to undo the damage done by his prototype in the earlier work. The Conjurer and his cohort, the Unveiled Lady, will not have an easy time redirecting the traffic, not least because their allies suspect that such arts of Prospero are either pernicious or useless. It depends on what one thinks of as being potentially efficacious. Some will say that the Horned Shell-Helmeted Man has chosen the better way, playing with fire, deriving his sustenance from radical roots, and pointing to the mistakes of others. But in the Dante picture he is forlorn when oppression ceases to dominate him and the Whirlwind acts so as to connect what were formerly seen as Waters of Death. His deliverance is itself a trial because it depends on the proper articulation of water and air with fire. The Conjurer in Red has the best chance to effect it,[13] but he must remember that Dante failed because he depended upon too Classical a Conception of the Emanation.

NOTES

1. John E. Grant, "You Can't Write About Blake's Pictures Like That," *Blake Studies*, 1 (Spring 1969), esp. 195.

2. Northrop Frye, "The Archetypes of Literature," *Fables of Identity: Studies in Poetic Mythology* (New York: Harcourt, Brace & World, 1963), p. 13.

3. I have detailed these charges, with particular reference to discussions of the *Arlington Court Picture,* in a two-part article: "Discussing the *Arlington Court Picture:* Part I: A Report on the Warner-Simmons Theory," and "Part II: Studying Blake's Iconography for Guidance in Interpreting the *Arlington Court Picture,*" *Blake Newsletter,* 4 (May, August 1970).

4. See Illustration 15. Both the watercolor and the engraving are reproduced in Albert S. Roe, *Blake's Illustrations to the Divine Comedy* (Princeton: Princeton U. Press, 1953), pls. 10 and 10E. Roe's interpretation, pp. 63-65, though not adequate, remains the standard one. The watercolor is well reproduced in color in Darrel Figgis, *The Paintings of William Blake* (London: Ernest Benn, 1925), pl. 92.

5. The phrase is taken from Blake's description of the sixth design for Milton's *L'Allegro,* as transcribed in David V. Erdman, ed., *The Poetry and Prose of William Blake,* with a commentary by Harold Bloom (New York: Doubleday & Co., 1965), p. 665. The phrase, however, requires interpretation when applied to *L'Allegro,* as I indicate in a note on the picture in *Blake's Visionary Forms Dramatic,* ed. David V. Erdman and John E. Grant (Princeton: Princeton U. Press, 1971), pp. xi-xiv.

6. Geoffrey Keynes, ed., *Engravings by William Blake: The Separate Plates* (Dublin: Emery Walker, 1956), pls. 35 and 36.

7. Reproduced in color in Figgis, *Paintings of Blake,* pl. 9.

8. See also *Jerusalem*, pl. 2, and Joseph Wicksteed, [*A commentary on*] *William Blake's Jerusalem* (London: Trianon Press, 1953), pp. 111-12. It is also noteworthy that there is a crescent-shaped area delineated beside the *right* ear of the Sea Goddess' counterpart in the watercolor version of *The Whirlwind of Lovers.* Whether this is an inadvertency in the drawing of the hair cannot be determined without study of the actual picture, which I have seen but before this question had occurred to me.

9. See Jean H. Hagstrum, *William Blake: Poet and Painter* (Chicago: Chicago U. Press, 1964), pls. 19A & B and 20; Laurence Binyon, *The Followers of William Blake* (London: H. & G. Smith, 1925, New York: Benjamin Blom, Inc., 1968), pl. 14.

10. Illustration 141. Reproduced in color in Adrian Van Sinderen, *Blake: The Mystic Genius* (Syracuse, N.Y.: Syracuse U. Press, 1949), p. 99. I have a discussion of this entire series forthcoming in the *Blake Newsletter* (Ed.: reprinted in this collection).

11. Illustration 136; Van Sinderen, p. 71.

12. Cf. her later image in Paradise, design no. 95, where she is also crowned and in a horizontal position with outspread arms, though seen from the rear.

13. Any doubt that the Conjurer in Red is a redemptive contrary to the malign conjurer in the title page of *Visions of the Daughters of Albion*, should be dispelled when one recognizes the essential identity in gesture of this man in *ACP* and the figure of the youthful John the Baptist in the frontispiece to *All Religions Are One*, pl. 2.

BLAKE AND THE TRADITIONS
OF REPRODUCTIVE ENGRAVING

by
Robert N. Essick

$(B$lake's productions as a commercial engraver are often seen by his interpreters as little more than a footnote to an understanding of his life and art.[1] It could hardly have seemed so to Blake himself. Seven years of apprenticeship (1772-1779) in the engraver's shop of James Basire and the subsequent production of over 380 commercial prints stand witness to the fact that a good deal of Blake's life was spent in the practice of his trade as an etcher-engraver. The intaglio engravings will never attract the wealth of attention and admiration given to Blake's poetry, nor should they; but a just appreciation of Blake's visionary works requires some understanding of his commercial endeavors. The sources and life-long development of Blake's engraving style are in themselves worthy of close scrutiny,

Ed.: Reprinted by permission of the publisher from *Blake Studies*, 5 (Fall, 1972), 59-103.

150. "View of St. Peter's Church," engraved by James Basire after a design by Thyne O'Niell. Detail, lower right corner. Essick Collection.

but the complex relationships between Blake the commercial engraver and Blake the poet-painter lend additional importance to these topics.

The term "line engraving," frequently applied to Blake's intaglio work, leads to the false belief that Blake worked exclusively with an engraving tool to build up his lines. He was, however, trained by Basire in the "mixed method" which involves a good deal of etching prior to any engraving.[2] Many plates by Blake and his contemporaries actually have more etched than engraved lines. The techniques common to the mixed method of Basire and Blake can be seen through a comparison of a detail from "View of St. Peter's Church" [Illustration 150], engraved by Basire after Thyne O'Niell, and a detail from a plate engraved by Blake after Stothard to illustrate Hoole's edition of *Orlando Furioso*, 1783 [Illustration 151]. The technical similarities

151. Illustration to John Hoole's edition of Ariosto's *Orlando Furioso* (London, 1783), III, 164. Engraved by Blake after Stothard. Detail, lower third of the plate. Essick Collection.

between the two plates are striking, in spite of the fact that Blake engraved his plate at least three years after the end of his apprenticeship. The ground in both designs is delineated with the same sort of heavily etched, short wavy lines with dots and flicks in the spaces between that are a characteristic particularly noticeable in the work of Basire and his most famous pupil. Shading and textures are indicated by the thickness of lines and their proximity to each other in both plates. Only the human figures escape this simple system, for the rounded shape of Orlando's legs and arm and the legs of the man in Basire's engraving are formed by the dot and lozenge technique that had become by the late eighteenth century a standard linear pattern for reproductive engraving. But these similarities between Blake's and Basire's techniques indicate nothing unique in these engravings that can be used as the basis for attribution on stylistic grounds. Indeed, the same system of lines can be found in literally thousands of eighteenth and early nineteenth-century prints, giving ocular proof to Binyon's contention that Blake "adopted more of the conventions of his time than his admirers have been wont to admit."[3] The basic styles exhibited here had evolved during the seventeenth and eighteenth centuries into a fixed system, a visual cliché, universally applicable to the representation of all spatial forms.

In *Prints and Visual Communication*, William M. Ivins, Jr. brilliantly delineates the development of the reproductive engraving style and the ways it distorts our perceptions.[4] The system exemplified by Illustrations 150 and 151 reduces all objects to a linear "net" or "web," as Ivins calls it, beneath which the objects reproduced almost disappear. Ivins' descriptive, and implicitly evaluative, terms become literal rather than metaphoric when applied to dot and lozenge engravings of the sort reproduced here as Illustration 152.

152. Physiognomic profile, engraved by Blake, illustrating John Caspar Lavater's *Essays on Physiognomy* (London, 1789), I, 225. Essick Collection.

Except for the hair and eye, this print, executed by Blake for
Lavater's *Essays on Physiognomy* (1789), creates a profile
through an abstract network of lines, which at once both
delineates and entraps the human forms represented. The
man looks almost as though he had pulled a nylon stocking
over his head and become one with its mesh; for the actual
lineation on the plate has little direct correspondence to the
surfaces, textures, or bounding lines of the human face. In
Blake's *Orlando* engraving, only the lines picturing the helmet
follow the actual forms of the object, but even in this case
some crosshatching has been added to give the illusion of
textures and shading. The result is a "visual syntax" (Ivins'
term for any method used to communicate information
pictorially) that stands as a barrier between the viewer and
the things represented in the print. In many cases, including
most of Blake's commercial plates, the engraver's product is
twice removed from the sculpture or painting reproduced; for
the engraver does not work directly from the original but
from a preliminary drawing. The visual syntax of the original
artifact is reduced in the engraver's preliminary, "squared"
into segments for easy step-by-step reproduction, to a visual
statement that can be further abstracted to the engraver's
linear web. Whether grass, stone, or the human form, all is
dominated by the system of lines which constitutes an
eighteenth-century engraver's technique, passed on from
master to apprentice as the essence of his craft. If one were
to magnify Illustration 150, 151, and 152 several more times
than that presented here, form and bounding line would
merge and nothing but the syntax, without the visual
statement itself, would survive. The only difference between
this standardized and standardizing process of reproductive
engraving and a modern half-tone reproduction in a news-
paper is that the system of dots in the half-tone lies beneath

the threshold of vision, whereas the engraver's net is all too readily apparent to the naked eye.

The benefits derived from the eighteenth-century reproductive system are clear. The engraver could learn a repertoire of a dozen or so linear patterns, master their quick execution, and construct an economically advantageous and rational system whereby several workers, each proficient in one particular technique but all schooled in the same basic style, could work in assembly-line fashion. The solitary engraver could logically divide his time between the various operations required to build up different types of lines as a temporal extension of the spatial divisions in his squared preliminary drawings. All engravings so produced would be of uniform quality acceptable to a public which had come to believe in the validity of linear syntax as a truthful method of reproducing works of art. Ivins (pp. 167-168) points out the fallacy of this faith:

> Everything that went through the procrustean engraving shops came out of them in a form that had been schematized and made reasonable—and reasonability meant conformity to the generalized abstract conventional webbing of lines that was an incident of manufacture. As every great work of art is as by definition unconventional in its most important aspects, a representation of it in terms of a convention that leaves out those aspects is by definition a misrepresentation.

The destructive and limiting nature of this entire artistic-commerical system, extending its net from apprentice to connoisseur, was no doubt equally apparent to Blake. His revolt against this system manifests itself in three imaginative forms: separate plates and book illustrations designed and executed for aesthetic purposes beyond the commercial, relief etching, and prophetic narrative in which the abstracting processes of reproductive engraving become basic metaphors in a myth of creation, fall, and entrapment.

A complete collection of Blake's intaglio engravings would be composed of a remarkable combination of reproductive plates, many of the most pedestrian character, and powerfully imaginative designs that escape the linear net. A comparison between two of Blake's earliest recorded separate plates, "Joseph of Arimathea Among the Rocks of Albion" (first state, 1773) and "The Dance of Albion" (1780-c. 1790), demonstrates the distinction between these two groups.[5] The "Joseph" [Illustration 153] is a copy engraving

153. Blake, "Joseph of Arimathea Among the Rocks of Albion," first state. Sir Geoffrey Keynes Collection.

based on a drawing after Michelangelo, produced when Blake
was still an apprentice in Basire's shop. It exhibits all the
typical features of the linear net. The three elements of earth,
air, and water do not stand boldly juxtaposed and set off,
one from the other, by strong bounding lines, but rather tend
to dissolve before the eye into a single mesh of crosshatching.
The heavier lines forming the rocks and the short, choppy
strokes of the waves show a certain compatibility between
technique and subject, but the same Basire style is particu-
larly unsuccessful when applied to the sky and clothing
where the image supposedly being reproduced disappears
beneath the syntax. Joseph himself is slightly bent over with
arms drawn in to his chest, almost as though he were aware
of the dot and lozenge net burdening his limbs.

The energetic figure in "The Dance of Albion" [Illus-
tration 10] stands in contrast to Joseph in both bodily
posture and engraving technique. Albion's limbs express
power liberated rather than power contained, and their
delineation shows the liberation of Blake's style from the
laborious syntax of "Joseph of Arimathea." Gone is the dot
and lozenge network that burdened Joseph, and with its
disappearance has emerged a more flexible and confident line
responsive to the outlines and surfaces of the human form.
Albion stands before a stormy scene which is a magnification,
and by that means a serious parody, of the linear net. The
background is almost pure syntax without image, suggesting
clouds in the form of parallel lines and rain in the form of
grossly enlarged crosshatching. "The Dance of Albion" not
only demonstrates the distinctions between Blake's com-
mercial and visionary styles, but also is itself a statement
about these styles. The iconographic dimension given to the
print by the juxtaposition of contrary techniques is under-
scored and expanded by the inscriptions:

WB inv 1780 [within the design]
Albion rose from where he labourd at the Mill with Slaves[.] *Giving*
himself for the Nations he danc'd the dance of Eternal Death[.]
[below the design]

Albion emerges radiantly from his murky backdrop as Blake escapes the bondage of his own commercial background. Like Albion, Blake had labored at the rational, mechanical mills of reproductive engraving with other "slaves" to its aesthetic and social systems in Basire's shop.[6] Now Blake will begin a new rhythm of etching needle and graver in his search for the self-annihilation transforming mortal life into the redemptive energies of eternal art. Perhaps the date on the plate finds its significance not as the year in which the composition was invented, but as the year after Blake's release from apprenticeship, the year in which Blake "invented" his new self as an artist.[7]

"The Dance of Albion" vigorously departs from the traditions of commercial technique, but Blake's new freedom is not wholly self-generated. Just as he used, but did not literally copy, sources for Albion's posture,[8] Blake also responded to several engraving techniques readily accessible in the work of his near contemporaries, and used them to develop his new style. During the crucial last few years of apprenticeship, the etchings of James Barry (1741-1806) and John Hamilton Mortimer (1741-1779) may have been, for Blake, sources of new methods quite different from those used in Basire's shop. Barry's "King Lear" (sometimes entitled "An Eastern Patriarch") of 1776 and Mortimer's nine etchings published in 1778 [see Illustration 154] have a vitality of line offering an escape from the syntax of copy engraving that could not have failed to attract Blake.[9] Like the central figure and foreground in "The Dance of Albion," these prints look as though the designs were drawn directly on the plate, without the squared engraver's preliminary

intervening between their conception and execution. A similarly liberated technique can be found in the caricatures of James Gillray (1756-1815). David Erdman has pointed to sources for some of Blake's designs in Gillray's etchings, [10] and a stylistic influence from this seemingly unlikely corner may have joined those of Barry and Mortimer to shape Blake's development out of the linear net and into the open forms of his own visions in copper.

Blake was never totally free from the system of reproductive engraving. Even into the last years of his life he labored over commercial plates, such as the illustrations to Rees' *Cyclopaedia*, which hardly go beyond the aesthetics of hack-work. But if he could not totally escape the linear net, Blake could at least make use of it for symbolic purposes, as he does in "The Dance of Albion" and elsewhere. On plate 3 of *For Children: The Gates of Paradise*, 1793 [Illustration 155], Blake shrouds most of his design with the dense web of lines he learned from Basire. The figure in this scene is much more freely developed than his surroundings, but his right leg tends to merge into the rocks because of heavy crosshatching. The man bound down to earthly existence, cut off from visions of eternity, is appropriately placed before a setting delineated in the style which binds the reproductive engraver to his commercial pursuits, cut off from the visions of true art. Blake's book illustrations copied after the work of another artist are in a few cases given symbolic significance through the development of contrasting techniques. The second, sixth, eighth, and fourteenth plates engraved by Blake for J. G. Stedman's *Narrative, of a five years' expedition, against the Revolted Negroes of Surinam* (1796) contain figures shaped by heavy linear nets placed against landscapes etched in a notably free and open style [see Illustration 156]. These figures are the slaves about whom

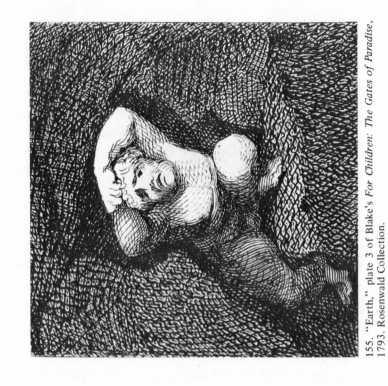

155. "Earth," plate 3 of Blake's *For Children: The Gates of Paradise,* 1793. Rosenwald Collection.

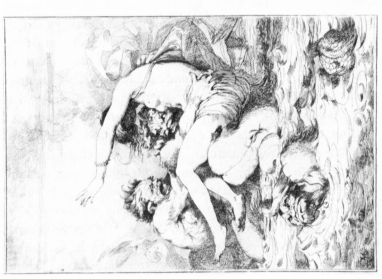

154. "Jealous Monster," designed and executed by John Hamilton Mortimer, 1778. Essick Collection.

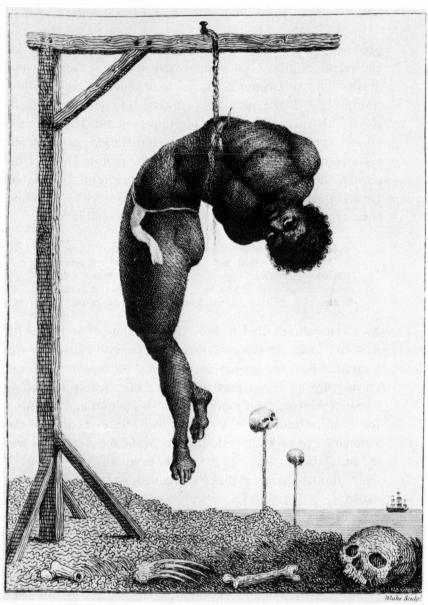

Blake Sculp!

156. "A Negro hung alive by the Ribs to a Gallows," engraved by Blake, probably after Stedman, for J. G. Stedman, *Narrative, of a five years' expedition, against the Revolted Negroes of Surinam* (London, 1796), I, 110. Essick Collection.

Stedman writes, their representations bound to the pictorial equivalent of the social system that imprisons them. In the illustration to Lavater's *Essays,* reproduced here as Illustration 152, Blake may be picturing through similar techniques his own bondage to limiting systems. The physiognomic type represented in this illustration bears some resemblance to Blake, particularly as he pictures himself on page 67 of the *Notebook (Rossetti Manuscript).* Parts of Lavater's description of this head, and another of the same basic type, are noteworthy in light of this resemblance:

> A luminous mind is here distinguishable at the first glance. That forehead contains solid and accurate ideas; that eye penetrates through the surface of objects. . . . The forehead is that of a thinker who embraces a vast field; a sweet sensibility is painted in the eye, and the man of taste is discernible in the nose and the mouth.[11]

As a man who desired to look through the eye and not with it, Blake may have found this portrait both flattering and accurate. But the linear abstractions of reproductive engraving are no less a part of Blake's life. Seeing the ironic disparity between the inner form of his genius and the outer forms of his trade, Blake wraps his own visage—except for the visionary eye and energetic hair—beneath the net which was at once both the essence and bane of his life as a conventional engraver. Blake was a man not entirely without masks.

Blake's talents are (quite literally) veiled in most of his commercial intaglio work, but through relief etching he found deliverance. The rugged lineation in the illuminated books is not an isolated phenomenon, but rather one result of Blake's reactions to reproductive engraving. The title-page to *Songs of Experience* [Illustration 157] needs no commentary to distinguish it from Blake's commercial plates. The freedom from the linear web announced in "The Dance of

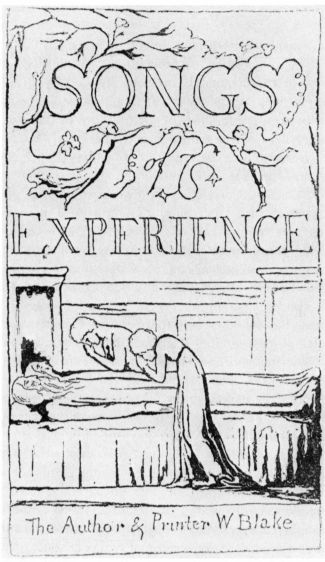

157. Blake, Title-page to *Songs of Experience*, reproduced from the
electrotype printed in Alexander Gilchrist, *Life of William Blake*
(London, 1863). This electrotype was not made from the plate used
by Blake in printing *Songs of Experience* (note that it lacks the date,
"1794," on the right hand column), but its very existence strongly
suggests that it was made in 1863 from an alternate plate etched by
Blake.

Albion" manifests itself more forcefully in the relief etchings
than in any other of Blake's productions. The illusory jumble
of lines in the commercial net are replaced by firm and
simple outlines. As in the outline engravings of Flaxman's
classical designs, [12] the lines of the print are the same as the
boundary lines between images, and thus the syntax of the
plate is very close to the original conceptions of the artist in
his outline drawing. But unlike the prints of Flaxman's
designs, Blake's relief etchings are works of original graphic
art in which the same mind that conceived the images
directed the production of the plate. The necessity of
mastering conventions capable of giving an illusion of the
painterly qualities of an oil or watercolor is completely
avoided. Tonality and shading are discarded in favor of solid
forms against large open spaces. In the title-page to *Ex-
perience*, the shadows and folds at the foot of the bed,
executed as masses rather than lines, have as firm a presence
as the human figures and letters. This essentially sculptural
conception of etching a plate in relief was very likely
influenced by Blake's early experiences in Westminster
Abbey, where he was sent by Basire to make sketches of the
sepulchral monuments. [13] Certainly the influence of tomb
sculpture can be seen in the supine figures on the title-page to
Experience. But whatever the sources for the motifs and style
of Blake's relief etchings, they are not *reproductions*; they
are the works-in-themselves, the final intentions of the artist
unencumbered by a syntax foreign to their essential qualities.
In the illuminated books, image and syntax are one.

As he freed his lines, Blake also freed his life from the
systems of reproductive engraving. By composing, etching,
and printing his own creations he avoided the division of
labor that reduced the engraver to a copying machine. By
adding color to his etchings, Blake lent a further personal

dimension to his work, giving a unique character to each printing of the exactly repeatable image on the copperplate. But the linear net is not totally absent from the illuminated books. As in "The Dance of Albion" and plate 3 of *For Children: The Gates of Paradise*, Blake found symbolic uses for the webs and nets that grew from his early lessons in copy engraving. In some of the illuminated books, Blake employed a technique he called "woodcut on copper"[14] to give the appearance of linear nets to his plates. Not only are such reproductive conventions opposed to Blake's purposes in his original graphics, but the methods employed to simulate the linear net are quite literally the negative of relief etching: woodcut on copper produces a white line against a black background, whereas Blake's usual form of relief etching produces a black line on a white background. The results are clearly evident on plate 9 of *America*, reproduced here as Illustration 158. The supine child almost disappears beneath the vegetation surrounding him, but the lines used to suggest vegetation can more immediately be recognized as constituting a linear web that develops into crosshatching on the right and up the left margin. The technique used to create the lines is at the heart of the design's iconography. Whatever the specific political or mythological interpretation of the print may be, Blake brings into his design an image of bondage, abstraction, and distortion by evoking reproductive conventions. On the left margin, the syntax almost completely dominates whatever the image may be (clouds? smoke? vegetation?), for in this case the linear net is itself the subject of the design rather than the means for delineating a subject.

The symbolic significance of the linear net must be taken into account when interpreting several other designs in the illuminated books. A system of crosshatching made by woodcut on copper completely covers the nude male

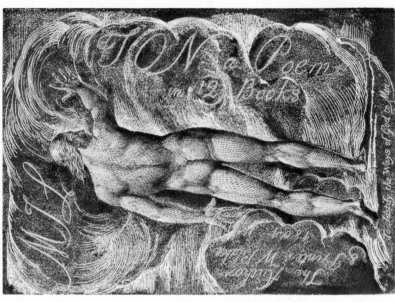

159. Blake, *Milton*, title-page, *Census* copy B. Huntington Library.

158. Blake, *America*, pl. 9, *Census* copy I. Huntington Library.

pictured on the title-page of *Milton* [Illustration 159]. If this
is a portrait of Milton, [15] then it is surely the poet bound to
conventions as potentially misleading as those dominating the
representation of his body. Similar crosshatching forms some
of the clouds surrounding the Urizenic figures on the
frontispiece to *Europe* ("The Ancient of Days"–see Illus-
tration 25) and plate 8 of *America* [Illustration 160]. [16] The
association of Urizen, creator of abstractions and obfus-
cations to which he becomes self-bound, with the linear
abstractions binding the reproductive engraver is part of the
iconography of these designs. Ivins' statement, quoted above,
implying that the schematized prints of the eighteenth
century are products of the "reasonable" processes of

160. Blake, *America*, pl. 8, detail of the figure above the text, *Census* copy I.
Huntington Library.

161. Blake, *Europe*, pl. 12, detail of the lower right corner, *Census* copy L. Huntington Library.

thought which, from Blake's point of view, dominated the age suggests further links between Urizen's world and the engraver's net. The image of webs and nets in Blake's poetry and the human form covered by a net in his designs [see Illustration 161] are monstrous forms of the engraver's limiting network of lines. Urizen's act of creation similarly limits perception:

> The Senses inward rush'd shrinking,
> Beneath the dark net of infection.
> 2. Till the shrunken eyes clouded over
> Discernd not the woven hipocrisy
> But the streaky slime in their heavens
> Brought together by narrowing perceptions
> Appeard transparent air; . . .
> (*Book of Urizen* 25:29-35)

Some of the imagery in this passage ("net," "clouded," "woven," and "streaky") implicates reproductive conventions in this narrowing of perceptions. Like the men of "shrunken eyes" described here, the eighteenth-century connoisseur looked at his landscape prints and saw "transparent air" where there was only a "woven" mesh of

crosshatching. The print makers and collectors of Blake's time had learned all too well the lessons of Enion:

> I have taught the thief a secret path into
> the house of the just
> I have taught pale artifice to spread his nets
> Upon the morning
> (*The Four Zoas* II, p. 35:7-8)

Not surprisingly, Ivins' most forceful denunciation of commercial engraving techniques (p. 70) makes for an accurate portrait of Urizen as builder of abstract systems, tyrant, and emblem of eighteenth-century man's shrunken sensibilities:

> The webs spun by these busy spiders of the exactly repeatable pictorial statement were in some respects much like what the geometers call the 'net of rationality', a geometrical construction that catches all the so-called rational points and lines in space but completely misses the infinitely more numerous and interesting irrational points and lines in space. The effect of these rationalized webs on both vision and visual statement was a tyranny, that, before it was broken up, had subjected large parts of the world to the rule of a blinding and methodically blighting visual common sense.

Urizen is the embodiment of this very system from which Blake the visionary labored to rescue Blake the commercial engraver. The paradoxical nature of this struggle—to liberate the artist from engraving *by means of* engraving—contributes to the involved conflicts of Los and Urizen in *The Book of Urizen* and of Los and his Spectre in *Jerusalem*. "And Los formed nets & gins / And threw the nets round about" (*Book of Urizen* 8:7-8) just as Blake continually returned to the linear nets of his commercial plates, although at times for reasons that ultimately served the purposes of art. In order to give "a body to Falshood that it may be cast off for ever" (*Jerusalem* 12:13) Blake-Los must even bring the imagery of reproductive conventions into the poetry and designs of the illuminated books. Los must cast "the nets round about" to

cast out the divisive and abstracting activities of the Spectre described on plate 6 of *Jerusalem*, but he can only accomplish this goal through the means available to him in the fallen world:

> To labours mighty, with vast strength, with
> his mighty chains,
> In pulsations of time, & extensions of space,
> like Urns of Beulah
> With great labour upon his anvils [;] & in his
> ladles the Ore
> He lifted, pouring it into the clay ground
> prepar'd with art;
> Striving with Systems to deliver Individuals
> from those Systems. . .
> (*Jerusalem* 11:1-5)

Blake labored to deliver the minute particulars of his visions from the generalizing systems of commercial copy engraving, but the techniques learned from Basire and their extension into relief etching were the only methods capable of giving form to those visions. Thus, like Los, he poured his art into the ground of his etchings. Blake could no more escape from his craft and its attendant limitations than he could avoid the "pulsations of time." But the artist can create eternal and infinite art by working within the dimensions of time and space. At the end of *Jerusalem*, Los redeems his emanations, and himself, not by attempting to flee them, but by uniting with them. Similarly, Blake unites his engraving skills to his visionary art in order to deliver his work and life from the shrunken state to which his profession had fallen.

The struggle against commercial engraving implicit in the pictorial syntax and poetic imagery of the illuminated books becomes explicit in the "Public Address" Blake wrote as scattered fragments in his *Notebook* about 1810. The main thrust of the "Address" is directed against the highly finished, tonal engravings of Woollett and Strange in a

defense of Basire's rougher, more old-fashioned style out of which developed Blake's own methods. Blake had, in 1808, seen his designs for Blair's *Grave* transformed into high finish plates by Schiavonetti. The controversy with Cromek, and the copy engravings that finally issued from Cromek's publishing scheme, could have provided the sufficient cause for Blake's outburst in the "Address." [17] Blake begins by stating that his training in the old style was *"sufficient to elevate"* his own work *"above the Mediocrity to which* [he had] *hitherto been the victim"* (E 560, K 591). Nothing in his career could have more thoroughly embodied Blake's victimization at the hands of mediocrity than what Cromek and Schiavonetti had done to his designs for Blair's poem. Later in the "Address," Blake writes that "Resentment for Personal Injuries has had some share in this Public Address" (E 563, K 594), very likely in direct reference to his struggles with Cromek. But Blake's relationship with Hayley may have also played a part in the composition of the "Address." While in Felpham (1800-1803) Blake had been reduced to such tasks as engraving (in what was for him a highly finished style) such mediocrities as Maria Flaxman's designs for Hayley's *Triumphs of Temper*. Cromek had reduced Blake's designs to the tonal net of Schiavonetti, but Hayley had been even more insidious, reducing Blake the poet-painter to a mere copy engraver and expecting gratitude in recompense. [18]

It seems odd to find Blake commending Basire's commercial style in the "Public Address"; but in comparison to Woollett, Strange, or Schiavonetti, Blake's inheritance from his master was relatively free of the "absurd Nonsense about dots & Lozenges & Clean Strokes" (E 571, K 602). Blake associated Woollett, Strange, and their followers with the paintings of "Titian & Correggio" (E 562, K 593) and

with the "Monotonous Sing Song" (E 570, K 600) of
Augustan verse as their equivalents in the sister arts. The
tonal style of engraving was an attempt to imitate the
painterly qualities of sixteenth, seventeenth, and eighteenth
century paintings of the very sort Blake abhorred. [19] Further,
the workshops of Woollett and Strange reduced the engraver
to "a Mill or Machine" (E 564, K 603) to "Produce System &
Monotony" (E 568, K 599). In their hands, engraving was
burdened by conventions no less mechanical than those
principles of versification that, in Blake's view, inhibited
eighteenth-century poetry. All are creators and inhabitants of
that "dark cavern" ("Public Address," E 568, K 599) of
Urizen's domain from which Blake labored to free his art.

In several ways, the "Public Address" is a ceremony of
exorcism, giving a body to false engraving in the form of
Woollett and Strange so it may be cast out. From 1809 to
1813 Blake completely avoided the linear net of copy
engraving, for during that four year period surrounding the
composition of the "Address" he produced no commercial
plates. [20] When he returned to his craft, Blake brought a new
vigor to it, finding resources both in the traditional tech-
niques he had learned as an apprentice and in the fashionable
styles of his day. Ceasing to struggle against conventions, he
began to use them for his own purposes, as if to fulfill in his
own career the prophecy of redemption and union at the end
of *Jerusalem*. This new mastery of techniques which had in
the past mastered Blake, harnessing him to copy engraving,
can be seen in a comparison of two similar heads, one from
the *Night Thoughts* engravings of 1797 [Illustration 162]
and the other from the *Job* engravings of 1825 [Illustration
163]. The god in the *Night Thoughts* is certainly forceful, his
face suggesting lines of energy rather than surfaces and
boundaries. The tension between Blake's bold lineation and

reproductive practices fills the engraving as though it were charged with electricity. The syntax used to model the god's face stands in stark contrast to the enlarged crosshatching and ruled lines of his background and to the pale outline of the man's face below. The great subtlety of the *Job* engraving demonstrates how far Blake had gone beyond these early struggles to escape the linear net, or to parody it through exaggeration. The opposing techniques of the *Night Thoughts* combine in *Job* to form a single style harmonizing all forms without loss of energy or bounding lines. Crosshatching and even stipple have their place in the *Job* plate. Lines are sinuous and flowing rather than stark; masses are given a three-dimensional presence rather than the two-dimensional outlines of the *Night Thoughts*. In spite of his earlier protestations against tonal effects, Blake uses a vast array of techniques in the *Job* to create light and shadow, textures and projections. Blake communicates his vision of *Job* through pictorial conventions that had once been the contraries to his imagination. Job's trials finally lead him to an understanding of himself and his God: Blake's trials have led him to a deeper understanding and mastery of his craft.

Much of Blake's thought is essentially dialectical—innocence and experience, heaven and hell, order and energy. I have attempted to demonstrate here that the struggle between the commercial engraver and the visionary poet-painter must be included among these Blakean contraries where opposition is true friendship. I hope that I have indicated the broad outline of this dialectical structure and a few of the more important ways it influenced Blake's graphic art and the imagery of his poetry. It begins with the traditions of reproductive engraving learned in Basire's shop. In turn, these commercial methods produced as their antithesis the intaglio style of "The Dance of Albion" and

162. Blake, illustration to Young's *Night Thoughts* (London, 1797), page 80. Detail, left margin. Essick Collection.

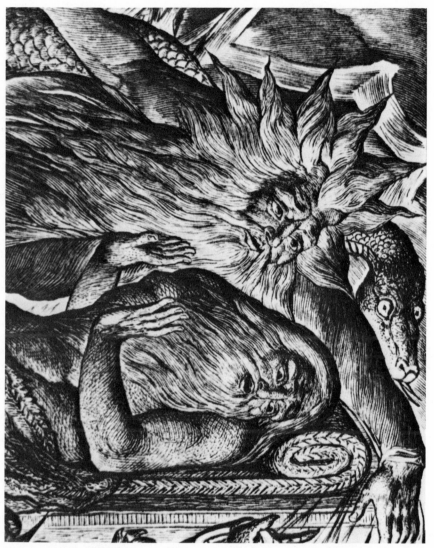

163. Blake, *Job* engraving, pl. 11. Detail, left margin of the central design. Essick Collection. For the complete engraving, see Illustration 164.

the relief etchings of the illuminated books. It ends with the synthesis of discordant styles, of tradition and imaginative vision, that shapes the *Job* engravings. In this sense Blake's career as an engraver is the biographical equivalent to his epic myth of creation, fall, struggle, and final union.

NOTES

1. The biographical facts of Blake's career as an engraver are set forth in G. E. Bentley, Jr., *Blake Records* (Oxford: Clarendon Press, 1969). A great deal of information on the early work done in Basire's shop, the *Night Thoughts* illustrations, and "Little Tom the Sailor" is to be found in Geoffrey Keynes, *Blake Studies*, 2nd ed. (Oxford: Clarendon Press, 1971). Other than the essay by Laurence Binyon reprinted in this collection, most critical commentaries on Blake's techniques as an intaglio engraver are presented as introductions to catalogues and collections of reproductions. See particularly Archibald G. B. Russell, *The Engravings of William Blake* (Boston and New York: Houghton Mifflin, 1912), pp. 17-50, Binyon, *The Engraved Designs of William Blake* (London: Ernest Benn, 1926), pp. 3-22, *William Blake's Engravings*, ed. with intro. by Geoffrey Keynes (London: Faber and Faber, 1950), pp. 7-22, Keynes, *Engravings by William Blake: The Separate Plates* (Dublin: Emery Walker, 1956), passim, and *William Blake, Engraver*, a descriptive catalogue of an exhibition by Charles Ryskamp with an introductory essay by Geoffrey Keynes (Princeton: Princeton Univ. Press, 1969), pp. 1-18. Ruthven Todd's *William Blake the Artist* (London and New York: Studio Vista and

Dutton, 1971) presents a chronological survey of Blake's career with suggestive juxtapositions of Blake's commercial and visionary works, but lacks supportive analysis.

2. On the development of the mixed method as a basic characteristic of eighteenth-century English engraving, see Arthur M. Hind, *A History of Engraving and Etching* (Boston: Houghton Mifflin, 1923), pp. 203-208 and Basil Gray, *The English Print* (London: Adam and Charles Black, 1937), pp. 25-38.

3. *The Engraved Designs of William Blake*, p. 4.

4. (1953; rept. Cambridge, Mass.: M.I.T. Press, n.d.). See particularly Chapter IV, "The Tyranny of the Rule–the Seventeenth and Eighteenth Centuries." Although Ivins mentions Blake only incidentally, his point of view and critical vocabularly have a surprisingly Blakean quality. Many of the technical phrases used in this article, such as "linear net," "visual syntax," and "system" in reference to a fixed style of engraving, are taken from Ivins' influential work.

5. All titles and dating of Blake's separate plates are taken from Keynes, *Engravings by William Blake: The Separate Plates*. For dating, see also David V. Erdman, "The Dating of William Blake's Engravings," reprinted in this collection.

6. My point here is not to suggest any personal animosity between Blake and Basire, for which there is no evidence. Both master and apprentice are equally bound to the conventions of their trade.

7. Keynes, *Engravings by William Blake: The Separate Plates*, p. 8, suggests that the inscription, as well as the

design itself, was engraved in the 1790's. In "Dating
Blake's Script," *Blake Newsletter*, 3 (1969), 11 David V.
Erdman argues for a date of about 1800 for the
inscription. The fact that Blake retained the 1780 date
to mark his first composition of the design lends
support to the idea that the year held particular
importance for Blake. The fullest analysis of the
iconography of the print and the significance of the
inscription can be found in Anthony Blunt, "Blake's
Glad Day," *Journal of the Warburg and Courtauld
Institute*, 2 (1938), 65-68. Blunt's interpretation of
motifs and of their relationship to ideas in Blake's
poetry is very different from, but compatible with, the
interpretation of styles and their relationship to Blake's
development as an engraver presented here.

8. Blunt, "Blake's Glad Day," p. 65, proposes an engraving
 in Scamozzi's *Idea dell' Architettura Universale* as a
 source. Other proportion figures of this type may also
 have influenced Blake's composition.

9. Barry and Mortimer may have also influenced Blake's
 motifs and style as a painter. See Anthony Blunt, *The
 Art of William Blake* (New York: Columbia Univ. Press,
 1959), pp. 10-12, 19-20, and pls. 8d, 9a-c, and 31a-c,
 and David V. Erdman, *Blake: Prophet Against Empire*,
 rev. ed. (Garden City, N.Y.: Doubleday and Co., 1969),
 pp. 38-42, 193-194.

10. See Erdman, "William Blake's Debt to James Gillray,"
 Art Quarterly, 12 (1949), 165-170 and *Blake: Prophet
 Against Empire*, pp. 203-205, 218-219. Nancy Bogen
 adds to Erdman's findings in "Blake's Debt to Gillray,"
 American Notes & Queries, 6 (1967), 35-38. Gray, *The
 English Print*, pp. 37-38, states that Gillray actually

drew directly on the copper without any preliminary sketching.

11. John Caspar Lavater, *Essays on Physiognomy*, trans. Henry Hunter (London: John Murray, H. Hunter, and T. Holloway, 1789), I, 224-225.

12. Flaxman's designs for *The Iliad* and *The Odyssey* were first published in 1793, and therefore cannot be grouped with the work of Barry and Mortimer as early influences on the development of Blake's etching and engraving style. They may, however, have been an influence on Blake's style of the mid-1700's, particularly on his use of outline techniques in the *Night Thoughts* engravings, published in 1797. Blake engraved three plates for an edition of *The Iliad*, designed by Flaxman and published in 1805, and all 37 plates for the first edition of the *Hesiod* designs, 1817. This last set was engraved in stipple, imitating the texture of a pencil line. See Bentley, *The Early Engravings of Flaxman's Classical Designs: A Bibliographical Study* (New York: New York Public Library, 1964).

13. On Blake's work in Westminster Abbey, see Benjamin Heath Malkin, *A Father's Memoirs of His Child* (London: Longman, Hurst, Rees, and Orme, 1806), pp. xx-xxi, Bentley, *Blake Records*, pp. 13-14, and Keynes, *Blake Studies*, pp. 14-25. Malkin, p. xx, writes that in Gothic sculpture Blake "saw the simple and plain road to the style of art at which he aimed, unentangled in the intricate windings of modern practice." Although Malkin is not specifically writing about the linear net of eighteenth-century engraving practice, his words "unentangled" and "intricate windings" suggest the very

subject of this article. In *Prints and Visual Communication*, p. 167, Ivins comments that "for practical purposes it is impossible to find a reproductive print by one of the masters of engraving that represents an early painting or a piece of mediaeval sculpture" because "they did not yield themselves to the kind of rendering which was implicitly required by the dominant and highly schematized linear practice of engraving." If Ivins is right, then Blake's experiences in Westminster Abbey would lead him to invent a new style of etching or engraving in order to bring the sculptural forms of medieval monuments into his own work.

14. The process is described by Blake in his *Notebook (Rossetti Manuscript)*, p. 10 (E 672, K 440).

15. This identification is made in Geoffrey Keynes and Edwin Wolf, *William Blake's Illuminated Books: A Census* (New York: Grolier Club, 1953), p. 98. The crosshatching is partly painted out in *Census* copy D (reproduced in the Blake Trust facsimile), but can be clearly seen covering the entire nude in copies B (reproduced here as Illustration 159) and A (reproduced in the Micro Methods, Ltd. filmstrip).

16. As with the title-page to *Milton*, the lines are painted over in some copies of these plates but are clearly visible in lightly painted or uncolored copies, such as the Huntington Library copy of *America* (*Census* copy I, reproduced here as Illustration 160) and the frontispiece to *Europe* printed in blue in the collection of Sir Geoffrey Keynes.

17. The facts of the Blake-Cromek controversy are most readily available in Bentley, *Blake Records*, pp. 166-174.

18. It is noteworthy in this regard that when Blake broke with Cromek in December, 1805, or January, 1806, he also ended his friendship with Hayley. See Bentley, *Blake Records*, p. 174.

19. Blake's pro-linear, anti-painterly attitudes are set forth most clearly in the "Public Address" (E 560-71, K 591-603), *A Descriptive Catalogue of Pictures* (E 520-41, K 563-86), and the annotations to *The Works of Sir Joshua Reynolds* (E 625-51, K 445-79). The following principles of painting given in *A Descriptive Catalogue of Pictures* are the same as those embodied in Blake's engraving style:

 Clearness and precision have been the chief objects in painting these Pictures. Clear colours unmudded by oil, and firm and determinate lineaments unbroken by shadows, which ought to display and not to hide form, as is the practice of the latter Schools of Italy and Flanders. (E 521, K 564)

20. See the chronological list of engravings in Bentley, *Blake Records*, p. 617.

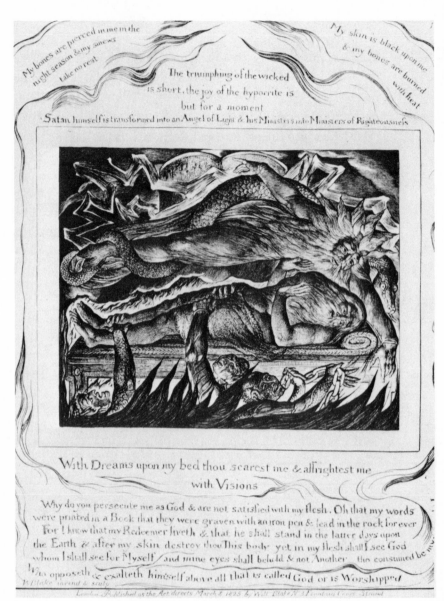

164. Blake, *Job*, pl. 11. Essick Collection.

WORDS GRAVEN WITH AN IRON PEN:
THE MARGINAL TEXTS IN BLAKE'S *JOB*

by
Jenijoy La Belle

*T*he marginal inscriptions in William Blake's *Illustrations of the Book of Job* are both a revision and a re-vision of the Bible story. Although every text accompanying the illustrations is made up of passages from the King James Bible, Blake's selections, modifications, and even positionings of these quotations contribute to his imaginative interpretation of Job. While most of the passages come from the Eighteenth Book of the Old Testament, over a third are from other books of the Bible, from Genesis to Revelation, suggesting that Northrop Frye's idea of Blake's *Job* as "a miniature Bible" is more than metaphoric.[1] In many instances the material from the Bible is recast and reformed: the words of the verses are rearranged; certain words are deleted; new words are added. S. Foster Damon

Ed.: This essay appears here for the first time.

wrote in 1924 in *William Blake: His Philosophy and Symbols* that Blake seemed to have quoted the passages from memory, "as they show unimportant textual variations."[2] By 1966 in his *Blake's Job*, he steps with a lighter tread: "Some of Blake's variations seem to be slips of an imperfect memory, but others are intentional."[3] A more generative critical attitude towards Blake is one which assumes that all the alterations are deliberate and that the minute particulars of the marginal text are as worthy of close inspection as the details of the designs they accompany.

It is difficult for us to imagine how familiar Blake must have been with the Bible. A phrase from it would undoubtedly bring to his mind the entire passage from which it came. And when Blake quotes a line from the Bible, he expects that it will summon to our minds also the completing context. Hence, when we read the text accompanying the illustrations to the Book of Job, we must recollect the background of the quotations. Further, Blake chooses from the Bible those passages most compatible with his own interpretation of the story of Job—which rendition has much in common with Blake's other writings. Just as his pictorial art combines traditional motifs and his private vision, so too the text should be read not simply as direct quotation from the Bible but as a language resonating between its wellsprings in the Bible and Blake's own poetry. Thus the allusiveness of this text operates in two directions—to the biblical passage from which a quotation comes and, at times, to the complete canon of Blake's works.

To classify and arrange in groups the kinds of changes Blake made in the inscriptions would be a difficult task: every change seems to have its own method. It may be best to begin with a catalogue of some of the variations and their particular significances.[4]

PLATE I

The importance of reading the inscriptions within their contexts can be seen by looking at the words at the top of the margin in Plate I:

Our Father which art in Heaven / hallowed be thy Name[5]

Blake begins his story of the Old Testament hero with the first line from the prayer Jesus taught to his disciples. The Lord's Prayer occurs twice in the New Testament, in St. Matthew 6 and St. Luke 11. Verse 7 in chapter 6 of Matthew exhorts, "When ye pray, use not vain repetitions." But beneath Blake's first design we read, *"Thus did Job continually"* (Job 1:5). Verse 19 of the same chapter in Matthew states, "Lay not up for yourselves treasures upon earth"; yet we see Job surrounded, almost circumscribed, by earthly possessions. In verses 39 and 40 of Luke 11, the Lord reproves the Pharisees' outward show of holiness:

> Ye . . . make clean the *outside* of the cup and the platter; but your *inward* part is full of ravening and wickedness.
>
> Ye fools, did not he that made that which is *without* make that which is *within* also? [emphasis added]

Like the Pharisees, Blake's Job observes only the outward forms of piety and has no inward realization of spiritual life. At the beginning of the Bible story Job is an "upright" man; Blake's version begins with a fallen Job who follows the Law of Moses literally rather than spiritually. He is "upright" in neither his physical nor his moral position—and will not be so pictured until the eighteenth design.

The text further reveals that God and Job are not yet one. The opening words of the Lord's Prayer engraved in the clouds at the top of the margin

Our Father which art in Heaven

contrast in meaning and in positioning on the plate with the
opening words of the Book of Job almost on the ground in
the lower border

There was a Man in the / Land of Uz
(Job 1:1).

There is in Blake's view of the Lord's Prayer a false division
between God and man, Heaven and earth. In Lavater's
Aphorisms on Man, Blake underlined "He, who adores an
impersonal God, has none" and wrote, "Most superlatively
beautiful & most affectionately Holy & pure; would to God
that all men would consider it" (K 82, E 586).[6] Clearly Blake
would feel that Job has yet to consider it.

PLATE II

The words written at the top of Plate II, *"I beheld the /
Ancient of Days,"* are from a passage in the Book of Daniel
(7:9) describing a vision of God's Kingdom where God is seen
as the lawgiver. Verse 22 begins, "The Ancient of days came,
and judgment was given," and verse 10 ends, "The judgment
was set, and the books were opened." In Blake's design God
is also the judge, holding on his lap the open book of law
containing the letter that killeth. Below this excerpt from
Daniel referring to God appear the words *"The Angel of the
Divine Presence."* According to Joseph Wicksteed in *Blake's
Vision of the Book of Job,*

> God . . . is—as the marginal texts describe—both "Angel of the
> Divine Presence" and "Ancient of Days." For the everpresent
> consciousness of man is the same Divine force which, in other
> forms, has been working from the dawn of things in the worm and
> even the clod.[7]

Both Wicksteed and Andrew Wright cite Isaiah 63:9 ("the
angel of his presence saved them") as the reference for
Blake's text. Damon, on the other hand, states that the

phrase "Angel of the Divine Presence" "does not appear in the Bible."[8] It does, however, appear twice in Blake's own writing–in *A Vision of The Last Judgment* and in the *Laocoön* inscriptions. And the significance of this angel is revealed in Blake's description of the "Angel of the Presence Divine" (in his poem *The Everlasting Gospel*) who wrote "Laws," created "Hell," and "didst all to Chaos roll" (K 754, E 513). In other words, the Angel is Satan. That the design and text are similarly arranged supports this interpretation: Satan appears just below God in the illustration and the words *"The Angel of the Divine Presence"* appear below *"Ancient of Days"* in the text. In this marginal inscription Blake has mingled a quotation from the Bible with his own biblical interpolations first presented in works earlier than his *Job* engravings.

"Hast thou considered my Servant Job" (Job 1:8) is written between the names for God and Satan, showing that the question may be asked of either power: Job is the servant of the Accusing Satan and well as of the Judging God. Both are in his mind. Within its biblical context, *"Thou art our Father"* (Isaiah 64:8) means that God has made man. In the context of Blake's design it can also mean that Job has created God and Satan.

The source of *"We shall awake up / in thy Likeness"* is Psalm 17:15: "I shall be satisfied, when I awake, with thy likeness." Blake, however, is not content to have Job awake "with" the Lord's likeness–that is, to wake up beholding the Lord's face. Job will awake "in" His likeness–he and God will be one. In this illustration Job and God have the same semblance, of course, but Job conceives of God in his own physical image because his perception of spiritual existence is merely a projection of his physical experience. *"We shall awake up"* implies that Job is still asleep, an idea supported

by the slumbering sheep of the first illustration and the inactive Job and his wife, the sleeping dog, and the reclining sons and daughters of the second illustration. Job is not yet conscious of the spirit that giveth life, and, as the use of the future tense in *"I shall see God"* (Job 19:26) indicates, Job has still not seen God, but only his mistaken conception of Him.

PLATE III

Blake often freely applies to an event passages referring to other but similar events. In the Bible, *"The Fire of God is / fallen from Heaven"* (Job 1:16) refers to the burning up of the sheep and the servants. In Plate III Blake applies it to the destruction of Job's sons and daughters.

With the lines, *"And the Lord said unto Satan Behold All that he hath is in thy Power"* (Job 1:12), we realize that all of Job's material possessions are and always have been under Satan's control. The phrase *"All that he hath"* also reminds one of "all that a man hath" in the following passage from *The Four Zoas* which is in itself a capsule version of the Job story:

> What is the price of Experience? do men buy it for a song?
> Or wisdom for a dance in the street? No, it is bought with the price
> Of all that a man hath, his house, his wife, his children.
> <div align="right">(K 290, E 318)</div>

But this is quite likely a twofold echo since the lines of *The Four Zoas* were themselves inspired by the passage about "the price of wisdom" in Job 28:18. As with *"The Fire of God,"* we have a statement with multiple contexts.

PLATE IV

In the text at the top of the fourth design, Blake has changed "The Sabeans fell upon them" to *"the Sabeans came down"* and "they have slain the servants with . . . the sword"

to *"they have slain the Young Men with the Sword"* (Job 1:15). Since Satan is described as *"walking up and down"* in the Earth and is pictured with a sword in his hand, Blake shows us that it is actually Satan or, more exactly, the Satan in Job's mind, who brings the destruction. Blake, at least in this case, is reading the Book of Job allegorically and seeing that the Sabeans are a representation of Satanic forces. Since Blake leaves out any consideration of the servants in the designs and concentrates on Job's children, in the texts both above and below the illustration "servants" is replaced with *"the Young Men."*

PLATE V

The marginal text above the fifth design clearly points out that it is in Job's "right" actions that he is most wrong:

> *Did I not weep for him who was in trouble?*
> *Was not my Soul afflicted for the Poor*
> (Job 30:25)

Blake wrote in *A Vision of The Last Judgment,*

> he who performs Works of Mercy in Any shape
> whatever is punish'd &, if possible, destroy'd,
> not thro' envy or Hatred or Malice, but thro' Self
> Righteousness that thinks it does God service,
> which God is Satan.
> (K 616, E 554)

It is only in the relationship of the inscription to Blake's own writing that the inscription's true significance becomes clear. Job's self-righteous piety places him under the dominion of Satan.

On Plate V Blake quotes a line from the sixth chapter of Genesis explaining the evil thoughts of man that provoke God to wrath. The context of this line *("And it grieved him at his heart")* thus suggests not that God is afflicting Job without cause, but that there is some flaw in Job to which

God is responding. This line also resembles a passage from the
first book of Samuel in which the Lord prophesies of Eli's
house:

> And the man of thine . . . shall be . . .
> to grieve thine heart: and all the
> increase of thine house shall die
> in the flower of their age.
>
> (I Samuel 2:33)

In Plate III we saw the increase of Job's house die "in the
flower of their age." In the text to Plate X we read, *"he*
[man] *cometh up like a flower & is cut down"* (Job 14:2).
Both Job and God are grieved at their hearts.

PLATE VI

Beneath the sixth design is written

> *And smote Job with sore Boils*
> *from the sole of his foot to the crown of his head*
> (Job 2:7)

In *Jerusalem* and *The Four Zoas* we find references to boils
from "head" to "foot":

> And the dark Body of Albion left prostrate upon the crystal
> pavement,
> Cover'd with boils from head to foot, the terrible smitings of Luvah.
>
> (K 294, E 321)

> The disease of Shame covers me from head to feet. I have no hope.
> Every boil upon my body is a separate & deadly Sin . . .
> All is Eternal Death unless you can weave a chaste
> Body over an unchaste Mind!
>
> (K 643, E 164)

These quotations show the compatibility of the Job story
with Blake's own imaginative vision as recorded in the
prophetic books. Also these lines indicate that this part of
the biblical text had considerable influence on Blake's art
before he turned to dealing with the story of Job in a
sequence of designs and that before he had done his final

illustrating of the Book of Job he had already absorbed the biblical text as part of his own mode of expression.

The grasshopper and broken pitcher in the marginal design are a visual representation of Ecclesiastes 12:5-6. Blake's association of this passage with Job was very likely brought about by his quotation of Job 1:21 at the top of his design: *"Naked came I out of my / mothers womb & Naked shall I return thither."* As the marginal notes in many early Bibles point out, this same statement appears in Ecclesiastes: "As he came forth of his mother's womb, naked shall he return to go as he came" (5:15). Hence the association in Blake's mind between this particular episode of the Job story represented on Plate VI and Ecclesiastes.

PLATE VII

The text above Plate VII reveals that Job is still accepting what to Blake is the erroneous standard of Good and Evil:

> *What! shall we recieve Good*
> *at the hand of God & shall we not also*
> *recieve Evil*
> (Job 2:10)

In the Bible the *"they"* of *"they lifted up their eyes afar off and knew him not"* (Job 2:12) refers to Job's three friends, Eliphaz, Bildad, and Zophar. In Blake's design, *"they"* may also refer to Job and his wife who have lifted up their eyes to God and have known Him not. On Plate IV Job raises his eyes and sees Satan. Often it is the visual context that expands the meaning of the inscription beyond the biblical meaning with which Blake begins. Although the words themselves are exactly as they appear in the Bible, the design, in effect, changes the meaning of these words. The "emendation" is not verbal, but silent and pictorial.

A line from the epistle of James is written across the bottom of the margin: *"Ye have heard of the Patience of Job and have seen the end of the Lord"* (James 5:11). Job's comforters are reprimanded by the biblical context of this quotation, for chapter 3 of this brief book warns that we are not rashly or arrogantly to reprove others but rather to bridle the tongue; yet, a third of the Book of Job is made up of the friends' rebukes and arguments.

PLATE VIII

Wicksteed correctly writes of the design in Plate VIII that it represents "the utter absence of all spiritual life. Even Satan is nowhere suggested."[9] Similarly, in the inscriptions, words referring to spiritual existence are wanting. This is, in fact, the only text in the series not containing the words "God," "Lord," or "Father," showing that Blake is very carefully coordinating text and design.

PLATE IX

In Plate IX Eliphaz tells of his vision. He makes God in his image just as Job has been making Him in his image. Job is thereby made aware of his own sin against God. In the Bible it is Eliphaz who says, *"Then a Spirit passed before my face"* (Job 4:15): here a spirit also passes before Job's face — the spirit that giveth life. Job's realization of his blasphemy against God marks the beginning of his spiritual rescue. Eliphaz reproves Job twice — the first time in chapters 4 and 5, the second time in chapter 15. Chapter 4, verse 18 reads "Behold, he put no trust in his servants; and his angels he charged with folly." Chapter 15, verse 5 reads "Behold, he putteth no trust in his saints." In the top margin of this plate, Blake writes *"Behold he putteth no trust in his Saints & his Angels he chargeth with folly,"* thus combining two quotations in one inscription to refer the reader to both contexts.

PLATE X

In Plate X Job is alone in his suffering: his friends look away from him, his wife looks beyond him. Job also looks above and beyond his friends and wife in his appeal to God. But Job's concern is with himself. His solitariness as well as his self-righteousness are emphasized in the text with its abundant use of the first person singular pronoun, *I*:

> *But he knoweth the way I take*
> *when he hath tried me I shall come forth like gold*
>
> *Have pity upon me! Have pity upon me! O ye my friends*
> *for the hand of God hath touched me*
>
> *Though he slays me yet will I trust in him*
> (Job 23:10. 19:21, 13:15)

PLATE XI

For Job there is no avoiding the terrible vision of Plate XI: the God he calls upon is selfhood, and thus is Satan. In the text to the design we see again in the use of *I* "the Great Selfhood, / Satan, Worship'd as God" (*Jerusalem*, K 659, E 173): *"why do you persecute me," "my flesh," "my words," "I know," "my Redeemer," "my skin," "my flesh," "I see," "I shall see," "for Myself," "mine eyes,"* and *"my wrought Image"* (from Job 19:22-27). Blake has altered "worms destroy this body" to *"destroy thou This body."* Job's destruction does not come from the exterior world of nature, but from within — from the "thou" of his own mind. Wicksteed writes of this text that it is nearly the same as the biblical passage

> until we come to the last sentence, where Blake alters "though my reins be consumed within me" of the Bible to (presumably his own) "tho consumed be my wrought Image." This suggests that Job is now learning the insignificance of his personal life as being merely the "wrought image" of his own eternal being.[10]

Job, however, has yet to realize the insignificance of self. He has wrought God in his own image, and it is this image that

must be destroyed before he can see the true God. Job is still
accurately characterized by the passage from II Thessalonians
2:4 written at the very bottom of the design: *"Who opposeth
& exalteth himself above all that is called God or is
Worshipped."* This passage also describes the God Job has
been worshipping—which God is called by St. Paul in II
Corinthians 4:4 "the god of this world" or Satan. Blake
wrote in his annotations to Watson's *Apology for The Bible*,

> there is a God of this World, A God
> Worship'd in this World as God & set
> above all that is call'd God.
> (K 394, E 608)

In the Bible *"the triumphing of the wicked / is short,
the joy of the hypocrite is / but for a moment"* (Job 20:5)
are words spoken by Zophar about Job. But in Blake's
interpretation they apply to the God Job has created and not
to himself. Job's error has not been wickedness but self-
righteousness. He has not put on a pretense of virtue: his
fault has been in the mistaken conception of a morality that
conforms to the letter of the Law. It is rather Job's
conception of the deity, who seems to be God when he is
actually Satan, that is hypocritical. This god is now triumph-
ing, but his triumph will end when Job recognizes his error.
The very words *"my wrought Image"* are already starting to
go up in flames in the lower right hand corner of the border
[see Illustration 164].

PLATE XII

The text of Plate XII is made up entirely of Elihu's
speeches. He is right in condemning the prideful Job but
makes the mistake of creating an abstract god who is above
man's powers to comprehend. Both Elihu and Job have a
false image of God: Job made a god in his own mind in his

own image; Elihu makes a god who has no personal relationship with man, an indifferent god upon whom man's actions have no effect: *"If thou sinnest what / doest thou against him, or if thou be / righteous what givest thou unto him"* (Job 35:6-7). The marginal designs connecting the sleeping Job with the heavens through rising bands of human and angelic figures point out the fallacy of Elihu's words. In the previous plate, the designs and the inscriptions reinforce each other, whereas in this plate they stand as contraries.

PLATE XIII

Plate XIII shows the Lord answering Job out of the whirlwind. The question *"Who is this that darkeneth counsel by words without knowledge"* (Job 38:2) applies to Elihu as well as to Job. In the last design it was Elihu who was counseling Job and explaining the ways of God. Now we see how mistaken Elihu was. He told Job to

> *Look upon the heavens & behold the clouds*
> *which are higher*
> *than thou*
> (Job 35:5).

But God is beneath the clouds, close to earth and to Job [see Illustration 14]. The text from Psalm 104:3 (*"Who maketh the Clouds his Chariot & walketh on the Wings of the Wind"*) describes God in this design and distinguishes him from the God of Law in Plate V *"Who maketh his Angels Spirits & his Ministers a Flaming Fire."* When choosing the inscriptions for this plate, Blake very likely was influenced by the traditional association of chapter 38 of Job with Psalm 104, as recorded in the marginal notes to many seventeenth and eighteenth century Bibles. In certain ways the marginal inscriptions on Blake's plates serve the same function as the marginal notes in these Bibles: both refer the reader to similar events or

images to establish new perspectives from which one can view the biblical text – or in Blake's case, the central design.

Up until this plate God has not been referred to in the text as "Father" except in the first two illustrations when He was the Father in Heaven. Now He has come to earth, and the word "Father" establishes a relationship between God and Job that has not existed before. Job no longer makes God in his image, but He comes in the image of Job. As Blake wrote in *There is no Natural Religion*, "God becomes as we are, that we may be as he is" (K 98, E 2).

PLATE XIV

In Plate XIV Job realizes it is God who is the creator both of man and of the universe – not only of the minute spheres, *"the Drops of the Dew"* (Plate XIII), but of the greatest spheres, sun, moon, and earth. And he further realizes that it is God who makes the commands,

> *Let there Be*
> *Light*
> (Genesis 1:3).

and not Job,

> *Let the Day perish wherein I was Born*
> (Job 3:3, quoted on Plate VIII).

It is also in the text of this design that we begin to have images of unity and harmony rather than images of division. In earlier texts there have been contrasts between Letter and Spirit, killeth and giveth life, to and fro, up and down, foot and head, come and return, give and take, Good and Evil, Young and Old. In the inscriptions to Plate X Blake even changed "cometh forth" to *"cometh up"* which then stands in direct opposition to *"cut down."* In this text, however, we have images of fusion:

Canst thou bind the sweet influences of Pleiades
(Job 38:31)
Let the Waters be gathered
together into one place
(Genesis 1:9)
When the morning Stars sang together
(Job 38:7)

And it is God who is at the center of the design binding all together. For the first time, Job sees a unity beyond the division.

PLATE XV

The texts at the top and on the left side of Plate XV are both from Elihu's rebuke. The one from verse 29 of chapter 36 (*"Can any understand the spreadings of the Clouds / the noise of his Tabernacle"*) is spoken by Elihu to show that man cannot know God. In the text from verse 12, chapter 37 (*"Also by watering he wearieth the thick cloud / He scattereth the bright cloud also it is turned about by his counsels"*), Elihu is stating that God is to be feared. But in this design we see that Elihu's idea of God was incorrect since He is explaining his works to Job and looks kind rather than terrifying. Instead of defying Job to understand, Blake's God teaches him to understand.

PLATE XVI

The text of the sixteenth illustration contains the widest variety of books from the Bible of any of the plates: Job, Revelation, John, Luke, and I Corinthians. As his interpretation of Job moves farther and farther away from the Bible story, Blake must reach out to other books of the Bible to find appropriate passages to substantiate his designs. With the quotation from Revelation,

The Accuser of our Brethren is Cast down
which accused them before our God day & night
(Revelation 12:10),

we realize that this design is not simply an illustration of the fall of Satan, but a vision of the Last Judgment of Job and his wife.

> *Canst thou by searching find out God*
> *Canst thou find out the Almighty to perfection*
> (Job 11:7)

and

> *It is higher than Heaven what canst thou do*
> *It is deeper than Hell what canst thou know*
> (Job 11:8)

are questions asked by Zophar in his reproof of Job. The answer Zophar expected to the first questions was "no." The reply Job is able to give now is "yes." And the second group of questions have become statements. With proper vision Job can find out God, and he knows a higher vision of Heaven than his old conception allowed. With the realization of God's powers has come Job's knowledge of his own powers.

Another instance of Job's increasing awareness of this strength is the quotation from Luke 10:17:

> *Even the Devils are Subject to Us thro thy Name.*
> *Jesus said unto them*

Through his spiritual vision Job can control the devils inside him. The casting out of *"The Prince of this World"* (John 12:31) is also a rejection of Job's vision of this world, the fall of Satan also the fall of Job's old material self. "To be an Error & to be Cast out is a part of God's design," writes Blake in *A Vision of The Last Judgment* (K 613, E 551). Job has satisfied the conditions of that design: *"Thou hast fulfilled the Judgment of the Wicked"* (Job 36:17).

PLATE XVII

In the text to Plates XV and XVI, we have seen the words of Zophar, Elihu, and Bildad disproved. In the text

above the seventeenth illustration, we find statements similar
to those Job has made earlier:

> *He bringeth down to / the Grave & bringeth up*
> (I Samuel 2:6)

Job said in chapter 1:21 (Plate VI),

> *The Lord gave & the Lord hath taken away.*

The text from I John 3:2 states

> *we know that when he shall appear we shall be like him*
> *for we shall see him as He Is.*

In chapter 19, verse 26 (Plate XI), Job said

> *yet in my flesh shall I see God.*

Psalm 8:3-4 asks

> *What is Man that thou art mindful of him?*
> *& the Son of Man that thou visitest him.*

Job asked in chapter 7:17-18:

> *What is man . . . that thou shouldest visit him*
> *every morning, and try him every moment?*[11]

The seeds of redemption were present even in Job's false
conception of God and his limited apprehension of spiritual
existence. And with the realization of God the creator and
God the redeemer, these seeds have grown into a true vision
of spiritual life.

In the text from Job 42:5 immediately below the
design, Blake has changed "I have heard of thee by the
hearing of the ear" to *"I have heard thee with the hearing of
the Ear."* By leaving out the first "of," he makes the
communication between God and Job a direct one and at the
same time sets up a difference between hearing and seeing—
"but now my Eye seeth thee." For Blake, the painter-
engraver, hearing is a lesser mode of perception than seeing.

The line is thus another example of Job's awakening vision.

All of the rest of the lengthy text accompanying this design is from chapter 14 of St. John. In both the text and the design, heaven and earth are not distinguished; the two worlds have become one as Jesus brings God to man and man to God. *"I & my Father are One."* (John 10:30), Jesus reveals. It is also Job who can now say the same. Henry Crabb Robinson wrote in his diary (10th Dec. 1825) that Blake said of Jesus, "He is the only God and so am I and So are you."[12]

Up until Plate XVII whenever an inscription has passages from more than one book of the Bible other than Job, the quotations are always from the same testament:

Plate I—Matthew, Luke, I Corinthians, II Corinthians (New Testament)

Plate II—Psalms, Isaiah, Daniel (Old Testament)

Plate V—Genesis, Psalms (Old Testament)

Plate XI—II Corinthians, II Thessalonians (New Testament)

Plate XVI—Luke, John, I Corinthians, Revelation (New Testament)

In this plate there are quotations from both the Old (I Samuel, Psalms) and the New (I John, St. John) Testaments. The old dispensation and the new dispensation are textually intermingled, showing that the God of creation and the God of redemption are ultimately the same.

"The Spirit of Truth" (St. John 14:17) rather than the letter that killeth is to abide with Job, but not with his friends: they do not see God and thus cannot know him.

PLATE XVIII

Job prays for his friends in Plate XVIII not with a burnt offering of seven bullocks and seven rams as in the Bible, but

with the offering of himself. Job has accepted the Lord. As the inscription makes clear, *"Also the Lord accepted Job"* (Job 42:9).

Blake has changed "he maketh his sun to rise" (Matthew 5:45) to *"he maketh his sun / to shine"* to accord with his design. In the text to this illustration, there are no longer any false standards of Good as opposed to Evil. God *"maketh his sun / to shine on the E / vil & the Good & / sendeth rain on / the Just & the Unjust / Be ye therefor perfect as your Father which is in heaven is perfect"* (Matthew 5:45 and 48; see also Luke 6:36). Job is not to be *"perfect"* as in the first plate where he *"eschewed Evil,"* but is to model his perfection on God who realizes and encompasses moral contraries. In the next plate, He is God of rich and poor, high and low—of all creation.

In the inscription *"And the Lord turned the captivity of Job when he prayed for his Friends"* (Job 42:10), *"turning"* refers both to Job's condition of turning to God and to his position in the design.[13] The figure of Job is turned around so that he faces inward and his prayer is thereby an inward, spiritual act.

PLATE XIX

Plate XIX is the counterpart of Plate V. In the earlier illustration, Job was setting himself up as a God. Now, humble, he realizes that it is God who *"maketh Poor & maketh Rich"* (I Samuel 2:7). Job was unable to give properly because he did not know how to receive. He must be a poor man in his acceptance of charity, a rich man in his bestowal of charity. In the Bible, the friends bring money and also comfort Job for "all the evil that the Lord had brought upon him" (Job 42:11). In Blake's interpretation, however, any loss Job experiences has been brought upon him by himself.

In the lower border the words *"Who remembered us in our low estate"* (Psalm 136:23) apply not only to this design in which low estate refers to Job's material possessions but also to earlier designs in which low estate describes his position in the illustration (lying down or sitting) and his inability to rise above his material existence to a vision of spiritual realities.

PLATE XX

In the twentieth design there is again a marriage of Heaven and Hell:

> *If I ascend up into Heaven thou art there*
> *If I make my bed in Hell behold Thou*
> *art there*
> (Psalm 139:8).

Ultimately all separations are unified in God.

Job was rich in material possessions in the first illustrations, but his values have now changed, as Blake shows us with the quotation from Psalm 139:17:

> *How precious are thy thoughts*
> *unto me O God*
> *how great is the sum of them.*

The inheritance that Job leaves his daughters and sons in the Bible is his property: *"& their Father gave them Inheritance / among their Brethren"* (Job 42:15). But from the design and the text of Psalm 139, we see that the heritage Job leaves to his children is the story of his suffering. Just as Blake is giving us a vision of Job, Job is revealing to his daughters his vision of God. As God taught Job, Job teaches his children.

PLATE XXI

In the last illustration, the quotation on the altar,

> *In burnt Offerings for Sin*
> *thou hast had no Pleasure*
> (Hebrews 10:6, see also Psalm 40:6),

points out that the burnt offerings and all of Job's other material conceptions are ineffectual in bringing blessedness and vision to Job and his family.

We found in Plate XVII a beginning of a combination of the Old and New Testaments. The passage at the top of the margin in this final design deals with an ultimate synthesis of the two parts of the Bible. The verse from which these lines come begins, "And they sing the song of Moses the servant of God, and the song of the Lamb" (Revelation 15:3). Seeing that both of these testaments are compatible is a result of Job's increasing vision and parallels his perception of both Good and Evil, Heaven and Hell, as part of God's creating powers. When the Lord *"blessed the latter end of Job"* (Job 42:12) in the Bible, He blessed him by conferring material prosperity upon him. In Blake's interpretation, God also blesses Job in the sense of pronouncing him holy.

As has often been pointed out, the central design on Plate XXI brings us back full circle to Plate I. Also the texts from the two plates are symmetrically arranged: the words enclosed in the clouds on the first plate are from the first book of the New Testament, and those in clouds on the last plate are from the last book of the New Testament; the texts on each side of the altar on the first plate are the first words of the Book of Job, and the texts similarly placed on the last plate are the last words of the Book of Job. Further, the text above the final design uniting the Old and New Testaments carries us back to the title page with its seven angels, for in Revelation it is these angels who sing the prophecy of union quoted in part in the upper border of Plate XXI. In most of Blake's illuminated books, he begins with an introduction to the visionary speaker from whose point of view the poetry springs. Thus in the "Introduction" to *Song of Innocence* we meet the piper and in the "Introduction" to *Experience* the

ancient bard. Similarly the title page of *Job* pictures those prophetic angels from whose point of view Blake's final and consummate vision of Job is presented.

Although I have pointed out a few patterns in Blake's selections and alterations, the very lack of a principle accounting for all modifications is perhaps more significant. Blake's freely ranging mind imaginatively associated different parts of the Bible in order to provide textual authority for his own interpretation of Job. This process, in effect, results in a Blakean typology, a way of bringing together biblical passages that reanimates the figural interpretations of the Bible which by Blake's time had lost their intellectual respectability. Blake's purpose, of course, is not arcane theology, but the striving toward his continual goal of expanded vision. His *Job* not only is a new reading of a single book in the Bible, but implies a reading of the whole Bible in terms of the life of one man. Job's spiritual re-creation, for example, is a genesis, and thus on Plate XIV Blake re-creates the Book of Genesis in the marginal texts and designs. While he restores and recasts the story of Job, he is in his textual selections restoring a methodology of biblical analysis. Blake's version of Job is a struggle from division toward a higher union; the bringing together of passages from several books of the Bible provides a formal parallel to this central theme.

NOTES

1. "Blake's Reading of the Book of Job" in *William Blake: Essays for S. Foster Damon*, ed. Alvin H. Rosenfeld (Providence, Rhode Island: Brown University Press, 1969), p. 222.

2. (London: Constable, 1924), p. 226, note 1.

3. *William Blake's Illustrations of the Book of Job* (Providence, Rhode Island: Brown University Press, 1966), p. 55.

4. I first dealt with some of these ideas in an unpublished paper written in 1966. Some of the material in this paper has been incorporated into Andrew Wright's *Blake's Job: A Commentary* (Oxford: The Clarendon Press, 1972).

5. All quotations appearing on Blake's *Job* engravings are printed in italics to distinguish them from quotations from the Bible not appearing in the *Job* illustrations. The lineation of the inscriptions on Blake's plates is indicated with a diagonal.

6. *Blake: Complete Writings*, ed. Geoffrey Keynes (London: Oxford University Press, 1971), p. 82—hereafter cited as K. *The Poetry and Prose of William Blake*, ed. David V. Erdman (Garden City, New York: Doubleday, 1965), p. 586—hereafter cited as E.

7. 2nd ed. (London: J.M. Dent, 1924), p. 94.

8. Wicksteed, p. 85; Wright, p. 54; Damon, *Blake's Job*, p. 56.

9. Wicksteed, p. 134.

10. Wicksteed, p. 147.

11. This quotation does not appear in the series of the Job engravings, but it does appear in part on the second state of Blake's large separate plate of Job, 1793. See Geoffrey Keynes, *Engravings by William Blake: The Separate Plates* (Dublin; Emery Walker, 1956), pp. 10-12, pl. 7 [reproduced here as Illustration 12].

12. Henry Crabb Robinson, from "Reminiscences," 1852, reprinted in G.E. Bentley, Jr., *Blake Records* (Oxford: Clarendon Press, 1969), p. 540.

13. In the first Job series, executed in watercolors for Thomas Butts, Job faces forward. The change in all subsequent series may very well have been suggested by the line in Job 42:10.

Index

Numbers in italic refer to illustrations by page.